N.2

THE ART *and* SCIENCE *of* WILLIAM BARTRAM

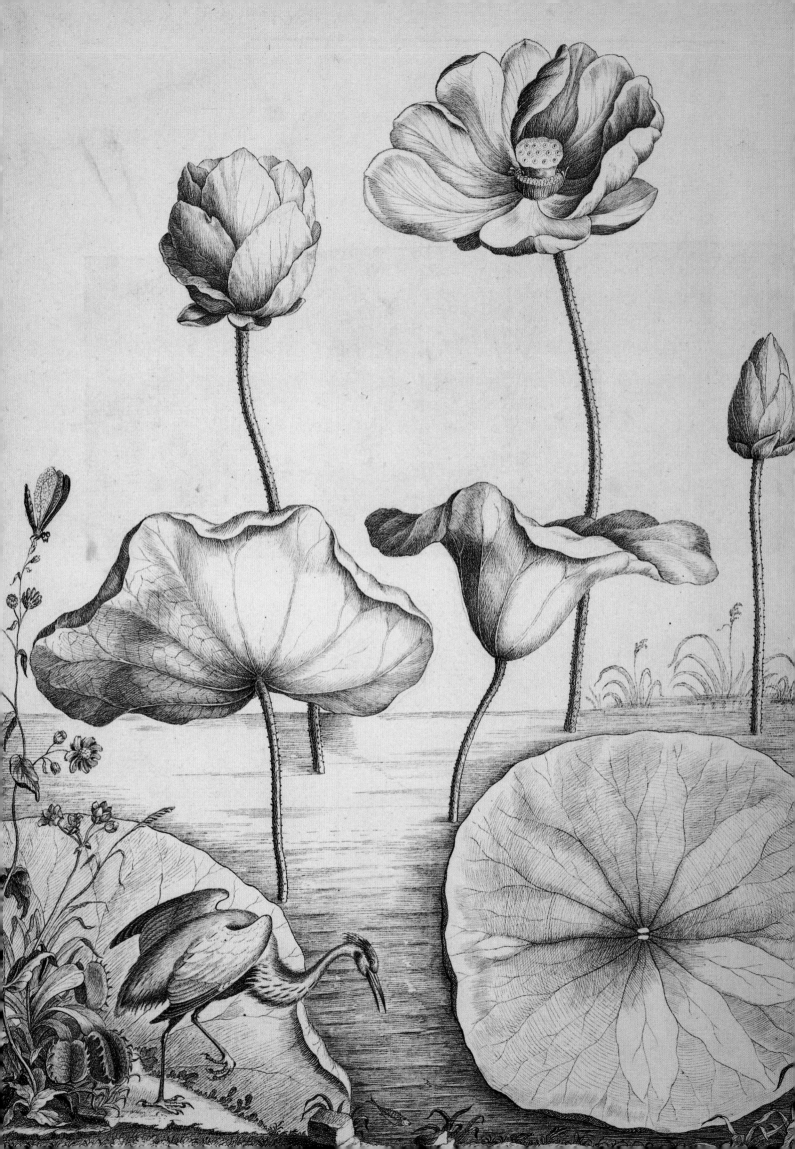

THE ART *and* SCIENCE *of* WILLIAM BARTRAM

JUDITH MAGEE

THE PENNSYLVANIA STATE UNIVERSITY PRESS
UNIVERSITY PARK, PENNSYLVANIA
in association with the
NATURAL HISTORY MUSEUM, LONDON

Library of Congress Cataloging-in-Publication Data

Magee, Judith, 1952–
 The art and science of William Bartram / Judith Magee.
 p. cm.
Includes bibliographical references and index.
ISBN-13: 978-0-271-02914-6 (cloth : alk. paper)
ISBN-10: 0-271-02914-5 (cloth : alk. paper)
1. Bartram, William, 1739–1823.
2. Naturalists—Pennsylvania—Biography.
3. Natural history illustrators—Pennsylvania—Biography.
I. Title.

QH31.B23M34 2007
508.092—dc22
[B]
2006020012

Contents

vii *Acknowledgments*

ix *Chronology*

1 Prologue: Explorer, Naturalist, and Artist

PART ONE: FORMATION

15 1 Plant Hunting and the Seed Trade

33 2 The Merchant's Apprentice

45 3 Cape Fear and Competition

PART TWO: EXPERIENCE

63 4 Travels in Florida with the King's Botanist

81 5 Finding a Patron

PART THREE: INDEPENDENCE

97 6 Travels: Revisiting Old Haunts and Discovering New Ones

123 7 Encounters and Observations

133 8 The Arcadian Dream

141 9 Describing, Classifying, and Naming

PART FOUR: INFLUENCE

157 10 American Science Comes of Age: Ornithology

181 11 American Science Comes of Age: Entomology

193 12 Following in Bartram's Footsteps

211 Epilogue: Contentment and Serenity

217 *List of Illustrations*

237 *Biographical Notes*

243 *Notes*

251 *Bibliography*

259 *Index*

Acknowledgments

I OWE DEBTS OF GRATITUDE to many people for discussing William Bartram with me, reading through lengthy typescripts, identifying species, and providing support and encouragement.

My main support came from Michael Schlesinger, who, with Ella Schlesinger and Chris Mills, ungrudgingly read through the manuscript and made appropriate suggestions.

Special thanks go to Amy Myers and Alan Armstrong, two people whose generosity with their knowledge and insight is unsurpassed and whose discussions with me were stimulating and instructive.

A very big thank-you to Victor Schonfield for checking the text and offering helpful suggestions. To Nigel Frith from Alecto Editions, who listened endlessly to my tales of William Bartram and his travels.

Further thanks go to a long list of staff from the Natural History Museum: Malcolm Beasley, Fiona Baker, and Armando Mendez from the Botany Library; Sandy Knapp, Charlie Jarvis, and Chris Humphries from the Botany Department; Martin Honey from the Entomology Department; Colin McCarthy, Barry Clark, and Jonathan Ablett from the Zoology Department; and Mark Adams and Michael Walters from the Bird Division of the Zoology Department, all of whom helped in the identification of species and current nomenclature. Thanks to all the staff from the Libraries of the Natural History Museum who continued to give encouragement throughout the project. Lorraine Portch from the Reprographics Unit was always willing and helpful in providing copies at very short notice, as were Rupert Calvocoressi and Jamie Owen in the Picture Library.

A special thanks goes to Pat Hart from the Photo Unit, who reproduced all the images for this book, and to Trudy Brannan, from the publishing division of the Museum. From Penn State University Press, Gloria Kury for her insight and encouragement, Cherene Holland for her excellent editing skills, and Stephanie Grace and Cali Buckley, all of whom were a delight to work with.

The following institutions have generously given permission to use quotations from unpublished material in their possession: the Academy of Natural Sciences, Philadelphia; the American Antiquarian Society; the American Philosophical Society; the Ernst Mayr Library, Museum of Comparative Zoology, Harvard University; the Historical Society of Pennsylvania; the Library of Congress, Manuscript Division; the Linnean Society of London; the New-York Historical Society; the National Library of Scotland, Manuscripts Division; and The Royal Society.

Thomas Slaughter, Edward Cashin, Charles Nelson, and Daniel McKinley also gave their support and permission to quote from their published works.

For Mike, Ella,
and Leon

Chronology

1682 The first ships set sail for Pennsylvania from England. The passengers were mainly Quakers, members of the Society of Friends, a dissenter group fleeing persecution. William Penn, the proprietor of Pennsylvania, was himself a Quaker and saw the new colony as "a holy experiment" that would become "the seed of a nation."

1699 John Bartram is born to a Quaker family in Darby, Pennsylvania.

1729 Marriage of John Bartram and Ann Mendenhall.

1730 Matthew Tindal publishes *Christianity as Old as the Creation*.

1731 The Library Company is established in Philadelphia by Benjamin Franklin.

1735 Linnaeus publishes *Systema Natura*.

1739 9 April, William Bartram and his twin sister, Elizabeth, are born.

1743 The American Philosophical Society is founded by Benjamin Franklin with John Bartram.

1749 Buffon's *Histoire Naturelle* is published (1749–1804).

1753 Linnaeus publishes *Species Plantarum*. ❧ John Bartram visits the Colden estate with his son William.

1756 William Bartram completes his formal education at the College of Philadelphia. In December he starts his apprenticeship as merchant with Captain James Child in Philadelphia.

1759 Arthur Dobbs, governor of North Carolina, writes to Peter Collinson about the "catch sensitive" plant, *Dionaea muscipula*, Venus Flytrap.

1761 William Bartram embarks on a career as a merchant at Cape Fear, North Carolina. He lodges with his uncle, also named William Bartram, and his family.

1762 John Bartram succeeds in cultivating the Venus Flytrap.

1763 William Young is appointed the Queen's Botanist. The Treaty of Paris ends the French and Indian War in America and opens up Spanish Florida to the British.

1764 William Young sets sail for England in September to be tutored by John Hill.

1765 John Bartram is appointed King's Botanist. ❧ John and William Bartram embark on a ten-month plant-hunting trip to Georgia and Florida. In October they wander from their path and discover the beautiful *Franklinia alatamaha*, a plant now extinct in the wild.

1766 William Bartram remains in Florida at Six Mile Creek, north of Picolata, and attempts to make a living as a planter, growing rice and indigo. This endeavor soon ends in disaster and by November he has abandoned his plantation.

1767 William returns to Philadelphia either in the late spring or summer and by the end of the year is working as a day laborer. William completes a number

of drawings for Peter Collinson, one of which is the first depiction of the Venus Flytrap. He completes the drawing about the same time as William Young's drawing of the same plant.

1768 Death of Peter Collinson in August. ❧ William Young sails to England with living plants, some of which are Venus Flytraps.

1770 In late summer William flees to North Carolina to escape creditors. In the fall he writes to his father of the death of his uncle and cousin at Cape Fear.

1771 William considers moving to Augustine, Florida, an idea his father considers ruinous.

1772 William moves to Charleston, South Carolina, and in late summer writes to John Fothergill requesting support for a plant-hunting trip through Florida, to which Fothergill agrees. By the end of the year, William returns to Philadelphia to prepare for his travels.

1773 In March, William sets sail from Philadelphia to Charleston for the start of his travels. ❧ In June he attends the Congress of Augusta between the British and the Creek and Cherokee nations. ❧ He spends the winter in Savannah, Georgia.

1774 From March to September, William travels the St. Johns River using the lower and upper Spalding trading stores as his base. In April he pays his first visit to Cuscowilla and the Alachua Savanna. His second visit is in June.

1775 From June to October, William travels through West Florida as far as the Mississippi River.

1776 Thomas Paine publishes *Common Sense*. ❧ From January to October, William stays with the McIntosh family in Darien. He travels along the Georgia coast and Altamaha River. ❧ 4 July. The Declaration of Independence and the onset of the American Revolution. ❧ In November, William returns to Philadelphia.

1777 William arrives at Kingsessing in early January. September. John Bartram dies. He leaves the garden and seed trade to his son John.

1778 William Bartram takes the oath of allegiance to the United States.

1779 14 March. Pennsylvania becomes the first state to abolish slavery.

1780 Death of John Fothergill.

1782 William Bartram is offered the position of professor of botany at the University of Pennsylvania. (No record exists of his declining the position, but he never gave any lectures.)

1783 The Treaty of Paris brings peace between the United States and Britain, thus ending the American Revolution. ❧ John and William Bartram produce a catalogue of plants from their garden.

1784 Death of Ann Mendenhall Bartram, William's mother.

1785 William Young plunges to his death at Gunpowder Creek, Maryland. ❧ André Michaux arrives in America from France.

1786 Charles Willson Peale opens the first public museum in the United States in Philadelphia. ❧ William falls from a cypress tree in his garden and breaks his leg.

1787 10 June. George Washington visits the Bartram garden. ❧ 14 July. Alexander Hamilton, James Madison, and other members of the Constitutional Convention visit the Bartram garden.

1788 William completes a watercolor drawing of *Franklinia alatamaha* and sends it to Robert Barclay in London in an attempt to have it recognized as a new genus.

1791 *Travels through North & South Carolina, Georgia, East & West Florida* is published.

1794 Alexander Wilson leaves Scotland for America.

1801 Thomas Jefferson is elected president of the United States.

1802 William Bartram meets Alexander Wilson for the first time.

1803 The last recording of *Franklinia alatamaha* in the wild is made by John Lyon. ❧ Benjamin Smith Barton publishes *Elements of Botany*.

1803 The beginning of the Lewis and Clark Expedition (1803–6).

1804 A celebratory dinner for Alexander von Humboldt is held at Peale's Museum.

1805 William Bartram is invited to be a member of the Red River Expedition, which he eventually declines.

1808 The first volume of *American Ornithology* (1808–14) is published. ✹ Thomas Nuttall arrives in Philadelphia from England.

1809 Marriage of Nancy Bartram and Robert Carr.

1812 The beginning of the war between the United States and Britain (1812–15). ✹ The Academy of Natural Sciences is founded in Philadelphia. William is unanimously elected a member. ✹ Death of John Bartram Jr.

1813 Death of Alexander Wilson.

1815 Death of Benjamin Smith Barton.

1817 An expedition is organized by William Maclure to Georgia and Florida to retrace Bartram's footsteps.

1819 Major Stephen Long conducts an expedition to the Platte River and Rocky Mountains. ✹ Death of William Baldwin.

1823 22 July. Death of William Bartram.

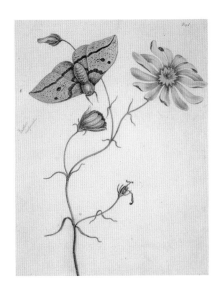

Explorer, Naturalist, and Artist

ONE WARM AND SULTRY DAY IN MAY 1775, William Bartram lay under the shade of spreading trees and floriferous fragrant shrubs watching the "unparalleled cascade of Falling Creek, rolling and leaping off the rocks." The heat of the day and the fatigue of climbing the mountain had taken its toll. Surrounded by "vegetable beauties," some of which plunged "their perfumed heads" and bathed their "flexible limbs in the silver stream," Bartram embraced the sheer beauty and "sublime magnificence" of the landscape. In time, he collected specimens at this friendly retreat and continued his "lonesome pilgrimage."[1] William Bartram had by then been traveling for some two years in the southeastern region of North America, the first American to travel extensively in these parts previously unexplored by naturalists. Here he gathered seed and plant specimens, made drawings of animals and plants, and wrote a journal for his patron, Dr. John Fothergill of London. When he returned to his family home in Kingsessing, Philadelphia, in 1777, he began to write about his travels, which resulted in his remarkable book, *Travels through North & South Carolina, Georgia, East & West Florida*, published in 1791.

By 1791 America was struggling to shape itself into an independent nation, particularly in the areas of politics, culture, and science. The future president of the United States, Thomas Jefferson, lamented in 1785 that in the field of natural history Americans had "done too little for [themselves] and depend[ed] too long

on the ancient and inaccurate observation of other nations."[2] Within forty years of this statement, science in America had made considerable headway and a science distinct from British colonial science began to emerge. An independent scientific establishment developed, one that contributed significantly to the forging of the identity of a new nation. It was this momentous task of creating a nation that the revolutionary leaders of America were faced with in 1776, when they declared that "these United Colonies are, and of Right ought to be Free and Independent States." For many of those political leaders it was to the sciences, and particularly natural history, that they looked for help in developing cultural independence. The pursuit of the study of the natural history of America was in itself a patriotic activity because it described the productions of the New World. The desire to explore, discover, describe, name, and classify the natural world helped serve the utilitarian principles of the age and define the character and future of the young nation. The analogy of a social order with that of the natural order was a strong one and by giving identity to the natural world through the science of taxonomy, the identifying and naming of species, a national identity evolved. The identification and naming of American species by Americans was of enormous significance in the development of the new nation. William Bartram's protégé, Alexander Wilson, summed up the mood of the time when he laid down the challenge to American scientists in his proposal for the publication of his *American Ornithology:* "It remains now with Americans themselves to decide, whether they will still send across the Atlantic for an account of the productions of their own country, or become, like every other enlightened people, the proper historians of their own territories."[3]

William Bartram today is recognized as someone who represented a link in the transitional period of a country by bridging the two eras of American history: the one reliant on Europe for every aspect of its science, the other of a nation-state with its own scientific community. This community would come to be regarded by the end of the first quarter of the nineteenth century as an equal member within the international scientific fraternity. Bartram was a pivotal figure in the development of botany and zoology in the new republic and had a special understanding of Native American affairs, having lived and traveled among the indigenous people of the southeastern states and observed their traditions and cultures firsthand. He was regarded by his contemporaries as one of the most generous and influential of men in sharing his knowledge of natural history, a knowledge that was in some areas second to none during his lifetime. Although such characteristics are important to help understand the kind of man William Bartram was, with most individuals who are remembered it is not solely for such qualities. It was his views and understanding of nature that represented something quite different from the dominant ideas of the late eighteenth century that led him to be truly inspirational to many of the young minds in American science in the nineteenth century.

William Bartram spent most of his adult life content in what was often a solitary activity—the study and contemplation of nature. He avoided public recognition and believed that personal ambition was a characteristic that led to avarice and war, and thereby to human unhappiness. Because of his genuine modesty, he

never really appreciated his own influence among the naturalists and poets of his day, many of whom were indebted to Bartram for his depth of knowledge, his assistance in their own work, and, above all, his friendship. His own writings and his encouragement of other naturalists, men such as Alexander Wilson, Thomas Say, and Benjamin Smith Barton, helped to shape American science in its struggle to be distinct and independent.

As British colonies until the mid-1770s, America had been dependent on Europe for printing, publishing, and, more often than not, the writing of scientific literature. Similarly, the identification, naming, and classification of species was also carried out by Europeans, many of whom had never traveled to the New World but relied on specimens that were sent to Europe, either by visitors or residents of the country. In addition to this intellectual dependency, Americans relied on Europe for all equipment and materials, ranging from pens, ink, and paper to scientific instruments. No scientific journals were published in America in the first half of the eighteenth century and, until the American Philosophical Society was founded in 1743, there were no scientific organizations or societies such as existed in Europe. By the early years of the nineteenth century, America had been independent for thirty years and a new, self-reliant nation was emerging. In several cities, societies for the arts and sciences were formed, each publishing journals and transactions of their own. Precision-instrument makers, paper manufacturers, and quality printers were now established in many cities.[4]

A new approach to the study of science emerged, an approach that was directed by the patriotism of the day and inspired by the ideals of Thomas Jefferson. The systematic study of the flora and fauna of America began to predominate in science and helped define the country's new political identity. The assertion of an American interpretation of such research countered the conjectures and unfounded opinions of European naturalists, such as those expressed by George Louis Leclerc, Comte de Buffon, who considered New World species inferior to those of Europe. Buffon argued that species that originated in Europe but at some time in their history had made their way to America had deteriorated because of the change in climate and nutrients. Many, including Thomas Jefferson and William Bartram, gave spirited rebuttals to such assertions. It was also recognized that such theories could be refuted only through scientific research. Taxonomy, the naming and describing of plants and animals, thus began to flourish in America and plant hunting now had a new purpose in addition to serving the medical profession.

In the one hundred years before the American Revolution in 1776, Europe had undergone its own scientific revolution, dominated by the theories of Isaac Newton. The impact of Newtonian science on eighteenth-century philosophical thought was profound. Newtonian laws that applied to the physical sciences and explained certain phenomena, such as falling objects and the orbit of the planets, were adopted as a model for other sciences. The "mechanical philosophy" that everything could be explained by mechanical laws encouraged the questioning and sometimes a denial in the existence of a spiritual God and a belief that all physiological processes, including the spiritual life, could be explained by the laws of nature. When the Royal Society of London was founded in 1660, it set in

motion an explosion of scientific activity that was distinctly separate from the two domineering forces of religion and politics.

In the eighteenth century, the Age of Enlightenment, leading figures of the day critically examined previous beliefs and claimed to be guided by rationalism rather than superstition and revelation. The overriding characteristics of the Enlightenment were an emphasis on reason, a belief in the universality of science and education, and a faith in humankind to manipulate and exploit the environment for the benefit of society. The empiricism of Newtonian science, that all knowledge came from experience, was united with the eighteenth-century philosophical idea of Rationalism, in which knowledge came from reasoning. A further expression of the Enlightenment was the philosophical ideas associated with Gottfried Leibniz, who was an advocate of the theory of the Great Chain of Being, in which every living organism had its place but also attributed a linear progression to the chain, with God's chosen species dominating all. The fashion for collecting natural history specimens, so prevalent in the eighteenth century, fitted neatly into the Great Chain theory. The cabinets were seen as miniature worlds with humans in complete control. At the same time, these overflowing cabinets were in urgent need of order. Nature itself was one enormous cabinet and applying order to the riches within it became a priority. This desire for order that came to characterize Enlightenment thought, and that is seen today as one of its lasting achievements, was epitomized by the Linnaean classification system, which was applied to all living things. By the end of the century, taxonomy and systematics began to dominate over the other trend in the study of natural history, that of observation and description.

The success of the Royal Society in London was by no means unique. By the first half of the eighteenth century, national scientific societies modeled on the Royal Society were being established in most European capitals, as well as in provincial and regional towns. Between 1660 and 1793, Europe had "seventy official scientific societies and almost as many private ones."[5] The publications of these societies expressed the philosophical views of thinkers and all aspects of science, including technology. The growth of literature and publications in science together with the trend toward systematizing knowledge meant that science could be studied by a much wider audience. One of the most influential of such works was Buffon's *Histoire Naturelle*, published in forty-four volumes between 1749 and 1804. *Histoire Naturelle* was written in a language comprehensible to those with an interest in natural history and from all levels of society, not just the scientist. The publication of popular scientific works enabled an exchange of ideas that previously had been confined to a small network of individual correspondents. This global exchange of letters among scientists, philosophers, and enthusiasts that dominated the first half of the century was fundamental to the development of science as a whole. The personal relationships that existed through letter writing and the debates they engendered stimulated the growth of the scientific societies and their publications.

At the same time, nautical exploration was opening up new parts of the world to Europe and with it brought economic benefits and scientific discoveries, par-

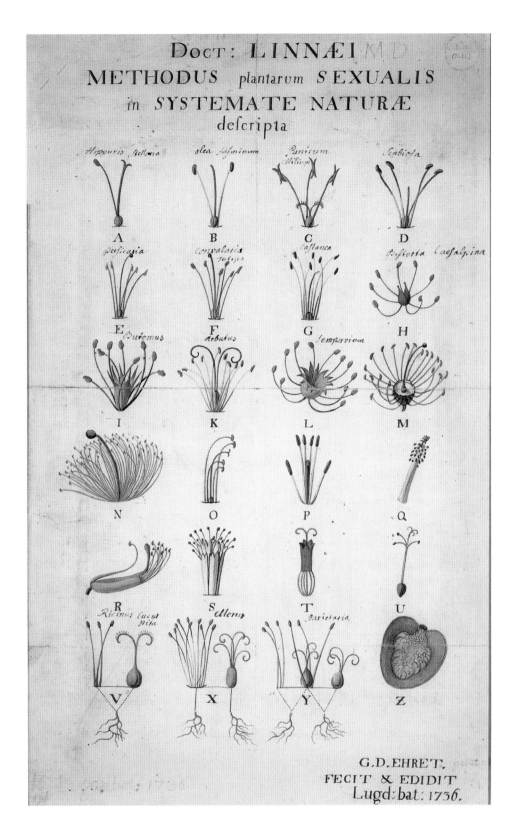

GEORG DIONYSIUS EHRET
(1708–1770)
Methodus plantarum sexualis in sistemate naturae descripta: The sexual system of Linnaeus.

ticularly in natural history. By the eighteenth century, exploration, scientific discoveries, and the development of technology created what became known as a culture of "the curious." The wealth resulting from colonialism, the increased trade in Europe, and the beginning of manufacturing allowed certain layers of society to explore their own leisure interests, including scientific pursuits and in-

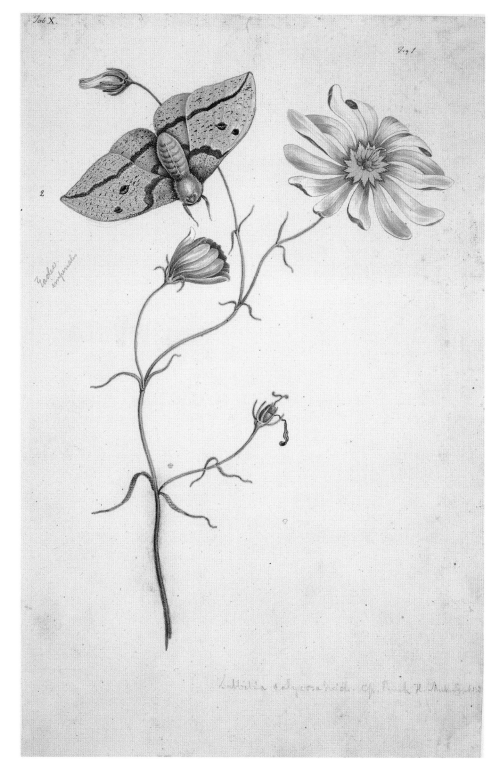

SAVANNAH PINK OR
BARTRAM'S SABATIA
Sabatia bartramii Wilbur
(Gentianaceae)

IMPERIAL MOTH
Eacles imperialis
(Drury) (Saturnidae)

dulging in the pleasures of growing exotic plants and creating splendid gardens. The increase in wealth for some and their enlightened thinking meant that science, and particularly natural science, began to assume a prominent role within society at large.

In America, science underwent a similar process, but at a much slower rate. Before the revolutionary war, contact with Europe was the key to all scientific

development. Despite the increase in scientific literature, the major vehicle for such intellectual contact between the curious of the two continents remained the network of men who debated and developed ideas through their letters and exchanged natural objects and artifacts. Plants, animals, both dead and alive, and minerals and fossils were sent to Europe in exchange for live European plants and intellectual knowledge in the form of books, pamphlets, and scientific instruments. The Bartram family was an important contributor to this trade with Europe. John Bartram, William's father, was one of the major participants in the exchange of plants during his lifetime and was responsible for introducing as much as one-third to one-half of all North American plants to Europe from 1730 to 1770. He created one of the first botanical gardens in America on the banks of the Schuylkill River at Kingsessing, four miles from Philadelphia, and was appointed the King's Botanist in 1765. Alongside Benjamin Franklin, he was a founding member of the American Philosophical Society. Of possibly even greater repute was his son William, who through his writing helped influence the young naturalists who would shape the future of American science.

William Bartram's early years were marked by an extremely close relationship with his father. They traveled extensively together and shared the same love of nature. From a large family of siblings, William was the only one to attend the Academy of Philadelphia. Here he studied the classics, philosophy, and poetry, but it was his father who educated him in natural history and took him as his companion on his plant-hunting trips. With his father, William learned about plants, animals and birds, minerals, and the structure of the earth. With his father's encouragement, he developed a skillful hand at drawing accurate renderings of what he observed in nature. This common interest was strong enough to sustain the close relationship between the two men throughout their lives, but not without some major upsets along the way. The designs and aspirations John held for his son in finding employment and establishing a career contrasted significantly with William's own vision and desires. William's first love was nature, observing, drawing, and writing about it, and he was content to devote his life to it. As an adult, William had to contend with his father's imposing nature, while his own gentle and sensitive disposition left him ill equipped for such struggles.

When in 1773 William embarked on a journey of his own, and for the next four years wandered through the wilderness of North and South Carolina, Georgia, and East and West Florida, traveling as far as the Mississippi, he was ostensibly in search of plants and natural products that would be useful to society. In reality, though, the trip was truly a quest for his personal freedom. During these same years, America was struggling to become a nation and fighting against the tyranny of colonialism. When William returned to Philadelphia from the South in early 1777, the American people had freed themselves from the yoke of British rule, while William as well had succeeded in asserting his own independence. He now began to write about his travel experiences, conveying to his readers his own love and distinct understanding of nature and pioneering a trend in narrative travel books that were published in America. His *Travels*, published in numerous

editions, was read by an array of scholars, scientists, and poets. Together with Jefferson's *Notes on Virginia*, Bartram's book helped American science assert its independence from Europe. Throughout the book Bartram describes the grandeur and robust beauty of native plants and animals and of the indigenous peoples he encountered. He demonstrated in his writings and drawings that America's flora and fauna were equal to those of any other country.

In his *Travels*, Bartram accurately observes the flora and fauna of the region and describes the habitat of individual species and the behavior of various animals. But the book was not only a scientific work that recorded the natural history of a particular region of North America, much of it new to science. In it, Bartram also told of his exciting encounters with rattlesnakes and alligators, of grieving bears and giant spiders, and his surviving subtropical storms. Another significant part of his work is his firsthand observations of the Native American peoples of the region. *Travels*, however, is also a work of literature, written in a style that bursts with poetic imagery. Its prose was so powerful that it gripped the imaginations of the great Romantic poets such as Samuel Taylor Coleridge and William Wordsworth, who borrowed heavily from *Travels* to give color and imagery to their poetry. One commentator described Bartram as having the mind of a scientist and the soul of a poet.[6]

Despite Bartram's semireclusive nature during the last forty years of his life, he was nevertheless the most influential single figure in natural history in postrevolutionary America. His knowledge of American birds was unsurpassed by anyone during his lifetime; his plant discoveries were followed up and sought after by botanists; he was also an important mentor to many young naturalists. His views on nature were quite uncommon during his life and have only more recently been incorporated into modern environmental and ecological theories of nature. There are three areas where William Bartram challenged the current thinking of the late eighteenth century. These were given center stage in his introduction to *Travels* and permeate the book. He challenged the hierarchical theory of the Great Chain of Being, refuted the ideas of Buffon and his followers, and made clear his admiration of Native Americans' relationship with nature.

William Bartram was not only a botanist and writer, he was also an artist. From the time he was a child, he immersed himself in drawing plants and animals. His drawings complement his writings in revealing his understanding of the complexities of nature. Some of his artworks are delicately executed in watercolor, but his real talent lay in his fine pen-and-ink drawings. The excellent hatching technique he developed lent itself beautifully to displaying fine detail. Many an observer has been deceived at first sight into thinking the image was an engraving rather than a drawing. The collection of artwork held in the Natural History Museum in London comprises sixty-eight drawings, forty-three of them completed during Bartram's travels in the American South. In 1968, the American Philosophical Society, under the direction of Joseph Ewan, published most of these drawings. Three drawings from the collection were omitted from the book and were thought to have been missing. These drawings have now been correctly identified and are included here.

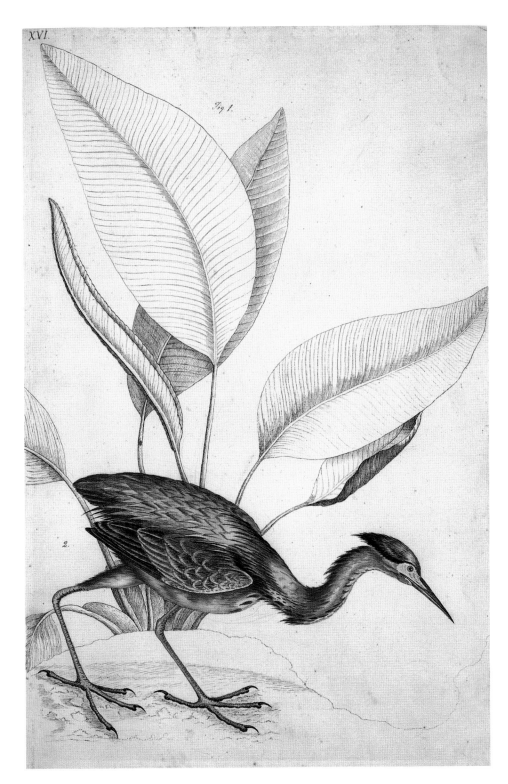

XVI.

THALIA
Thalia sp L. (Marantaceae)

GREEN HERON
Butorides virescens
(Linnaeus)

Although William Bartram suffered some neglect in the nineteenth and early twentieth centuries, certain scholars, particularly botanists, such as Joseph Ewan and his wife, Nester Ewan, have revisited his work and collections to bring attention to Bartram's important contribution to the formation of American science. Francis Harper's edition of William Bartram's *Travels* with commentary and an annotated index is invaluable for anyone wishing to have a broader un-

derstanding of the places and events mentioned in the book.[7] Nathan Bryllion Fagin and John Livingston Lowes have both published books on the influence of Bartram's descriptive and evocative language on the European Romantic poets.[8] More recently, a body of work has contributed to the understanding of William Bartram and his place in American science, including, among others, Thomas Slaughter's book on John and William Bartram, Edward Cashin on Bartram and the American revolution, papers by Joel Fry on *Franklinia alatamaha*, and Robert Peck, Bruce Silver, and Larry Clarke on Bartram's religious and philosophical views.[9] There is also the interesting commentary on Bartram's writings on Native Americans by Gregory Waselkov and Kathryn Braund.[10] The present book brings together many of the strands developed by these authors in one volume to provide a more rounded picture of William's achievements. Primary sources such as original correspondence are important in understanding the people and the times and several books provide essential access to these sources. William Darlington's work of 1849 and the more recent and comprehensive volume of John Bartram's correspondence edited by Edmund and Dorothy Smith Berkeley have been invaluable.[11] Of similar merit is Clark Hunter's volume of Alexander Wilson's correspondence.[12]

Today William Bartram's *Travels* remains in print and continues to be read by a wide variety of scholars in natural history and the arts. Zoologists, botanists, and ethnographers still refer to Bartram as a source and some present-day writers of fiction are as influenced by Bartram as much as Coleridge was two hundred years ago. In the novel *Cold Mountain*, Charles Frazier's hero, Inman, claims that Bartram's *Travels* never failed to ease his thoughts and that it "stood nigh to holiness and was of such richness that one might dip into it at random and read only one sentence and yet be sure of finding instruction and delight."[13]

PART ONE

Formation

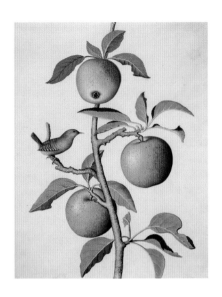

Plant Hunting
and the Seed Trade

ON 9 APRIL 1739, William and his twin sister, Elizabeth, were born to Ann and John Bartram. Both children survived to adulthood, as did seven of their brothers and sisters. Ann Mendenhall, William's mother, was a strong, healthy woman who bore nine children and raised and cared for them while working alongside her husband in farming the land. She lived into old age and died in the house that she and John moved to when they married in 1729. Ann was the second wife of John Bartram and their marriage took place two years after the death of John's first wife, Mary Maris, and their eldest son, Richard, three years old. Mary's second son, Isaac, survived and lived with his father and Ann and in later life became an apothecary, working in Philadelphia. The house and farm that John brought Ann to on their marriage was situated at Kingsessing on the west bank of the Schuylkill River, some four miles southwest of Philadelphia. John had substantially enlarged the house himself using stone that he hewed from local bedrock. The house still exists today, kept by the John Bartram Association as a museum and botanical garden. To visit the house, one can take a trolley from City Hall in Philadelphia, which takes the visitor southwest of the city to a stop across from the garden.

The grounds of the Bartram house are nestled between the Schuylkill River, which flows past the far end of the garden, and municipal housing of red brick and weatherboard houses that stretches block upon block along the busy main road.

All Nature is but Art Unknown to Thee.

—ALEXANDER POPE,
"ESSAY ON MAN," EPISTLE I

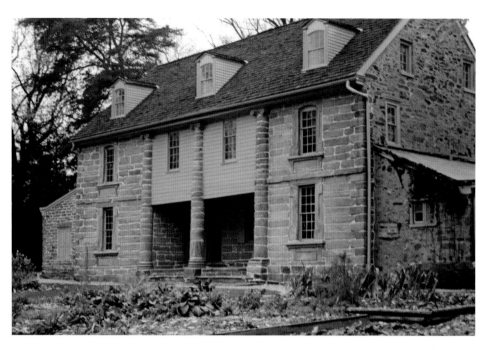

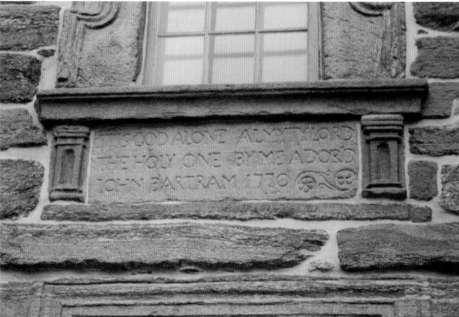

Photograph of the house and upper terrace garden built by John Bartram. The inscription on the lintel reads:

"IT IS GOD ALONE ALMYTY LORD / THE HOLY ONE BY ME ADOR'D / JOHN BARTRAM 1770."

These houses are not visible from the house or garden, which allows the visitor to capture a glimpse of what life was like in the eighteenth century. The large, well-proportioned stone house overlooks a rambling garden that rolls gently down to the river. Herbs, shrubs, and trees abound, including the oldest Gingko tree in the country and the famous *Franklinia* that John and William discovered in 1765. The various sections of the garden are full of native plants that the Bartrams grew and listed in their 1783 *Catalogue of American Trees, Shrubs and Herbacious Plants*. It was in this house that Ann and John lived out their lives, farming the adjacent land and raising and educating their large family.

The Bartrams were members of the Religious Society of Friends and lived within a large Quaker community that had settled in Pennsylvania in the late

seventeenth century. Pennsylvania was born out of religious dissent. Its founder and proprietor, William Penn, had secured the land west of the Delaware River in 1681 as payment of a debt owed to his father by King Charles II. William named the land in memory of his late father. Like the Bartrams, Penn was also a member of the Society of Friends, a group that questioned the established beliefs of the age. As a result, they were severely persecuted in England, where punitive laws existed that prevented them from worshiping in chartered towns and excluded them from holding public office, teaching, and attending university. William Penn had spent almost nine months imprisoned in the Tower of London for his beliefs and recognized that his newly acquired land could be a refuge for the persecuted members of his religious sect, a land where religious freedom would prevail. In 1682 the first of many ships set sail from England bound for the New World and the colony that Penn described as "a holy experiment" that would become "the seed of a nation." Pennsylvania expanded at a considerable rate and was the fastest-growing colony of the time. The predominant settlers were English Quakers, but there was also a large community of Germans, the so-called Pennsylvania Dutch. The colony prospered rapidly because of several factors: the rich farmland that was cleared by the settlers, the industrious nature of the settlers, and, above all, the success of William Penn in establishing peace with the local Native Americans. In 1683 Penn signed several treaties with the Delaware Indians that were essentially maintained for fifty years. These fifty years of peace, which no other colony in America experienced, allowed Pennsylvania to establish a city building program, commerce, industry, and farming. Stimulated by economic success, Philadelphia soon became the intellectual and cultural center of North America.

Among those early settlers in Philadelphia were William Bartram's great-grandparents, who had left Derby, England, in 1683 for their new life of farming the land in Darby, Pennsylvania. It was here that William's father, John, was born in 1699. John inherited land from his grandmother and uncle when they died and in 1728 added to that already substantial landholding by purchasing an additional 112 acres at Kingsessing. It was here that he built his house, farmed his land, and established what was to become the first botanical garden-cum-nursery in America. The garden at one time probably contained a greater variety of plants from around the world than any other on the North American continent, including an array of indigenous plants from the Northeast. It was never landscaped for aesthetic splendor but remained a working garden and nursery, propagating plants for their interest, beauty, and, above all, for the seed trade that John Bartram established. It was from this garden that John supplemented his income by growing plants he collected on expeditions up and down the eastern coast of North America and by processing the seeds to send to Europe. During his long life, John Bartram built up such a successful trade in plants and seeds to Europe that it allowed one of his sons, also named John, to earn his living solely from this trade. John Bartram Jr. had taken an early interest in the seed trade and assisted his father from adolescence, thereby earning praise from his father's English friend, fellow correspondent and agent Peter Collinson, who described him

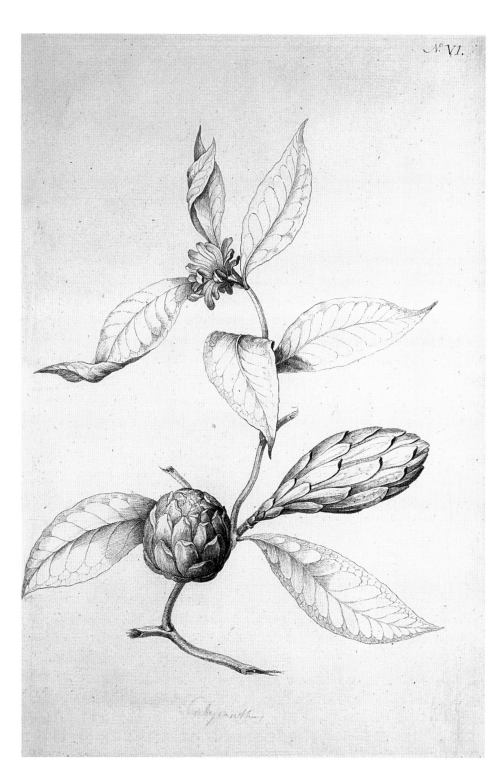

CAROLINA ALLSPICE OR
STRAWBERRY SHRUB
Calycanthus floridus L.
(Calycanthaceae)

as "Our [John & Peter's] right hand man," and proclaimed, "How happy is it to have children of so agreeable a Cast."[1] It was John Jr. who inherited, on his father's death, the garden and the seed trade.

John Bartram's love and care for his family is unquestionable, but he was a formidable father who was ambitious for his children. He passed down to all his children his own interest in nature, particularly plants. His son John took a great interest in the garden and James, the son who inherited the farmland, was an

authority on local flora. Two other sons, Isaac and Moses, became apothecaries, their interest lying in the medicinal properties of plants. But it was William, John's fifth son, a twin, physically rather fragile, artistically talented, and exceedingly sensitive, with whom John had a special affinity. It was William who traveled as a boy with his father, collecting plants for the garden and drawing the plants and animals they encountered on their expeditions. In later life it was William who continued to explore the wilderness so loved by his father and who succeeded in reaching the Mississippi River in his travels, something his father had dreamed about but never accomplished. It was William who became the son publicly associated with Bartram's Garden, where, in later years, visitors from around the world would venture out of their way to pay their respects to the "venerable" old man. It was also William who presented the greatest challenge to his father. He was a son whose own nature and vision of his future were contrary to his father's. While William revered his father and tried to please him, he rarely did so and found that the only way he could resist his father's overpowering presence was to retreat rather than confront.

John Bartram was a strong, resolute, and steadfast man who would never truly appreciate the doubts, dilemmas, and internal struggles that at times troubled others. John revealed his anxieties and frustrations with William in some of his letters to Peter Collinson, asking advice on William's career and relating his own disappointments with his son. Toward the end of John's life, the relationship between father and son became less fraught. From the few letters that exist between them during those years, John's seem to have a tone of resignation rather than reconciliation. William's liberation came through his travels and by his mid-thirties he reveals in his last extant letter to his father a relationship of equal partnership.

John and Ann Bartram were relatively wealthy in terms of land ownership, but they also had a large family to support and were happy to supplement their income through the sale to Europe of John's five-guinea boxes of seeds of indigenous American plants. Throughout the eighteenth century, European demand for new and unusual plants never abated. In the early years, Europe was entering the golden age of pleasure and landscape gardens. This was the period of the emerging English Enlightenment, with greater religious tolerance and liberal ideals regarding the progress and unity of humankind and personal freedoms. The Glorious Revolution of 1688 put in place many elements that were fundamental to the English Enlightenment, including the rule of law, Parliament, and greater religious freedom. The 1689 so-called Toleration Act had been passed, which gave greater freedom to those who had been oppressed in earlier decades. However, Unitarianism remained punishable by penal law and Catholics and non-Christians were still denied the right to public worship. Nevertheless, gone were the repressive laws that had forced William Penn and his fellow Quakers to seek refuge across the Atlantic.

Religious toleration reflected other changes taking place in late seventeenth- and early eighteenth-century England. It was a period of scientific innovation with Newtonian science of experimentation replacing that of mere observation. This in turn encouraged inquiry into religious and theological traditional beliefs

and reason began to replace revelation and dogma. The ideas expressed by John Locke, the man seen as the father of the English Enlightenment, who championed the natural freedom of mankind, were being espoused by Deists such as Matthew Tindal, whose *Christianity as Old as the Creation*, published in 1730, was considered the Deists' bible. Tindal argued that God had given mankind the means, through rationality, of knowing whatever he required of them. Tindal's beliefs were based on the Creation and universal reason. He argued that "God's will is so clearly and fully manifested in the Book of Nature, that he who runs may read it."[2] The eighteenth-century Deists tended to be anticlerical and believed in one true God who was revealed by the light of Reason and not through written text or an intermediary priest. John Bartram's own religious belief was not much removed from Locke's and Tindal's. Like Locke, Bartram read the Bible and accepted that there was a place for revealed truth by applying reason. Reason explained the scriptures and validated the existence of God. And like Tindal, Bartram was a Unitarian who rejected the Trinity and the divinity of Christ.

Hand in hand with greater liberalism in law and religious toleration in England came material wealth for a certain sector of the country's citizens. In the first half of the eighteenth century, the British economy was affected by several factors. An increase in agricultural productivity and growth in manufacturing and mineral technologies moved Britain and its economy toward industrialization. A rapid growth in the population of the American colonies that depended on the more advanced industrial processes of the home country gave the British export market a considerable boost. Adding stimulus to these factors was the expanding Empire and the British dominance of the slave trade. Thus, for some there was a visible rise in disposable income. This wealth provided the opportunity for many to explore science and the natural world and man's place within it. Some expressed their interest by collecting natural objects such as fossils, rocks and minerals, insects, birds, animals, and plants. The desire to possess ornamental and curious plants from around the world was insatiable. The great expeditions that opened up to Europe new worlds of exotic flora and fauna came later in the century with Captain Cook's voyages, but in the 1730s, for many in Europe, the American colonies were the main source for new plants.

The passion for interesting and unknown plants was not wholly new to Europeans. Hysteria had gripped Western Europe in the seventeenth century with what became known as "Tulipomania," when many a wealthy family was brought to economic ruin through the speculation of all they possessed on a handful of tulip bulbs. The mania reached its peak between 1633 and 1637 with examples of traders paying as much as twenty times for a single bulb as what an average family could live on for a single year.

Such mania for plants was replaced in the eighteenth century by a calmer, more rational attempt at re-creating miniature plant habitats of distant lands, particularly American, and the use of plants in sculpting scenes modeled on the landscape paintings of artists such as Claude Lorrain and Nicolas Poussin. Alexander Pope, one of the first to apply painting techniques to gardening, wrote the Reverend Joseph Spence in 1734 that "All gardening is landscape painting."[3] The

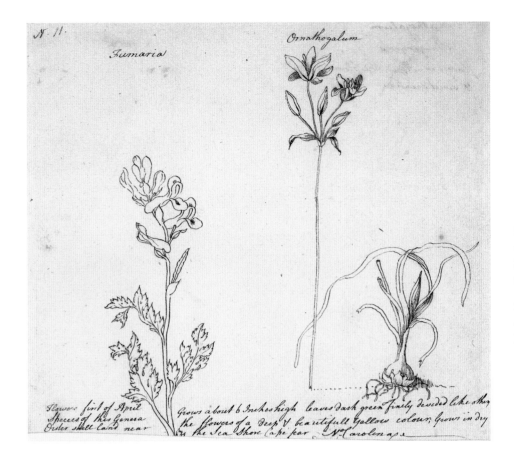

HALE'S CORYDALIS
Corydalis halei (Small)
Fernald & B.G.Schub.
(Fumariaceae)

FALSE GARLIC
Nothoscordum bivalve (L.)
Britton (Liliaceae)

renaissance of the classical with Palladian architecture was transposed to garden design. Nature was now made to imitate art. Not only were royalty and nobility creating grand and majestic gardens, but so too were the wealthy commoners of Europe. As John Loudon explained in 1838, the Enclosure Acts in England soon changed the face of the country, which then "bore a closer resemblance to country seats laid out in the geometrical style; and, for this reason, an attempt to imitate the irregularity of nature in laying out pleasure grounds was made in England."[4] New methods of growing plants in heated glass houses enabled enthusiasts, gardeners, and nurserymen to enjoy plants never before seen in Europe. More than 320 plants were introduced from America between 1736 and 1776 (after which trade was disrupted by the revolutionary war) and almost half of these plants were from John Bartram.

The introduction of North American plants into Europe had begun in the sixteenth century with the arrival of corn and tobacco. By the seventeenth century, Parisian gardeners were growing plants from Canada, while English gardens contained plants from Virginia. In addition, botanical literature, such as John Parkinson's books *Paradisus* (1629) and *Theatrum Botanicum* (1640) and Jacques Cornut's *Canadensium Plantarum* (1635), recorded North American plants. Many of the plants were introduced because they had an economic or medicinal value and only toward the end of the seventeenth century were plants sought for purely ornamental purposes. These plants were recorded in the works of Leonard Plukenet, Robert Morison, and Paul Hermann and were collected by travelers

TRUMPET OR YELLOW
PITCHER PLANT
Sarracenia flava L.
(Sarraceniaceae)

sent to America by wealthy patrons. John Tradescant the younger made three visits to Virginia and John Banister traveled in Virginia and sent a large collection of specimens and seeds to Bishop Compton of Lambeth. Other major recipients of specimens were James Petiver, a London apothecary, and Sir Hans Sloane, an Irish physician and founder of the British Museum, who himself had collected a large quantity of plants from Jamaica while employed as the surgeon to the Governor of the Island.

Both Petiver and Sloane were Fellows of the Royal Society and both had a list of correspondents who sent specimens of plants, insects, minerals, shells, and fossils from the colonies. One of Petiver's main correspondents was John Lawson, who traveled through the Carolinas and wrote an account of the flora and fauna of the region, *A New Voyage to Carolina*, in 1709. A much more impressive work was that of Mark Catesby, who embarked on two excursions across the Atlantic, traveling through the Carolinas and the Caribbean in 1712–19 and again in 1722–26. He sent plants back to England for several years and from these collections and his sketches made during his visits he produced the first illustrated natural history

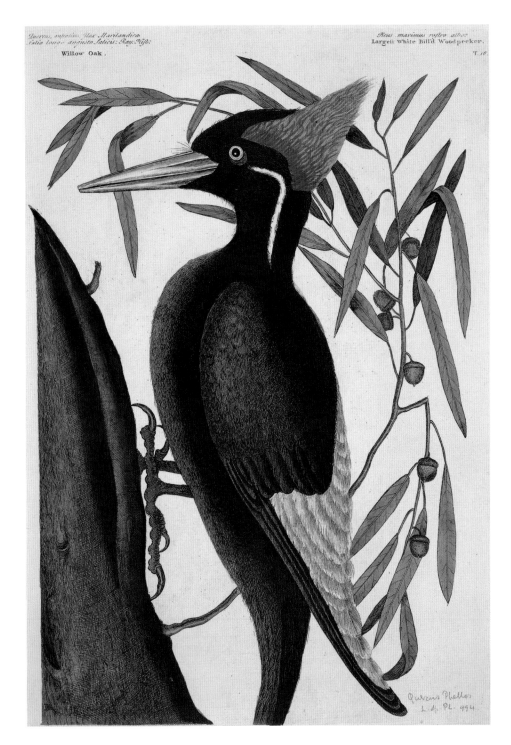

Willow Oak.

Largest White Bill'd Woodpecker.

MARK CATESBY
(1683–1749)

IVORY-BILLED
WOODPECKER
Campephilus principalis
(Linnaeus)

WILLOW OAK
Quercus phellos L.
(Fagaceae)

book of North America, *The Natural History of Carolina, Florida, and the Bahama Islands* (1731–43). Many of the plant collectors who visited the American colonies remained there only for short periods of time, while even the contributions of residents paled in comparison to those of John Bartram.

John Bartram had been interested in plants from a young age: "I have had ever since I was 12 years of age A great inclination to botany & natural history."[5] He used his knowledge of medicinal plants to treat his family and neighbors. As a Quaker, John Bartram's interest in plants and medicine was not unusual. The

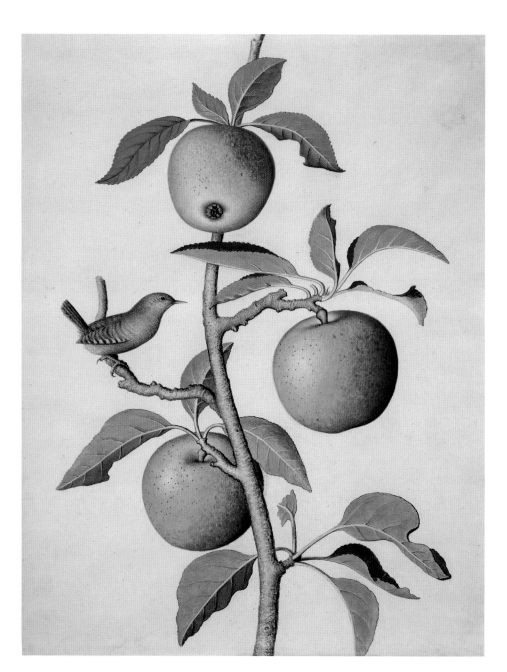

Society of Friends had been founded in 1651 by George Fox and was one of the few sects that survived the Cromwellian years of the Protectorate and the persecution that followed after the Restoration. The Test Act of 1673 politically disqualified Dissenters, excluded them from a range of professions, and barred them from obtaining a university education in England. This prompted the Quakers to establish their own schools, where they encouraged the study of natural history. George Fox had insisted that "the nature of herbs, roots, plants and trees" be taught in the schools. It was with this knowledge of plants that many Quakers were attracted to the medical profession, becoming apothecaries or attending universities in Europe or Scotland and becoming doctors.

John Bartram's botanical knowledge was mostly self-taught since he had received only a limited formal education from the local Quaker school. He became

a farmer as a young man and his doctoring and use of medicinal plants were of a practical rather than a theoretical nature. Many of the local plants in his garden in its early years were used for treating ailments. By the 1730s, Bartram had an extensive knowledge of local flora of all kinds. It was this knowledge that led him to begin a botanical correspondence with an Englishman and fellow Quaker, Peter Collinson.

Peter Collinson, born in London in 1694, was five years older than John Bartram. He too was born into a Quaker family, which originally hailed from the Lake District in Cumbria. With his brother he inherited his father's wholesale woollen business in Gracechurch Street, London. Much of their trade was with the American colonies and this enabled Collinson to develop a large circle of correspondents in the country. Collinson's extensive knowledge of science was rewarded in 1728 with his election to the Royal Society, but his main passion was his love of plants and gardening. His gardens, first at Peckham, then later at Mill Hill, were among the finest in London, ranking alongside the garden of his very good friend and fellow Quaker John Fothergill in Essex, and were visited by botanical artists such as Georg Ehret and William King. Collinson corresponded with botanists and plant collectors from all over the world, including Jesuit priests in China and Dr. Mounsey, physician to the Tsarina of Russia. In his *Memorandum*, written two years before his death in 1768, Collinson recalled how in the early 1730s he had been searching for a reliable source in the American colonies who would send him seeds of new plants on a regular basis: "I labour'd in vain, or to little purpose; for some years." Eventually in 1733, Joseph Breintnall, a Quaker merchant whose main occupation was as a copier of deeds and who worked in Benjamin Franklin's stationers' shop, suggested John Bartram as his man. Again in his *Memorandum*, Collinson wrote, "Accordingly John Bartram was recommended, as a very proper Person for that purpose, being a native of Pensylvania, with a numerous Family—the profits ariseing from Gathering Seeds would Enable Him to support It."[6] Thus in 1733 a correspondence began that would continue over thirty-four years between these two men, who never met in person as neither man ever left his native country, but who became intimate friends and comrades through their love of plants.

Both men were great letter writers and we are fortunate that much of their correspondence has been preserved. Collinson's circle included the leading men of science and politics of the day and he introduced many of these men to John Bartram. Within several years of their first letter, John Bartram was supplying his "five-guinea box" of seeds to a long list of customers in England. Each box contained seeds of 100 to 105 different plants, mainly woody shrubs and trees. The customers who repeatedly came back for more included some of the most notable aristocrats, nurserymen, and scientists of the day. The Prince of Wales purchased boxes for several years in succession. Noblemen such as Lord Bute, who directed the planting at Kew Gardens, the Dukes of Bedford, Argyll, and Richmond, the Earl of Essex, Sir James Dashwood, and General Napier were some whose splendid gardens were rich in American productions sent by John Bartram. Nurserymen such as James Gordon, one of the most highly regarded

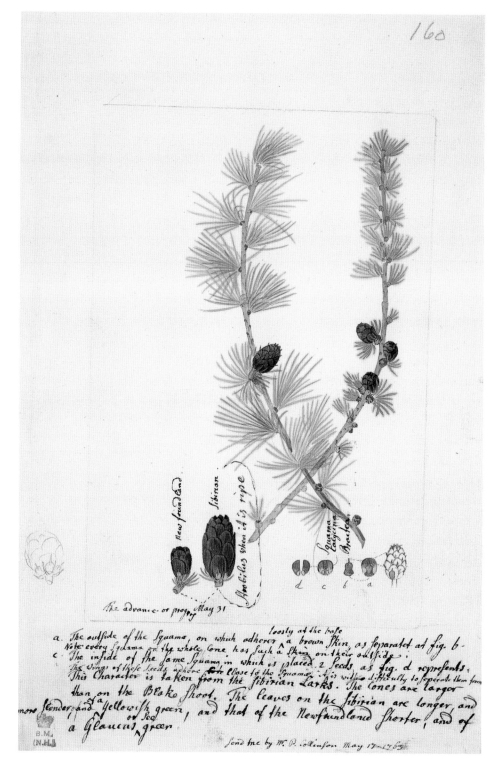

and influential professionals in the seed trade in the mid-century, and gardeners such as the Reverend William Hanbury and Philip Miller of Chelsea Physic Garden relied on Bartram for American seeds. Customers in France, Ireland, and Germany also ordered Bartram's seeds. Among the scientists who parted with five guineas were Humphrey Sibthorp and Sir Hans Sloane. The trade was so extensive that it helped shape the appearance of English landscape gardens.

Lord Petre was one of the first Englishmen to be introduced to John Bartram and during his short life was one of Bartram's major patrons, helping to finance an "annual allowance to Encourage & Enable" Bartram to "prosecute further discoveries."[7] Lord Petre, with the help of his then gardener, James Gordon, created one of the most magnificent gardens of the time at Thorndon Hall in Essex. In one of his letters, Collinson, who was awaiting new discoveries from America, reveals the scale of Bartram's success: "The Trees & shrubs raised from thy first seeds is grown to great maturity Last year Ld petre planted out about Tenn thousand Americans wch being att the Same Time mixed with about Twenty Thousand Europeans, & some Asians make a very beautifull appearance . . . when I walk amongst them, One cannot well help thinking He is in North American thickets."[8]

In order to "prosecute further discoveries," Bartram made regular trips along the length of the eastern coast of North America between the harvesting and sowing on his own farm. He became one of the most traveled men in America, covering thousands of miles from Lake Ontario in the north to Florida in the south and west to the Ohio River. He met in person many of those with whom he was already corresponding, men such as John Byrd, who owned a large and splendid garden in Virginia and was one of the few American members of the Royal Society of London. Among others were Alexander Garden, a Scottish doctor who had settled in South Carolina and had a medical practice in Charleston that kept him "from his desire to botanise"; James Logan, secretary to William Penn in Philadelphia, who was reputed to have the best library in America, and who helped Bartram with his Latin and introduced him to Linnaeus; and by no means least, Benjamin Franklin, with whom Bartram remained a lifelong friend and who together founded the American Philosophical Society in 1743. A friend whom Bartram visited several times on his plant-collecting trips was Cadwallader Colden of New York, one of the most articulate and knowledgeable men of science in the colonies, and with whom Bartram corresponded for many years, exchanged plants and seeds, and maintained a dialogue on botany and natural history.

Colden was born in Ireland of Scottish parents, who then returned to Berwickshire, Scotland, where Cadwallader was raised and educated. In early life he intended to follow his father's profession as a Presbyterian minister, but while at Edinburgh University he became interested in the sciences and in 1705 went to London to study medicine. He completed his studies in 1708 and decided to practice as a physician in the colonies. In 1710 he set sail for Pennsylvania and settled in Philadelphia. He returned to Scotland several times, and on one of these visits, in 1715, he married Alice Christy, the daughter of a Scottish minister, and the two returned to America the following year.

Cadwallader Colden did not practice as physician for very long in America, for he soon became the surveyor general for New York, a post that allowed him to be involved in land speculation and become relatively wealthy. He purchased three thousand acres of land north of New York City in the Hudson River Valley, now the town of Montgomery in Orange County. Here he built a grand house and named his estate Coldengham, where the family settled permanently in 1728. The

Coldens had ten children, whom they educated at home. Colden's son, Cadwallader Jr., wrote that his mother, Alice, conducted much of the children's early education and that all of them were encouraged to develop their own intellectual pursuits.

Colden was himself part of the international network of scientific correspondents that included Linnaeus, Gronovius, Collinson, Franklin, and John Bartram. His interests were far-ranging and he had a broad knowledge of science. His study of history and ethnography led him to write a *History of the Five Indian Nations Depending upon New York* (1727). He became a serious botanist after reading Linnaeus's *Plantarum Naturae* and was one of the first to apply Linnaeus's classification system to plants in America. He wrote a local flora of New York entitled *Plantae Coldinghamiae*, which was published by Linnaeus in 1749. This was the first attempt at the systematic classification of American plants. In later life Colden diverted his energies toward his interest in physics, writing *An Explication of the First Causes of Action in Matter*, in which he attempted to explain Newton's theory of gravity. Colden was one of the few Americans to observe the transit of Venus across the face of the Sun in 1768. He also took an interest in politics and became a member of the Council of New York and later, in 1761–76, served as lieutenant governor of New York.

In 1753 John Bartram visited the Colden estate as part of his excursion to the Catskill Mountains. He wrote to Collinson before he left, "I am preparing for A Journey to dr. Coldens & ye mountains I desighn to set out with my little botanist ye first of September."[9] The "little botanist" was his son William, then fourteen. William was as young as twelve when he started to accompany his father on his trips. "I have A little Son about fifteen years of age that has traveled with me now three years & readily knows most of ye plants that grows in our four governments."[10] Through John's friendship, William had already been introduced to Peter Collinson and had presented him with some of his drawings of plants and birds. Both Collinson and George Edwards, the author of *A Natural History of Birds* (1743), were recipients of William's early drawings, and Edwards used the drawings for his engravings in his books, while Collinson showed them to scientists and artists of natural history. "There is a Little Token to my pretty artist Billey His Drawings has been much admir'd,"[11] wrote Collinson in appreciation.

The expedition of 1753 resulted in the Bartrams spending three days at Coldengham, where they met with Colden's second daughter, Jane, who had developed a keen interest in botany. Jane was born in 1724 and according to her father exhibited intellectual prowess at an early age and also possessed "a curiosity for natural philosophy or natural history." Colden took particular interest in his daughter's education and provided an extensive library of botanical literature. He explained to a friend that Jane did not read Latin and so Colden "took the pains to explain Linnaeus's System, and to put it in English form for her use by freeing it from the technical terms."[12] The translation of *Genera Plantarum* enabled her to master Linnaeus's classification system and apply it to her own work.

Jane Colden became well known in botanical circles in both America and Europe and was without doubt highly respected by those who met her or knew

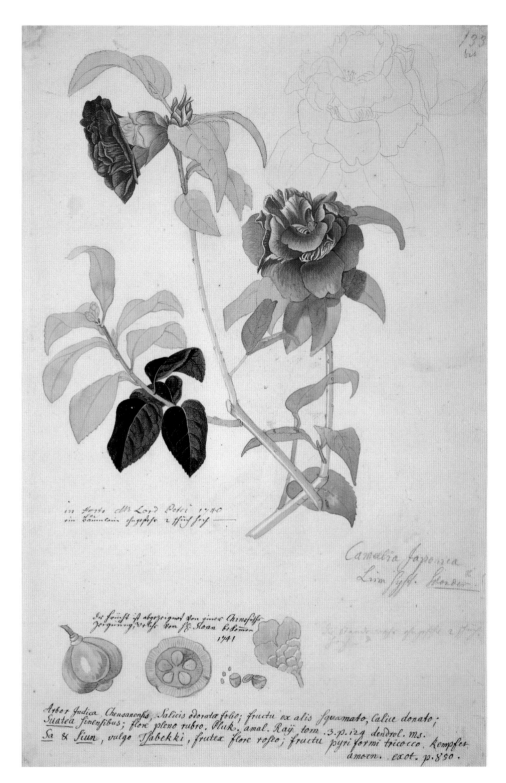

GEORG DIONYSIUS EHRET
(1708–1770)

CAMELLIA
Camellia japonica L.
(Theaceae)

of her work. Peter Collinson wrote to John Bartram about their "Friend Coldens Daughter," explaining that Jane had sent him some sheets of plants with scientific descriptions that she had done according to the Linnaean method: "I believe she is the first Lady that has Attempted any thing of this Nature."[13] The following year, in one of his letters to Colden, Collinson enclosed "2 Vol. of Edinburgh Essays for the sake of the Curious Botanic Dissertation of your Ingenious Daughter.

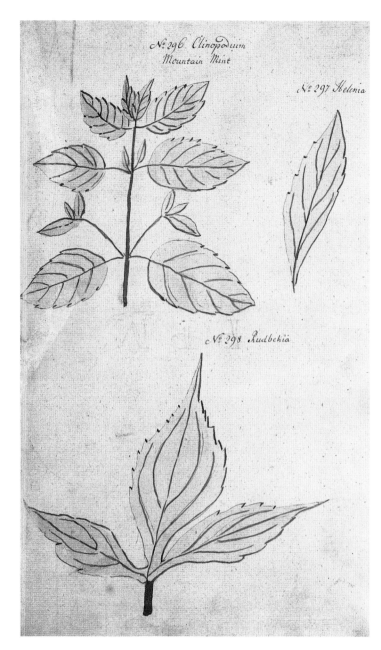

JANE COLDEN
(1724–1766)

WILD BASIL
OR DOG MINT
Clinopodium vulgare L.
(Labiatae)

Being the Only Lady that I have yett heard off that is a professor [of] the Linnaean system of which He is not a Little proud."[14]

Alexander Garden was a friend and correspondent of Colden and was himself an amateur plant collector and botanist. In 1755 he wrote to John Ellis of London about Colden and his daughter: "Not only the doctor himself is a great botanist, but his lovely daughter is greatly master of the Linnaen method and cultivates it with great assiduity."[15] Jane Colden is now recognized as the first American woman botanist and several attempts were made during her lifetime to have a plant named after her, both Collinson and John Ellis suggested this to Linnaeus. Collinson presented his request in 1756; "I but lately heard from Mr Colden. He is well; but, what is marvelous, his Daughter is perhaps the First Lady that has so perfectly studied your system. She deserves to be celebrated."[16] John Ellis went

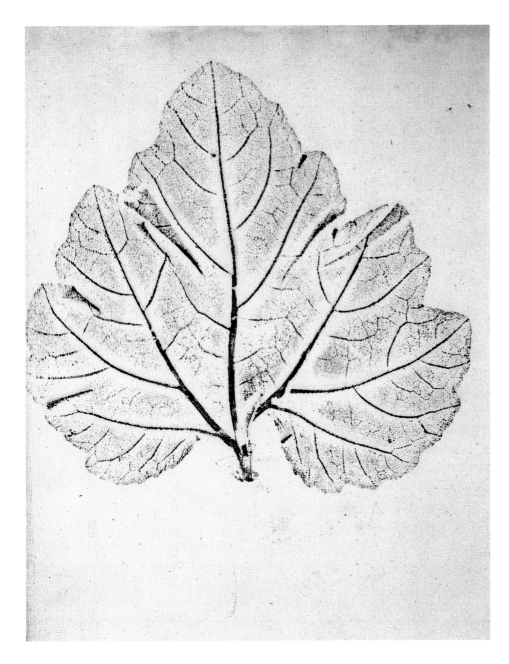

JANE COLDEN
(1724–1766)

LEAF

a step further in 1758, when he sent one of Jane's plant descriptions that he had translated into Latin to Linnaeus: "This young lady merits your esteem, and does honour to your system. She has drawn and described 400 plants in your method only. . . . Her father has a plant called after him *Coldenia*, suppose you should call this *Coldenella* or any other name that might distinguish her among your Genera."[17] Although Linnaeus may well have been a little proud and flattered by Jane's work, none of the above pleas was successful and no plant exists today that honors Jane Colden's name.

Few of Jane Colden's writings have survived. Her main work is the manuscript held in the Natural History Museum in London, of the flora of New York, *Flora Nov-Eboracensis*. The volume consists of 284 sheets of line drawings of leaves and scientific description of each plant. The descriptions, written in

English with Latin names and the common name where known, are considered to be excellent. For some plants she has added their medicinal and folk use, explaining who used the plant and for what ailments, and even included the prescribed dosage and method of application. "This S'eneca Snake Root is much used by some Physicians in America, principally Long Island, in the Pleurisy, especially when it inclines to a Perip neumony, they give it either in Powder or a Decoction. The usual Dose of the powder is thirty grains."[18]

Jane Colden's drawings are, as James Britten notes, "very poor, and consist only of leaves. The figures are merely ink outlines washed in with neutral tint."[19] The last image in the collection is a nature print. These drawings probably do not do justice to how skilled an artist Jane Colden was. According to several letters, she is described as an accomplished draftswoman. Her father describes to Johann Gronovius that "She was shown a method of taking the impression of the leaves on paper with printer's ink, by a simple kind of rolling press. . . . No description in words alone can give so clear an idea, as when assisted with a picture."[20] Nature printing was a fashionable pastime for many and Joseph Breintnall, the man who introduced Bartram to Collinson, produced many such illustrations, and indeed relied on John Bartram to find specimens and identify them for him. A letter by Walter Rutherford reports of a visit to the Colden estate, "the abode of the venerable Philosopher." Here Rutherford describes Jane as "a botanist, she has discovered a great number of Plants never before described . . . and she draws and colors them with great beauty."[21]

When William visited the Coldens for the first time in 1753, he and his father spent time looking over some of Jane's "botanical curious observations,"[22] which no doubt would have included her drawings and nature prints. William Bartram may well have considered Jane Colden a respectable artist judging from the reply John Bartram gives to one of her letters, which he received on 26 October 1756, and had read "several times" to his great satisfaction: "I should be extreamly glad to see thee at my house & to shew thee my garden. . . . I shewed him [William] thy letter & he was so well pleased with it that he presently made a pockit of very fine drawings for the far beyond Catesbys took them to town & tould me he would send them very soon."[23] The keenness of William to send Jane some of his drawings hints that he had been impressed with Jane's attempts at illustration and that it was their equal love of drawing that was the key to the cultivation of such an affectionate friendship between Jane and the Bartrams. It is not known whether Jane ever made the trip to Philadelphia to visit the Bartram garden. By 1759 she had married Dr. William Farquhar, a widower practicing medicine in New York City, and there is nothing to suggest that she continued her botanical investigations after her marriage. Tragically Jane died in 1766, soon after giving birth to her only child, who did not survive.

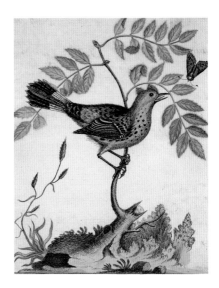

CHAPTER 2

The Merchant's Apprentice

JOHN BARTRAM WORKED HARD all his life and adhered to the Quaker maxims of industriousness and honesty. His friend Peter Collinson described him as a "down right plain Country Man."[1] Nevertheless, he improved his own wealth and status within the community and he expected the same industry and success from his children. He espoused modesty and temperance but at the same time expected his children to prosper. In a letter of 1771 he took delight in the future marriages of his children: "John is safely married to my Brothers grandaughter much to our likeing & lives with us. Benjamin is to all appearance likely to have John Knowles daughter with a large fortune. Elizabeth is likely in a few weeks to have a man liveing near Lancaster of good Character," but then continues with a sour note: "Mary is a widow & was courted by a man of tolerable Character but with indifferent Connections & I suppose will not succeed."[2] Mary had married Benjamin Bonsall in 1755, "a very worthy rich young man,"[3] but he died early in life, leaving Mary a widow with two children. John Bartram's desire for status and security was evident in his letters. On occasion, these aspirations verged on pomposity, as when he had made for himself a family coat of arms that he placed in a gilt frame and had engraved as bookplates. As early as 1743, he had Peter Collinson spend the five guineas, presented to him by Sir Hans Sloane, on a silver cup, "which I or mine may keep to entertain our friends withal, in remember-ance of my noble benefactor."[4] These shows of ostentation were somewhat out of

Botany and Drawing are his darling delight.

—JB TO PC, 28 SEPTEMBER 1755

character for John Bartram, who normally displayed a more down-to-earth approach to life and dismissed the affectations of others. When it came to the future of his sons, he rejected any thought of them being what he called "gentlemen." He believed that it was essential for his sons to learn a respectable trade or profession that brought in a regular income, so when he wrote to Jane Colden in 1757, inviting her to visit his garden, there is a sense of relief fused with a little sadness and loss when he explains that "My Billy is gone from me to learn to be A merchant in Philadelphia."[5]

William was by then seventeen and to please his father had agreed to settle into a respectable trade. For eighteen months he had resisted his father's various schemes as well as those of his father's friends, preferring to devote his time to observing and illustrating nature, monitoring the migration of birds, and studying bird anatomy by dissecting and mounting specimens. The earliest reference to William possessing artistic talent is in early 1753, when John Bartram sent some of William's drawings to Peter Collinson. William was still only thirteen but had by then developed a keen observational eye and a passion for drawing. He willingly shared his knowledge with men such as Collinson and George Edwards in England and would have been content to do this for many years.

As a young man, George Edwards trained as an accountant and in early life made his living through this profession, but he then abandoned the security and comfort of a regular income to travel and paint. In 1743 he published the first of four volumes entitled the *Natural History of Birds* (1743–51) and added a further three volumes under the title *Gleanings of Natural History* (1758–64). It was to these later volumes that William Bartram contributed, sending information, drawings, and skins of native American birds to Edwards. Edwards was delighted with William's drawings and duly acknowledged his artistic ability. Scattered throughout the text are references to specimens and drawings that Edwards received from Bartram: "The Marsh-Hawk is engraved from a drawing done from the life in Pennsilvania, and sent to me, by my obliging friend, Mr. William Bartram. . . . Though I have not seen the Bird itself, I have great reason to think Mr. Bartram very correct in his drawing, and exact in his colouring, having compared many of his drawings with the natural subjects, and found a very good agreement between them."[6]

Another of William's drawings that Edwards reproduced in volume five of his *Natural History of Birds* is that of the Pine-barren Gentian, which Bartram completed when he was sixteen or seventeen. Edwards places the plant with the Magnolia Warbler, which he called the Yellow-rumped Flycatcher, and notes that he received the bird preserved and dry with a drawing of the gentian. William's own drawing of the Magnolia Warbler was completed about the same time as his gentian as John Bartram, who sent them both to Collinson, wrote details of the plant found in Maryland on the verso of the bird drawing. William continued to send Edwards material for his work until he left for North Carolina in 1761, and these included not only birds and drawings but also nests and even a snake, all of which Edwards incorporated into his illustrated volumes. As each volume of his work was published, Edwards presented copies to William, and it cannot be

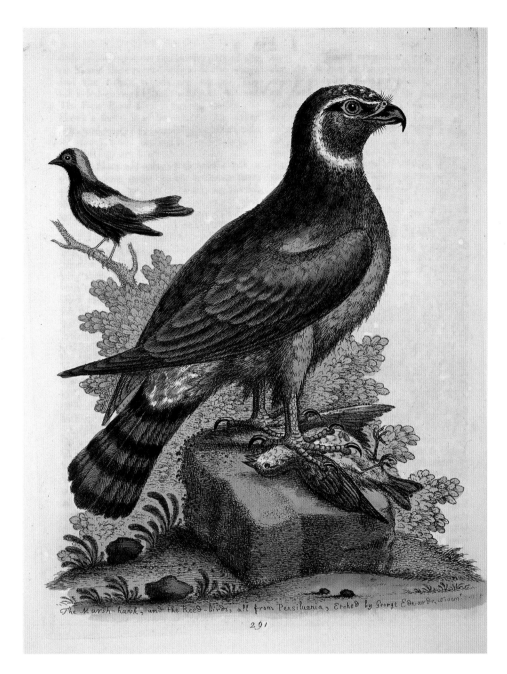

The Marsh-hawk, and the Reed-birds, all from Pensiluania; Etched by George Edwards, drawn

291

exaggerated how influential Edwards was on William, particularly in his early draftsmanship. At that early age in his life, William would have been thrilled to follow in the footsteps of such a man as Edwards.

John Bartram, however, had little faith that botany and drawing would provide a financially secure future for William, and expressed great anxiety over the subject when writing to Collinson and other friends asking for advice. "My son William is just turned of sixteen it is now time to propose some way for him to get his liveing by. I dont want him to be what is commonly called A gentleman I want to put him to some business by which he may with care & industry get A temperate reasonable liveing I am afraid Botany & drawing will not afford him one & hard labour does not agree with him I have desighned several years to put him to A doctor to learn Phisick & surgery but that will take him from his drawing which

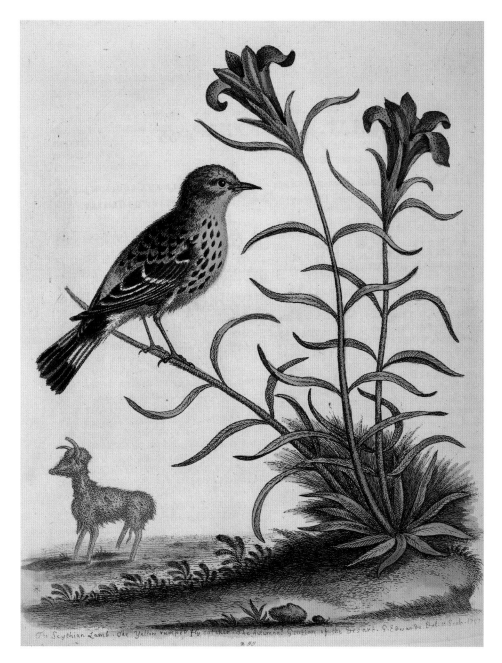

he takes perticular delight in pray my dear Peter let me have thy opinion about it."[7] In proposing to William the idea of becoming a doctor, John had gone so far as to consult Alexander Garden of South Carolina. Garden responded by offering William an apprenticeship, but William showed no interest in becoming a surgeon, John explained to Garden. John could not get William to "read a page" of the books he had on the subject: "Botany & drawing are his delight but I'm afraid won't get him his living."[8] John Bartram also consulted Benjamin Franklin about William's future and Franklin responded by making an "obligeing offer," first with a career in printing and, when that was rejected, one as an engraver. Collinson encouraged John in all of these careers: "By all means make Billy a Printer it is a pretty Ingenious Imploy—never lett him reproach thee & say Father if thou had putt Mee to some Business by which I might gett my Bread I should have by

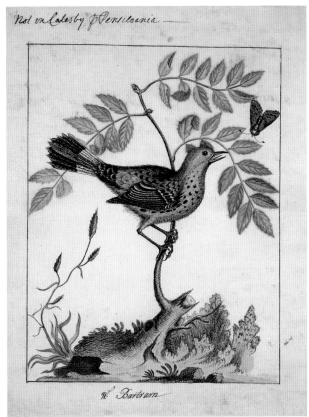

my Industry Lived in Life as well as other people lett the fault be his, not thine."[9] Peter Collinson's own advice was for William to become a surveyor, but this too William rejected, and as John pointed out, "we have five times more surveyors allready than can get half employ."[10]

William Bartram's education had equipped him for all the professions suggested to him. Unlike his father, William received a classical education. From 1754 he attended the Philadelphia Academy, which later became the University of Pennsylvania. He was the only one of John and Ann Bartram's children to attend the Academy. Whether it was because he displayed such promise or because he was somewhat physically frail as a child is not known, but the admission fee of twenty shillings and the tuition fee of four pounds per year was not offered to any of his siblings. At the Academy, William read Virgil, Cicero and Livy, Locke, Pope, Newton, Bacon, and Hutcheson. Now adding to his understanding and love of nature were the elements of poetry, aesthetics, and philosophy. William's education was richer and far more catholic than his father's and enabled him to proclaim the wonders and beauty of nature in an imaginative and poetic language that he used in his later writings.

John Bartram's own formal education had been limited to the elementary level at the local Quaker school. Unlike William, he was not taught Latin. Traditionally Quakers believed that Latin reinforced the powers of the ruling oligarchies in England and that it mystified most people and thereby maintained the hierarchical structures within society, where those without the language were forced to look

PINE-BARREN GENTIAN
(LEFT)
Gentiana autumnalis L.
(Gentianaceae)

MAGNOLIA WARBLER
(RIGHT)
Dendroica magnolia
(Wilson)

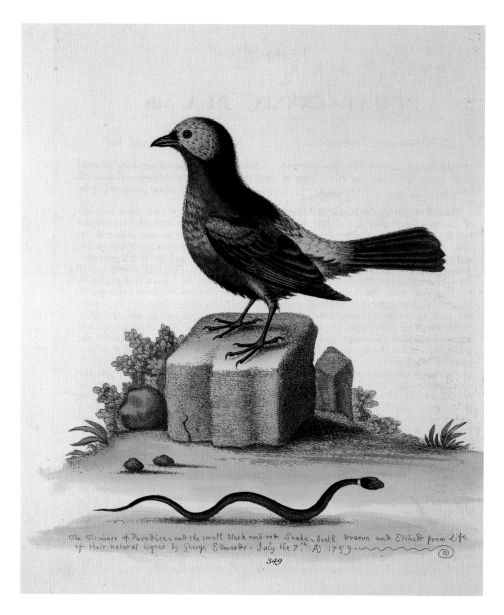

up to authority. It was only as an adult that John purchased a Latin dictionary to assist him in reading botanical works, and throughout his life he had to rely on friends and family to translate the letters he received in Latin. Cadwallader Colden and James Logan were such friends: "I return inclosed to you Doctor Gronovius's letter to you. . . . That part of learning of which it treats, I am so little acquainted with, that if I were to translate what he writes, it is probable I may make nothing but a series of blunders; but for your satisfaction, I shall turn the first sentence the best I can."[11]

Despite never mastering Latin, John was truly a self-educated man. In the language of the day, he was considered "a curious man," a term that described someone of keen intellect eager to discover more about the natural world. His reading was relatively extensive for a man of his time and for a farmer. His own library consisted of botanical works purchased or presented to him from friends and customers in Europe. Titles such as Parkinson's *Paradisio* and Miller's *Gardeners Dictionary* lay alongside Catesby's *Natural History of Carolina* and Sloane's

Natural History of Jamaica, both presented to him by the authors. Lord Petre, owner of one of the grandest gardens in England and one of John Bartram's most loyal supporters, presented him with volumes of Tournefort's and Turner's *Herbal*. However, John's reading was not confined to works of natural history. His intellectual interests were broader and included the philosophy of Confucius and the poetry of Alexander Pope. So influenced was he by Pope that he carved in the stone lintel above the door of his greenhouse the words from Pope's *Essay on Man*, "Slave to no sect, who takes no private road, But looks through Nature up to Nature's God."

In 1731 Benjamin Franklin established the Library Company of Philadelphia, a public subscription library to which members paid forty shillings for a share plus an annual fee of ten shillings, which went toward the purchase of books from Europe. Peter Collinson became the agent for the Library in London, purchasing the books that Americans requested. These tended to be predominantly scientific works, including books on husbandry and gardening, but seldom, if at all, on theology. The Library Company also collected scientific instruments such as microscopes and even an electrical tube donated by Collinson. Other contributions included a fossil collection by Bartram in 1743 and a collection of nature prints, impressions of leaves of plants made by Franklin and Breintnall, similar to the one in Jane Colden's manuscript. John Bartram borrowed books from the Library at sixpence for the hire but complained to Collinson that Breintnall had asked him to leave "ye value of ye booke in security besides six pence."[12] Bartram was reluctant to become a member and pay the annual fee because "they [have] few books of botany or natural history."[13] However, in the spring of 1743, and through the request of Peter Collinson, the Library Company made a present to John Bartram of "a share during life."[14]

Bartram also had access to James Logan's library, believed to have been the largest and most eclectic private library in America. James Logan was the agent for the proprietor of the province, William Penn. He was of Scottish origin and a Quaker and was considered one of the finest intellects in America, having been lauded with the title of "Philadelphia's first scientist" by later commentators. It was Logan who introduced the theoretical study of botany to John Bartram and lent him the first copy to arrive in America of Linnaeus's *Systema Naturae*. Logan's work on the sexuality of plants based on experimentation rather than hypothetical observations of nature helped lay the foundation for the study of the subject. Some of the papers he wrote on his experiments were published in the Philosophical Transactions of the Royal Society.

Perhaps one of the more significant books John Bartram read was a translation of the life and works of Confucius, which included the *Morals of Confucius*. The work had been translated from the Chinese into Latin by Prospero Intocetto and later from the Latin into English by Randal Taylor in 1691. Bartram read this book in 1757 and the following year he was "Named" at the Meeting of Darby Quakers, and expelled for his denial of the divinity of Christ. The overseers of the Darby Meeting "entered a complaint against John Bartram for disbelieving in Christ as the Son of God." Some twelve months later, at the February Meeting,

John Bartram was declared to be "no member of our Christian Society."[15] Such treatment by other Quakers did not deter him from continuing to attend meetings and neither did it weaken his commitment to his brand of theology.

John's library was also available to William, who, in addition, was exposed to the ideas and views of his tutor, Charles Thomson. Thomson was only ten years older than William. He was orphaned at the age of ten and was taken in by a Presbyterian minister, who gave him a sound classical education that enabled him to become Headmaster of Friends Grammar School and later a tutor at the Academy. Thomson held radical views on several issues; he was fervently antislavery and sympathized and worked with Native Americans. In 1757 he was appointed personal secretary to the Delaware king, Teedyuscung, at the treaty discussions held in Easton in the summer of that year. He became a committed republican and held the post of Secretary of the Continental Congress between 1774 and 1789. William Bartram's own "republican principles" he believed had been instilled in him by Charles Thomson.[16] William's education and the influence of his much-loved tutor helped liberate him from what could have been an undistinguished life as a merchant.

By 1756 Peter Collinson was showing William's drawings to many of his friends in Europe. "Billy's Drawing & painting of the Tupelo is fine & is Deservedly admired by Everyone."[17] Collinson compared William's drawings to those of George Edwards and Georg Ehret, believing that neither artist could surpass William's drawing of a Marsh Hawk. He also wrote to Linnaeus that William was "an admirable painter of plants. He will Soone be another Ehret, His performances are So Elegant."[18] Such a comparison was praise indeed. Georg Dionysius Ehret was the foremost botanical artist of his time. Born in Germany, the son of a gardener, his talent for drawing was discovered by Christoph Trew, a wealthy physician from Nuremberg, who became his lifelong patron. Ehret traveled through France and Holland, visiting Leiden and Haarlem, where he met Linnaeus. Here he worked with Linnaeus on the sexual system of plants, contributing the illustrations for his *Hortus Cliffortianus*. Linnaeus's method of plant description was enhanced by exact illustrative interpretation of the plant and Ehret excelled in this art form. Ehret eventually settled in England, where he taught art and also produced a vast number of botanical illustrations. Ehret regularly visited Peter Collinson's garden at Mill Hill, where he would sketch and paint the plants, many of them new to Europe. Collinson's garden was one of the most diverse in England for plants from around the world and attracted many botanical artists, including William King and Simon Taylor. On seeing William Bartram's drawings of oaks, Georg Ehret agreed with Collinson to engrave some of them: "Yesterday I had a Letter from Docr Gronovius He Admires much the Drawings of the Oakes but He can gett nobody to Engrave & print them so will Return them to Mee Our Friend Ehret will do them he Tells Mee but I can't say when."[19] This project never materialized and unfortunately the drawings of oaks have never been discovered. John Bartram was no doubt proud of the praises bestowed on William: "I am well pleased that Billy gives you such satisfaction in his drawing. I wish he could get A handsom livelihood by it Botany and Drawing are his darling delight."[20]

GEORG DIONYSIUS EHRET
(1708–1770)

TARO
Colocasia esculenta (L.)
Schott (Araceae)

colocasia

ARUM Maximum Ægyptiacum
quod vulgo Colocasia. C.B.P.

Linn: Sp: Pl: 965.

G. D Ehret. fecit.

By 1756 John Bartram had become a regular correspondent with Philip Miller of Chelsea Physic Garden and author of the *Gardeners Dictionary*. In the second volume of *Figures for Gardeners Dictionary*, published in 1758, Miller included an engraving from a drawing by William Bartram of the plant *Veratrum*. Miller credits John Bartram with the drawing: "I was first favoured with a Plant of this sort by Mr. Peter Collinson, FRS and afterwards received a Plant, with a Drawing of it, made in the Country where it naturally grows, by Mr. John Bartram junior."[21] In a letter to Collinson, John Bartram explains that enclosed in the dispatch "My billy hath sent . . . several drawings of rare birds of passage for thee . . . & A letter & A drawing of ye flower of my evergreen veratrum for miller."[22] Thus by 1758 William's drawings had been copied for some of the most influential books of natural history in

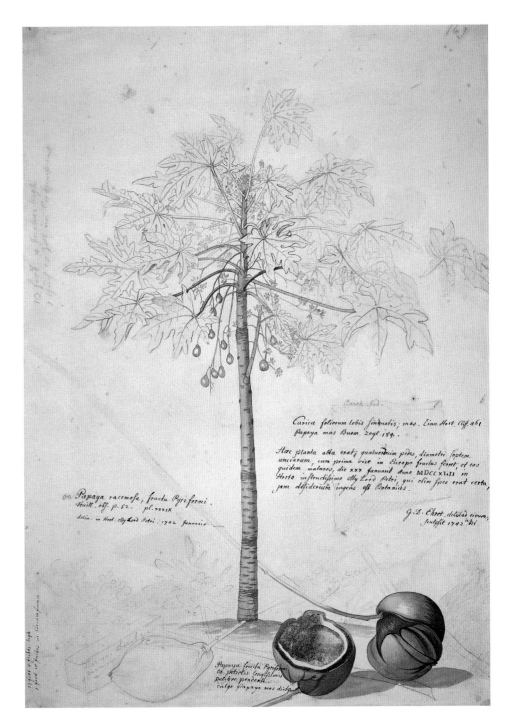

print, Edwards's *Birds* and Miller's *Gardeners Dictionary*. While at school, William's spare time was taken up with drawing, "which is only seventh days in ye afternoon & first day morning for he is constantly kept to scool to learn Latin and french."[23] As to instruction in art, there is no evidence that William received any. His talent as a draftsman appears to be a result of a natural ability and his own passion for the subject. There is no doubt that his art developed from studying the engravings of naturalist artists such as Catesby, Edwards, and Ehret.

Eventually at the end of 1756 and at the age of seventeen, William agreed to go to Philadelphia and live with Captain James Child and his wife and train as

WILLIAM BARTRAM
(1739–1823)

SWAMP PINK
Helonias bullata L.
(Liliaceae)

a merchant. He opted for the one trade that would allow him a small amount of independence from his father and his father's friends. The Childs became very fond of William, who remained with them for over four years. When William left them for Cape Fear, North Carolina, to set himself up as a merchant, they lamented "thair loss" of William "as one of thair family."[24] As apprentice to Captain Child, William learned the trade but continued to draw plants, birds, and turtle shells and sent many of his drawings to England. Collinson, Edwards, and Jared Elliott in Connecticut all received drawings throughout this period. It was at Cape Fear that William's uncle and namesake and half-brother to John Bartram lived. And it was here that William entered into his new family and soon became as much loved by them as he had been with the Childs. So highly did his uncle regard him that in 1762 he wrote to his brother: "The Parting with your Son Bille this Day felt; harder to Me than the Parting with My own son: his Behaviour to me: & my family has Bene so Agreeable as well: as to others: which gave A Concern to Many. But one Comfort to me is: I am in great hopes he will Return & Live with us Again."[25]

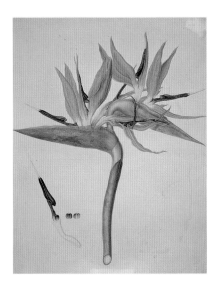

CHAPTER 3

Cape Fear and Competition

WILLIAM SET SAIL FROM PHILADELPHIA and arrived at Cape Fear on 6 May 1761. He wrote to his father soon after his arrival describing how he had suffered the most dreadful seasickness on the journey, and in an expression of his homesickness he adds a postscript, "I should be glad to Hear from Dear Mother Sisters &brothers."[1] Another letter, two weeks later, continued with what became a succession of misfortunes that seemed to dog him throughout his life of trying to make a successful living. He arrived in North Carolina at an unfortunate time. The market he described as bad and the season of the year was wrong. His first few weeks in the region were met by excessive rainfall that destroyed much of the country and drove many people from their houses near the river to seek refuge in the woods. Worst was to come in that his uncle's boat, which he was relying on to transport his goods, had been lent to another trader and William was forced to hire a boat "at the Rate of Ten Shillings p Day." William explained to his father that he had already sent some plants to him, one of them being "the most extraordinary Beauty in the Vegitable Kingdom that Comicle Sensitive Plant which grows in the Savannas."[2] Unfortunately, even this activity so well known to William met with disaster. The plants were lost when they were washed overboard. Once again William adds a plea for news from his family. He was rewarded in early summer by a letter from John, who makes light of William's troubles and promptly admonishes him for sending plants to him at such an "im-

These sportive vegetables the ludicrous DIONAEA MUSCIPULA.

—WILLIAM BARTRAM, *Travels*

proper time." John went on to provide William with a list of plants and seeds he required and, as in all his letters, endeavored to give counsel, "fear God & walk humble before him."[3]

Three months later William had very little to show for himself either in his trade or in his plant collecting. In September, John Bartram wrote to his son again, "I should have been glad of A letter & to have had an account of thy Success in merchandise." This complaint was repeated many times as William's letters to his family became less and less frequent. John's sound advice to William this time was to "keep to vertue, piety, moderation & frugality be obligeing to all but dont Joyn with ye vitious; beware of the deludeing snares of excess. keep in ye narrow paths of strick temperance in all things which leads to ye Bowers of Tranquility."[4] With the complaint and good counsel came John's usual plea for plants from William. He also gave William instructions on how to pack and transport the plants. When the seeds failed to appear, John began to get impatient and implored William to look out for seeds that John did not already have. John had gone to "great pains to instruct" William in his plant knowledge, but now implies that William is lazy and inconsiderate, "thee disapointed my expectation much in not sending to me any seeds . . . & know your seeds was some or other ripening from ye day thee set foot on Carolina shore . . . & such as was within A mile or two of thy common walks . . . & yet I have not received one single seed from my son who glories so much in ye knowledge of plants."[5]

Despite John's expression of anger and resentment in this letter, he was nevertheless concerned about the welfare of his son. He suspected that William's lack of productivity might reflect other problems. He wrote another letter that same day, this time to his brother, "I and most of my son Billys relations is concerned that he never writes how his trade affairs succeeds we are afraid he doth not make out so well as he expected."[6] John Bartram's fears were justified. William had not managed to be successful in trade, and he never did. He seemed to meet one obstacle after another and the greatest of these was William himself. John had tried to advise William in how to succeed in the business, explaining that he would need to make himself and his trade known to the governor and the important people of North Carolina. Because William was young and new to the business, he needed to seek their approval and "in A pleasant Cheerful obligeing manner desire thair good will & concurrance therein."[7] However, for William such self-promotion and interaction with others did not fit well with his temperament and his foray into trade went from bad to worse.

In June the following year William returned to Philadelphia for the summer, but to the joy of his uncle he was back in North Carolina by the September. He traveled down and overland with his father to within two hundred miles of his uncle's home at Ashwood. Here the father and son parted, William traveling on to Cape Fear, while John went on to Georgia. John Bartram considered this trip "ye most prosperous Journey that ever I was favoured with every thing succeeded beyond my expectation. . . . I was pleased with Billys temperance & patience in his Journey & shall soon be daly expecting A packet of seeds & A box of plants from you which with hearing of your welfare will make glad ye heart

SOUTHERN ARROW-WOOD
Viburnum dentatum L.
(Caprifoliaceae)

of your Loveing father."[8] This time William did not disappoint his father and he sent a box of plants from Cape Fear the following May. He continued to struggle, however, in making a living from trade: "my John is A worthy sober industrious son & delights in plants but I doubt Will[iam] he will be ruined in Carolina every thing goes wrong with him there,"[9] wrote his father to Collinson in 1764. Collinson's response offered only his perplexity, "I am concerned that Billy so Ingenious a Lad—is as it were Lost in Indolence & obscurity."[10]

The "comical sensitive plant" that William attempted to send his father in 1761 had first come to the attention of Peter Collinson in 1759 through his correspondence with Arthur Dobbs, then governor of North Carolina. Arthur Dobbs was born in Ayrshire, Scotland, in 1689 but was brought up in Carrickfergus in Ulster, the fourth generation of the Dobbs family in Ireland. He had from an early age taken an interest in science and contributed to the Philosophical Transactions

of the Royal Society. In 1754, at the age of sixty-five, he left Ireland and sailed with his son to America to become the governor of North Carolina. For many years Dobbs had been a keen gardener and had purchased boxes of seed from John Bartram as early as 1749 for his garden in Ireland. When he settled in North Carolina, he continued his botanical interest, and when he had time, he ventured into the swamps and savannas of North Carolina, where he discovered a fascinating species, "a kind of a Catch Fly sensitive which closes upon any thing that touches it."[11] Dobbs was describing the Venus Flytrap, *Dionaea muscipula*, which grows in a restricted area of the extreme southeastern part of North Carolina, overlapping into a narrow strip of northeastern South Carolina. Today it is protected by law and appears on the International Union for Conservation of Nature list of threatened plants. When Dobbs wrote this sentence about the catchfly sensitive to Collinson in 1759, he sparked an immediate curiosity, and without delay Collinson wrote to John Bartram with the news.

An amusing and sometimes desperate correspondence developed between Collinson and John Bartram in Collinson's eagerness to have the plant. In the summer of 1762, Collinson wrote: "I expect some Discoveries from William who has curiosity & Ingenuity—I much wish he could give a sketch of the Sensitive Leafe if He is with his uncle it may then be no Difficult thing to procure—I wish I could hear it was Once in thy own Garden & that I had good Specimens I then could forme some Idea of this Wagish plant,—as Wagishly Described."[12] As Collinson was penning these sentiments, John Bartram was growing the plant

in his greenhouse and had given it the name Tipitiwitchet, "my little tipitiwitchet sensitive stimulates laughter in all ye beholders."[13] Whether William sent seeds to John or brought some back with him when he returned home in June is unknown; John mentions only that he received seeds from the Congaree but fails to mention from whom. By August 1762 the "hot weather" had killed one of the plants that had germinated, but John managed to succeed with two others that survived into living specimens. It is therefore safe to say that John Bartram was the first to cultivate the Venus Flytrap, a task many, even the best gardeners, had difficulty in doing. As time passed, Collinson became increasingly impatient to see the plant and advised John to "never lett a letter pass without a Specimen as it advances," and not for the first time he asks, "Is it possible for Billie to paint it."[14] When John failed to deliver a specimen, Collinson protested, "if I have not a Specimen in thy next Letter—never write Mee more for it is Cruel to tantalize Mee."[15] After John's several attempts at sending leaves and dried specimens of the plant to England, Collinson finally received his first samples and reports to John that he had "sent Linnaeus a Specimen & one leafe of Tipitiwitchet—Sensitive—Only to Him would I spare such a jewel—pray send More Specimens I am afraid Wee can never Raise It—Linnaeus will be In raptures at the Sight of It."[16]

The name Tipitiwitchet, given by John Bartram, was once thought to have been of Native American origin. This assumption is incorrect and Daniel McKinley has proposed a new explanation on the etymology of the word, arguing that in Elizabethan vernacular "Tipitiwitchet was a salacious reference to the female pudendal region." He explained that it is formed from two words, "tipit" and "witchit," or "twitchet," which have several similar meanings equal to that of "snatch box," a term "used for vulva in popular parlance."[17] The term Bartram coined refers to the lobes of the trap of the Flycatcher, which he believed resembled the female anatomy. In the correspondence between Bartram and Collinson, there is a considerable exchange of ribald banter wherein the plant is described as "waggish" and, in order to stimulate the leaves into closing, it was necessary to "tease" and "tickle" the "sensitive" leaves. Evidence in favor of this interpretation of Tipitiwitchet comes in a letter to Bartram from Collinson: "I hear my Friend Dobbs at 73 had gott a Colts Tooth in his Head & has married a young lady of 22 It is now in vain to write to Him for seeds or plants of Tipitiwitchit now He has gott one of his Own to play with." By this time Collinson had reached a point of "almost Despair" when he wrote Bartram that "I am afraid Wee shall not raise one of the Many Vegitable Wonders (the Tippitiwichet) for Gordon with all his skill cannot bring it to light."[18]

Although Collinson had received dried specimens of the plant from Bartram as early as 1763, it was not until 1768 that a living plant arrived in London and caused a sensation throughout Europe. John Bartram was the first to grow specimens of *Dionaea* and it took many years to succeed, but it was William Young, a neighbor of the Bartrams and rival of John's as a supplier of plants and seed who set sail on his second voyage to England, bringing with him over one hundred living plants from North America. About a dozen of these plants were the Tipitiwitchet and they were sold through nurserymen such as James Gordon of

JOHN BARTRAM
(1699–1777)

VENUS FLYTRAP
Dionaea muscipula J. Ellis
(Droseraceae). Specimen

Fenchurch Street and Mr. Brookes in Holborn, two of the leading commercial gardeners in England.

John Ellis, Fellow of the Royal Society from 1754 and author of many scientific papers, managed to obtain a plant and wrote a description that was first published as a letter to the editor of the *St. James's Chronicle*, a London newspaper, on 3 September 1768. It was later attached as an appendix to a pamphlet entitled *Directions for bringing over seeds and plants from the East Indies*, published in February 1770. Ellis named the plant *Dionaea muscipula*, "Or Venus's flytrap," and described each leaf as "a miniature figure of a Rat trap with teeth."[19] The name *Dionaea* (Dione) in Greek mythology was the mother of Aphrodite (Venus), the goddess of love, and was first suggested by Daniel Solander, who had earlier described the plant from a dried specimen. Solander was about to set sail with Captain Cook and Sir Joseph Banks on the voyage of the *Endeavour* to monitor the transit of Venus across the face of the sun, and some believe this is what had influenced him. However, Venus and Dionaea, the two goddesses of love, were not unfamiliar to scientists in the eighteenth century. Linnaeus, in 1771, gave the name *Venus dione* to a little-known mollusc that he described in a rather crude manner by referring to the female anatomy for parts of the clam shell. Such language was clearly commonplace and considered amusing by many.

For his work on *Dionaea*, Ellis was made an honorary member of the Royal Society of Uppsala and his description of the plant was published in the Society's Transactions. Linnaeus expressed the thanks of the Swedish Royal Academy of Sciences to Ellis in a letter in October 1768, confessing that he "never met with so wonderful a phaenomenon."[20] *Dionaea* caught the imagination of Europe in the 1770s and has continued to fascinate. Linnaeus is reported also to have exclaimed "Miraculum Naturae" after seeing it, and Charles Darwin some one hundred years later stated that the plant "is one of the most wonderful in the world."[21]

The allure of carnivorous plants such as *Dionaea* was that they appeared to possess an intelligence, that they were capable of intention and thereby deserved a higher position in the Great Chain of Being, the popular eighteenth-century theory of the natural world. William Bartram described *Dionaea* as a "sportive vegetable," a wonderful example of plants having the power of will, "But admirable are the properties of the extraordinary Dionea muscipula! . . . the incarnate lobes expanding, . . . ready on the spring to intrap incautious deluded insects, what artifice! . . . Can we after viewing this object, hesitate a moment to confess, that vegetable beings are endued with some sensible faculties or attributes, similar to those that dignify animal nature; they are organical, living and self-moving bodies, for we see here, in this plant, motion and volition"(xx–xxi). John Bartram was also struck by this notion of plants possessing some form of sense. He wrote to Benjamin Rush, congratulating him on his discovery of "nerves in plants," and encouraged him to continue his research in order to dispel all the "pretended Revelations of our Mistrey mongers & thair inspirations." John believed that if plants had "not absolute sense yet thay has such faculties as came so near to it."[22]

Soon after John Ellis published his description of *Dionaea*, he arranged for James Roberts to complete an engraving of the plant, so by mid-September 1768

WILLIAM YOUNG
(1742–1785)

VENUS FLYTRAP (FIG. 8)
Dionaea muscipula J. Ellis
(Droseraceae)

Ellis had a colored engraving of *Dionaea* ready to send to his correspondents. The engraving was not published until 1770 and though it was the first published image of the plant, two other drawings preceded it. One was by William Young, the man who brought the living plant to Europe, the other by William Bartram. Both drawings were completed in 1767

William Young had made himself known within the circle of plant lovers and nurserymen from an early age. He was but nineteen years old when he was first introduced to those involved in the English and American plant trade, and within three years he was honored by royalty. In September 1764, at the request of Queen Charlotte, William Young set sail on his first voyage to England. Young had been appointed Queen's Botanist with a stipend of £300 a year and was brought to England to be trained by the botanist John Hill.

A year earlier Young had sent a package containing "a large collection of seed" directly to Queen Charlotte. Such boldness and presumption was unheard of. The normal procedure for currying favor at Court would be to work through a host of petty officials and lesser nobility in the hope of eventually catching the attention of someone currently in favor. Nevertheless, the queen and the royal family were "much pleased with his present" and desired "to see him in Eng-

Gardenia

WILLIAM KING
(FL. 1750S)

GARDENIA
Gardenia sp. J. Ellis
(Rubiaceae)

land."[23] As Young set sail for London, John Bartram wrote to Collinson expressing his dismay and chagrin at the news of William Young's appointment as Royal Botanist: "My neighbour youngs sudden preferment has astonished great part of our inhabitants thay are daily talking to me about him that he has got more honour by A few miles traveling to pick up A few common plants than I have by near 30 years travail with great danger & peril it is shocking ye plants you have had many of them known 100 years & most 20 or 30 should be esteemed at court as new discoveries."[24] Bartram, nevertheless, took the opportunity of Young's journey to use him as courier for sending specimens to Collinson. The same day,

John Bartram wrote to Louisa Ulrika Drotting, the queen of Holland, enclosing a collection of plants and expressing his hopes that he would find his labors rewarded. John Bartram was taking a leaf out of Young's book and learning to be more audacious.

The reason why William Young had endeared himself to Queen Charlotte is uncertain. He was born in Cassel Hesse, Germany, on 30 November 1742 to Elizabeth and William Young. His father's ancestors were English, the great-grandparents of William Sr. having left England in May 1556 as a direct result of religious persecution during the reign of Queen Mary. In 1744 the Young family left Germany for America and arrived in Philadelphia on 24 December 1744.[25] The family settled in Kingsessing and became the neighbors of the Bartrams in 1755. William Young was well acquainted with the Bartram garden and John Bartram's plant collecting and successful seed business. The first known reference to William Young becoming a nurseryman-cum-plant collector was when he was nineteen and Alexander Garden of Charleston, South Carolina, wrote to his friend John Ellis in London, "I have at last met with a man who is to commence nurseryman and gardener, and to collect seeds, plants etc. for the London market." Garden described Young as a sensible, careful man and promised that he would receive "all the advice and assistance that I can give him."[26]

When Young sent his seed package to the queen in 1763, his success was probably secured in that the accompanying letter was likely to have been written in German. Charlotte arrived from Germany for her marriage to the king in September 1761. Her English was then very poor, as was testified by Mark Beaufoy. He attended an address presented to the king by a group from the Society of Friends. "Dr. Fothergill read the address to the king . . . Jacob Hagen, on account of being able to speak the German tongue, was appointed to read the address to the Queen."[27] John Bartram also implied that Young's German origins may have given him some preference when he wrote, "Various are the opinions of his success some think he will make such an awkward appearance at Court that he will soon come back again. others that ye Queen will take care of ye german Gentleman."[28] Queen Charlotte herself showed a keen interest in gardening. She maintained a pleasure in botanical studies throughout her life and took art lessons from the great resident botanical artist at Kew, Franz Bauer. Her involvement in the garden at Kew and her own garden at Frogmore was always an active one. Her patronage of Kew was commemorated in 1773, when the Bird of Paradise plant from the Cape of Good Hope was introduced into the botanical garden and named *Strelitzia reginae* by Sir Joseph Banks.[29]

Despite being promoted by Alexander Garden and favored by royalty, very little is known of William Young. Certain aspects of his character can be deduced from his own activities that convey the image of an ambitious, self-promoting but at the same time hardworking young man determined to succeed. John Bartram, who knew Young before his trip to England, conceded that Young "is very industrious & hath A good share of ingenuity."[30] With the assistance of men such as Alexander Garden and John Ellis in London, William Young managed to make a significant impact on the English plant market. Within two and a half

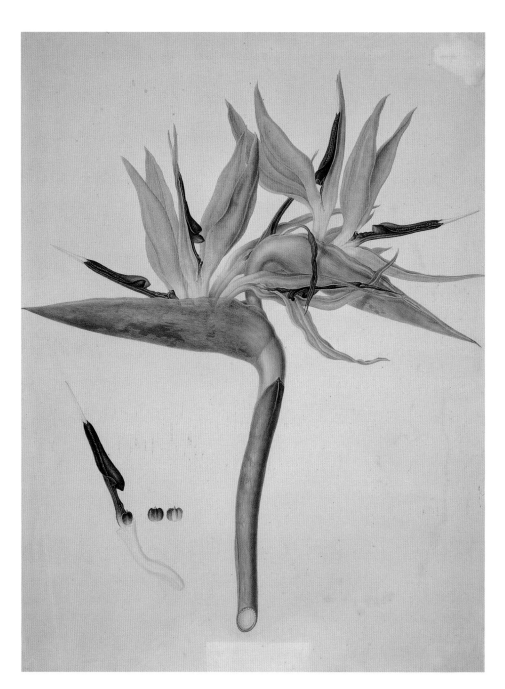

years he was sending plants to a wide variety of people in England and receiving £300 a year as Queen's Botanist. This was no small accomplishment for a young man of twenty-one.

When Young arrived in London, he established connections with some of the leading nurserymen and became acquainted with Peter Collinson, John Fothergill, and John Ellis. He was also ideally placed to meet the landed aristocracy through his relationship with John Hill. Young had been tutored by John Hill, a fact that John Bartram observed may redeem him: "I think that if he is put under dr. Hills care that he will make A Botanist."[31] John Hill was patronized by, and a friend to, Lord Bute, a favorite of King George III and his mother, Augusta. Bute was the adviser to Princess Augusta for the garden at Kew and became, all

but in name, Kew's first director. Through Bute, John Hill had access to many wealthy landowners with large gardens, men such as the Dukes of Richmond and Northumberland. Hill enjoyed great popularity among the aristocracy, but his standing within the scientific community was not one of admiration. He attracted such little respect from men of science that he was unable to find the necessary two nominations required for election to the Royal Society.

Hill published a vast amount of literature, churning out one book after another. A substantial number of these works were botanical—his *Vegetable System* alone ran to twenty-six volumes—but these were considered by many to be full of flaws. Even John Bartram acknowledged that there were "many great omisions & errors."[32] Despite the flaws, Hill's contribution to science was not unimportant. His books contained colored illustrations that were aids to identification and they were certainly read throughout the botanical world. Hill was the first to use the Linnaeus classification system in his work, although he recognized the weakness of the system and did not hesitate to say so. He was also one of the few who challenged the absurdities sometimes published in the Transactions of the Royal Society. Such outspokenness inevitably created enemies and Hill developed a reputation, part of which was probably undeserved. He was considered by many

to be vain and possess an overbearing ego and a desire for recognition from the great scientists of the day, which was equaled only by his desire for fortune. In his description of Hill, Samuel Johnson stated that if Hill "would have been contented to tell the world no more than he knew, he might have been a considerable man."[33] Hill practiced as a physician, performed as an actor, wrote as a journalist and author of botanical books, and became well known as an apothecary and dispenser of medicines. It was from this last profession that he made much of his money, devising new medicines that were sold in large quantities. William Young's own father became one of the agents for Hill's elixirs in America.

It was to this man and under his influence that William Young found himself. Two men with not dissimilar characters—sharp, industrious, ambitious, and bombastic. The elder was a competent botanist but too eager for recognition, while the younger was headstrong and daring and with little botanical experience. "It cannot be expected that his knowledge is very extensive,"[34] wrote Israel Pemberton to John Fothergill soon after Young's departure from America. Soon Young fell victim to the London fashion scene and the pleasure seeking frequently associated with those on the fringes of Court. Collinson complained, "as a friend I advised Him often to oeconomy and industry, & not sacrifice every thing to his pleasures."[35] Debts began to accrue and before long Young found himself in prison. He was rescued by the queen and his debts paid on the proviso that he go "straight to Philadelphia." Young was placed on board ship in the custody of an officer in the autumn of 1766, homeward bound with his reputation somewhat tarnished. The following March, Thomas Penn wrote to Young from London, advising him to remain in America: "I think you should give over all thoughts of returning here, and fix yourself in Pennsylvania."[36] So ended the first phase of William Young's flirtation with fame and plant collecting.

Young's return to America in November 1766 continued to cause a stir. John Bartram described him as cutting the "greatest figure in town struts along ye streets whisling with his sword & gold lace etc. he hath been 3 times to visit me pretends a grat respect for me he is Just going to winter in ye Carolinas sayeth there is 300 pounds sterling annually settled upon him."[37] Young may have boasted of £300 as his stipend, but the amount had been reduced, as Thomas Penn explained, "He will never have more than the £50 a year while John Bartram lives."[38] Bartram's rather bitter remark about Young was a little unfair. When the king asked Young about the character of John Bartram, Young replied that he had "a very great regard for him gave an account of his long labours in botanical matters and said he much deserved regard."[39]

When news of Young's appointment as Queen's Botanist in 1764 was made known in Philadelphia, many of John Bartram's friends, including Benjamin Franklin, urged Bartram to send similar seed packages to the king: "I have put A little Box of such specimens as I am sure he never found & I believe never came to England before I sent them."[40] Franklin wrote to Collinson urging him to do something about "our Old Friend who has done so much" and, in Franklin's view, had been "quite forgotten." Franklin found it "odd that a German lad . . . who had only a smattering of botany"[41] could be favored by the queen. With

such endeavors and the considerable assistance of Peter Collinson, the king finally looked favorably upon John Bartram and Collinson was eventually able to write to John: "I have the pleasure to Inform my Good Friend that my Repeated Solicitations have not been in Vain for this Day I received certain Intelligence from our Gracious King that He had appointed thee His Botanist with a salary of Fifty pounds a Year."[42] This was not equal to Young's claim of £300, but it was enough to dispel Bartram's envy and bitterness and redress the indignation he felt by Young's appointment.

Bartram continued to receive the stipend up to 1776 and the Declaration of Independence. Although many of John Bartram's friends believed he deserved such an honor, some expressed surprise. Alexander Garden of Charleston, after whom Ellis named the Gardenia, was one. He wrote to John Ellis: "Surely John is a worthy man; but yet to give the title of King's Botanist to a man who can scarcely spell, much less make out the characters of any one genus of plants, appears rather hyperbolical."[43] Such a response exposes a distinct snobbery on Garden's behalf, who rather contradicts himself in his promotion of Young. It is true he was a man who never hesitated to criticize. He did not think very well of Sloane's work on Jamaica, he considered Buffon "superficial and trifling," and he referred to Catesby's work as full of "blunders and gross misrepresentations."[44] Garden was scathing about Catesby's drawings, stating that Catesby's "sole object was to make showy figures of the productions of Nature, rather than to give correct and accurate representations. This is rather to invent than to describe. It is indulging the fancies of his own brain."[45] Nevertheless, Garden was instrumental in promoting William Young and found nothing to criticize in Young's royal appointment.

William Young made several trips to England, despite being advised against doing so, taking living plants and seeds with him each time. On his return from his first trip, he spent much of 1767 in North and South Carolina collecting and drawing plants. This work culminated in two books of specimens mounted on paper and a corresponding volume of drawings of each of the plants. The volume of drawings consists of ninety-six sheets with an average of three plants to a page. He dedicated the book to King George and Queen Charlotte and dated it 1 December 1767. The drawings of William Young are highly stylized and clearly the work of a man who seems to have had no artistic training. He made no attempt to draw the different parts of the plant and the transverse sections that would assist in their identification. This is surprising because having been a pupil of John Hill, Young should have learned the rudiments of botanical drawing. The layout of the drawings in most cases is identical to the arrangement of the specimens, which would indicate that they were probably drawn from the specimens after they were mounted, rather than from life, as Young claimed. Those specimens that have retained their roots are included in the drawing. Jonas Dryander described the drawings as "icones pictae rudes,"[46] and they are certainly of a style unsophisticated and naïve, similar to those in early herbals. His colors are rather crudely applied without any subtlety or gradation of tone. Nevertheless, the plants are in most cases identifiable and possess a childlike freshness.

Accompanying the illustrations is an alphabetical and numerical list with the generic or English names, some of which Young invented. Included in these drawings is *Dionaea muscipula*. Young was not known for his sense of modesty and so in true form, he named the plant *Youngsonia*. This is probably the first known drawing of the plant since the volume was completed by 1 December and *Dionaea* is numbered eight in the sequence. *Dionaea* flowers from mid-May through the first two weeks of June. Young's image of the plant was very likely completed in the summer of 1767, sometime after the flowering month, as Young's drawing is devoid of flowers. John Ellis made some sketches of *Dionaea* after receiving the living specimen that Young brought to England in 1768 and the engraving by Roberts for Ellis's publication was completed in September of that year. Another early drawing is that of Johannes Miller, who illustrated *Dionaea* in 1772. Despite pleas from Collinson to "sketch the plant" as early as 1763, William Bartram's first known drawing of the plant was completed sometime in 1767, the same year as Young's. William Bartram probably drew his image of *Dionaea* sometime between September, after his return from Florida, and late autumn, when it was dispatched to Peter Collinson, who acknowledges receipt of it on 2 February 1768.

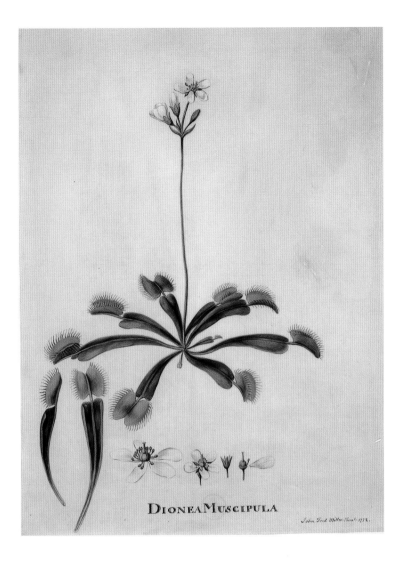

DIONEA MUSCIPULA

John Fred Miller Pinx! 1772.

JOHN MILLER
(FL. 1772–96)

VENUS FLYTRAP
Dionaea muscipula J. Ellis
(Droseraceae)

Bartram's *Dionaea* is included in a large portrait where the center stage is taken by *Nelumbo lutaea*.

William Young continued in the plant trade and became a competent collector and nurseryman. When the American Revolution and the War of Independence broke out, Young moved his business interests to France and in 1783 published the first catalogue of American flora by an American entitled *Catalogue d'Arbres Arbustes et Plantes Herbacées d'Amerique*. Sadly Young died a few years after the publication of his catalogue. He was out plant collecting at Gunpowder Creek, Maryland, in 1785 when he tragically fell from a height into the creek below, where he drowned.

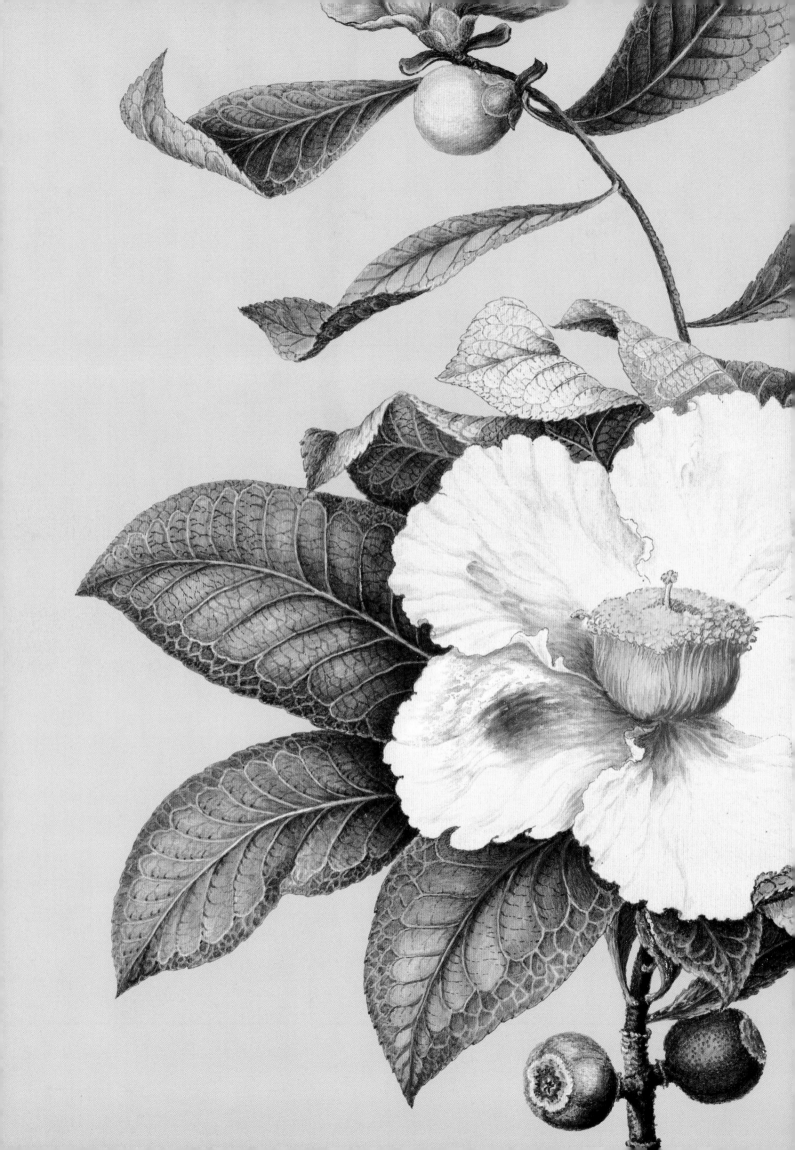

PART TWO

Experience

CHAPTER 4

Travels in Florida
with the King's Botanist

W HILE W ILLIAM Y OUNG was making an impact on the English plant market, William Bartram, two years his senior, and far superior in his knowledge of plants, continued to struggle to make a success of his trading post at Cape Fear. Four years had passed since William first went to live at his uncle's house at Ashwood, but he had made almost no progress in his life as a merchant. The allure of nature in North Carolina was far more attractive to him than the mercantile life. His father's comment of him being "ruined in Carolina" was becoming more real each day. So when William received a letter in June 1765 from his father, now the King's Botanist, asking William to accompany him on a trip to Florida, William did not hesitate: "Our vesail is to sail in about two or three weeks therefore I advise thee to sell of all thy goods at A public vendu."[1] William needed no prompting; he appointed his "well beloved friend & uncle Wm. Bartram of North Carolina . . . my true & lawful attorney"[2] to collect any debts owed to him.

The trip to Georgia and Florida was significant for both father and son because it was the last major plant-hunting excursion for John, who, at the journey's end, ten months later, would be sixty-seven years old. For William, this expedition would give him the inspiration and confidence to conduct his own travels alone seven years later.

The Bartrams were the first to explore the natural history of Florida. Catesby's book includes in its long title the phrase *Natural History of Florida,* but the

area he visited was in present-day Georgia. When Catesby was in this region, Florida was under Spanish rule, and it was not until the Treaty of Paris in 1763 that Spanish Florida was opened up to the British. This was the first time John Bartram had traveled so far south and he kept a record of his experiences, parts of which were published in 1767 and later given the title *John Bartram's Diary: kept during his Excursion in the Carolinas, Georgia and Florida from July 1 1765 to April 10 1766*. John Bartram's work has been described as excellent in many ways, but by no means does it give a thorough account of the natural history of the region. He was quite capable of presenting a more detailed work, but unfortunately he never did so. The Swedish naturalist Peter Kalm, a student of Linnaeus, who visited North America and stayed with the Bartrams, wrote that the world should be grateful to Bartram for discovering and introducing many rare and previously unknown plants. He described Bartram as being born with a peculiar genius for the science of natural philosophy and of showing great judgment and "an attention which lets nothing escape unnoticed." Kalm goes on to criticize Bartram, for despite having these qualities, he was negligent, Kalm thought, in that "he did not care to write down his numerous and useful observations."[3] The journal of John Bartram's trip to Florida is very much a diary, the jottings of daily sightings and events. Bartram made no attempt to embellish his descriptions with florid language or literary analogy such as William would do in his own writings.

Traveling in unknown regions at this time could be hazardous and was no mean undertaking, particularly for a man in his mid-sixties. Conditions were harsh and the Bartrams were equipped with little protection against the elements, let alone for any comforts. For most of their journey they did not even have a tent to sleep in at night. They traveled with one horse each, which carried all the provisions needed for their survival, as well as their collecting materials and the numerous specimens they acquired. When they ventured beyond the frontier settlements and the military forts or camps that gave them some protection, they would sleep beneath the stars or "under a pine." They suffered from heavy rains, trudging through swamps, and the torment of the relentless mosquitoes. It was here, Francis Harper claims, that John Bartram first contracted malaria.[4] Bartram's diary relates how father and son were witness to important historical events, such as the signing of the Treaty between the Creek Nation, the local indigenous people, and Governor Grant at the Congress of Picolata on 18 November 1765. It also includes accounts of Creek ceremonies, one of which was the first and "only description of the calumet ceremony," the smoking of the Peace Pipe, that had occurred "so far east."[5]

For John and William Bartram, the important event of their trip was the discovery of several new plants. John opens his entry for 1 October by describing the day as a "fine clear cool morning." The riding was hard through many swamps as there had been a great deal of rain. As they came near the Altamaha River in Georgia, John wrote, "We mised our way and fell 4 mile below fort barrington . . . this day we found severall very curious shrubs."[6] Two of these shrubs were unknown to science, the Georgia or Fever Bark, *Pinckneya bracteata* and the *Franklinia alatamaha*. The plant *Franklinia* no longer exists in the wild

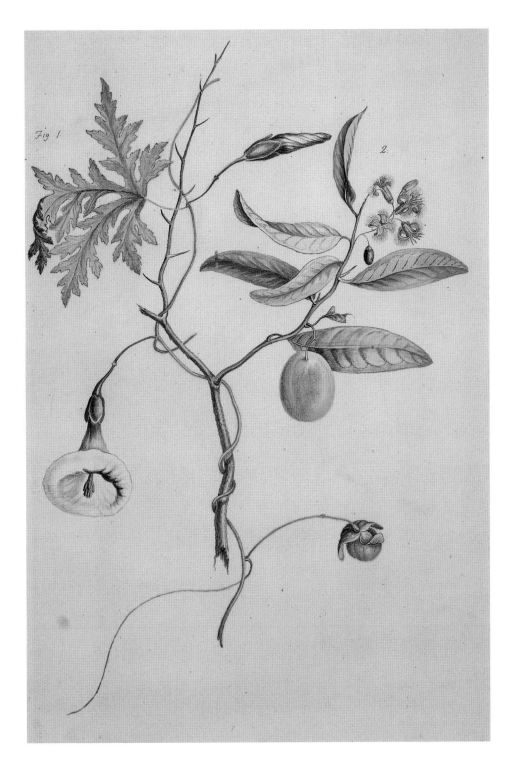

MORNING GLORY (FIG. 1)
Merremia dissecta
(Jacq.) Hallier f.
(Convolvulaceae)

TALLOW-WOOD OR HOG
PLUM (FIG. 2)
Ximenia americana L.
(Olacaceae)

and all remaining cultivated specimens are thought to have originated from seeds grown by William Bartram. Bartram recorded in his *Travels* seeing *Franklinia* three times in the wild, the first with his father and then again in 1773 and 1776 on his travels alone. The accuracy of the dates of these sightings is unreliable as many of the dates in *Travels* are incorrect. William does not mention in his journal, sent to John Fothergill, the 1773 sighting that he reports in *Travels*. On the second of these solitary sightings, William describes *Franklinia* as being in perfect

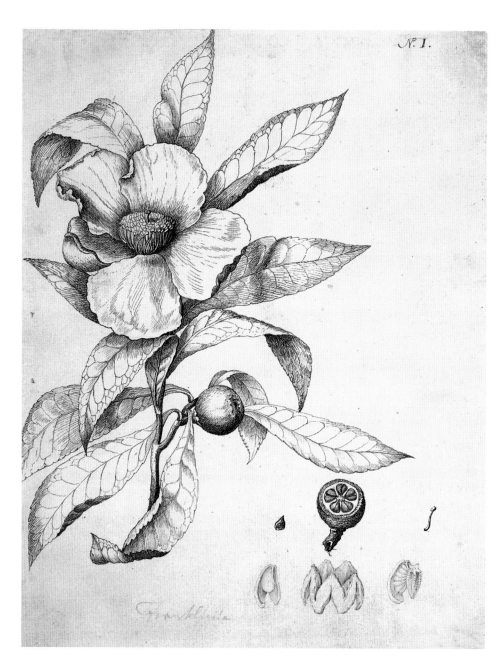

Nᵒ I.

FRANKLINIA
Franklinia alatamaha
W. Bartram ex
Marshall. (Theaceae)

bloom. Humphry Marshall, John Bartram's cousin, explained that it was then that *Franklinia* was "brought into Pennsylvania." William "revisited the place where it had been before observed . . . and bearing ripe seeds at the same time; some of which he collected and brought home, and raised several plants therefrom."[7] It first flowered in the Bartram garden in 1781 and thereafter thrived, the garden becoming the means of its survival. In 1790 Moses Marshall, Humphry's nephew, collected *Franklinia* at a site in Georgia, and the Italian Luigi Castiglioni published a description of it the same year.

The last reported sighting of *Franklinia* in the wild was in 1803 by John Lyon, a Scottish nurseryman and plant hunter who closely followed the Bartram trail into Georgia and East Florida. When Lyon reported his sighting of *Franklinia* in his diary entry for 1 June 1803, he expressed surprise that "this plant has never

been found growing naturally in any other part of the United States as far as I can learn, and here there is not more than 6 or 8 full grown trees of it."[8] William Bartram makes the same observation in his *Travels* and again in his description of the plant accompanying the specimen that he sent to Robert Barclay in 1788. "I have travelled by land from Pensylvania to the banks of the Mississippi, over almost all the Territory in that distance between the Sea shore & the first mountains, cross'd all the Rivers, and assended them from their capes a many miles; & search'd their various branches Yet never saw This beautiful Tree growing wild but in one spot on the Alatamaha about 30 miles from the Sea Coast."[9] Stephen Elliott from Charleston made an entry in his "collection journal" of *Gordonia pubescens* (*Franklinia*) dated 1814, but the entry is unclear and there is no certainty that he collected *Franklinia* from its native habitat that year. Several attempts to locate the plant in the wild had been made throughout the nineteenth and twentieth centuries, the most thorough being a series of searches by John Bozeman and George Rogers in the 1970s, but without success.[10] Bartram expressed surprise as to the hardiness of *Franklinia*, it having survived growing in an open, exposed spot in the garden in Pennsylvania. He described this particular plant as having grown to twenty feet in the 1790s, but when Constantine Rafinesque visited the garden some forty years later the tree was "nearly 40 feet high."[11]

William named the rare plant in honor of his and his father's friend "the illustrious Dr. Benjamin Franklin" (468n), while the specific name of *alatamaha* is that given by the Native Americans to the local river, today spelled Altamaha. William recognized and claimed *Franklinia* as a new discovery, but the dispute between American and European botanists as to the genus and official name of the plant continues to this day. On 16 August 1783, William Bartram wrote to Linnaeus fils giving a description of the plant and enclosed with the letter a drawing of *Franklinia*. Linnaeus had replaced his father as Chair of Botany at Uppsala University and was ideally situated to scientifically confirm the genus *Franklinia*. Unfortunately, Linnaeus died in November 1783, before having the opportunity to reply to William's letter. This letter is now held in the Uppsala University Library, but the drawing that accompanied it has never been located. The letter and drawing was William's attempt to establish the plant as a new genus, something he continued to plead for throughout his life. In a second attempt, he sent a full watercolor drawing of the plant to Robert Barclay in England in 1788. Within a few months, Dr. Thomas Parke remarked that Barclay was much pleased with the drawing but, "The botanists in England will not, however, allow it to be properly named."[12] Sir Joseph Banks, the newly elected president of the Royal Society, placed the plant in the genus *Gordonia*. Banks wrote to Marshall in 1789 confirming this: "The *Franklinia* is, as you conjecture, a species of *Gordonia*. A drawing of that plant, sent here by MR. BARTRAM TO MR. BARCLAY, has been compared with specimens; so that no doubt now can remain on that subject."[13] Joel Fry, present-day curator of the Historic Collections, Bartram's Garden, and an authority on the history of *Franklinia*, has pointed out that Banks's comments possessed "a surprising lack of scientific discourse" and that this may well have been intended "to enforce European supremacy in botanical nomenclature."[14] Fry also points

WILLIAM BARTRAM
(1739–1823)

FRANKLINIA
Franklinia alatamaha
W. Bartram ex Marshall
(Theaceae). Specimen

* Page numbers in parentheses refer to William Bartram's *Travels*.

out that to celebrate Benjamin Franklin in this way would certainly have raised the hackles of English botanists. First, Franklin was not a botanist, but more important, it was too soon after the American Revolution to be naming plants in honor of one of its leading figures.

William Bartram made several drawings of *Franklinia*. He drew a pen-and-ink illustration for his patron John Fothergill in 1776 and he completed a splendid watercolor in 1788 that he sent to his friend Robert Barclay, a fellow Quaker and enthusiastic amateur botanist living in London. As early as 1756, Peter Collinson impressed upon William to draw his plants after the "Linnaeus Method which seems to be the prevailing tast."[15] This method included the distinct representation of the stile and stamen of the plant. Bartram never readily adopted the Linnaean style of drawing, so John Fothergill also found it necessary to give instructions to William outlining the Linnaean convention for illustration and asking if it was possible "to be a little more exact in the parts of fructification and where these parts are very diminutive to have them drawn a little magnified."[16] Despite these instructions, William did not consistently adhere to the Linnaean convention for illustration, although the watercolor of *Franklinia* meets all the requirements of a botanical drawing. Sir Joseph Banks, in his praise of the botanical artist Franz Bauer, explained that "each figure is intended to answer itself every question a Botanist can wish to ask, respecting the structure of the plant it represents . . . nothing therefore appears to be wanting."[17] William Bartram's watercolor of *Franklinia* does exactly that. Today, cultivated specimens of *Franklinia* can be found growing all over North America and Europe, and with each flowering and each new plant William Bartram is commemorated for saving the plant from extinction.

Despite the illnesses John Bartram suffered during his Florida trip, of which he complained bitterly to Peter Collinson after he returned to Philadelphia, he wasted little time during those months of traveling. With William, he collected specimens of plants and fossils, observed the wildlife as they journeyed by water and land for many miles, and visited all the important towns that John described in his diary. John and William Bartram were primarily botanists, but like all good naturalists of the day they were interested in every aspect of natural history. Both men had a particular fascination with rattlesnakes, and both wrote about the creatures in answer to questions posed concerning the belief in the rattlesnake's power to mesmerize other animals. John admitted that there might be some hypnotic power in rattlesnakes, though he never witnessed it himself. He had, nevertheless, received "accounts from several persons of undoubted Credit, who have affirmed to me that there is a surprising Fascination in the looks of this snake."[18] Despite these reports, John Bartram remained skeptical, especially after he attempted to engage a rattlesnake himself: "he drew up in a quoil & rattled then I stood staring at him to observe whether he would have any way afected mee by his looks but found no alteration."[19]

Later in life, William discussed rattlesnakes with his friend Benjamin Smith Barton, who went on to publish his thoughts in a *Memoir Concerning the Fascinating Faculty Which Has Been Ascribed to the Rattle-Snake*. Here Barton remarked

FRANKLINIA
Franklinia alatamaha
W. Bartram ex Marshall
(Theaceae)

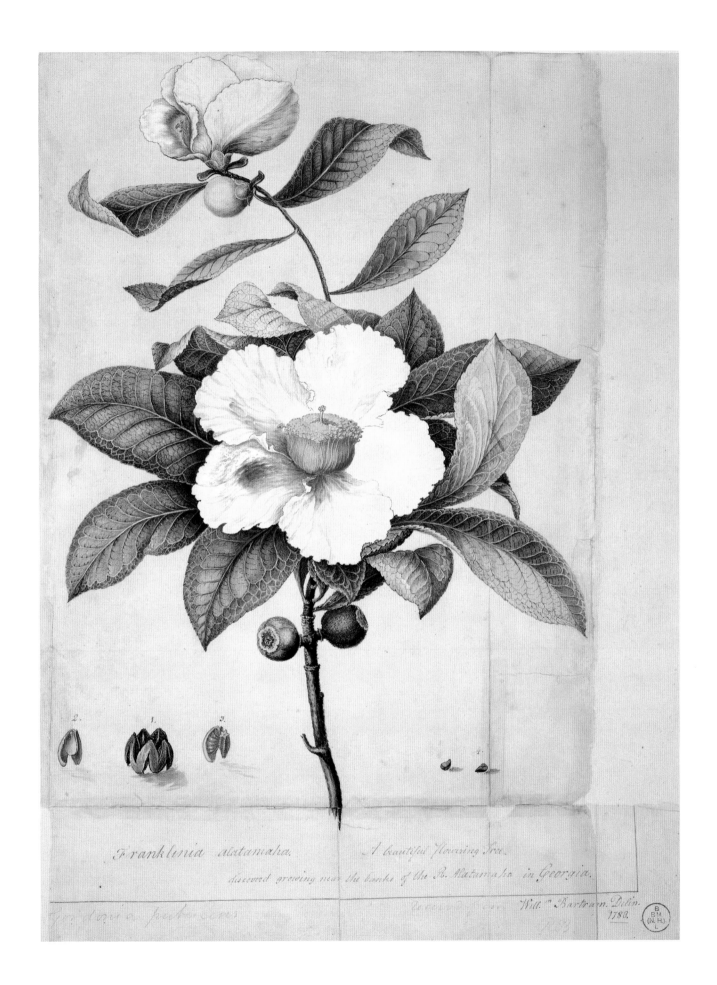

Franklinia alatamaha. *A beautiful flowering Tree*

discovered growing near the banks of the R. Alatamaha in Georgia.

Will.^m Bartram. Delin.
1780.

that the only animals ever fascinated by the rattlesnake were the credulous naturalists themselves. William was most certainly not of the opinion that the snake held such a power when he wrote: "They are supposed to have the power of fascination in an eminent degree, so as to enthral their prey. It is generally believed that they charm birds, rabbits, squirrels and other animals" (267). William gives a strong defense of rattlesnakes in his writings, attributing to them human characteristics. In *Travels* he describes the rattlesnake as "a wonderful creature . . . he is never known to strike until he is first assaulted or fears himself in danger, and even then always gives the earliest warning by the rattles at the extremity of his tail" (264). William encountered the snake on his travels, almost unknowingly stepping on one, but the snake remained "motionless as if inanimate." William puts this down to the generosity and "magnanimous" disposition of the creature, something that he believed all humans could learn from (ibid.).

The entry in John's Florida diary for 21 November 1765 is in William's hand, "fine morning. Killed a monstrous snake." William elaborated on this comment in his *Travels*. He explained that the day before the Treaty discussions commenced at Picolata he and his father went on a botanical excursion around the fort. Here they chanced upon a rattlesnake that in its defense formed itself into a high spiral coil. William claimed that he was at that time "entirely insensible to gratitude or mercy" and so with a sapling killed the snake. They carried the dead creature back to the camp and William "readily delivered up the body of the snake to the cooks." Governor Grant, the commanding officer, was fond of snake and invited Bartram to dinner. "I tasted of it but could not swallow it. I however, was sorry after killing the serpent when coolly recollecting every circumstance. . . . I promised myself that I would never again be accessory to the death of a rattle snake, which promise I have invariably kept to" (271–72). It is interesting that Bartram makes this statement only pages after relating an incident that occurred to him on his travels in 1774, some nine years later. On this occasion he was at the trading post, where a group of Seminole Indians were encamped, and where he was able to observe "their extraordinary veneration or dread of the rattle snake." One day while working on his drawings, a great commotion erupted outside his room and Bartram discovered that a snake had found its way into the camp. He was reluctant to get involved, but after three young men pleaded with him to deal with the snake as they did not possess the "freedom or courage to expel him," he finally consented. Bartram managed to dispatch the snake instantly and taking out his knife "severed his head from his body. . . . I carried off the head of the serpent bleeding in my hand as a trophy of victory, and taking out the mortal fangs, deposited them carefully amongst my collection" (260–62). The apparent contradiction in the two tales within pages of each other is inexplicable, but his sentiment about the killing of innocent animals remains potent.

John and William Bartram remained in Florida and Georgia for ten months. Their travels brought them into contact with men such as John Stuart, the Superintendent of Southern Indians, Henry Laurens, a wealthy merchant of Charleston, South Carolina, and future president of the Continental Congress, and George Galphin, a prosperous planter and trader at Silver Bluff. All these men were to be of assistance to William when he returned to the region in the following decade.

With their travels coming to an end in the spring of 1766, John returned to Philadelphia, but William chose to remain in Florida. The natural history of Florida had been distinctly new to both Bartrams. For William, the exotic flora and fauna of this wilderness was such an attraction that he determined to settle there and try to succeed as a planter, growing rice and indigo. John held out for a short time against what he called "this frolic" of his son's and never looked favorably on the venture. He eventually succumbed to William's wishes and agreed to assist by contributing capital for the scheme. He wrote to Collinson expressing concern, "I have left my son Billy in florida. nothing will do with him now but he will be A planter upon St Johns River."[20]

As with William's other commercial ventures, this too was doomed to failure. The land selected for him to plant, in the vicinity of Six Mile Creek near the St. Johns River, was particularly poor.[21] This is all the more curious as one would have thought John Bartram of all people would have recognized the difference between fertile and unproductive land. Henry Laurens, who visited William a few months after the purchase, described it as "the least agreeable of all the places that I have seen" and considered "the place always unhealthy."[22] It was John who purchased the land and all necessary equipment for William, including seed, provisions, and six slaves. His letter to William listing everything he had bought, with additional words of advice and warning, was no doubt an attempt to prepare him for the worst and encourage him to be vigilant and industrious. Yet it also reflected John's doubts and his lack of confidence in William. In the same letter John states, "All thy friends here laments thy resolute choice to live at St johns & leave off drawing or writeing."[23] It can only be conjectured as to why at this stage, when William needed all the encouragement he could get, his father undermined him and condoned a way of life for him that he had discouraged in the past. In a later letter responding to one from William that has not survived, John berated William for not acknowledging his gifts, "which I suppose thy usual ingratitude would not suffer the to mention," and accused him of being "indolent."[24] There is more than the regular parental concern in these letters. John's frustration had

(LEFT)
EASTERN DIAMONDBACK RATTLESNAKE
Crotalus adamanteus De Beauvois

(RIGHT)
COTTONMOUTH
Agkistrodon piscivorus (Lacepede)

turned to anger over his son's inability to conform and be a success. William was by now twenty-seven years old, but to his father he was still his young son, and as throughout his life until then, John continued to think and plan for William.

At the time that John was writing this letter, William was descending into a deep depression. When Laurens visited him for the second time that summer, he was alarmed at the depth of William's despair. Laurens promptly wrote to John expressing his concern: "The house, or rather hovel, that he lives in, is extremely confined, and not proof against the weather." Laurens continued that William had few provisions and asserted that "his own health very imperfect. He had the fever, when I was first with him, and looked very poorly the second visit. . . . No colouring can do justice to the forlorn state of poor Billy Bartram. A gentle, mild young man, no human inhabitant within nine miles of him, the nearest by water, no boat to come at them . . . totally void of all the comforts of life, except an inimitable degree of patience."[25]

Twentieth-century commentators such as Thomas Slaughter have interpreted William Bartram's reclusive tendencies, his inability to make decisions in early life, and his periods of noncommunication as symptoms of clinical depression.[26] The circumstances and conditions during his time as a planter in Florida were perfect for triggering such a bout of depression. Laurens, having described William being of "a tender and delicate frame of body and intellects," expressed this aptly, "I had been informed . . . that he had felt the pressure of his solitary and hopeless condition so heavily, as almost to drive him to despondency." These conditions, Laurens claimed, "are discouragements enough to break the spirit of any modest young man."[27]

William himself recognized the depths he had reached when he wrote in his commonplace book, a form of diary, "If I seem to neglect any friend I have, I do [no] more than seem to neglect myself as I find daily by the increasing ill constitution of my body and mind." Through his torment, he began to articulate his resentment at having attempted to conform to others' expectations of him. He had spent his whole life wanting to please his father and be considered worthy by his father and his father's friends. For the first time, he resolves to follow his own course: "It is great folly to sacrifice one's self, one's time, one's quiet (the very life of life itself) to forms, complaisances, and amusements, which do not inwardly please me, and only please a set of people who regard me no farther than a musical instrument of their present idleness or vanity."[28]

John Bartram's response to the plight of his son was not unsympathetic, but he lacked any understanding of William's fragile mental state. John wrote to Collinson, "He is so whimsical & so unhappy as not to take any of his friends advice mr. De Bram wanted him to go with him to draw draughts for him in his survey of florida but Billy would not tho by that Journey he would have had ye finest opertunity of seeing ye countrey & its productions."[29] It would appear that William's depression was more powerful than the temptation of being able to travel through Florida, something he would have loved to do under different circumstances. His father, however, interprets it as being whimsical. The venture into planting did not last long. In a letter to William in April 1767, Thomas Lamboll mentioned that

he had heard that William had left Augustine the previous November. It is more than likely that William had abandoned his plantation by then but had remained in Florida until the summer of 1767, only then returning to Philadelphia. A letter from Collinson to John Bartram in July suggests that William would soon be returning or was already back and settled in Philadelphia. Collinson enclosed a letter for William thanking him for the seven charming drawings that he received from him.

The land at Six Mile Creek was sold, as were, presumably, the six slaves John had purchased. John Bartram never recorded his views on slavery and only much later in his life does William express opinions condemning it. In the short biography of his father written for Benjamin Smith Barton's Journal, published in 1804, William stated that his father "zealously testified against slavery; and, that his philanthropic precepts, on this subject, might have their due weight and force, he gave liberty to a most valuable slave, then in the prime of his life, who had been bred up in the family almost from his infancy." Barton himself adds weight to this claim in a note to the essay, stating that "Mr. Bartram was, certainly, one of the earliest espousers of the cause of the Blacks, in Pennsylvania."[30] Such testaments appear to modern readers to contradict some of the comments John made in his letters to William during his time as a planter. "I have sent thee six likely young negroes among which is two young breeding wenches thee desired." From this it is apparent that both John and William believed they would continue to hold slaves for more than one generation. John continues to relate to William that "ye negros in charlestown is excessive dear so is ye plantation negroes which is dayly running away ye people was forced to hire ye Catawba indians to hunt them & if they can take them alive to do it for double price of those thay killed."[31] No plea for the "cause of Blacks" is made here. In the following sentence, John continues with a description of a new method of catching mullet.

William Bartram lived in and traveled through a land where people struggled to survive against the hardships imposed upon them by nature and where cruelty and inhumanity were regular facts of life. Slavery was an accepted institution in America. By the second half of the eighteenth century, it was estimated that seven hundred thousand slaves were living in the American colonies, the great majority in the southern states. Over 50 percent of the population in South Carolina were slaves and 40 percent in the state of Virginia. Further north, in colonies such as Pennsylvania and Massachusetts, the ownership of slaves was not uncommon. It would be foolish to view the activities and mores of mid-eighteenth-century men and women by the standards of today. Nevertheless, distinctions can be made between the different opinions held at the time. By the mid-1700s the campaign against slavery was already under way. Debates on this subject became more common and opposition to slavery was gaining strength, particularly in Philadelphia and among the Quaker community. In 1754, John Woolman, a Quaker tailor from New Jersey, published one of the first antislavery publications under the title *Some Considerations on the keeping of Negroes*, a pamphlet that declared slavery an immoral institution that imperiled the salvation of any Christian slave owner. Other Quakers soon added their voices and in 1758 the Philadelphia Yearly

whelmed with joy. In the opening sentence of a letter to John Bartram, Collinson praises "Billys Wonderfull performances"[37] and tells John that he is now amply gratified and wishes for nothing more. So great was Collinson's gratitude that he wrote a separate letter to William, expressing his wonderment with the drawing, "I and my son opened my ingenious fr[iend] WILLIAM's inimitable picture of the Colocasia, So great was the deception, it being candle light, that we disputed for some time whether it was an engraving, or a drawing. It is really a noble piece of pencil work; and the skill of the artist is shown in following nature in her progressive operations. I will not say more in its commendation because I shall say too little where so much [is] due."[38]

The American Lotus, *Nelumbo lutea*, is what Collinson called the colocasia and William's drawing depicted it in different stages of flowering, "nature in progressive operations." Included in the bottom left of the picture is a drawing of the Venus Flytrap, *Dionaea muscipula*, drawn the same year that William Young completed his drawing of the North Carolina plant. In this image Bartram reveals an unusual humor of surreal quality where images are of interesting, but disproportionate, scale to each other. The lobes of the flytrap are open waiting for some unsuspecting insect to alight, perhaps the mayfly perched on the plant directly above. A heron is captured in the act of making a kill, poised on one leg, beak slightly agape, about to spear a fish in the water below. This drawing was completed in late 1767 as William was emerging from his presumed depression. He had experienced the beauty and power of nature during his travels in Florida with his father, but he had also been the recipient of the brutal and indiscriminate side of nature during his time as a planter. This point in William's life and in the following few years, 1767 to 1772, is a period in which he produced what is probably his most interesting artwork. A second drawing William sent to Collinson with the Flytrap appears to complete the life cycle of the *Nelumbo*, with the seed vessel of the colocasia surrounded by several insectivorous plants. The trumpet and pitcher plant, *Sarracenias*, are depicted together with a snake engorging a frog and a lizard about to devour a very large ant. The concept of involution dominates the drawing from the shell of the snail to where each image coils around another through the action of consumption that is taking place. The interactive manifestation of the two drawings together manages to capture the complete cycle of nature. The viewer is absorbed into the image as one follows nature in its unsentimental "progressive operations."

Several of William's drawings of this time depict the same theme where activity and movement are present in the plants and animals portrayed. Nature in its interactive, interdependent, and all-consuming form is laid out on the paper for the viewer. Less than two years later, Bartram completed a similar drawing, this time for John Fothergill. A tail emerges from beneath the seed vessel and it is only possible by half hidden clues to connect it to the snake devouring the frog hidden behind the Blackroot, *Pterocaulon pycnostachyum*, at the left of the picture. The spiral of the shells and curve of the lines that so dominate the 1767 drawing are not duplicated here. Instead, the drawing is in watercolor, which, rather than enhancing it, evokes a bleaker and rather nightmarish image of na-

AMERICAN LOTUS OR
WATER CHINQUAPIN
Nelumbo lutea Willd.
(Nymphaeaceae)

VENUS FLYTRAP
Dionaea muscipula J. Ellis
(Droseraceae)

GREAT BLUE HERON
Ardea herodias Linnaeus

ture in comparison to that of the pen-and-ink drawing. These drawings depict
nature not just as scientific specimens in a clinical Linnaean style, but in an
environmental setting that shows nature in action demonstrating behavior and
exhibiting habitat.

Illustrators such as Edwards and Ehret attempted to draw specimens as true
to themselves as possible, "as things justly and truly representing nature."[39] Such
drawings were the medium to identify and describe the thing itself. The Lin-
naean sexual system of classification was based on visually recordable charac-
teristics, the number, the figure, and the proportion of the reproductive organs.
This enabled botanical illustration to act as a means to transmit knowledge, and
its function assumed greater significance with Linnaean classification. Catesby,
Edwards, and Ehret were all convinced that a good representation of a plant or

Tab. II.

TRUMPETS OR YELLOW
PITCHER PLANT
Sarracenia flava L.
(Sarraceniaceae)

PITCHER PLANT
Sarracenia purpurea L.
(Sarraceniaceae)

SEED VESSEL OF THE
AMERICAN LOTUS
Nelumbo lutea Willd.
(Nymphaeaceae)

WHITELIP SNAIL
Triodopsis albolabris (Say)

SCARLET SNAKE
Unidentified snake pos-
sibly *Cemophora coccinea*
(Blumenbach)

animal was more powerful in conveying knowledge about the species than a mere text description. "The illuminating of Natural History is so particularly essential to the perfect understanding of it, that I may aver a clearer Idea may be conceived from the Figures of Animals and Plants in their proper colours, that from the most exact Description without them,"[40] wrote Catesby. Edwards gave greater emphasis to the importance of illustration in his work: "Where accurate figures are given, much pains may be spared in verbal descriptions, by referring to the figures, which lineally describe the minutest parts of them, and such as would be very doubtfully understood by words only; indeed, the figures in this work cannot be deemed perfect without their descriptions, and the descriptions are nothing without the figures . . . in many respects, good figures from nature surpass the best verbal descriptions."[41] Catesby was one of the first naturalists to portray his birds and animals against a botanical backdrop to give some context to the specimens, but the plants were not always, as Catesby claimed, those on which the birds "fed, or have any relation to."[42] Edwards and Ehret strove to represent a species so that there would be no doubt as to its identification, but as Victoria Dickenson points out, such illustrations "depict surface characteristics" only. William Bartram succeeded in portraying accurate depictions when requested by Peter Collinson and

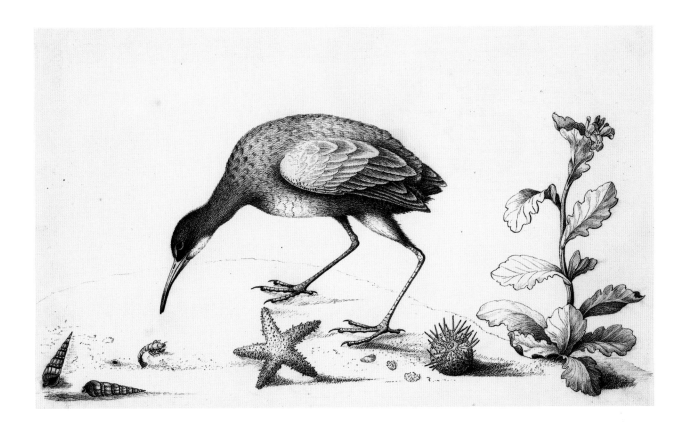

later by John Fothergill, but many of his drawings reveal a new form of nature illustration. Bartram portrayed behavior, habitat, and, most important, the inter-relationship between species.

Two distinct trends had emerged in the field of natural sciences by the second half of the eighteenth century—that of the classifier and the observer. The dominance of classification in the natural sciences today demonstrates the achievement of those who introduced new methods by which to identify and understand living species. However, in the eighteenth century, many naturalists were not as obsessed as Linnaeus was with classification. Buffon was one who rejected Linnaeus's classification system, arguing that it was not a science. Buffon, like many, considered description a much more useful method. He was a master of observing and describing living species and, from that, drawing conclusions about plant habitat and animal behavior. William Bartram very much belonged to the Buffon camp. He declared himself not to be a systemisist and he disliked the clear-cut divisions in nature that Linnaean classification produced. In his illustrations Bartram went beyond mere surface characteristics and depicted the balance in nature, the harmony as well as the violent and all-consuming side of it. In so doing, he brought life to his subjects.

In addition to drawing and working as a hired hand, William started to describe plants in a style that gives the reader a foretaste of his later writings, which combined the keen eye of a scientist with the imaginative prose of a poet. In a letter to Benjamin Rush started by his father but completed by William, he gives a description of the "Purple Flower'd Ixia of St. Johns Rivr. Et. Florida. Every species or variety of this Tribe of Plants exhibet very eminent beauties, but this with applause claims the preeminence, its elegant form of growth with the

AMERICAN SEA ROCKET
Cakile edentula (Bigelow) Hook. (Brassicaceae)

NORTHERN CLAPPER RAIL
Possibly *Rallus longirostris crepitans* Gmelin

PURPLE SPINED SEA URCHIN
Arbacia punctulata (L)

SEA STAR, FORBES
Asterias forbesi (L)

TOWER SHELL
Terebra dislocata (Say)

SPINY SOFTSHELL
Apalone spinifera
(Le Sueur)

brilliant colouring of its Flowers strikes on the imagination delight; and one can't look on it but with admiration."[43]

Peter Collinson did all he could to promote William Bartram to his friends. He showed his drawings to Daniel Solander, the Swedish botanist, who came to work for Sir Joseph Banks, and who much admired them, to the Duchess of Portland, who immediately requested drawings of "Land, River, and Sea Shells, as he can afford for twenty guineas,"[44] and to John Fothergill, who in his letter to John Bartram wrote, "I called upon my Friend one morning this summer, when he showed me some exquisite drawings of thy son's. He proposed that I should engage thy son to make drawings of all your land tortoises. I wish he would be kind enough to undertake this for me."[45]

It was very soon after that visit of Fothergill's to Mill Hill that Peter Collinson was taken ill with a kidney ailment. After a week of confinement, in which he declined rapidly, on 11 August 1768 he died. For John Bartram, a friendship that had blossomed for nearly forty years came abruptly to an end. The man who had been the prime instigator of John Bartram's success and had worked assiduously to develop the trade in plants between the continents, as well as encouraging and supporting the work of men such as Colden, Bartram, and Franklin, was gone. John Fothergill described Collinson soon after his death as someone who had been instrumental in introducing natural history to him. He claimed Collinson was one "of the most diligent and useful members of that respectable body," the Royal Society, and that "he was the means of introducing more new and beautiful plants into Britain than any man of his time."[46]

CHAPTER 5

Finding a Patron

DR. JOHN FOTHERGILL was a highly successful physician living in London. He was born in Yorkshire in 1712 into a Quaker family, some of whom had been founding members of the sect. His father, a Quaker minister, had traveled to the American colonies on three occasions. John was left with an uncle during his childhood and was educated at Sedbury Grammar School. In 1728 he was apprenticed to an apothecary, Benjamin Bartlett, in Bradford, who also kept a bookshop. Fothergill's interest in the use of plants for medicinal purposes and his access to Bartlett's library stimulated a desire to continue his schooling. As a Quaker, Fothergill was excluded from English universities and so for his further education he was sent to Scotland, where the established church was Presbyterian and the universities admitted dissenters. Fothergill attended Edinburgh School of Medicine from 1734 to 1736 and earned a medical degree. From there he moved to London, where he worked at St. Thomas's Hospital to acquire clinical experience, and by 1740 he had established his own independent practice. Fothergill became one of the most respected doctors in London and was considered for the position of King's Physician but was eventually rejected on the grounds of his being a member of the Society of Friends. He was the first doctor to recognize and describe the disease diphtheria in England and was elected to the Royal Society in 1763. Fothergill also had a passion for plants. In a letter to Linnaeus, he claimed, "It was our Collinson who taught me to love plants. . . . He persuaded me to create a garden."[1]

The word of God is the creation we behold. And it is in this Word . . . that God speaketh universally to man.

—THOMAS PAINE, *The Age of Reason*

GREEN-WINGED TEAL
Anas crecca carolinensis
Gmelin

WATER SHIELD
Brasenia schreberi
J. F. Gmel (Nymphaeceae)

In 1762 Fothergill purchased an estate in Upton, Essex, with grounds of some thirty acres. A "year or two after" he bought a "parcel of land" that extended from his house to the Ilford Road and here he began his plantation. He created the largest botanical garden of the time, with "a suit of Hot and Green-House apartments nearly 260 feet extent, containing upwards of 3400 distinct species of exotics" from around the world. Fothergill had a particularly large collection of flora from the American colonies. His love of plants was so great that Joseph Banks commented: "Those whose gratitude for restored health prompted them to do what was acceptable to their benefactor, were always informed by him that presents of rare plants . . . would be more acceptable to him than most generous fees."[2] His garden became famous and a limited number of visitors could apply for a ticket from the British Museum to view the garden at Upton on appointed days.[3] Fothergill was friend to and corresponded with the leading scientists of Europe and America and became intimate friends with Peter Collinson and Benjamin Franklin. He corresponded with John Bartram from as early as 1743 and after Collinson's death offered to become a "poor" replacement for Collinson in corresponding and receiving seeds and plants from Bartram. He expressed a desire for seeds and young plants and "a root or two of the Colocasia in autumn in a tub of mud or in wet Moss?"[4]

The Wardian case, named after Nathaniel Ward, revolutionized the transportation of plants, but it was not invented until 1833. Therefore, in the eighteenth century, the method of sending plants safely to England from abroad was of concern to many nurserymen and collectors. The hazards involved were numerous. Long voyages submitted the plants to climatic changes, drought, poor lighting, and saltwater, and for long periods throughout the century the threat of capture

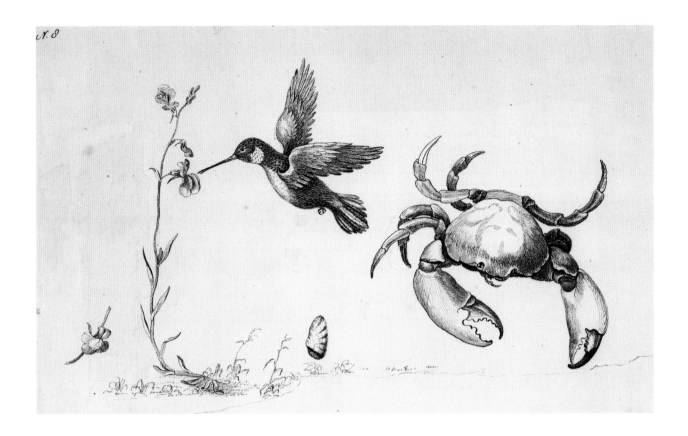

N. 8

by enemy ships. John Fothergill took particular interest in this subject and wrote to everyone sending him plants from America giving them advice on appropriate transport methods. In his letters of 1772 and 1773, he acknowledged that William Bartram was well "acquainted with the method of packing up plants and seeds"[5] and that he "need not give any directions about packing the plants as doubtless thou has frequently seen how this is done by thy father."[6] Nevertheless, he found it impossible to avoid giving him specific instructions on how to transport his collections. Francis Harper believed the contents of this last letter to be "one of the earliest sets of instructions ever issued for an American biological exploration."[7]

Peter Collinson often lamented the loss of plants due to poor packaging and regularly gave some words of recently acquired wisdom to his friend John Bartram. There was no shortage of opinions on the packing and transporting of plants. Sir Thomas Hanmer and John Evelyn in the seventeenth century both wrote on the subject, and in 1689 James Petiver printed a broadsheet with instructions for preserving specimens. Mark Catesby, Philip Miller, and Peter Collinson all had their own ideas of what worked best. Some, like John Ellis, believed that seeds were successfully transported if first covered in beeswax. Linnaeus advocated placing the seeds in paper bags filled with sand to absorb moisture, then put into earthenware jars and placed in containers of nitre, salt, and sal ameriac to keep the seeds cool. Joseph Banks was a strong advocate of circulating air to help keep the plants fresh and argued this from his own experience of his travels on the _Endeavour_ voyage with Captain Cook between 1768 and 1771. André Michaux, the French plant collector who traveled through Florida in the 1790s

BLUE TOAD FLAX
Linaria canadensis
(L.) Dumort.
(Scrophulariaceae)

RUBY-THROATED
HUMMINGBIRD
Archilochus colubris
(Linnaeus)

STONE CRAB
Menippe mercenaria (Say)

VARIABLE COQUINA
Donax variabilis Say

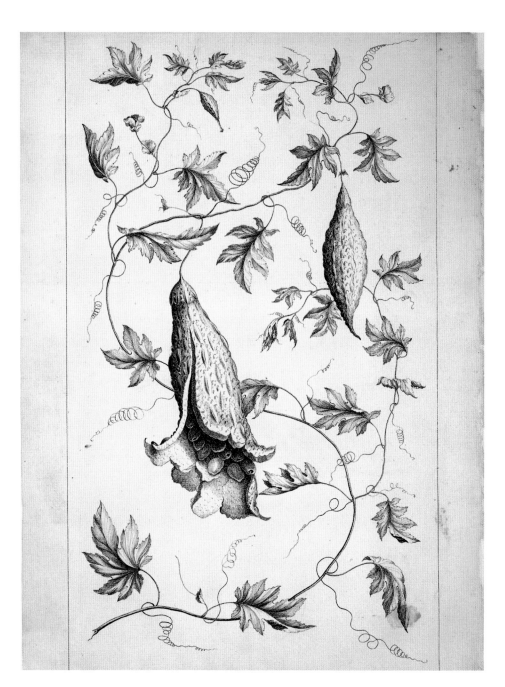

BALSAM PEAR OR
BITTER MELON
Momordica charantia L.
(Cucurbitaceae)

was advised to dip the roots of plants in a mixture of clay soil and cow manure. In 1770 Ellis published *Directions for Bringing over Seeds and Plants from the East Indies* and interestingly attached as an appendix his description of *Dionaea*, a plant that presented a problem for many growers in Europe. It was a particularly delicate plant and did not travel well. Ellis received many a lamentation from Linnaeus concerning the failure to transport the plant: "I know too well the nature of the Dionaea, ever to hope for it in a living condition,"[8] and "Dionaea died, as might be expected, in the voyage."[9] The most influential writer on the subject was John Coakley Lettsom, friend and colleague of Fothergill. Lettsom's book *The Naturalist's and Traveller's Companion*, first published in 1772, included a whole chapter entitled *Directions for bringing over seeds and plants from distant countries*. It

proved to be a popular book and by 1799 had gone into its third edition. Lettsom encouraged the method of wrapping the soil around the roots of plants in damp moss to help retain moisture. James Alexander, gardener to Thomas Penn and the first to take up such a profession in America, was one of the first to adopt this practice. As early as 1761, Peter Collinson had praised James Alexander for his success in packing plants in moss. It was probably from Alexander that William Young learned this method and successfully transported over a hundred plants to England in 1768, including several Venus Flytraps. Young too was duly praised by both Fothergill and Collinson for his success: "William Young sends his plants over very safely, by wrapping them up in moss, and packing them pretty close in a box. They come very safe, and we lose very few of them."[10]

With Peter Collinson dead, William now found support and admiration for his drawings from collectors such as the Duchess of Portland, who had one of the finest and largest collections of natural history drawings and artifacts in Europe, and John Fothergill, who, as Joseph Banks noted: "That Science might not suffer a loss, when a plant he had cultivated should die, he liberally paid the best artist the country afforded to draw the new ones as they came to perfection, and so numerous were they at last, that he found it necessary to employ more artists than one."[11] Interest from such patrons was not enough for trouble to have abandoned William altogether and in 1770 he fled Philadelphia from creditors, one of whom had physically threatened him. Where and when these debts originated is unknown. They could possibly have been ones acquired ten years before, during his time as a merchant in North Carolina. Or Bartram may well have made a second attempt as a mercantile trader, this time in Philadelphia, but again without success. It was to North Carolina that he now sought refuge and, according to his father, was attempting to recover some of his own monies owed to him there. Unfortunately for William, he was not as belligerent as the creditors in Philadelphia and rather than raising the money to square his debts he made arrangement to retreat further south to his beloved Florida. When William first fled, his family had no idea of his whereabouts. John wrote to Fothergill, "Poor Billy hath had ye greatest misfortunes in trade that could be & gone thro ye most grievous disapointments & is now absconded I know not whither."[12]

William spent several months with his much-loved uncle in North Carolina before his family in Philadelphia heard from him. William's letter, now lost, written in September but not received by his family until December, relates the sad news of the death of his uncle, John's half-brother, and his uncle's son, also named William, who had died a few weeks later. His uncle's home that William so loved, recalling it in later life as a place "where reigns spring eternal,"[13] was now a place of sadness and emptiness. John Bartram delayed his response to William's news. He had himself been suffering from weak eyesight and claimed he could hardly recognize his own children if they stood more than a foot away from him, and this may have restricted his writing at the time, but the letter reveals in its opening line remnants of bitterness: "I received thy letter of september about three months after ye date & never heard ye least account of thee after thee left us so unaturaly." He explained that William's debts had been paid by his brother-in-law George "on my account he allso paid that

NETTED OLIVE
Oliva reticularis Lamarck

troublesome man who threatened thee on his own account."[14] William, however, was not returning home, debts or no debts, so John also sent his trunk and papers to North Carolina as requested. During the course of the following twelve months, William continued to draw and sent much of his work to John Fothergill.

Before he fled to North Carolina, William had sent Fothergill a set of six drawings, "three of them he designhed for ye Duches of Portland,"[15] John Bartram explained to Fothergill. The remaining three included the seed vessel of the *colocasia* discussed earlier, a pen-and-ink drawing of a *Momordica* in its three stages of flowering, which William explained was drawn from a "Species . . . raised by Mr. Alexander the Proprieter's Gardener in this Province . . . from whome I obtain'd a branch." The third was a watercolor of a water tortoise and two snakes, one devouring the other. William wrote a note to this image: "our Wampom Snake swallowing a small snake of another species both of natural colors. I found them nearly in the action I have here endeavourd to imitate he had almost taken him in his body befor I caught them and separated them with difficulty."[16] John Bartram related a similar tale to Peter Collinson many years before. His wife had come across two snakes, one within the other's mouth, "My wife seeing this fetch'd the Tongs & pulled very hard to get him out of the black Snake's mouth for he was near half swallowed down."[17] The two snakes in William's drawing were included in the package and sent to John Fothergill with a warning, "not for fear of being bit by them, but least thay should entangled in ye Moss & miss finding them."[18]

William remained in North Carolina until the following summer, but with his uncle and cousin dead he found little reason to stay and decided to move to Augustine in East Florida. John Bartram called this a "wild notion" and made it clear that he did not "intend to have any more of my estate spent there or to ye southward

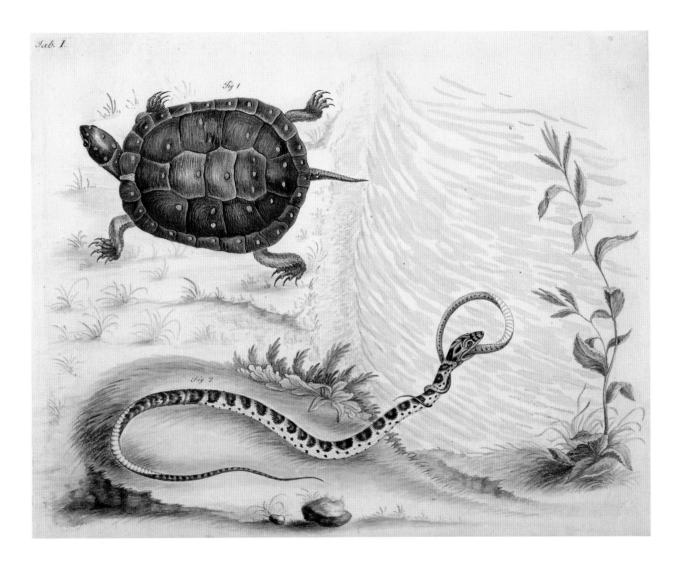

Tab. I.

upon any pretense whatever." He thought it much better for William to "come home and dwell amongst thy relatives & friends who I doubt not will endeavour to put thee in A way of profitable business."[19] John's frustration and concern was evident and was shared by others in the family. Moses, William's older brother, also wrote in an attempt to persuade William to return home: "But what can tempt thee to try Augustine a gain this deems astonishing to all thy friends here. We would therefore I believe jointly advise thee to return home for as thee art now clear of the world in these parts perhaps the land of thy Nativity would yet smile upon thee."[20] Now that his father and family were no longer prepared to assist him, William was free to seek patronage elsewhere. He moved to Charleston, South Carolina, and in the late summer of 1772 wrote to John Fothergill proposing a trip through Georgia and Florida in search of new flora and fauna, and asking him for financial support. With this letter he sent a collection of drawings from North Carolina.

Fothergill's response was promising. He would be "glad to contribute to thy assistance in collecting the plants of Florida" and was impressed with William's drawings: "They are very neatly executed, and I should be glad to receive the like of any new plant or animal that occurs to thee."[21] He then wrote to William's father of his willingness to assist as it would be a "pity that such genius should sink un-

SPOTTED TURTLE
Clemmys guttata
(Schneider)

MILK SNAKE OR
CORN SNAKE
*Lampropeltis triangulum
triangulum* (Lacepede) or
Elaphe guttata (Linnaeus)

PINE WOODS SPARROW
(FIG. 1)
Aimophila aestivalis
(Lichtenstein)

CAROLINA WREN (FIG. 2)
Thryothorus ludovicianus
ludovicianus (Latham)

der distress" and wished to know from John whether William was "sober & diligent."[22] Fothergill then proceeded to make arrangements with Dr. Lionel Chalmers of Charleston, who was to lend William "any assistance that may seem expedient, at my expense" and suggested "ten guineas to fit him out with some necessaries immediately, and to allow him any other sum not exceeding 50 £ per annum."[23]

Fothergill gave detailed instructions to William as to what he should collect and draw and how he should transport the plants. As to William's drawing ability, Fothergill wrote, "Thy hand is a good one, and by attention and care may become excellent."[24] To Dr. Chalmers, he explained that William would be paid for his drawings "proportionate to their accuracy."[25] His final advice was to remind William that "in the midst of all this attention, forget not the one thing needful. In studying nature forget not its author. Study to be grateful to that hand which has endowed thee with a capacity to distinguish thyself as an artist."[26]

This was William Bartram's first step toward independence and the beginning of his break from his reliance on his father and his escape from the ambitious desires of his family and friends. He no longer needed to conform to the expectations others had of him. At the age of thirty-four, he had become his own master. Before now, he had never even come close to succeeding as a merchant or a planter, or even in recovering his debts from North Carolina. He was now about to embark on his first independent trial, truly of his own making. This was

MALLARD
*Anas platyrhynchos
platyrhynchos* Linnaeus

something he not only wanted to do but also felt he could do well, as he had written in his commonplace book six years earlier, "the only business I was born for, and which I am only good for."[27] This time William did not fail. It was his first major collecting trip without his father and he spent almost four years traveling through the Carolinas, Georgia, Florida, and as far as the Mississippi and Alabama. He collected plants, kept journals of his travels, completed sketches, and finished drawings, and through his contact with Native Americans, he became a close and accurate observer of their lifestyle.

On his return to Philadelphia, he wrote his now-famous *Travels through North & South Carolina, Georgia, East & West Florida*. He completed it in the mid-1780s, but it was not published until 1791. In writing the book, Bartram relied heavily on his memory together with his field notes. He had sent his two journals for 1773 and 1774 to John Fothergill and these would have been written up from his field notes either at his base in Charleston, at Darien, in Georgia, or at one of Spalding's trading stores that he stayed at on the St. Johns River in Florida. When he left Charleston in late 1776 to return home, his trunk remained with Mary Thomas, a woman who was "excellent in goodness beyond her sex with expressions of the same affable & cordial friendship so particular in the character of her antient excellent Parent."[28] That parent was Thomas Lamboll, fellow Quaker and friend of the family and it was with the Lambolls that William lodged when in Charleston. As a result of the War of Independence, which ensued soon after he departed from the region, he did not retrieve his trunk for another ten years. During that same year Bartram suffered a serious accident. While collecting seeds from a bald cypress tree in his garden, he fell some twenty feet and received a compound

fracture to his leg, just above the ankle, "which laid me up for near 12 months."[29] During this time he was able to peruse his notes and other papers that had been locked away for the past decade and make amendments to his manuscript.

William Bartram's account of his travels between 1773 and 1777 relates his observations and reflections on nature. The flora and fauna of the region are accurately described and his observations of the Native Americans are regarded as "one of the finest ethnographic accounts of the southeastern Indians written in the eighteenth century."[30] The course of events in the book is not told in chronological order and is further complicated by a series of errors by both the printer and Bartram in regards to dates. It would appear that for Bartram the sequence of events was not important, for the main thrust of travels was his celebration of God's work, made manifest through nature in all its beauty. This he achieved by his accurate scientific observation of nature fused with an aesthetic appreciation of its wonders.

In comparing the characters of John and William Bartram, Bryllion Fagin in 1933 described John as "robust, positive, assertive," while William he believed was "gentle, timid," and "sensitive."[31] As accurate as this characterization is, it is true that William and John held similar religious and philosophical views, and both father and son espoused many of the conventional ideas of the Enlightenment. By the eighteenth century the Cartesian view of a mechanical universe designed by a benevolent Creator who then allowed it to run like clockwork was widespread among those interested in natural philosophy. The Newtonian revolution in physics, which explained physical phenomena through simple mechanical laws, had come to be used as a model in other areas of science. And as the century progressed, the idea that knowledge was acquired through experience and experimentation was combined with the rationalism of the Enlightenment, that knowledge came from reasoning. The Deists of the eighteenth century, of whom John Bartram was one, believed in a God on the testimony of reason while rejecting revelation. The laws of nature were God given, just like the laws of physics, but to understand those laws it was necessary to observe the natural world and apply reasoned and rational arguments to such observations. It was through scientific observation and inquiry of nature, by measuring and classifying all living things, that divine wisdom could be discerned. This view of the universe produced a perceived gap between humans and nature itself, as by studying the natural world the distinction between the observer and the observed became more evident.

Such reasoning stood well with John Bartram because, for him, there were no doubts and likewise nothing to prove, nothing to argue, cloud, or "confuse the mind." John Bartram had no interest in debating theology; his concern was the natural world, and it was in nature that God revealed himself. His defense of his religious beliefs was inherent in his own morality and lifestyle. True faith was obtained by contemplating "the wisdom and power of ye deity" that was "perspicuously manifested" in all the animal and vegetable tribes.[32] John would have agreed with Tom Paine, who took the argument of design to its ultimate conclusion. In "Defining the true revelation," Paine asserted that "The word of God is the creation we behold. . . . It preaches to all nations and to all worlds; and this Word of God reveals to man all that is necessary for man to know of God. In fine,

do we want to know that God is? Search not the book called the Scripture, which any human hand might make, but the Scripture called the creation."³³ For William, the world and all within it was much more complex. When he was young, William revealed in his commonplace book doubts and feelings of abandonment. By the time he wrote *Travels*, his understanding of the unpredictability of life was more comprehensive. Like the sudden tempest that throws nature into turmoil, the "well contrived system" of life's journey could "at once become chaos" and the individual be apt to "shut our eyes upon our guide and protector, doubt of his power, and despair of his assistance" (52).

John and William Bartram both claimed they were of the Quaker faith, but they were not typical of many Quakers of the day. When John received from Peter Collinson Robert Barclay's *An Apology for the True Christian Divinity*, he thanked Collinson for it as he would spend little time reading it compared to a botanical work, "which I should have spent ten times ye hours in reading of" and that would have kept him from labouring to maintain his family. " indeed I have little respect to apologies & disputes about ye ceremonial parts of religion which often introduce animosities confusion and disorders in ye mind & sometimes body too but dear Peter let us live in love & innocency & worship ye one allmighty power . . . living in innocency we may die in hope then if you don't go to heaven I believe we shant go to hell."³⁴ Here John not only shows disinterest in religious debate and a preference for natural history but also hints at his skepticism concerning heaven and hell. In 1770 John Bartram reaffirmed his position of 1758, when he was named by the Darby Meeting of Quakers for his "disbelieving in Christ as the Son of God." John Bartram had no regrets. He carved into the

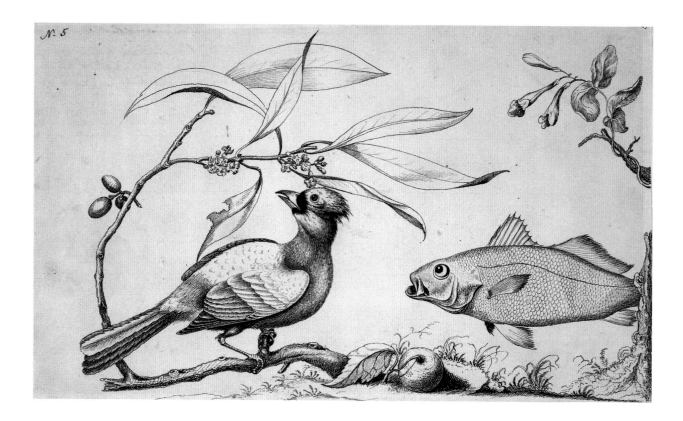

N. 5

DEVILWOOD OR
WILD OLIVE
Osmanthus americanus (L.)
A. Gray (Oleaceae)

CARDINAL (POSSIBLY
NORTHERN CARDINAL)
Cardinalis cardinalis
(Linnaeus)

CRAB APPLE
Pyrus angustifolia Aiton
(Rosaceae)

ATLANTIC CROAKER
Micropogonias undulatus
(Linnaeus)

stone of his house the verse, "It is God alone, Almighty Lord, the Holy one by Me ador'd."

John was not alone in his denial of the divinity of Christ. Isaac Newton privately disbelieved in the doctrine of the Trinity but managed to retain the Chair of Science at Cambridge without subscribing to the thirty-nine articles of faith. His successor, William Whiston, was not so fortunate; he "lost his Cambridge chair by going public on that very issue."[35] John Locke, by keeping silent on the question of the Trinity, was accused of tacitly supporting Unitarianism, while in America Thomas Jefferson very nearly lost the election as president in 1801 because of his refusal to accept the Trinity. William differed little from his father in this matter. He "was a member of the Society of Friends," wrote his first biographer, George Ord, "but his religious opinions inclined to Unitarianism."[36] William Bartram was a product of the eighteenth-century Enlightenment and believed that by studying the natural world one discovered God and the meaning of his great plan. "I, continually impelled by a restless spirit of curiosity, in pursuit of new productions of nature, my chief happiness consisted in tracing and admiring the infinite power, majesty and perfection of the great Almighty Creator" (73). For William Bartram there existed an underlying force that united the natural world. Science was the study of that underlying force and William dedicated most of his life to that study. However, Bartram recognized that this well-designed and harmonious natural system contained many imperfections. He accepted that nature was ordered and spiritual overall, but within that order there were contradictions and violence. William's own experience as a planter and a well-worn traveler had shown him that. The complex and contradictory workings within nature somewhat challenged the

concept of order and the reasoned, logical ideas that dominated in the eighteenth century. The imperfections made him question how much this world reflected God's intrinsic nature. Bartram felt that the complexities could be understood only when seen as part of the whole workings of the universe.

By the end of the century a new group of scientists was emerging who began to question the design theory and the concept of a well-run mechanical universe. They began to identify a cyclical system of destruction and regeneration of the earth. James Hutton, the Scottish geologist, concluded that the existing landscape had been built from the materials of former landscapes, which in turn had been built from earlier landscapes. "For having, in the natural history of this earth, seen a succession of worlds, we may from this conclude that there is a system in nature; in like manner as, from seeing revolutions of the planets, it is concluded, that there is a system by which they are intended to continue those revolutions. But if the succession of worlds is established in the system of nature, it is in vain to look for any thing higher in the origin of the earth. The result, therefore, of this physical inquiry is, that we find no vestige of a beginning—no prospect of an end."[37] William Bartram saw the cyclical character of nature in its birth, life, death, and rebirth and went beyond the eighteenth-century rational view of an ordered hierarchy of nature. He rejected the obsessive collecting habits that caused many to fill their cabinets with curiosities, all of which were devoid of life. The world to these collectors was permanent and fixed and their cabinets were attempts to display in miniature a world in which everything had its rightful place. For William, the world was in a state of flux, forever changing. He was concerned with the living and he questioned the permanence of things within a predetermined system. Such questioning was significant, but it would take Charles Darwin, nearly half a century later, for those traditional seventeenth- and eighteenth-century views to be fully challenged and overturned.

Many of Bartram's observations were in keeping with the science of the day, but, like the Romantic poets he inspired, William Bartram was unable to separate himself from nature and saw it as an organic whole. His view of nature as a scientist and as a celebrator of God's creation was one and the same thing. The goodness of God was there for all to see, "inexpressibly beautiful and pleasing, equally free to the inspection and enjoyment of all his creatures" (xiv). For William, a Divine presence existed in all things. To him, this was the underlying force that united the natural world.

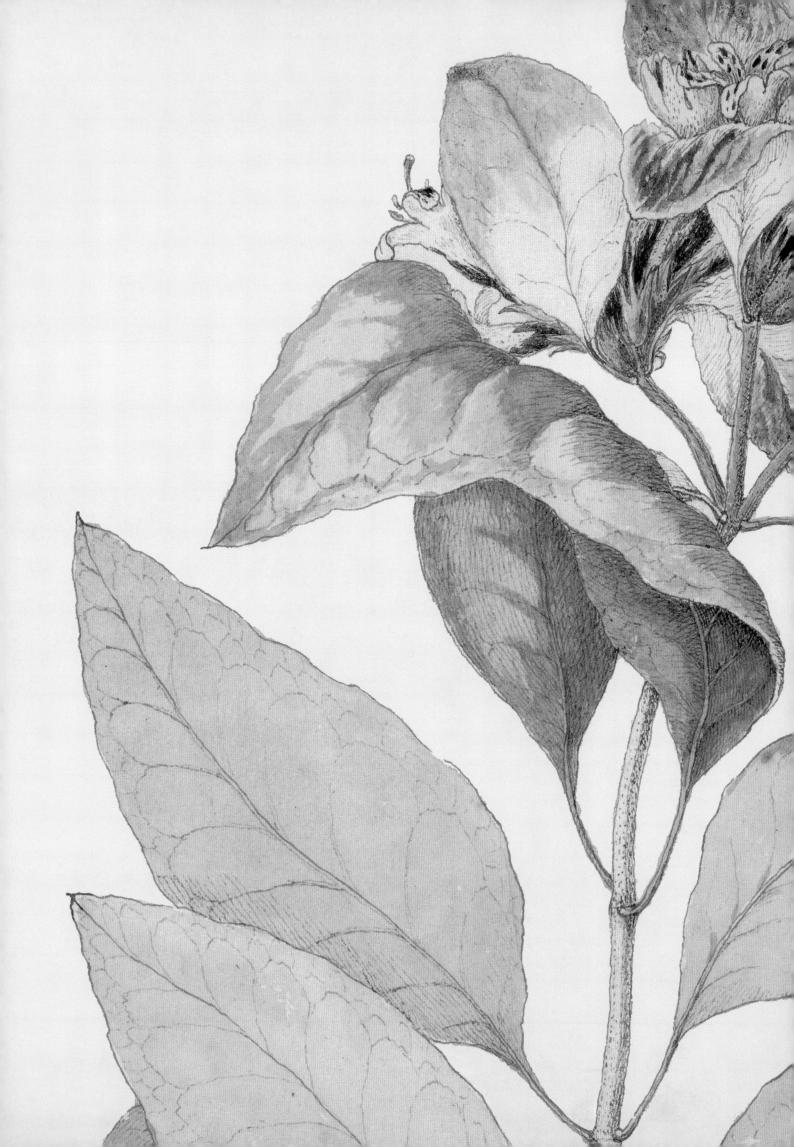

PART THREE

Independence

Travels: Revisiting Old Haunts and Discovering New Ones

WILLIAM BARTRAM WAS WITNESS to some of the most significant events in the early history of the southern states of America during his four years of traveling in the region. It was a momentous time of civil and political unrest in which the course of history was fundamentally changed. He attended the Congress of Augusta in June 1773, considered by ethnographers as "one of the most important events of the era for the eighteenth century Creeks and Cherokees."[1] William Bartram was friends with and lived among men who became the leading figures on both sides of the American Revolution: loyalists such as Lionel Chalmers, Alexander Garden, and John Stuart, who was eventually forced to flee Georgia, and patriots such as George Galphin and Lachlan McIntosh, alongside whom William fought in the defense of Georgia in 1776. William's journey took him through South Carolina and Georgia as far north as Cowee and deep into the Appalachian Mountains. He traveled along the south coast of Georgia and into East Florida as far as Blue Springs and Lake George and down the Little St. Johns River to the Gulf of Mexico. And in 1775 his long-awaited desire to cross West Florida (and what today is Alabama) to the Mississippi River was finally fulfilled.

In the opening chapter of *Travels*, Bartram states, "At the request of Dr. Fothergill, of London, to search the Floridas, and the western parts of Carolina and Georgia, for the discovery of rare and useful productions of nature, chiefly in

Everything on earth is in constant flux which permits nothing to take on a constant form. Everything around us changes.

—JEAN-JACQUES ROUSSEAU,
9TH WALK, *The Reveries
of the Solitary Walker*

the vegetable kingdom; in April, 1773, I embarked for Charleston, South Carolina" (1). In many ways William Bartram was very much a man of the Enlightenment, which was obsessed with the idea of progression, the triumph of civilization over nature, and what was termed the "perfectibility of man." The theorists of the day believed that nature was intended for the advantage of mankind; knowing the laws of nature meant humans could wield power over it, and the cultivation of the land came to symbolize progress. For Bartram, the natural world was not only the manifestation of a benevolent Creator but was also instructive and useful. He revealed his own utilitarian sentiments when he stated that "through divine aid and permission, I might be instrumental in discovering, and introducing into my native country some original productions of nature, which might become useful to society" (73–74). He recognized the enormous potential in nature, land that could be turned into plantations, timber that would be useful for shipbuilding, and plants that could be major economic crops or useful in medicine. He saw the importance of well-managed cultivation of the land, having come from a farming community. At the same time, like John Evelyn, who a century earlier, in his book *Sylva*, condemned wasteful land practices, William too condemned poor farming practices of the new, land-hungry settlers and the destruction and devastation of the "fruitful orange groves of St. Juan." In his journals, he delights in the scenes of primitive nature and the "wonderfull Harmony & perfection in the lovely simplicity of Nature tho naked yet unviolated by the rude touch of the human hand."[2]

The idea of progression in nature was understood by many to mean that humans were preeminent among the creatures on Earth and that plants and animals existed purely for human exploitation. William Bartram accepted the preeminence of man. He saw the world as "a glorious apartment of the boundless palace of the sovereign creator" (xiv), the contents of which were there for human use. Many seventeenth- and eighteenth-century thinkers viewed the

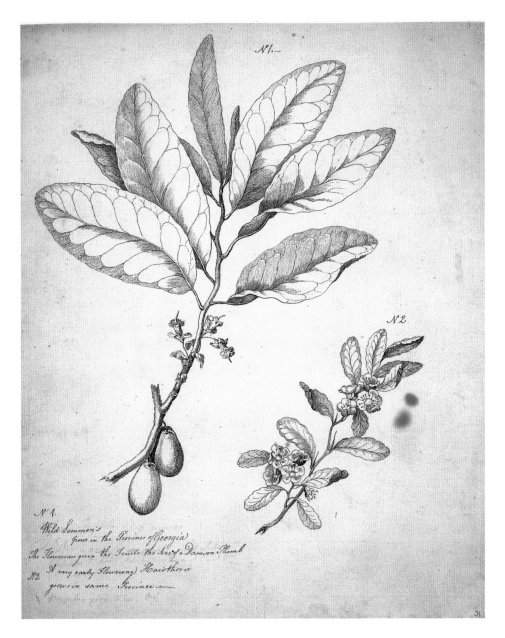

OGEECHEE TUPELO
(FIG. 1)
Nyssa ogeche W. Bartram
ex Marshall (Nyssaceae)

HAWTHORN
(FIG. 2)
Crataegus sp. L.
(Rosaceae)

Earth in this way. Oliver Goldsmith described it as "one vast mansion,"[3] while John Ray believed that man had been placed in "a spacious and well furnished world."[4] With this idea went the view expressed by Matthew Hale that man was on the earth as "God's steward . . . invested with power . . . to preserve the face of the earth in beauty, usefulness and fruitfulness,"[5] and also there to care for all creatures upon the earth. William Bartram concurred with this notion that with progress came responsibility. He offered up a prayer imploring that mankind be "illuminated with wisdom" and "a due sense of charity" that would enable them to protect those creatures "submitted to our service" (101). The habitat destruction and possible extinction of certain species of plants and animals through the intervention of humans who were intent on transforming the wilderness into plantations was something that William feared, just as his father had. John Bartram was particularly concerned that the buffalo, beaver, and rattlesnake of

WILLIAM BARTRAM
(1739–1823)
Journal of Travels
in Georgia

North America were being destroyed at such a rate that there would "be but few left." And John Fothergill expressed his disquiet at the increase in the number of inhabitants in America, fearing that the tortoises and "native plants" would be "thinned."[6]

On arriving in Charleston, Bartram made contact with Dr. Lionel Chalmers and was introduced to John Stuart, Superintendent of Southern Indians. Stuart remembered Bartram from his previous visit with his father in 1765 and invited William to attend the Congress that was to be held in June at Augusta "between the Creek Indians and the White People."[7] This left Bartram with six weeks to occupy himself before going to Augusta and he chose to spend it in Savannah and along the Georgian coast, territory that he knew from his trip several years before. He would tread familiar ground, routes he had traveled with his father, and rekindle old friendships. He would employ his time "searching the natural productions of the Maritime parts."[8] William made his way to Savannah and from there traveled by horse to Sunbury, where he remained some days "in the family of the good Mr. B. Andrews,"[9] a planter and member of the House of Assembly for the Province. From here he traveled down to the Altamaha River and to Darien, the home of Lachlan McIntosh. McIntosh was one of two men of particular importance to William Bartram, the other being Henry Laurens, the man who helped rescue him from his fated Florida plantation. They became father figures during his period of travels and he remained lifelong friends with them. Lachlan McIntosh was a member of a large, extended family who welcomed William into his home as a son. "When I came up to his door, the friendly man, smiling, and with a grace and dignity peculiar to himself, took me by the hand, and accosted

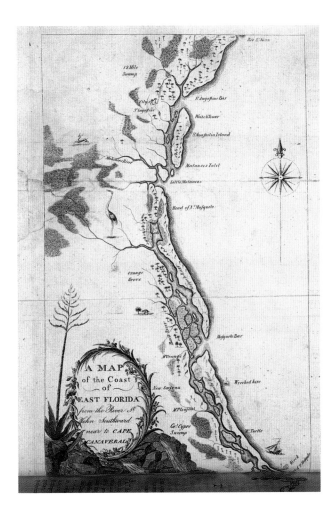

WILLIAM BARTRAM
(1739–1823)
Map of the Coast of East
Florida

me thus: 'Friend Bartram, come under my roof, and I desire you to make my house your home, as long as convenient to your self; remember, from this moment, that you are a part of my family'" (15).

McIntosh was a patriot and later became colonel of the first regiment during the war with England. On hearing of Bartram's intentions of traveling to Augusta, McIntosh's eldest son, John, expressed a desire to accompany him. William was happy to oblige and flattered by the respect Lachlan McIntosh had paid him in allowing his son to travel with him. But before they could leave, Bartram had to wait for the "difficult point" of "Mrs. M'intosh's final consent to give up her son to the perils and hardships of so long a journey" (27). The sixteen-year-old John McIntosh became Bartram's "fellow pilgrim" during his travels through Georgia in 1773. Bartram describes him as a "sensible virtuous youth, and a very agreeable companion through a long and toilsome journey of near a thousand miles" (15) and referred to him as his "philosophic companion" (43). For the first time William was the senior figure on an excursion, no longer having to take the subordinate role that he had experienced for so many years traveling with his father. On several occasions William described his travels as a pilgrimage, but his journey was as much a quest for personal independence as it was for discerning God's plan. Bartram may well have recognized that same quest in his young companion and fellow pilgrim.

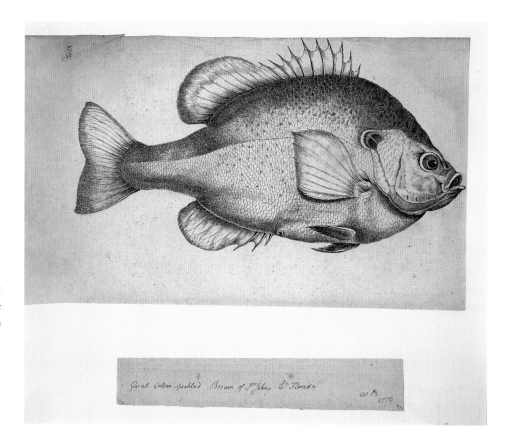

Great Golden speckled Bream of S.t John's E. Florida

w B
1774

On the first day of May, William and John McIntosh set off for Augusta from Darien. They arrived in Savannah two days later, from where William dispatched his first collection of specimens and drawings to John Fothergill. From Savannah they traveled north along the Savannah River, passing through Ebenezar, a town Bartram described with great admiration. The townsfolk were descendants of a German Swiss colony and spent their time cultivating silk, a subject that must have been of interest to William because his own twin sister, Elizabeth, had tried to establish a silk farm in 1771. The Savannah River forms the boundary between the Carolinas and Georgia and Bartram crisscrossed the river exploring the vegetation going from Georgia to South Carolina and back into Georgia on several occasions. The travelers would be awakened in the mornings by the balmy fragrance of the *Calycanthus* and birdsong. "The watchfull Savanah Crane's shrill Voice rang the Alarm through the echoing Forests, & The gay lively Mockbird invited all to action, I obeyed the friendly Summons, & began this day's progress."[10]

Arriving in Augusta in mid-May, Bartram was eager to make contact with the men who would assist him in traveling through the Cherokee and Creek country, the traders and leaders of the two Indian nations. One of the leading traders was George Galphin, whose trading store was in Silver Bluff, South Carolina, some twelve miles south of Augusta. Bartram had met Galphin in 1765 with his father and made several visits to his estate during his travels. It was from Galphin that Bartram received some of the most helpful letters of recommendation for his travels through west Florida and Alabama. Galphin, a staunch patriot, became one of the leading figures in the war with Britain and was a rival of John

Stuart. He considered himself the true representative of the "Southern Indians" and considered colonial agents as interfering in his relationships with the Native Americans and thereby his trade. Stuart, on the other hand, blamed Galphin and other traders like him for the existing problems with the Cherokees. He believed they had taken advantage of the Cherokees, allowing them to run up debts that were now about to be paid by surrendering their land. Stuart was not wrong in his assessment. The truth of the matter was that by the mid–eighteenth century in Southern Appalachia most Native Americans were utterly dependent on the English. The Cherokee economy had been manipulated and transformed in favor of the English traders. The Cherokees had been introduced to European commodities, the most insidious of which was rum, and paid for in deerskins. This situation had reached such heights by the 1760s that many Cherokee societies had become wholly dependent on the deerskin trade for survival. In the decade leading to the American Revolution, more than one million skins had been exported to Europe. William Bartram observed that many Native Americans had lost their skills in producing their traditional arts and crafts and instead "all their dependence had rested upon the Traders, who supplied them with European Manufactures."[11] To make matters worse, unpaid debts by any member of a Cherokee town became the obligation of the entire settlement. The Augusta Congress was called as a result of the conflict that had continued for some years since 1766 between the Cherokees, Creeks, and the white settlers. During this time the Cherokees had fallen increasingly into debt with the white traders and the Congress was supposed to arrive at some way of settling this debt.

The Congress was attended by more than three hundred Upper and Lower Creeks and about one hundred Cherokees. Bartram's account of the Congress is the only available report of the proceedings; nothing appears to have survived from the British side, apart from the clauses of the treaty itself. Part four of Bartram's *Travels* gives some of his reflections on those present at the Congress. He comments little on the terms of the treaty itself and merely mentions that the merchants of Georgia demanded some two million acres of land that was eventually ceded by the Creeks and Cherokees. The Congress lasted for only a few days, after which William and his young companion, John McIntosh, joined the team of surveyors assigned to map the newly ceded land.

The British part of the team numbered seventy to eighty people and, led by Colonel Barnett, they set off from Augusta on 7 June: "We joined the caravan, consisting of surveyors, astronomers, artisans, chain-carriers, markers, guides and hunters, besides a very respectable number of gentlemen, who joined us . . . together with ten or twelve Indians" (35). William described the midday temperatures as insufferably hot and sultry. He accompanied the group as far as the upper reaches of the Savannah River, making notes of the plants and animals and observing the behavior of the Cherokees. The first destination of the group was the Great Buffalo Lick on the Great Ridge, which separates the Savannah and Altamaha rivers and was one of the boundary checkpoints of the treaty. Their journey took them through the pleasant Quaker town of Wrightsborough, a town quite different from most towns in Georgia, which tended to be a jumble of

Scottish or Irish plantations. The party then continued through the fertile plains and forests of walnut, beech, and oak trees of such magnitude and grandeur the description of which, Bartram believed, if kept "within the bounds of truth and reality . . . would . . . fail of credibility" (37). Buffalo Lick itself was visited by deer, cattle, and horses, which had carved out vast pits and caves through their consistent licking of the clay earth. The common opinion, Bartram explained, was that the animals were attracted to the saline vapors in the clay, but Bartram said he "could discover nothing saline in its taste" (39). Bartram accompanied the party of surveyors to Tugilo, the river that feeds into the Savannah River high in the Cherokee mountains and on to Cowee, the furthest point in their journey. He then returned to Augusta and traveled south to Savannah, arriving in midsummer. The terms of the treaty had by no means been agreeable to many in the Indian nations and discontent was now prevalent, fueled by what John Stuart termed "our incessant requisitions for land."[12] Relations between white settlers and Cherokees became increasingly delicate. The fragility of the peace was eventually broken when soon after the return of the party of surveyors from Tugilo two of the Cherokee members of the group were brutally murdered by white homesteaders. This in turn sparked other incidents in which white settlers, Cherokees, and Creeks were killed. Panic began to spread throughout Georgia and into Florida. The governor imposed an embargo on the Creek trade in the hope of quelling any disorder and forcing them to submit to the terms previously agreed upon. A trade embargo effectively impoverished the Creeks, who were by now heavily reliant on white trade. By midsummer of 1773, there was a threat of an "Indian War" and Bartram's travels were now restricted: "I was advised not to venture amongst them but as the lower Creeks in east Florida were not openly concerned in the mischief I imagined I might with safety turn my discoveries in that quarter."[13]

William chose to return to the Georgia coast and East Florida, revisiting the sites he and his father had visited in 1766. John McIntosh was returned to the loving care of his family and later went to Jamaica to live with his uncle. He returned to Georgia after the war with Britain and assisted his father as a rice planter. In 1792 he died at the age of thirty-five, a year after the publication of Bartram's book, in which he makes an appearance.[14] For the remainder of 1773 and for much of 1774, William spent his time exploring the regions of the St. Mary's River, visiting Amelia Island and the plantations of Lord Egmont. He purchased a canoe to travel along the St. Johns River between the upper and lower Spalding trading posts. He traveled across country to the Indian towns of Cuscowilla and on to Talahasochte on the Little St. Johns River. Bartram relates in his journal a trip along the Satilla River, passing through the parishes of St. David and St. Patrick and describes his discovery of a new species of *Annona* and an "elegant diminutive kalmia."

For much of his travels, Bartram was reliant on the traders who operated in the region. It was they who knew the routes to travel, served as interpreters, and provided introductions to planters and Native Americans. These men, licensed by the commissioners and agents appointed by the House of Assembly of the state, made their living by bartering goods manufactured in Europe or the Caribbean in exchange for skins, predominantly deerskins. William Bartram was a very gen-

Bream | White Perch Savanah River near Tugilo Georgia.

ROCK BASS
Ambloplites rupestris
(Rafinesque)

erous man when it came to assessing people's characters. He was never quick to criticize or be judgmental, but he was also never condoning of actions he considered uncivilized, immoral, or inhuman. He, nevertheless, found it impossible not to comment on the behavior of the traders he traveled with and met during his time in the South. He makes some exceptions, naming such men, as in the case of Mr. Galahan, an honest trader "esteemed and beloved by the Indians for his humanity." In the same paragraph Bartram describes the majority of this undistinguished band of men as being dishonest and violent in "their commerce with the Indians" (353). In March 1774, Bartram set out with a group of these men to visit the "Indian Town of Cuscowilla" on the Alachua Savanna, a place he described as the Elysian Fields. On reaching a little lake surrounded by meadows, Bartram wrote that this "would have been alone sufficient to surprise and delight the traveller, but being placed so near the great savanna, the attention is quickly drawn off, and wholly engaged in the contemplation of the unlimited, varied, and truly astonishing native wild scenes of landscape and perspective." It is scenes such as this that confirmed for Bartram the supreme power and benevolence of God. "On the first view of such an amazing display of the wisdom and power of the supreme author of nature," wrote Bartram, "the mind for a moment seems suspended, and impressed with awe" (189). This for Bartram was the sublime.

At Cuscowilla, Bartram met and dined with the head Seminole named Cowkeeper. Bartram described how on hearing of his purpose in traveling, Cowkeeper

was a sinkhole that had in recent years been formed by an eruption of water. Presiding over this hole containing abundant fish was "a very large alligator," which Bartram proceeded to draw. Bartram had several encounters with alligators on his travels. He described the roar of the alligator as loud and terrifying, resembling "heavy distant thunder." On occasion, Bartram was forced to lose a night's sleep while these beasts roamed close to his camp, and as a consequence he feared for his life more than once. His description of alligators along the St. Johns River invited some ridicule and disbelief when *Travels* was first published. He painted a picture of a beast that was so ferocious that few inhabitants living in cities north of Georgia would find credible. "Behold him rushing forth from the flags and reeds. His enormous body swells. His plaited tail brandished

high, floats upon the lake. The waters like a cataract descend from his opening jaws. Clouds of smoke issue from his dilated nostrils. The earth trembles with his thunder" (118). When camping close to the river, Bartram occasionally would be awakened by the roar of the alligators. "At the approach of day, the dreaded voice of the alligators shook the isle, and resounded along the neighbouring coasts, proclaiming the appearance of the glorious sun" (106). The hazards of sleeping in the wild were numerous. One of the less dangerous but equally inconvenient of these was being disturbed from his slumber. When not roused by the roar of the alligator, Bartram was often awakened by the "cheering converse of the wild turkey-cock" (83) or "the music of the seraphic Crane" (245).

The Savanna Crane, or the Wattoola, as Bartram called it, makes several appearances in his book. On one occasion his fellow travelers caught "this stately bird" and Bartram completed a drawing. He described it as "about six feet in length . . . and the wings expand eight or nine feet. . . . We had this fowl dressed for supper and it made excellent soup" (220–21). For the reason the bird was eaten, the drawing now serves as the type specimen, that is, the original specimen on which a description of a new species is made. Traveling through the wilds of Florida, encamping along the riverbanks and savannas, meant that many of the animals Bartram encountered ended up in the pot as the evening meal. He gave detailed accounts of which parts of the turtle tasted best and how these should be prepared and cooked. He described the cooking of trout heads "stewed in the juice of Oranges" (158) and had on several occasions roasted oysters for supper that he described as excellent. He also laughs at himself when describing how on his trip to Cowee with the surveyors in 1773, some "Indian boy's . . . drew up a large Trout near 2 feet long" and with a great number of bream returned to camp. Bartram's contribution to the meal was a "large and beautifull Glass Snake, which however was not generally so acceptable as the fish, as none chose to have him in the Mess."[15] Despite the delight that he exhibits in the preparation of some of his food, he is loath to condone some of his companions' wanton killing of animals. Although he eats the venison shot by others, he does not admit to killing any animal larger than turkey cocks or raccoons. He observed that his traveling companions "seemed regardless" of the "extravagant waste" (179) created by killing animals too large to be fully consumed by the group. And as to the Savanna Crane, he wrote that "as long as I can get any other necessary food I shall prefer his seraphic music in the ethereal skies" (221).

The drawings William provided John Fothergill during his travels were completed when he was resting from traveling in the field, either at the Spalding trading stores, the McIntosh home in Darien, or the Lamboll home in Charleston. It was here that he also wrote up his journals from his field notes. The first dispatch to Fothergill included a drawing of the Purple Finch and is acknowledged in a letter dated September 1773, in which Fothergill remarks, "The bird is extremely well executed; the *Starry Anis* was done in a hurry and too picturesquely." Fothergill continues by instructing Bartram to collect seeds and plants in the autumn and to draw any new plants in flower, "draw the flower and a leaf or two carefully on

FLORIDA SANDHILL
CRANE
Grus canadensis pratensis
F. A. A. Meyer

the spot, and mark the outline of the branch or shrub. The rest can be finished at leisure. The same may be done with any other article of natural history that deserves notice."[16] In volume one of his journal, Bartram remarks that during those first few weeks in Georgia in 1773 he discovered "a pretty species of Asphodelus called here by the Inhabitants Fly poison," the roots of which were used to destroy flying insects, a most useful plant, Bartram believed, in a "Country so infested with these troublesom little Animals."[17] He also observed a "very singular Species of Ledum or Andromeda, whose white campanulate Flowers, become monstrous excrescences every Part of the Flower inlarging proportionably . . . some approaching to the size of a Teacup."[18]

These were some of the first drawings Bartram prepared in his travels and, though undated, form part of a group of eight completed in 1773 and sent to Fothergill via Dr. Chalmers in November of that year. Chalmers expressed disappointment that the drawings were not in color, "nor any minute description given

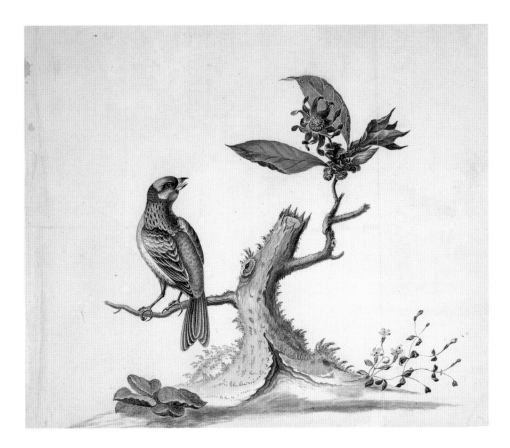

of them," and for this reason believed they would "not prove so satisfactory as otherwise they might."[19] One of the illustrations, of Fever Bark, was reproduced later in Bartram's life, in 1788, and sent to his friend Robert Barclay in London. In the description accompanying the image, he states that "I saw this plant in flower at the same time as Franklinia."[20] Although Bartram claims in *Travels* that he saw the *Franklinia* in all its "blooming graces" in April 1773, he did not draw the plant until three years later and did not mention it in his journals of the time. The first image of the Fever Bark is not in flower and it is probable that Bartram did not see it in flower until 1776, when he revisited the area in the spring and early summer and saw it with the *Franklinia*, which, he observed, was "in perfect bloom, as well as bearing ripe fruit" (467). William was rather neglectful in the amount of living plants that he sent to Fothergill, who complained to John Bartram that he "received . . . about one hundred dried specimens of plants, . . . a very few drawings, but neither a seed nor a plant." By now more than a year had passed since William first set out on his travels and Fothergill was rather expecting much more from his ward. He complained, "I have paid the bills he drew upon me; but must be greatly out of pocket, if he does not take some opportunity of doing what I expressly directed, which was, to send me seeds or roots."[21] Fothergill's complaint was unwarranted; William was no spendthrift but in fact was "an excellent Oeconomist,"[22] according to Chalmers, and had drawn only £12 since his first advance. In January 1774, disappointed at the paucity of living plants arriving in England, Fothergill attempted to encourage William by dispatching specially made boxes for collecting plants, but Bartram did not receive the boxes until the

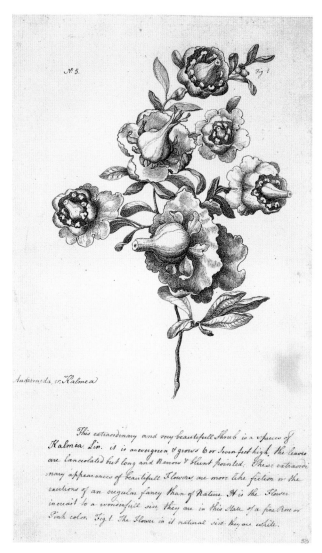

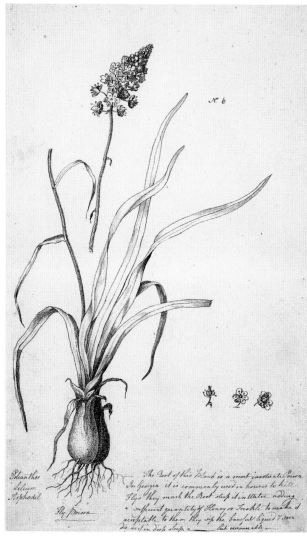

summer and it is not known whether he ever used them. Chalmers also sent paper designed for holding specimens to William at the Spalding trading stores. In the accompanying letter Chalmers mentions William's drawings again and asks him, "would it not be better to colour [and] describe them botanically."[23] William himself stated that he complied with Fothergill's request and that he "collected seeds, roots and specimens, making drawings of such curious subjects as could not be preserved in their native state of excellence"(48). By the spring of 1775, he had certainly made some reparation and wrote to his father that he had recently dispatched "3 large boxes of roots and one of seeds" to Fothergill.

Bartram spent most of 1774 exploring the environs of southern Georgia and East Florida around the St. Mary's, St. Johns, and Little St. Johns rivers. The drawings for this year, comprising some thirty images of plants and animals, are the largest single group within the Natural History Museum collection and were completed in 1774 and early 1775. Bartram had taken his patron's advice and applied the Linnaean method of illustration in his portrait of plants. Each plant has been depicted in the different stages of flowering. Some of the animal drawings,

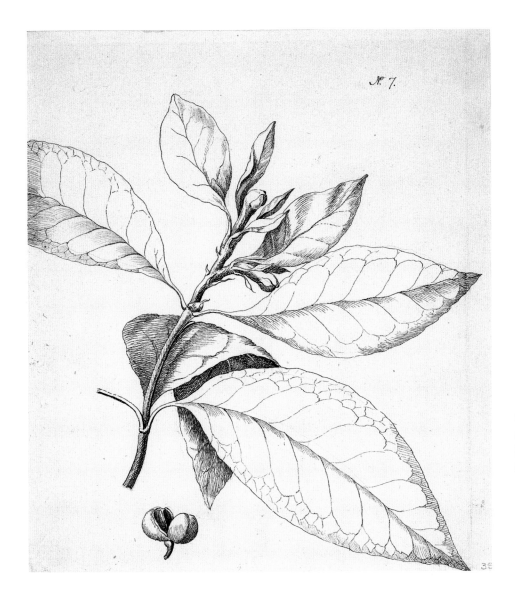

particularly of birds and fish, are considered good examples for identification of a species. However, even here Bartram lapses from the demands of a strict Linnaean style, which aids scientific identification, into depicting his specimens in a more complete environmental and ecological setting. The Bobolink or rice bird is one example of this. Here the bird is feeding on the rice plant, *Oryza*, a seed of which is held in the bird's beak. The snake is the one Bartram describes in his journal as "a pretty little snake about 12 inches long . . . but take it to be a young wampo[m] snake"[24] which is being tempted by a large fly resting on the leaf of the rice plant. The fourth specimen is the green tree frog of Florida, which Bartram refers to as "the little luced green frogs, keeps on Rushes, Weeds & Bushes or Trees by River banks. they make a musical noise, in evening & morning all summer . . . the noise resembling the chiming of bells."[25] All these species inhabit the same area and Bartram depicts them together, demonstrating their interaction, similarly to the drawings he completed in earlier years.

In late 1774, Bartram returned to Charleston, South Carolina, and lodged with several families before ending his stay in the house of Mrs. Thomas, the daughter

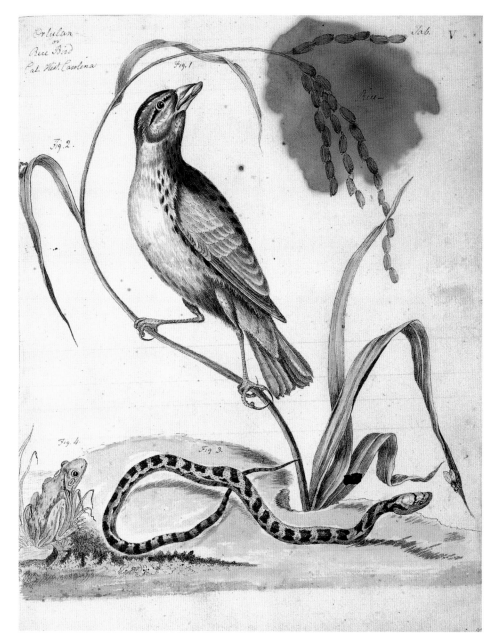

BOBOLINK (FIG. 1)
Dolichonyx oryzivorus
(Linnaeus)

RICE (FIG. 2)
Oryza sativa L.
(Gramineae)

**IMMATURE CORN SNAKE
(FIG. 3)**
Elaphe guttata guttata
(Linnaeus)

**GREEN TREE FROG
(FIG. 4)**
Hyla cinerea cinerea
(Schneider)

of Thomas Lamboll. Here he spent time completing his journals and drawings and preparing for his travels through West Florida in the early summer of the following year. In writing to his parents, Bartram describes his travels through East Florida and informs them of his intentions to travel for yet another year "through the Cherokee and Creek countries" and on to the Mississippi River. One of John Bartram's dreams had been to reach the Mississippi, and in 1764 he expressed this desire to "make A thorough search not only at pensacola but ye coast of florida alabama, Georgia and ye banks of ye Misisppi."[26] Now William was planning the journey that would realize that dream. William finished his letter by commenting, "I have not had the favour of a line from my Father or Mother."[27] The tone of this letter is one of confidence and maturity and the last complaint is for once a reversal of the roles between father and son.

In the spring of 1775, Bartram set off for Augusta intent on traveling to the country of the Creek and Cherokee nations. From Augusta he traveled up the Savannah River to Fort James, where he forded the river into South Carolina and took the road to the Cherokee town of Seneca. Continuing his lonesome journey, he traveled on to Cowee, the heart of the Cherokee middle settlements that is surrounded by the Cowee and Jore mountains. He then journeyed west, exploring the mountains and valleys where he met with Ata-culculla, the Little Carpenter, Grand Chief of the Cherokees. Soon after this encounter, Bartram heard of a party of "adventurers" preparing to travel to West Florida and, resolving to join them, he began his return journey.

The caravan of travelers set off from Fort Charlotte on 22 June and the route took Bartram across the Creek country of piedmont Georgia and lower Alabama to Mobile. Five days into the journey Bartram and his companions arrived at Flat-Rock, a rendezvous place for traders and Native Americans. Here Bartram's party met up with two companies of "Indian traders," who offered their assistance, since they were also "bound to the Nation" (377). Passing through the territory of the Lower Creeks from the banks of the Oakmulge, now the Ocmulgee, to a beautiful large brook called Sweet Water, Bartram came across the Oak-leaf Hydrangea, *Hydrangea quercifolia*, named and described by Bartram and depicted in a drawing that he included in the first edition of *Travels*. In 1788 he completed a second drawing of this plant, this time in watercolor, and sent it to Robert Barclay in London. He stated that it was drawn from an accurate drawing made from the living, flourishing subject when on his travels. The journey to Mobile was at times "very pleasing" but at other times oppressive and torturous. Some days the heat and the biting flies that tormented the horses would, Bartram claimed, "excite compassion even in the hearts of pack-horsemen" (384). This statement gives more than a glimpse of Bartram's opinion of such men, even if written with a smile on his face. Bartram traveled through one Indian town after another. He was impressed with Uche town on the banks of the Chata Uche River, describing it as "the largest, most compact and best situated Indian town" he ever saw. He documented the size and situation of the town along with the building materials of the houses. He noted that the language of the inhabitants of this town was "radically different from the Creek or Muscogulge tongue." From Uche, Bartram moved on to Apalachucla, considered the "mother town or capital of the Creek or Muscogulge confederacy" and a place sacred to peace. Twelve miles further north was the town of Coweta, which contrasted with Apalachucla as the town of blood and where "chiefs and warriors assemble when a general war is proposed" (388–89). Bartram pressed on through the hot summer with the band of adventurers, understood to be land speculators, having said farewell to the Indian traders who had dispersed to the various towns of the nation around Apalachucla.

By the end of July, Bartram arrived in Mobile. Not having any means to continue immediately to the Mississippi, he decided to take up the invitation of Major Farmer, a large plantation owner, to spend some time with his family and explore the environs north of Mobile to the confluence of the Tombigbee and the Ala-

bama rivers. Along "the rich low lands on the Mobile River" Bartram discovered the giant evening primrose, *Oenothera grandiflora*. This was yet another plant he had named and he was the first to introduce it into England. He describes it as the "most pompous and brilliant herbaceous plant yet known to exist" (406). Everything seemed to be going well for Bartram. He was exploring totally new territory and discovering new plants. But as he made his descent of the river, Bartram fell ill with a fever and was forced to remain inactive for a few days at Major Farmer's residence. As he started to recuperate, he heard of a chance to travel to Manchac on the Mississippi, so, collecting his possessions, he returned to Mobile but still had to wait several days before the boat was due to sail. In order not to waste time, he took passage on another boat traveling east to Pensacola, the capital of West Florida, where he met with Governor Chester. Impressed with Bartram's work, the governor attempted to persuade him to remain in the colony to continue his research and document the local flora at the governor's expense. However, Bartram could not be distracted from reaching the goal first set by his father. Concerned about losing his passage to the Mississippi, he declined the offer. Bartram had not fully recovered from his earlier fever and on his return to Mobile suffered a relapse, finding that he was "very ill, and not a little alarmed by an excessive pain in my head . . . this disorder soon settled in my eyes" (418). Alarmed but undeterred, he continued his journey west as the malady increasingly worsened, and during the course of the following days he felt his "situation was now becoming dangerous." The French family he was lodging with could do nothing for him and suggested he be moved to the residence of Mr. Rumsey, an Englishman living on Pearl Island, some twelve miles away. Bartram agreed and was taken there to receive treatment. He later wrote that "the night however after my arrival here I sincerely thought would be my last." With the care given him, William "began to mend . . . but it was several weeks before I could expose my eyes to open day light, and at last I found my left eye considerably injured" (420–21). For the rest of his life Bartram occasionally suffered from problems with his eyes and gave this as a reason for his decision to reject offers of further expeditions.

It took up to five weeks for Bartram to recover sufficiently to continue his journey. He then took leave of "friendly Mr. Rumsey" and set off from Pearl Island traveling via Lake Pontchartrain through marshes and cypress swamps. Bartram camped on sandbanks at night and was roused at times by the "alarms from the crocodiles," which were present in great numbers. Proceeding up the Amete River, a tributary of the Pearl, he was so plagued by insects that even the flames and smoke from the fire that he kindled "were insufficient to expel the hosts of mosquitoes that invested our camp, and kept us awake during the long and tedious night, so that the alligators had no chance of taking us napping" (426). Continuing up the Amete River, he came to a landing point nine miles from his destination. He had only to travel these last miles on land to reach Manchac on the banks of the Mississippi, just south of Baton Rouge. William Bartram had finally arrived at that great river, having achieved with adversity what his father had only dreamed of. His joy was complete, and he wrote, "At evening ar-

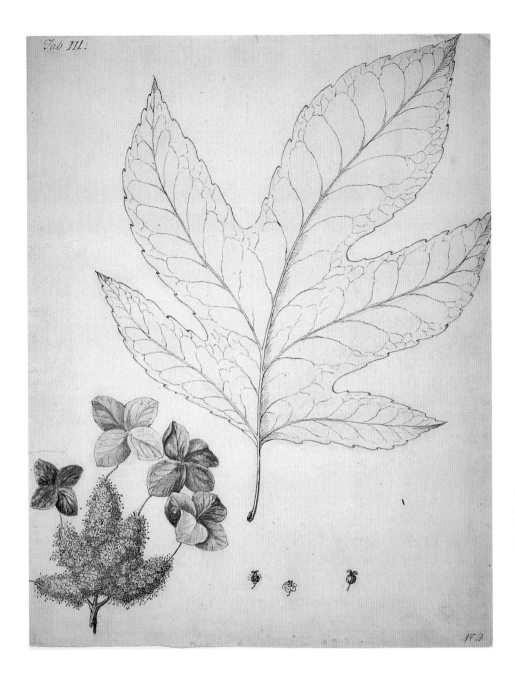

OAKLEAF HYDRANGEA
Hydrangea quercifolia
W. Bartram
(Saxifragaceae)

rived at Manchac, where I directed my steps to the banks of the Mississipi, where I stood for a time as it were fascinated by the magnificence of the great sire of rivers" (427).

Bartram remained only a short time, a matter of a few weeks, investigating the vegetation of this region and gave as the reason for his departure the severe disorder in his eyes that "subverted the plan of my peregrinations, and contracted the span of my pilgrimage South-Westward. The disappointment affected me very sensibly. . . . I submitted and determined to return to Carolina" (436). On 13 November, Bartram departed from Manchac for Mobile, where he dispatched his "collections of growing roots, seeds and curious specimens left to the care of Messrs. Swanson and McGilavry to be forwarded to Dr. Fothergill of London" (438). There is no mention of any drawings in this dispatch and within the col-

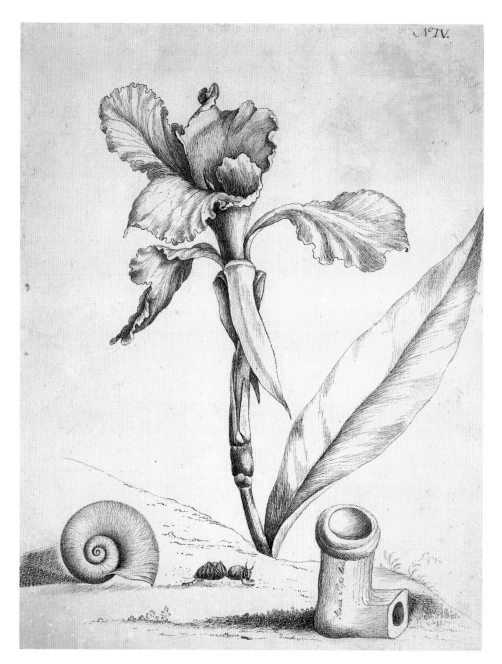

BANDANA OF THE
EVERGLADES OR
GOLDEN CANNA
Canna flaccida Salisb.
(Cannaceae)

STONE PIPE-BOWL
GASTROPOD
INSECT

lection very few are of West Florida flora. Those that exist were completed in the summer of 1776, after his return to Georgia.

William Bartram's return journey to Augusta from Mobile was in the company of traders taking horses and goods to the Creek Nation. There were three men, one of whom was a young Creek who was to be married on his arrival at Mucclasse. Bartram's "trusty slave," his horse, which had carried him over some one thousand miles, was in need of rest and William was forced to sell him in exchange for a stronger specimen. Close to their destination, the two white traders went on ahead and William and the young groom-to-be were left to manage the horses and merchandise. In approaching a wide, furiously flowing creek, the two men improvised a raft, which they hauled back and forth to transport the goods. With the goods safely on dry land, William sent the horses across. Last of all,

boasting that he was a good swimmer, he took the plunge. He stripped off only to his breeches, for, as Bartram stated, "they contained matters of more value and consequence than all the rest of my property put together; and besides I did not choose to expose myself entirely naked to the alligators and serpents in crossing the flood" (445). At the town of Mucclasse, Bartram was able to rest for a few days and take in the environs and study the inhabitants. One morning the head trader of the town invited him to go to the public square to present gifts to the Indian chiefs. Bartram met with "the most ancient chief of the town," who was "stone-blind by extreme old age." This old chief impressed William not only in his appearance with his snow-white hair and smiling, cheerful face but also by the reverence others held for him. Bartram presented him with his gift of "a fine handkerchief." In return, William was given a "stone pipe & catskin of tobacco" (499). This was a significant gesture for Bartram, similar to when he was given the Seminole name of Puc Puggy, and he places the stone pipe in his drawing of the plant *Canna flaccida*, known as Bandana of the Everglades. Bartram had come across these "rich golden flowers" along the banks of the serpentine rivulet leading to Lake Dexter in the late summer of 1774. By February 1776, Bartram was back in Savannah, and during the spring and summer he revisited the districts of Georgia where he had "noted the most curious subjects." He retraced his now-familiar journey along the Altamaha River, collecting and drawing plants, when for the first time he saw in flower the *Franklinia* and Fever Bark.

As spring turned to summer in the American colonies, political events came to a head and on 4 July 1776 the Continental Congress submitted the Declaration of Independence. After cataloguing the crimes of George III, it declared, "These United Colonies are, and of Right ought to be Free and Independent States."[28] The series of events that led to this momentous statement had been in the making for the past twelve years and the causes of these events went back far beyond then. The American colonies enjoyed many political freedoms. Laws were chiefly made by the Assemblies of each of the thirteen colonies with little interference from the government in London. But there was one area in which Britain held sway, and that was trade. A series of laws regulating colonial trade and manufacture were introduced to add to the Navigation and Iron Act. These laws, together with the Molasses Act of 1733, the Stamp Act of 1766, and finally the Tea Act of 1773, which allowed the East India Company to sell teas directly to the colonies, while the colonists continued to pay tax on the product, caused great discontent. The ensuing events of the Boston Tea Party and the passing of the Boston Port Act, which closed the port of Boston, resulted in the first meeting of the Continental Congress in Philadelphia in 1774. Representatives from each of the colonies, with the exception of Georgia, attended and it demonstrated that individual colonies, which until then had been great rivals, could unite over major issues. This was the first step toward nationhood. In April 1775, British troops were sent to take possession of military stores at Concord, some twenty miles northwest of Boston. As they passed through Lexington at the dawn of day, they were confronted by a handful of colonists. The British troops fired upon them, killing eight. The troops managed to make their way to Concord only to find the stores gone. They now

had to return to Boston, battling their way through a countryside that had risen in rebellion and indignation over the killings. This journey of twenty miles cost the British more than two hundred and fifty casualties and heralded the start of the American Revolution.

In January 1776, Tom Paine published his pamphlet *Common Sense*, a vigorous statement of the case for independence. Within three months one hundred and fifty thousand copies of the pamphlet had been printed in America, numerous editions were published, seven in Philadelphia alone, and it was also translated into French and German. Benjamin Rush, the well-known Philadelphia physician, a signatory of the Declaration of Independence and friend of Paine, wrote that *Common Sense* was "read by public men, repeated in clubs, spouted in Schools, and in one instance, delivered from the pulpit . . . in Connecticut."[29] Rush, for his part, claimed to have suggested the title for the pamphlet.

The major battles of the War of Independence took place in the colonies north of Georgia and South Carolina, at Brandywine Creek and Germanstown in the fight for Philadelphia, on Long Island and in New York, and on Christmas night amidst a snowstorm in Trenton and later Princeton. A major turning point of the revolution was the victory by the Americans at Saratoga in October 1777, which helped convince the French that the colonists had a chance at defeating the British. While these battles raged in the north, the frontier regions experienced dramatic events and Georgia was no exception. As early as March 1776, Georgia was threatened with invasion by British troops.

Two of the most important men in Bartram's life during this period, Henry Laurens and Lachlan McIntosh, whom Bartram referred to as "father friend," were pivotal in the events of the following few years in the region. Laurens was president of South Carolina's Council of Safety and McIntosh was made colonel of the first Georgia battalion by the Georgia Provincial Congress in January 1776. On the last day of that month, Bartram arrived in Savannah amidst a growing crisis in the colony, described by McIntosh as a time of "anarchy and confusion."[30] By March, British warships and troops arrived in Georgian waters and tensions were reaching breaking point. "These are the times that try men's souls," wrote Tom Paine. William Bartram, living with the McIntosh family in Darien, was now at the center of the conflict in the southern states, and it would have been impossible for him not to be fully aware of the events and their seriousness. George Ord, a friend of Bartram in later life, wrote in 1832 that Bartram "volunteered and joined a detachment of men, raised by Gen Lochlan McIntosh, to repel a supposed invasion of that state from St. Augustine by the British."[31] The little that Bartram wrote on the subject came in *Hints & Observations*, where he described the hostilities that occurred between British and Georgians on the banks of St. Mary's River. Bartram was no doubt present at the event, and Edward Cashin, a modern scholar of Bartram's activities in Georgia during the revolution, confirms that William accompanied McIntosh and the Continentals in May to the St. Mary's River with volunteers from the coastal Georgia counties.[32] Ord also claimed that Bartram was offered a lieutenant's commission by McIntosh if he remained in the

region. Defending against a possible attack was one thing, but being a full-time soldier was something quite different for a peace-loving Quaker.

The warships threatening Georgia were there, the British claimed, merely to procure provisions, but McIntosh and the Council of Safety were convinced the British meant to attack the capital. Some light fighting took place and a merchant ship carrying skins and rice was torched. Other merchant ships under the protection of the British managed to escape. The British claimed they got what they came for, while the Americans viewed it as their victory. Savannah had been protected from a British invasion.

By September, Lachlan McIntosh's property had come under attack several times and some of these assaults were known to have been carried out by so-called "friendly" troops from Carolina. Eventually McIntosh was forced to move his family to a place of greater safety and the environs of Savannah. All that Bartram wrote of this period in his *Travels* was that he revisited some of his favorite places along the Altamaha River and rediscovered the *Franklinia* in perfect bloom. He chose not to write about the conflict that he was witness to and that eventually persuaded him to return to his home in Philadelphia late in 1776. Although Bartram was close to men leading the rebellion, he also had friends who remained loyal to the king, men such as John Stuart, Superintendent of Southern Indians, and Lionel Chalmers, the man who acted as Fothergill's agent for William. Dr. Alexander Garden of Charleston, a confirmed loyalist and friend of the Bartram family, became so disillusioned by the events that he eventually returned to live in Britain. There is no doubt that Bartram himself was a supporter of American independence. His "republican principles were imbibed at a very early age" under the tutorship of Charles Thomson, who "on every possible occasion" instilled such principles "into the minds of his young pupils."[33] On 26 August 1778, Bartram took the oath of allegiance and fidelity to his new country. The impact of war had serious repercussions for members of the Society of Friends. By 1776 some Quakers had come to believe that it was lawful to take up arms in defense of American liberty. They paid allegiance to the United States and actively participated in the war in 1781. They called themselves "Free Quakers" and in 1783 built their own place of worship in Philadelphia. Several Bartrams were founding members of this group, including William's brother Moses, Isaac Howell, second husband of Mary Bartram, and Thomas Say, who married William's niece and was partner with Isaac Bartram in the apothecary business. By 1781 William's brothers John and James had both joined the group. William is not known to have committed himself to the Free Quakers, but his loyalty to the United States was never doubted. As has been seen during his days in Georgia, William's own brand of Quakerism did not rule out fighting for a just cause. The Free Quakers were not the first of the Society to abandon their testimony of peace. James Logan, Secretary to William Penn and elder friend to John Bartram, chose to stay and fight with the crew of the ship he was sailing with when it came under attack from the French. His fellow Friends, including Penn himself, went below deck and took no part in the fray.

Travels as a scientific work is an affirmation of American science that includes a straightforward listing of the flora and fauna of the region. This aspect is an important element of Bartram's book, but *Travels* is also a travel book and a poetic celebration of his reflections on nature. Within the American context, Bartram was one of the first to remove himself from society in order to reflect on that society and on nature and then to express those contemplations in writing. Others have followed in his footsteps, most notably Henry Thoreau and his work *Walden.* Bartram wrote his *Travels* as a narrative of events that at times pays little attention to chronological sequence. The opening page of Bartram's journal, sent to John Fothergill, is dated 20 March 1774, while in his *Travels* he states that he set sail in April 1773. Both these dates are incorrect: he set sail from Philadelphia on 20 March 1773 and arrived in Charleston, South Carolina, ten days later. The dates that appear throughout the text have proved to be almost always incorrect. Many of these errors were committed by the printer and Bartram expressed concern that "*Travels* had not been published under his own inspection."[1] But he also placed certain events out of sequence and this allowed him to give weight to the moral or aesthetic tale that he was telling. For instance, his description of meeting the lone Indian in southern Georgia that he writes about early in the book did not take place until much later, either in 1774 or, more likely, in the summer of 1776 as he makes no mention of the event in his Journals of 1773–75 to Fothergill.

Bartram tells how one day when he had "passed the utmost frontier of the white settlements" he came upon another lone traveler: "An Indian appeared crossing the path. On perceiving that he was armed with a rifle, the first sight of him startled me." The traveler galloped toward him in what Bartram called a menacing manner and for the first time in his life Bartram claimed he was afraid at the sight of an Indian and that his own "spirits were very much agitated." Bartram was unarmed and declares that at this point having entirely resigned himself to the will of the almighty he "resolved to meet the dreaded foe with resolution and cheerful confidence. The intrepid Siminole stopped suddenly . . . silently viewed me, his countenance angry and fierce, shifting his rifle from shoulder to shoulder. . . . I advanced toward him, and . . . offered him my hand, hailing him, brother." Eventually the Seminole approached and gave his hand in return with a dignified look that Bartram believed meant: "White man, thou art my enemy, and thou and thy brethren may have killed mine; yet it may not be so, and even were that the case though art now alone, and in my power. Live; the Great Spirit forbids me to touch thy life; go to thy brethren, tell them thou sawest an Indian in the forests, who knew how to be humane and compassionate." When Bartram arrived at the trading house, he learned that this same man had been "extremely ill treated the day before" (20–21) and had left vowing to kill the first white man he met. Bartram wrote this account some ten years after the event and was making a statement here rather than repeating a conversation. He sets the incident early in his writings to assert his opinions of Native Americans. It is his attempt to dismiss any preconceived ideas and prejudices held by the reader and to affirm his own acceptance of Native Americans as moral equals.

The rearrangement of events not only helps to make moral statements such as the one above but also creates a narrative tale that pulls together to give a cohesive picture of the region. Just as his drawings depict the interrelationship between species, so Bartram does the same in his writing. To give a complete view of nature in a particular region, he needed to show the interaction between species, the effects of weather and human interference on nature, and this sometimes meant altering the chronology of some of his experiences. This does not devalue the accurate observations that he made and the scientific method and understanding that underlie his observations. The book itself is punctuated throughout with dramatic episodes, such as his terrifying encounter with alligators and his experiences of typhoon-like thunderstorms. At other times he drifts into musings or fantasies with classical allusions: "The glorious sovereign of day, clothed in light refulgent, rolling on his gilded chariot, speeds to revisit the western realms" (50). In between these narratives are scientific lists and descriptions of species.

Travels is Bartram's contribution to and his vision for the future of the new nation, a vision that he expressed in his portrayal of the beauty of nature and his admiration of the Native American's relationship with nature. His writings on Native Americans were integral to his view of the development of an independent America and this material consists of a large proportion of part three of *Travels* and the whole of part four, entitled "An Account of the Persons, Manners, Customs and Government of the Muscogulges or Creeks, Cherokee, Chactaws etc. Aborigines of the Continent of North America." Bartram also wrote a paper in 1789 in response to a series of questions a friend and then correspondent Benjamin Smith Barton put to him, known as "Observations on the Creek and Cherokee Indians. . . ." Barton was in Europe at the time studying medicine when he wrote to Bartram, stating that his answers "will prove a valuable acquisition to science."[2] A third document, "Some hints and observations, concerning the civilization, of the Indian, or Aborigines of America," written sometime between 1789 and 1792, is Bartram's advice regarding American Indian policy. All three extended writings—*Accounts, Observations,* and *Hints*—are written in a style that attempts to be objective and scientific. Elsewhere in other chapters of *Travels* there is a scattering of comments and anecdotes on Native Americans that is written in a more romantic and subjective style that fits the narrative of the book. Bartram gives an account of the lifestyle, culture, and history of Native Americans that is overall sympathetic and admiring. In his description of indigenous peoples and the conclusions that he draws from them, Bartram presents his view of a people and culture equal to that of Europeans.

The prevailing ideas of the Enlightenment, personified by men such as Thomas Jefferson, were that all humans were potentially equal. Those belonging to a so-called primitive culture could be raised to a high level of civilization, as determined by contemporary Europe, and accomplished by the introduction of Christianity, Western morals and economics. In *Some Hints and Observations,* Bartram made a fundamental shift from his stance in *Travels* and espouses the Enlightenment's "civilizing" notion. He concedes that "In order to recover the friendship & union of our neighbouring, uncivilized nations, perhaps no more eligible, or

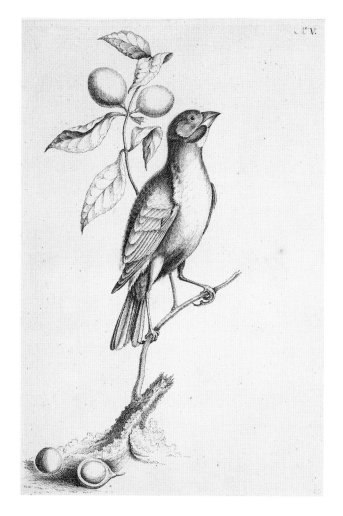

PHYSIC NUT OR
INDIAN OLIVE
Nestronia umbellula Raf.
(Santalaceae)

EVENING GROSBEAK
Possibly a female
Coccothraustes vespertinus
(Cooper)

laudable step can be pursued, than the introduction of our Language, System of Legislation, Religion, Manners Arts & Sciences."[3] In contrast, the predominant theme in *Travels* is closer to the philosophy of Jean-Jacques Rousseau, which argued that all men were naturally good, but that through the process of "civilizing" man was corrupted. In his meeting with the lone Indian, Bartram concludes, "Can it be denied, but that the moral principle, which directs the savages to virtuous and praiseworthy actions, is natural or innate?" (22). Here Bartram expresses his belief that an innate moral sense exists in all humans. He elevates those Indians "to the first rank amongst mankind" for resisting the "continual efforts of the complicated host of vices, that have for ages overrun the nations of the old world and so contaminated their morals."

Bartram was witness to coarse and brutal behavior from white settlers and traders with whom he traveled and he reproached the "immoral conduct of too many white people" (491). In *Travels*, Bartram questioned the notion of civilizing. He asked in the introduction whether Native Americans were "deserving of the severe censure . . . that they were incapable of civilisation" that was so prevalent among white people. He asked whether there was any inclination for them to adopt "European modes of civil society?" or, if this were achieved, could it be done without using "coercive or violent means?" Last of all, he challenges

the idea that if such changes were to occur whether it would be "of real benefit to them, and consequently beneficial to the public" (xxxiii). In describing the moral character of the Muscogulges in part four of *Travels*, Bartram states: "If we consider them with respect to their private character or in a moral view, they must, I think, claim our approbation, if we divest ourselves of prejudice and think freely. As moral men they certainly stand in no need of European civilisation." And he comments that they "appear evidently to have made greater advances towards the refinements of true civilisation, which cannot, in the least degree, be attributed to the good examples of the white people" (489–90). Bartram concludes the section of comparison of the Muscogulges to Europeans by asking, "Do we want wisdom and virtue?" And answers, "Let our youth then repair to the venerable councils of the Muscogulges" (493). Bartram was no exponent of Dryden's sentiment of the noble savage, nor did he have any illusions about what he called the "vices, immoralities and imperfections" of Native Americans. Nevertheless, by the time Bartram came to write *Travels*, he had a genuine commitment to the equality of all humans and a high opinion of Native American lifestyle, particularly in their understanding of nature.

Bartram's shift to the "civilizing" philosophy in later years was possibly influenced by the circumstances of the day and his continued friendship with Thomas Jefferson, who lived across the river from him when the federal government was situated in Philadelphia. It may also have been awareness that peace, the principle Bartram most valued, could only be achieved by such policies. He would certainly have known about the destruction of the Indian towns that he had visited in Georgia and West Florida soon after his return from them in 1776. He also recognized that the white man's "injustice & averice, in pressing upon their Borders & dispossessing them of their Lands"[4] was devastating the Creek and Cherokee nations. As a consequence, there had been several costly wars waged against various native peoples and the damage had been significant. By 1789 relations with the Creek People had deteriorated to the point where "all out war seemed a distinct possibility."[5] The policy of the Continental Congress and then the U.S. government was one of reeducation of the native people in religious, cultural, and economic terms—the introduction of Christianity, Enlightenment morals, and a society based on commercial farming rather than hunting. In the light of these events, Bartram wrote *Hints* that, despite the "civilising" theme that ran through it, remained, above all, a plea for compassion and benevolence in the treatment of Native Americans.

There are several origins of William Bartram's defense of Native American lifestyle and culture. His own gentle, sensitive, and tolerant nature together with his Quaker upbringing, albeit somewhat atypical, played some part in it. More influential was his formal education at the Philadelphia Academy under the tutorship of Charles Thomson, a committed defender of the indigenous peoples. Here he read the classics and political thinkers such as Francis Hutchinson, who promoted the idea that all humans were innately moral. Such belief would have contradicted the ideas of his father and that no doubt prevailed in the Bartram household. John Bartram had undergone a tragic experience as a child. At the age

of ten, his father, William Bartram Sr., and stepmother moved to North Carolina and left John and his younger brother James in the care of their grandparents in Darby. Soon after his parents arrived in North Carolina, a series of skirmishes occurred between white settlers and the Tuscarora Indians. In one skirmish, William Bartram Sr. was killed and his wife and her children were held for ransom (but later were released). Such an experience no doubt colored John Bartram's opinion of Native Americans, an opinion he expressed in his letters to Peter Collinson: "I cant tell when ye Indians can be trusted again not before they are soundly banged."[6] He became particularly vociferous on this issue when his precious plant collecting was threatened. On the scheme proposed by the British to search the Louisiana Territory for natural products, he warned, "All ye discoverers would be exposed to greatest Savage cruelty ye gun tomahawk torture or revengeful devouring Jaws before this scheme can be executed ye Indians must be subdued or drove above 1000 mile back."[7]

William rejected such sentiments long before he set out on his travels in the South. Nevertheless, the greatest influence on his regard for Native Americans came from his own experience while traveling through Creek and Cherokee country. In chapter four of *Travels*, he hints at abandoning his preconceived ideas as a consequence of his contact with the different people he stayed with. He dismisses the writings of historians "concerning the customs and usages of the aborigines of America" and the reports he had heard "Before I went amongst the Indians" as "too vague and general." Bartram makes clear that many preconceived notions were unfounded and that from his own "frequent opportunities of observation, and the information of respectable characters who have spent many years amongst them" (511), he would attempt to correct such notions and present a "just view" to his readers. William Bartram's time spent observing Native Americans resulted in his being considered one of the most informed men on the subject during his lifetime. When Benjamin Hawkins, Federal Indian Agent to the Southern Tribes, was appointed in 1798, he requested a copy of Bartram's *Travels*. Thomas Jefferson is also thought to have consulted Bartram on the subject. Others, such as John Stuart, Superintendent of Indian Affairs up to the time of Independence, may well have had as much knowledge as Bartram. Such men were in the employ of the British Government. They were diplomats, primarily there to smooth the way for white settlement. Their own compassion may have been heightened by their intimate contact with the indigenous people, but their motives were determined by political needs that were totally different from Bartram's. Bartram had no such obligations and was able to make his observations without any such prerequisites.

In his writings Bartram describes the lifestyle, culture, and history of the various native groups. He details their physical appearance, their dress, music, and language, distinguishing between the different dialects. Bartram himself relied on interpreters, usually traders, although he claimed he "had Indian enough" to make himself understood.[8] When it came to music, Bartram was more impressed by the Indian songs rather than their instruments. He did not appreciate the flutelike instrument on which, he commented judgmentally, "they perform badly, and at best it is rather a hideous melancholy discord, than harmony" (505). But the songs

he considered had "a languishing softness and melancholy air . . . especially of the amorous class, irresistibly moving, attractive, and exquisitely pleasing" (245). It is unknown how much exposure to music William had when he was young. Traditionally, Quakers did not consider music as important because "Plain" Friends did not sing. On the contrary, some believed music was sinful. George Fox said that music was almost as dangerous as gunpowder and Tom Paine, himself the son of a Quaker, wrote that "if the taste of a Quaker could have been consulted at the Creation. . . . Not a flower would have blossomed its gayeties, nor a bird been permitted to sing."[9] The Bartram family, it must be remembered, were not traditional Quakers, but the only musical instrument in the Bartram house, according to Hector St. John de Crèvecoeur when he visited in 1765, was an Aeolian harp. It is unlikely that the Bartrams were musicmakers.

Bartram also describes the architecture, social interactions, customs, and government of the Native Americans, relying on oral history and the mythology of the people. Of the Creek government he wrote that it was "the most simple, natural & rational, that can be imagined or desired. The same spirit that dictated to Montesquieu the idea of Rational Government, seems to superintend and guide the Indians."[10] Montesquieu's rational government was one that was related to the physical and social environment. He argued that laws must be adapted to the circumstances in which a nation lives. Montesquieu was influenced by the growing amount of travel literature of the seventeenth and eighteenth centuries, particularly books that dealt with the aborigines of America and Africa. It is therefore no surprise to find that William Bartram admired such ideas. Montesquieu subscribed to the idea that liberty came from the separation of the legislative, executive, and judicial powers and the balancing of these powers against each other. It is interesting that when the founding fathers drew up the American Constitution and Bill of Rights it was to Montesquieu's writings that they looked.

Bartram was aware of the prevailing opinions among European writers of the inferiority of Native Americans and his writings offer an alternative view based on his direct observations. Buffon had written, "For, though the American savage be nearly of the same stature with men in polished societies; yet this is not a sufficient exception to the general contraction of animated Nature throughout the whole Continent. In the savage, the organs of generation are small and feeble. He has no hair, no beard, no ardour for the female. . . . His sensations are less acute; and yet he is more timid and cowardly. He has no vivacity, no activity of mind. . . . Their love to parents and children is extremely weak. . . . Their heart is frozen, their society cold, and their empire cruel."[11] William Bartram owned a copy of the 1781 edition of Buffon's *Natural History*, presented to him by his friend Benjamin Smith Barton, and he comments on Buffon in his daybook. Although he does not mention Buffon by name in *Travels*, in his descriptions of the flora and fauna of the region Bartram regularly contradicts the idea of European superiority of species, and in his material on Native Americans he presents arguments for a long history and continuity of their culture, tradition, and architecture.

In his representation of the physical appearance of the different native peoples, Bartram by no means gives the impression that they were in any way inferior

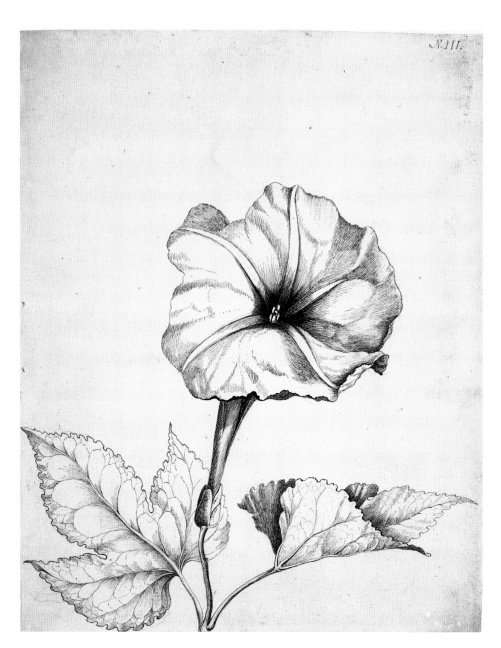

**LARGEROOT OR
INDIAN-MIDDEN
MORNING GLORY**
Ipomoea macrorhiza Michx.
(Convolvulaceae)

to Europeans. On meeting with one young Seminole prince, he describes him as "rather above the middle stature, and the most perfect human figure I ever saw" (245). The Cherokee people, he explained, were the "largest race of men" he had seen. Commenting on the language, Bartram declared that it was "beautiful, copious and easily learned."[12] His observations on the mounds and archaeological sites led him to conclude that they were of Native American origin. In the final paragraph of his book, he states that "none of them . . . discover the least signs of the arts, sciences, or architecture of the Europeans or other inhabitants of the old world: yet evidently betray every sign or mark of the most distant antiquity" (522). William Bartram stood alone in this assessment. By the nineteenth century the prevailing argument was that the mounds were built by a separate, advanced society that had now been replaced by less civilized, modern Indians. Bartram identified the mounds, architecture, and artifacts that he found in the mounds

as "Indian." He compared the artifacts with those of living Native Americans and concluded that the resemblance was enough to suggest that early Native Americans originally inhabited the sites. The mounds tended to be concentrated along the major river systems and Bartram came across a fair number of them on his travels. Concentric semicircular ridges or tumuli would sometimes surround platform mounds. Bartram excavated some of them and examined the pottery and other artifacts that he found inside. He wondered at the ingenuity of the earthworks and commented that the construction of them "would have required the united labour and attention of a whole nation" (325). In his *Observations*, he discusses this subject in detail, but it was not published until 1853. By then the notion of a "lost race" was firmly entrenched in the minds of the academics and public alike, who lapped up the fictitious stories of ancient civilizations that once roamed the land of America. The controversy over who built the mounds continued throughout the nineteenth and into the twentieth century. Both Benjamin Smith Barton and Thomas Jefferson, who excavated a mound on his own estate at Monticello, believed in the "lost race" theory. Barton was one of the earliest advocates of this theory and wrote about it in his 1797 *New views of the origin of the Tribes and nations of America*. Much of his information came from William Bartram's *Observations*. Barton, however, came to a different conclusion than Bartram and it may be for this reason that he mentions William only once in his work. Men such as James McCulloh in 1829 and Samuel Haven in 1856 questioned the "lost race" theory and even proposed that Native Americans were the builders, but they were mostly ignored. It was not until 1894 that Cyrus Thomas was able to influence the debate as to the origins of the mound builders. After seven years of intense fieldwork, he published his *Report of the Mound Exploration of the Bureau of Ethnology* and established that it was the ancestors of the Native Americans who had built the mounds. It is now accepted beyond any doubt that this is the case.

There is only one drawing of a Native American by Bartram, that of Mico Chlucco, Long Warrior, king of the Seminoles. When *Bartram* submitted his book for publication, the traditional procedure was to raise subscriptions in advance of publication. Robert Parrish took on this task and when he visited New York he wrote to Bartram on how well he was doing. Parrish signed up the President of the United States, who "Subscribed Readily" but who also declined to have the work dedicated to himself. He argued that having refused others he may "give offence" if he accepted Bartram's offer. Parrish encouraged William to send illustrations that would help in collecting subscriptions. "The drawings of the Crane and the Mocking Bird are very much admired here & have been of considerable advantage—but had I the head of the Indian Chief... it would be of still greater advantage."[13] This would have been particularly so in the northern states, where people were less familiar with Native Americans. William first met Mico Chlucco in 1765 at the Congress of Picolata. He later observed him when a group of Seminoles were encamped for several days at one of Spalding's trading stores in 1774. William obliged Parrish by completing the head of the Indian chief, the drawing that was used as the frontispiece for *Travels*.

WILLIAM BARTRAM
(1739–1823)

LONG WARRIOR
Mico Chlucco,
King of the Seminoles

MICO CHLUCCO the LONG WARIOR
or *KING of the SIMINOLES*

William Bartram's defense of Native Americans served two purposes. It presented evidence against the ideas of Buffon and other commentators who espoused the theory that Native Americans were a degraded and inferior species of humankind. At the same time, it was also a plea for the Native Americans' right to their land by demonstrating that their lifestyle and customs were as civilized as those of white men. The idea of progress, an essential component of Enlightenment thinking, with its faith in the ability of humans to exploit and control the environment, was in many ways contrary to the Native American relationship with nature. Bartram drew his conclusions from his own observations and experience. The Native American relationship and understanding of nature was something he aspired to and strove for all his life.

CHAPTER 8

The Arcadian Dream

Travels RECEIVED A MIXED RECEPTION when it first appeared in 1791. In America, one reviewer thought Bartram's description was "rather too luxuriant and florid," although he acknowledged that he had "accurately described a variety of birds, fish and reptiles, hitherto but little known."[1] A review earlier in the year was more critical. The anonymous author believed that Bartram "magnifies the virtues of the Indians, and views their vices through too friendly a medium. . . . Many rhapsodical effusions might, we think, have been omitted, with advantage to the work."[2] Despite Bartram's growing fame among scientists, no new edition of his book was published in America for another 136 years.

In contrast to this reception in America, appreciation of the book in Europe was considerable. Up to eight editions were published in six countries within the first ten years. *Travels* and William Bartram were not neglected by the scientific community in Europe: Bartram was considered one of the greatest American naturalists during his lifetime and his name is the only American included in the list of "all living zoologists" by F. A. A. Meyer in 1794.[3] Nevertheless, it was the Romantic poets and artists who truly embraced Bartram's book. *Travels* was read as a travel book; the scientific listings, descriptions, and observations were viewed as secondary to the language and imagery that the work invoked. By the last quarter of the eighteenth century, a reaction to the rational, logical ideas of the Enlightenment emerged. Scientific method, experimentation, and order were

All art should become science and all science art.

—KARL FRIEDRICH SCHLEGEL,
Lyceum Fragments

Coleridge recalled in his notebook reading Bartram, sitting by the open fire in Wordsworth's house on a winter's afternoon with Asra, Sara Hutchinson, with whom he was in love. In his notebooks written between 1795 and 1798, he noted phrases, complete sentences, and even whole paragraphs from Bartram's *Travels*. Sandwiched between these are entries that reflect how Coleridge had absorbed the imagery Bartram created and had become captivated by him. John Livingston Lowes states: "Probably none of the books which Coleridge was reading during the gestation of 'The Ancient Mariner' left more lively images in his memory than Bartram's Travels."[7] This is no doubt true for much of his poetry written in 1797–98. The thunder of Bartram's alligators, his "milk white fragrant blooms," and "inchanting and amazing crystal fountain" all find their way into Coleridge's poetry. The poem *Lewti*, written in 1797, includes the Tamaha stream, which is without doubt the Altamaha River. The descriptions of the desert landscape in *The Wanderings of Cain* and the "velvet black" of the water snakes of the *Ancient Mariner* come directly from Bartram. But it is *Kubla Khan* that is probably the poem most infused with Bartram's imagery.

> *And from this chasm, with ceaseless turmoil seething,*
> *As if this earth in fast thick pants were breathing,*
> *A mighty fountain momently was forced:*
> *Amid whose swift half-intermitted burst*
> *Huge fragments vaulted like rebounding hail,*
> *Or chaffy grain beneath the thresher's flail:*
> *And 'mid these dancing rocks at once and ever*
> *It flung up momently the sacred river.*
> *Five miles meandering with a mazy motion*
> *Through wood and dale the sacred river ran,*
> *Then reached the caverns measureless to man,*
> *And sank in tumult to a lifeless ocean.*

Coleridge wrote *Kubla Khan* between 1797 and 1798 and he claimed it first came to him in a vision or a dream. His dreams, his imagination, and his reveries were fed by Bartram's *Travels*. One evening while Bartram is traveling alone along the St. Johns River, he seats himself "upon a swelling green knoll . . . just under my feet was the enchanting and amazing crystal fountain, which incessantly threw up, from dark rocky caverns below, tons of water every minute, forming a bason, capacious enough for large shallops to ride in, and a creek of four or five feet depth of water, . . . which meanders six miles through green meadows, pouring its limpid waters into the great Lake George. . . . About twenty yards from the upper edge of the bason . . . is a continual and amazing ebullition, where the waters are thrown up in such abundance and amazing force, as to jet and swell up two or three feet above the common surface: white sand and small particles of shells are thrown up with the waters, near to the top, when they diverge from the center, subside with expanding flood, and gently sink again" (165–66). Another evening when traveling through East Florida en route to Cuscowilla, Bartram encamped by the cape of flat

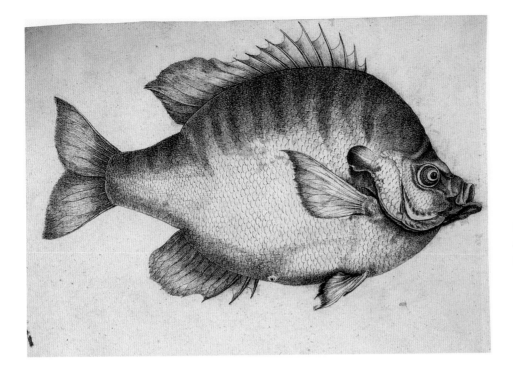

rocks at Halfway Pond. These rocks projected into the lake and formed one point of the crescent that partly surrounded the "vast grotto" that Bartram described as a "vortex to the subterranean receptacles of the water." Here he observed the movement of the fish: "Behold now at still evening, the sun yet streaking the embroidered savannas, armies of fish pursuing their pilgrimage to the grand pellucid fountain, and when here arrived, all quiet and peaceable, encircle the little cerulean hemisphere, descend into the dark caverns of the earth" (174–75). It is descriptions such as this that so inspired Coleridge when writing *Kubla Khan*, *The Wanderings of Cain*, *Christabel*, and *The Rime of the Ancient Mariner*.

Coleridge was not alone among the poets in his immersion in *Travels*. Many poets absorbed impressions created by Bartram and echoed his diction, mood, and philosophy of nature. William Wordsworth's *Ruth* was, as Lowes described, "saturated with Bartram." The poem, written while Wordsworth was in Germany and published in 1800, opens with: "There came a youth from Georgia's shore with splendid feathers drest, he brought them from the Cherokees." It continues with openings of verses that include, "He told of the magnolia spread; of flowers that with one scarlet gleam, cover a hundred leagues and seem, to set the hills on fire." In a note to the poem Wordsworth himself acknowledges Bartram as his authority and explained "Azaleas, the splendid appearance of these scarlet flowers, which are scattered with such profusion over the hills in the southern part of North America, is frequently mentioned by Bartram in his Travels." In another verse Wordsworth wrote:

> *He told of Girls, a happy rout*
> *Who quit their fold with dance and shout*
> *Their pleasant Indian town,*

STRAWBERRY
Fragaria sp. L. (Rosaceae)

PINELAND DAISY
Chaptalia tomentosa Vent.
(Compositae)

VIOLET
Viola emarginata (Nutt.)
LeConte (Violaceae)

To gather strawberries all day long,
Returning with a choral song,
When day-light is gone down.[8]

Once again Wordsworth calls upon Bartram's remembrances of past events for this passage. Bartram and a fellow traveler one evening ascend the hill of a ridge that overlooks the vale of Keowe, and as the two men gain its summit they enjoy a most enchanting view, "a vast expanse of green meadows and strawberry fields . . . companies of young, innocent Cherokee virgins, some busily gathering the rich fragrant fruit, others having already filled their baskets, lay reclined under the shade of . . . fragrant native bowers of magnolia, azalea and jasmine, disclosing their beauties to the fluttering breeze, and bathing their limbs in the cool fleeting streams; others yet collecting the strawberries or wantonly chasing their companions, tantalising them, staining their lips and cheeks with the rich fruit. This sylvan scene of primitive innocence was enchanting and perhaps too enticing for hearty young men long to continue idle spectators" (356–57).

William and his companion joined the group where, after some blushes of modesty, the maidens "with native innocence and cheerfulness, presented their little baskets, merrily telling us their fruit was ripe and sound" (358). It is here in these lines that the reader is given a rare glimpse of William Bartram in a more jovial and frivolous frame of mind. More so than not, William is depicted as shy, conservative, and unimposing but on this occasion he is a "hearty young" man with "nature prevailing over reason" (357).

William Bartram's experience of the natural world was at times stranger than fiction, and he was sometimes disturbed by scenes of nature. With his first encounter of the Alachua Savanna, an open plain that was a haven for wildlife, he exclaims, "How is the mind agitated and bewildered, at being thus, as it were, placed on the boarders of a new world" (189). His description of the plant Kalmia hints of the absurd: "These extraordinary appearances of beautifull Flowers, are more like fiction or the exertions of an eregular fancy than of Nature."[9] Bartram translates these exertions of irregular fancy by sometimes distorting the scale of the subjects in his drawings and transcending the normal human experience in his descriptions of beauty and horror. This is what in the eighteenth century would have been called the Sublime. Bartram expresses the rapture he experienced through his solitary contact with nature in this way. It is akin to Wordsworth's encounter with nature:

> *And I have felt*
> *A presence that disturbs me with the joy*
> *Of elevated thoughts; a sense sublime*
> *Of something far more deeply interfused,*
> *Whose dwelling is the light of setting suns,*
> *And the round ocean and the living air,*
> *And the blue sky, and in the mind of man.*[10]

Edmund Burke described the passion stirred by the sublime as astonishment "that state of the soul, in which all its motions are suspended . . . the mind is so entirely filled with its object, that it cannot entertain any other, nor by consequence reason on that object which employs it."[11] Bartram evokes the sublime by describing the vastness and awesomeness of the landscape and ocean and the grandeur of the forests. He transforms the physical quality of what he is describing into a spiritual emotion. Overlooking a grand view of the boundless ocean, Bartram exclaims, "O thou Creator supreme, almighty! how infinite and incomprehensible thy works most perfect, and every way astonishing! . . . But yet, how awfully great and sublime is the majestic scene eastward! The solemn sound of the beating surf strikes our ears; the dashing of yon liquid mountains, like mighty giants, in vain assail the skies; they are beaten back, and fall prostrate upon the shores of the trembling island" (59–61). This emotional expression of awe occurs throughout his work; his mind is "suspended" on mountain heights, at sea level, or on the Alachua Savanna. In his use of the term "sublime," Bartram always uses the vocabulary that was associated with the word in the current literature. On reaching the summit of Jore Mountains, he "beheld with rapture and astonishment, a sublimely awful scene of power and magnificence, a world of mountains piled upon mountains" (362). But the concept of the sublime could equally be applied to the terrible as well as the beautiful. Bartram's account of the furious tempest where the skies "appeared streaked with blood or purple flame," the world filled with fire and the earth in a "constant tremor" is certainly evocative of the fears and terrors of Burke's statement that "terror is in all cases . . . the ruling principle

of the sublime."[12] Bartram's description of the storm is also reminiscent of Virgil's *Georgics*, which Bartram read at school. Virgil depicts a storm in which

> *The Father himself in the midmost night of cloud*
> *Wields thunderbolts amain. The mighty earth*
> *Quakes at that shock. The wild beasts all are fled*
> *And mortal hearts worldwide are cowering . . .*[13]

The idea was that the true sublime freed the soul from all earthly limitations. William Bartram claimed to have experienced this freedom on various occasions during his travels. But more significantly, it was from the cumulative experiences of his travels that he found hard-won freedom from the strictures that had dominated his earlier life.

When William Bartram wrote in his poetic style, he was conscious of his choice of language that reflected his own experiences and impressions while attempting to engage and stimulate the reader. Scores of poets throughout Europe were indebted to Bartram. Robert Southey, Chateaubriand, Charles Lamb, and even Percy Bysshe Shelley found *Travels* stimulating and each became immersed in Bartram's poetic palette. Thomas Carlyle was so impressed with Bartram's *Travels* that he paid tribute to him when writing to Ralph Waldo Emerson in America urging him to read the work. Bartram himself was probably unaware of how influential he became among the European poets. There is no evidence of any contact having been made between Bartram and any of these men. Furthermore, he never received any remuneration from the publishers for the reprinting and the sales of the various editions of his book.

CHAPTER 9

Describing, Classifying, and Naming

LATE IN 1788 OR EARLY 1789, Bartram sent his watercolor of *Franklinia* to Robert Barclay in London. Barclay was born in Philadelphia in 1751, the son of Alexander and grandson of David Barclay of Cheapside, London. His great-grandfather was Robert Barclay, the Apologist (1648–90), whose religious tract was sent to John Bartram by Peter Collinson in 1742, but dismissed by Bartram as something that "confuses." The younger Robert Barclay's mother died when he was two years old, and when he reached the age of twelve his father sent him to England to live with his eldest "strictly Quaker" uncle. Although Barclay returned to Philadelphia in 1772 for two years to settle his affairs after his father's death in 1771, it is not likely that he met Bartram. William was in North Carolina in 1772 and only returned to Philadelphia early in 1773 for the sole purpose of arranging his passage to Charleston, the starting point of his travels. It is also unlikely that Bartram would have known the Barclays in Philadelphia through the Quaker fraternity. Neither the Bartrams nor the Barclays regularly attended meetings. On commenting in later years on his arrival in England, Robert Barclay said that he had no idea what a Quaker was. The gold lace that adorned his coat was stripped from him and his attendance at the Wandsworth Quaker School and residence in his "strictly Quaker" uncle's house soon put his ignorance to right.

It is more likely that it was John Fothergill who introduced Robert Barclay to Bartram. David Barclay of Youngsbury, Robert's uncle, was one of Fothergill's

Without Contraries Is No Progression.

—WILLIAM BLAKE, *The Marriage of Heaven and Hell*

closest friends, with whom he met and corresponded regularly. In the winter of 1774, when the crisis between Britain and the American colonies was coming to a head, John Fothergill, David Barclay, and Benjamin Franklin held frequent meetings in an attempt to find an acceptable settlement. They drew up a plan of conciliation, of which many of the points were adopted later in the Treaty of 1783. But in 1775 British ministers were not prepared to accede to such proposals and so the plan became redundant. John Fothergill also collaborated with the Barclays in the founding of Ackworth School, a Quaker school established in 1780 in Ackworth, Yorkshire. The committee meetings for the school were held at 108 Cheapside, the Barclay household, and Fothergill would stay over. In 1775 Robert Barclay wrote to his cousin, "Johnny for Short," that "Dr. Fothergill and I and my usual confederates remain the stable pillars of Cheapside mansion."[1]

The Barclays were an established family not only within the Quaker community but also in the world of business and finance. The Barclay family assiduously followed the Quaker practice of marrying within a small circle of families, and for at least six generations married first and second cousins. Marriage between one generation and another was not uncommon. While business alliances were encouraged, marriage between rich and poor was not. By keeping marriages within a small circle, chiefly between the Barclay and Gurney families, they were able to protect their wealth. The Barclay and Gurney family made their money through manufacture and trade, particularly with the American colonies. When the wool industry was transformed by the introduction of water- and steam-powered machines for spinning, the Norwich-based family diverted their money into banking. David Barclay's second marriage was to Priscilla Freame, whose family had set up the first Quaker bank in London. In 1770 major shares of the bank passed to Priscilla Barclay, and her two sons took over the running of the bank in 1776, renaming it Barclay's Bank. Another member of the large Barclay-Gurney family through marriage was Sampson Lloyd, father-in-law to David Barclay and uncle of Robert. He also went from manufacturing into banking, founding the present-day Lloyd's Bank. When war between America and Britain threatened the export trade, Robert Barclay and his Uncle David and two cousins bought the Anchor Brewery in Southwark for £30,000. Samuel Johnson, who approved of the new buyers, witnessed the transaction. The families were so well established within society that in 1761, when George III wanted his new bride to see her first Lord Mayor's Show, it was to David Barclay that he appealed. The balcony at 108 Cheapside was appropriately decked out and became the venue for this royal visit.

Soon after Robert Barclay's return from America in 1775, he married Rachel Gurney, his cousin and the sister of "Johnny for Short." They lived at 108 Cheapside for several years and it was here that he developed his friendship with John Fothergill. Robert also had a passion for plants. In 1780, with their family expanding rapidly—Rachel had fifteen children within nineteen years—they moved to a country house in Clapham. Here Barclay built a large greenhouse and spent his spare time cultivating water lilies. The genus *Barclayeria* is named for him. He was active in promoting botany and horticulture and was the prime instigator in the publication of the original *Botanical Magazine*, edited by William Curtis in

1787, and one of the founding members of the Linnean Society in London. It was to Clapham that Bartram sent his drawings and plant specimens. Accompanying the *Franklinia* watercolor were three other drawings: the *Pinckneya bracteata*, Bartram explained, was drawn from "very perfect dryed specimen," while the *Oenothera* and *Hydrangea* were "from accurate drawings made by myself from living flourishing subjects, when on my travels." The *Franklinia* itself had been drawn from a flowering specimen in Bartram's own garden.

By the 1780s the Linnaean system of naming plants was well established and accepted by scientists throughout the world. Linnaeus is regarded as the father of the binomial system of taxonomic nomenclature through his publication of *Species Plantarum*, published in 1753. The book was based on the ideas of Caspar Bauhin (among others) and gave two names to all living things, a general and trivial name, genus and species. Many of the names are either descriptive, designate a locality, or honor a distinguished botanist or the person who discovered

EVENING PRIMROSE
Oenothera grandiflora
L'Hér. (Onagraceae)

the plant. In sending the *Franklinia* to Barclay, Bartram was intending to have the plant confirmed by experts as a new genus. Bartram began his letter to Barclay requesting that he show the drawing of *Franklinia* to "Mr. Walters the celebrated Author of the Flor. Caroliniana." Thomas Walter was born in England but moved to South Carolina around 1768. It was here that he collected and described a great many plants of the region. In 1786 John Fraser, visiting from England, met with Walter and found that Walter had described some 640 plants of the area. By December of that year the number had risen to 1,060, the additions coming from plants Fraser had collected himself. Fraser returned to England with the manuscript and published Walter's *Flora of Carolinensia* in July 1788 at his own expense. It is known that Humphry Marshall had received a copy of the book by October that year, and there is no reason to doubt that Bartram too had seen a copy, thereby explaining his familiarity with Walter. What Bartram did not know

was that Walter had settled in South Carolina and would never return to England. In January 1789, Walter died before he could have seen Bartram's drawings or had any contact with him. Barclay instead showed the watercolor of *Franklinia* to Sir Joseph Banks.

In describing the Evening Primrose *Oenothera grandiflora*, the same "pompous, brilliant plant" that he discovered in Alabama in 1775, Bartram wrote that it "is a plant which perhaps exhibits the most brilliant shew of any yet known to exist." The *Hydrangea quercifolia* is similar to one that was produced for the first edition of *Travels*, where he described discovering this "very singular and beautiful shrub" growing on the banks of rivers and creeks soon after he had set out for West Florida and the Mississippi River. Of the *Pinckneya bracteata*, commonly known as Fever Bark, Bartram wrote Barclay that he first discovered this plant when traveling in Georgia with his father in 1765. The plant was one of the "very curious shrubs" discovered the same time as *Franklinia*. On returning to the area some ten years later, "in the Spring Season . . . I had the pleasure and satisfaction of seeing it in perfection, in full flower. together with the Franklinia which then flourish'd in sight of it." William then makes a plea for the naming of the plant. "If it should prove to be a New Genus, I have a request that It may be call'd *Bartramia (bracteata)* in Memory of my Father John Bartram deceas'd. *The American Botanist & Naturalist* whose labours Travels, collections & Communications to the Curious in Europe hath contribut'd perhaps as much as that of any Man of his time toward increasing the stores of Botanical knowledge, with respect to North american productions."[2] As with many of the plants Bartram discovered, his request fell on deaf ears and the plant is now known as *Pinckneya pubens*. Constantine Rafinesque at first adopted the species name of *bracteata* given by Bartram in his *Travels* because it was earlier than Michaux's description and species name of 1803. But in 1830, without any explanation, Rafinesque had reverted back to *pubens*. In 1945, E. D. Merrill argued convincingly that Bartram had every intention of naming the new species *bracteata* and Joseph Ewan has concluded from this that there is "no rational basis for rejecting Bartram's species name in favour of Michaux's Pinckneya pubens of 1803."[3]

Bartram discovered a long list of plants, including *Balduina*, *Befaria*, *Elliottia*, and *Macranthera*,[4] but none bears his name. The reasons for this are several and often complex. The naming of plants is bound by rules laid down by the International Code of Botanical Nomenclature, which credits the person who first describes and publishes a new species. William Bartram took fourteen years to publish his work after returning from his travels. During that interval, other naturalists gave their own names to many of Bartram's discoveries. Further, William Bartram sent his collection of specimens with accompanying descriptions in the early 1770s to John Fothergill. These were submitted to Daniel Solander, the botanist working with Sir Joseph Banks. Solander confirmed "most of them to be either New Genera or Species," but Solander died unexpectedly in 1782, not having made any progress on the collection from his initial observations. Both Joseph Banks and Daniel Solander had become more interested in the recent exotic species collected from the South Pacific as a result of Captain Cook's voyages and

TARFLOWER
Bejaria racemosa Vent.
(Ericaceae)

**ELLIOTTIA OR
GEORGIA PLUME**
Elliottia racemosa Muhl.
ex Elliott (Ericaceae)

spent little time on the American collections. In reference to his own specimens, Bartram complained that "very few of which I find have entered the Systema Vegetabilum, not even the latst Edition." He expressed some bitterness that his contribution had not been recognized, "expecting or desiring no other gratuity than the bare mention of my being the discoverer."[5]

Despite the publication of *Travels* in 1791, the scientific community has not accepted many of Bartram's plant and animal names. Concerning botanical names, Article 86 of the Rules of the International Code of Botanical Nomenclature has been applied to discredit Bartram discoveries. The contention here is that "the Linnaean System of binary nomenclature for species was not consistently employed" in Bartram's publication. E. D. Merrill argued against such a response and proposed Bartram's *Travels* "as a legitimate source of properly published binomials in botany." He presented evidence of 358 binomials Bartram used "as compared with only two 'descriptive phrases' or entries without binomials for plant species."[6] Merrill also argued that Bartram intended to follow the binomial system, that he was fully aware of the Linnaean system, but that he wished to avoid repeated long lists of technical names. Bartram's occasional lapses into polynomial nomenclature has invalidated his work for some scientists, but there are others, many of whom have made a study of his plant and animal names, who

PURPLE GERARDIA
(FIG. 1)
Agalinis fasciculata
(Elliott) Raf. (Scrophula-
riaceae)

WILLOW PRIMROSE
(FIG. 2)
Ludwigia leptocarpa
(Nutt.) H. Hara
(Onagraceae)

YELLOW BUTTERWORT
(FIG. 3)
Pinguicula lutea Walter
(Lentibulariaceae)

consider the recognition of Bartram's binomials long overdue. Robert L. Wilbur, a member on the Committee for the International Code at the time, wrote, "There seems to be no reason why Bartram's binomials, accompanied by a description, should not be treated as validly published."[7]

When it comes to his zoological names, many of which appear for the first time in *Travels*, Bartram has had the same problem. He has, in the main, been ignored by ichthyologists in their writings, and it is only recently, with a paper by Tim M. Berra in 1997, that someone has drawn attention to his descriptions of fish. Bartram was primarily a botanist and was not an expert on fish. Neverthe-less, he included six drawings of fish to Fothergill, one of which is a watercolor. Fish are discussed throughout his *Travels* and he describes in detail a number of different species. The most complete description is that of the warmouth, *Lepomis gulosus* (Cuvier). "What a most beautiful creature is this fish before me! gliding to and fro, and figuring in the still clear waters, with his orient attendants and associates: the yellow bream or sun fish" (153). In a footnote Bartram gives a scientific name, *Cyprinus coronaries*, for this species and continues in the passage to give a full description of its appearance and color, ending with, "He is a fish of prodigious strength and activity in the water; a warrior in a gilded coat of mail" (154). Berra explains that the major histories on fish give the earliest description of

the warmouth as 1829, almost forty years after Bartram published *Travels*. Berra refers to Francis Harper in his defense of Bartram's name for the fish, stating that Bartram's description fulfills all requirements of Article 25 of the International Rules of Zoological Nomenclature. Despite this and the fact that Bartram recorded at least forty different species of reptiles and amphibians in his book, many of which were new to science, the International Commission on Zoological Nomenclature in 1957 rejected Bartram's identifications on the grounds that there was no evidence he intended the first two names in his descriptions of species as binomial. Furthermore, the Commission argued, he was not consistent throughout his work in his use of binomials. Nevertheless, his watercolor of the warmouth serves as the type specimen.

Berra gives a thorough analysis of the quality of the drawing. He states that it is "adequate but not an especially good representation" of the fish but that it "is recognizable as a warmouth on the basis of coloration."[8] Today botanists and zoologists continue to defend Bartram's authorship of many plant and animal names and believe he should be given credit for his discoveries, but it is unlikely that after such a long period of time that any major changes in Bartram's favor will be made.

The Great Chain of Being theory predominated natural history in the eighteenth century. The idea that every living thing is linked to every other in a linear hierarchy was reinforced by applying Linnaeus's classification system. By gathering facts, identifying and naming each species, everything could be fixed in its correct place in the chain. Alexander Pope expressed it thus:

> *Vast Chain of being! Which from God began,*
> *Nature's aethereal, human, angel, man,*
> *Beast, bird, fish, insect! What no eye can see,*
> *No glass can reach! From Infinite to thee.*[9]

By placing each organism in this chain, it was then possible to read the order of creation and understand God's plan. The history of life on earth was one long tale of progress with a species at the higher end of it suitably equipped to glorify God's name and works. William Bartram in some ways accepted this linear, progressive view of life on earth, but he also saw the weakness of such a theory. His own experiences and wanderings led him to challenge such concepts. He never rejected the idea of an organized, unified universe, but he knew the natural world was far more complex. Nature was an organic system and in a dialectical process, through the interplay of opposite forces, underwent constant change. The whole cycle of life, death, and regeneration was a consequence of such changes, which also brought harmony and balance to nature. The term "environment" was not until coined in the early nineteenth century by Thomas Carlyle, but such an understanding of nature had become the new vision for many thinkers. Bartram was immersed in the ideas and context of his time and used the language and ideas of the Enlightenment, expressing the concepts of design for the universe and the chain of being for life on earth as his starting base. He then delved deeper, examining the intricate relationships between species and revealing qualities and characteristics that did not fall easily into the hierarchical structure. For Bartram, the complex interactions operating within nature reinforced the view that there was an overall harmony and divine presence.

William Bartram reevaluated the idea of nature as a linear hierarchy and leveled it somewhat, so that for him there was a greater parity between plants, animals, and humans. The categorical divisions between organisms that existed with the Chain of Being theory were not truly present in his concept of nature. The divisions are broken down and the boundaries are merged to reveal a complicated but cohesive world where organisms interconnect and interact with each other. His comments on the Venus Flytrap as having the same "sensible faculties . . . similar to those that dignify animal nature" (xx) can leave one in no doubt that Bartram attempted to elevate plants to an equal standing with animals. He saw little distinction between "the seed of peas, peaches and other tribes of plants" and that of the eggs of "oviparous animals." He argued that although some distinguish animals from plants because animals have the powers of sound and locomotion, plants too "have the power of moving and exercising their members, and have the means of transplanting or colonising their tribes almost over the surface of the whole earth" (xxii).

Bartram's observations of animal behavior led him to attribute human characteristics to them. He claimed that birds were "intelligent, ingenious, volatile, active beings" (xxxi) and called them his "ingeneous little philosophers, & my esteemed Associates." On a more serious note he asked, "Can any Man of sense & candour, who has the use of his Eyes, Rational faculty, doubt that Animals are rational creatures? Man undoubtedly excells, all the inhabitants or creatures of this World, Not only in the Organisation & Figure of his Body or Person, but also in his intellectual System . . . but if we compare the Moral System of the two Orders, & decide impartially, we must in many instances give preference to many Animals, which we hold beneath us. Animals seldom err in their choice

AMERICAN LOTUS (FIG. 1)
Nelumbo lutea Willd.
(Nymphaeaceae)

WHITELIP SNAIL (FIG. 2)
Triodopsis albolabris (Say)

RUBY-THROATED
HUMMINGBIRD
Possibly *Archilochus colubris* (Linnaeus)

BLACK-ROOT
Pterocaulon pycnostachyum
(Michx) Elliott (Compositae)

ARROW ARUM
Peltandra virginica (L.)
Schott (Araceae)

UNIDENTIFIED SNAKE,
DRAGONFLY, AND FROG

of food (& consequently, are healthy) & whatever concerns, the Senses & Appetites, & seldomer transgress the rules of Moderation & decency. & they often set us examples worthy of our imitation with respect civil concerns etc."[10] In the introduction to *Travels*, Bartram develops this idea to the point of attributing human emotions and sensitivities to animals as well as premeditation, artifice, and cunning. He cannot distinguish between "the moral system of the brute creature from that of mankind" and the animal system "we term instinct, which faculty we suppose to be inferior to reason in man." He continues to argue that "the parental, and filial affections seem to be as ardent, their sensibility and attachment, as active and faithful, as those observed to be in human nature" (xxv). To support that statement, Bartram recounts the hunting of a bear by one of his traveling companions, where he stealthily crept up on two bears on the banks of the river. The huntsman, who was an excellent shot, soon laid the adult low, on which "the other . . . approached the dead body, smelled, and pawed it, and appearing in agony, fell to weeping and looking upwards, then towards us, and cried out like a child." Bartram had accompanied the huntsman and he now felt himself to be an accomplice to "a cruel murder" (xxvi). He continues his examples of animal behavior with a tale of how the following day he is suddenly surprised by a spider

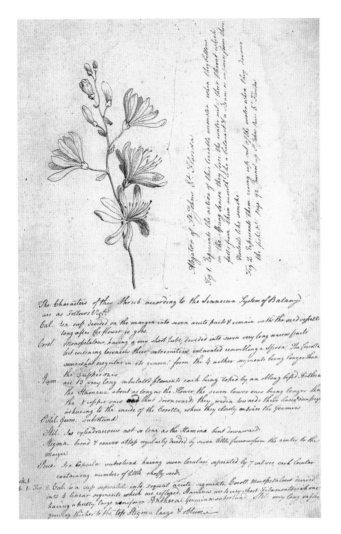

TARFLOWER
Bejaria racemosa Vent.
(Ericaceae)

"about the size of a pigeons egg" engaged in predatory activity, the prey being a "large fat bumble bee." He compares the method of hunting by the spider with that of a Seminole when hunting deer, "advancing with slow steps obliquely, or under cover of dense foliage." The bee is finally caught and after fifteen minutes of struggle is exhausted and expires, becoming a feast for the spider. Bartram completes the sequence by commenting that the spider "perhaps before night became himself, the delicious evening repast of a bird or lizard" (xxx–xxxi). Bartram saw animals and some plants as intelligent beings, and in describing such qualities he uses analogy in order to demonstrate the correlation between organisms. The use of analogy with human behavior is Bartram's attempt to reduce the gradation in the chain of being and bring uniformity to the universe by emphasizing the idea that different segments in the chain reflect other segments. His view of nature is much more egalitarian than the standard hierarchical structure.

The Chain of Being theory implied completeness and continuity, where everything had its place and there was no allowance for new species or extinctions. Neither William nor his father could accept this. Their understanding of the natural world in geological terms told them that this was unlikely. William reports of fossil oyster shells as being ancient and antediluvian, and both men feared for

particular species that were being hunted and driven from their natural habitat and recognized the possibilities of future extinctions by causes other than divine intervention. John Bartram wrote to Michael Collinson, Peter's son, in 1773 concerning his fears of the possible extinction of the rattlesnake, beaver, and even the Native American.[11]

In both his drawings and writings, Bartram reveals the relationship between living organisms and the world around them. The Linnaean method of taking species out of context of place and time and fixing them in recognizable categories also applied to botanical and zoological drawings. For many years various friends from Collinson to Barton had encouraged Bartram to use the Linnaean method for drawing and describing plants. He knew that to gain scientific recognition for the discovery of his plants, he had to apply the Linnaean method of description. It is for this reason that he reported many of his observations in a clinical and accurate manner, through lists of plant and animal names and scientific descriptions. He had received thorough scientific training as a young man from his father and his friends—Franklin, Collinson, Colden, and others—and so found no difficulty in accomplishing this task. But such an approach did not always come to him spontaneously. Having given scientific descriptions and lists, he then elaborated on his observations, describing his own emotional response to those observations, and drawing animals and plants in context with their environment and habitat, thus providing an even richer picture.

PART FOUR

Influence

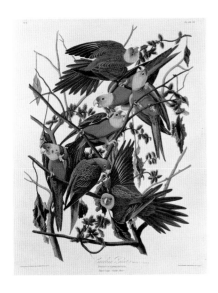

CHAPTER 10

American Science Comes of Age: Ornithology

WHEN HE RETURNED TO KINGSESSING IN 1777, William soon settled into assisting his brother John in the garden and with the seed business. By the spring of the following year, the British had withdrawn from Philadelphia, but the newly independent America remained at war with Britain until 1783, when peace was settled by the Treaty of Paris. During these years the Bartram garden fell into some "neglect." Trade with Britain was nonexistent and France had now become the major recipient of seeds and plants from America. Franklin wrote to John Bartram from Paris in 1777, "The communication between Britain and North America being cut off, the French botanists cannot, in that channel, be supplied as formerly with American seeds, etc. If you, or one of your sons, incline to continue that business, you may, I believe, send the same number of boxes here, that you used to send to England; because England will then send here, for what it wants in that way."[1] With the signing of the peace treaty, the Bartrams began to establish themselves once again and produced a catalogue of plants from their garden that included *Franklinia* and other plants from William's travels. When not cultivating the garden, William spent his time keeping the accounts for John, writing up his travels, monitoring the weather, and documenting bird migration.

The garden was a temporary haven for birds and wildlife as they passed through on their migratory routes. It also became home for many a wandering naturalist, who found a welcome beyond compare at the Bartram home. The en-

For he on honey-dew hath fed, and drunk the milk of paradise.

—SAMUEL TAYLOR COLERIDGE, *Kubla Khan*

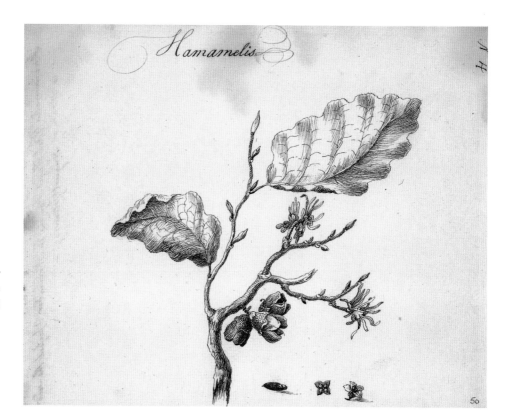

WITCH HAZEL
Hamamelis virginiana L.
(Hamamelidaceae)

couraging and stimulating conversations at meal times and the peace that pervaded the household provided them with the perfect setting to study and work. The Bartrams and the garden soon developed a reputation for receiving famous and interested people from around the world. Naturalists, travelers, and politicians, including Jefferson and Washington, all made their way to the renowned garden. Jefferson lived across the Schuylkill River on the opposite bank from 1790 to 1793 and became a regular visitor and friend to William. European naturalists included Constantine Rafinesque and the French father and son André and François Michaux. So comfortable was François at the Bartram house that during his sojourns from exploring the American wilds he would live there. Among the American naturalists who frequented the Bartram household were William Baldwin, Thomas Say, Benjamin Smith Barton, and George Ord, all of whom at one time or another became regular visitors. Each one was indebted to Bartram for his encouragement, friendship, and above all generosity in sharing his knowledge of natural history with them. The garden, the first garden of its kind in America and famous in its own right, was not visited for its beauty or exotic plants like the Hamilton garden, a few miles east of the Bartrams, but for William Bartram himself. People came to meet him, to see the man who, by the late 1790s, was recognized as the authority on the natural history of the Southeast and considered the most knowledgeable man about American birds.

One such visitor, William Dunlap, wrote that he and his friend "arrived at the Botanist's Garden, we approached an old man who, with a rake in his hand, was breaking the clods of earth in a tulip bed. His hat was old and flapped over his face, his coarse shirt was seen near his neck, as he wore no cravat or kerchief; his

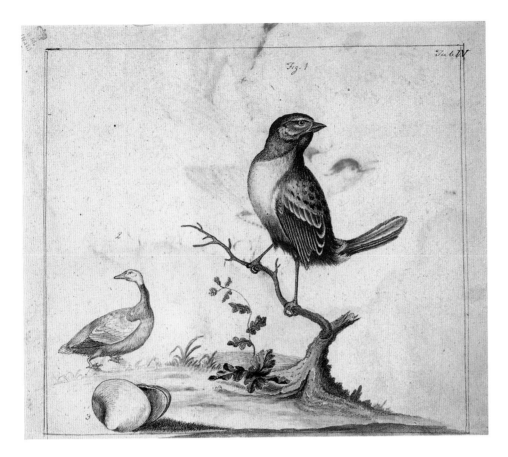

waistcoat and breeches were both of leather, and his shoes were tied with leather strings. We approached and accosted him. He ceased his work, and entered into conversation with the ease and politeness of nature's noblemen. His countenance was expressive of benignity and happiness. This was the botanist, traveller and philosopher we had come to see."[2]

William Bartram's influence on some of the key figures that shaped the study of American natural history cannot be exaggerated. One person was Alexander Wilson, the man who became known as the father of American ornithology and who produced the first work on this subject in a set of nine volumes. Like François Michaux, Wilson spent long periods living at the Bartram house, making it his home when he was not searching the country for specimens or raising subscriptions for his work.

Wilson was born in Paisley, Scotland, on 6 July 1766, but he emigrated to America in 1794 in the hope of avoiding incarceration and poverty, both of which he had experienced in Scotland. In Paisley, Wilson earned his living as a weaver but also was well known locally as a poet and musician. He was accomplished in both the violin and flute. He had a great interest in natural history and was a member of the local floral society. Wilson's politics were radical. He railed against social injustice and voiced his opinions in print through his poetry. In America he became a teacher and an assistant editor for the publication of *Rees's Cyclopaedia*. Wilson developed his interest in natural history and devised the idea of publishing an American ornithology, the first of its kind. His knowledge of American

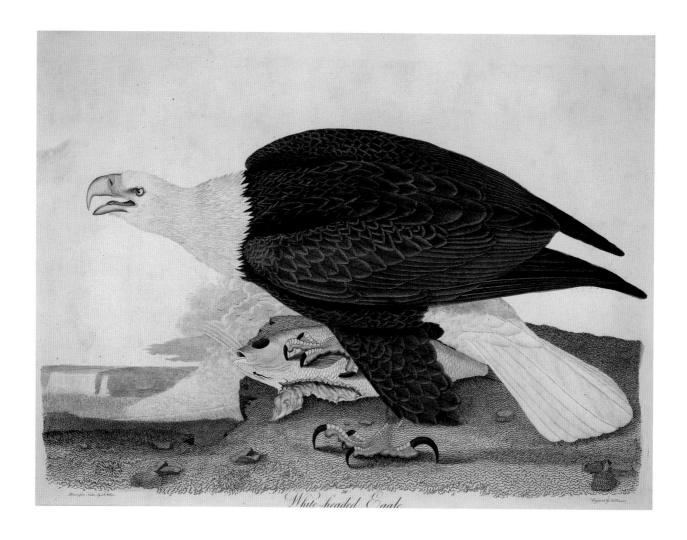

White-headed Eagle

ALEXANDER WILSON
(1766–1813)

BALD EAGLE
Haliaeetus leucocephalus
(Linnaeus)

birds was relatively poor and so he turned to William Bartram for instruction. It was also Bartram who advised him on his drawing skills and later in coloring the plates for his books. Wilson died in 1813, but by then eight volumes of *American Ornithology* had been published, and his friend George Ord published the ninth volume soon after his death. It was through this publication that Wilson earned his reputation as the father of American ornithology.

Alexander Wilson was a bright, able, and curious child and was given a relatively sound elementary education. His mother died when he was ten, and by the time he was thirteen he was apprenticed to his brother-in-law for three years to learn the weaving trade. He spent the following four years as a journeyman weaver and then attempted to improve his lot by becoming a traveling merchant, or peddler. This lifestyle suited Wilson's temperament with long tramps through the Scottish countryside, where he had time to muse over his poetry and contemplate nature. He was, however, paid very little, and he was soon forced back into weaving to supplement his income. Wilson was particularly fond of Robert Burns, the celebrated Scottish poet. Burns wrote much of his poetry in the local Scottish dialect and it was this element that was so attractive to Wilson. According to George Ord, who wrote a biography of Wilson in the introduction of volume nine of *American Ornithology*, Wilson met Robert Burns and "the

interview appeared to be pleasing to both; and they parted with the intention of continuing their acquaintance by correspondence."[3] Some of Wilson's poetry was published in the *Glasgow Advertiser*, but he first achieved notoriety with his poem "The Hollander," published in 1790. The poem is a comment on the social changes effected by the Industrial Revolution. The principal character of the poem was a local manufacturer in Paisley, one William Henry. On 10 June 1790, Henry took out a summons against Wilson for criminal libel and incitement to unrest. Wilson got off lightly in this affair and the trial, for reasons unknown, never took place. Wilson was by this time active in the radical faction of the Reform Movement in Paisley and is believed to have had a hand in writing *A Declaration of Rights and An Address to the people. Approved by a number of the Friends of Reform in Paisley.*

Another poem written early in 1792, entitled "The Shark; or Long Mills Detected," was considered more dangerous by the authorities, particularly in light of the events taking place in France. The poem was an indictment of the Industrial Revolution and took up the cause of the weavers. The attack was directed toward a local manufacturer, William Sharp, the owner of the Long Mills. An incident occurred that forced the authorities to take action. The poem was sent to Sharp with a letter demanding money. Wilson was subsequently arrested and brought to court, where he was fined and warned not to publish or distribute the poem. Wilson ignored these warnings and published the poem. As a consequence he was arrested, imprisoned, and bound over to the court for two years to keep the peace. At the same time, he was ordered to burn all known copies of the poem in the "Market Place" of Paisley. Less than a year later, in January 1794, Wilson was again arrested and accused of "framing and circulating an advertisement" and for calling a meeting of the Friends of Liberty and Reform. This charge could have found him guilty of treason and sedition and might have resulted in his death. The time had come for Wilson to take stock, and he concluded that America would be his salvation and future home.

Wilson's radical political views led him to the writings and influence of Thomas Paine. Soon after the reading public had become familiar with Paine's *Rights of Man*, Wilson wrote, "Tammy Paine the buik has penned, and lent the courts a lounder."[4] The *Declaration of Rights* from the Friends of Reform in Paisley and the Advertisement in the *Glasgow Advertiser* had strong echoes of Paine's philosophy. Although Wilson later dedicated his life to natural history, he never abandoned his radical leanings in his newly adopted country. On 4 March 1801, Wilson delivered a speech in celebration of Thomas Jefferson's election as President, "Oration on the Power and Value of National Liberty," which was later published in several newspapers. Wilson became fully committed to the newly liberated land and on 9 June 1804 he petitioned the government to become a citizen of the Republic and renounced allegiance to the "King of the United Nations of Great Britain and Ireland." He remained as much enamored with Paine in 1809, the year Paine died, as he was in 1791. Shortly before Paine's death, Wilson went out of his way to visit him in Greenwich, then a village outside New York City. Wilson wrote to Alexander Lawson of his visit. "While in New York I had

the curiosity to call on the celebrated author of the 'Rights of Man.' He lives in Greenwich. . . . I found this extraordinary man, sitting wrapt in a night gown, the table before him covered with newspapers, with pen and ink beside them . . . the penetration and intelligence of his eye bespeak the man of genius, and of the world. He . . . examined the book, leaf by leaf, with great attention—desired me to put his name as a subscriber."[5] The book that Paine was praising was a volume of Wilson's *Ornithology*. Thomas Paine died some months later in dire poverty and certainly would never have been able to afford Wilson's books, which sold for $120 a set.

Wilson set sail from Belfast for America with his sixteen-year-old nephew Billy Duncan as his companion and fellow traveler on 25 May 1794 on the ship *Swift of New York*. Throughout his life Wilson was dogged by poverty and his and Billy's arrival in Philadelphia was no exception. It was only through the kindness of a fellow passenger, who loaned him several shillings, that he managed to make his way until he found work. This work came in the form of an offer from a fellow Scot named John Aitken, a printer in Philadelphia (and possibly a relation of Robert Aitken, the printer-publisher and bookshop owner who employed Tom Paine when he first arrived in Philadelphia twenty-four years earlier). Wilson stayed only a short time with Aitken. He soon returned to his old trade of weaving and then became a peddler traveling through New Jersey. Eventually, in 1796, he moved to Milestown, some twenty miles from Philadelphia, where he took up teaching and remained for five years. In February 1802 he secured a teaching post at the Union School on the Schuylkill River at Kingsessing. It was here that Wilson first became acquainted with William Bartram. He found in Bartram a kindred spirit and the two men became lifelong friends. William Bartram became his teacher of ornithology, draftsmanship, and coloring technique, and above all was an inspiration to Wilson in his study of natural history. In a letter to Bartram in 1805 that included twenty-eight drawings of Pennsylvanian birds, Wilson states, "Criticise these, my dear friend, without fear of offending me—this will instruct, but not discourage me. For there is not among all our naturalists one who knows so well what they are, and how they ought to be represented. . . . To your advice and encouraging encomiums I am indebted for these few specimens, and for all that will follow. They may yet tell posterity that I was honoured with your friendship, and that to your inspiration they owe their existence."[6] Alexander Wilson spent a great deal of time at the Bartram house; in 1812 he wrote to François Michaux that he was "living at Mr. Bartram's," and when absent from there he wrote regularly to William requesting information and critical judgment. George Ord wrote that "Wilson resided the better part of the years 1811–12 at the Botanic Garden of his friend, Mr. Bartram."[7] Again in 1813 Wilson wrote to Bartram asking, "Will it be convenient for the family to accommodate me (as I shall be alone) this summer? Please let me know."[8]

By 1804 Wilson had decided to dedicate his life to American ornithology. To improve his collection of materials for his work, on 7 October 1804 he set out on an expedition to Niagara Falls, accompanied by his nephew Billy Duncan and a

Fig 1.
The Little Brown Marsh Sparow
of Florada
2. The grey or Brant Goose
3. Fresh water Clam of Florida

BLUE JAY
Possibly *Cyanocitta
cristata* (Linnaeus)

FLORIDA SCRUB JAY
Possibly *Aphelocoma
coerulescens* (Bosc)

young man named Isaac Leech. Nothing is known of Leech apart from the reference to him in Wilson's epic poem *The Foresters,* which tells of the travels by the three men. However, it is likely that Isaac was a member of the Leech family at Kingsessing, immediate neighbors of the Bartrams and related to William Young, Queen's botanist and rival of John Bartram. William Young's sister Ann Christiana married John Leech in 1753. They had six children, one of whom was named John. In 1786 this John Leech, William Young's nephew, bought the property at Kingsessing and continued to farm it. It is presumed that Isaac was related to this John Leech. Wilson was certainly well acquainted with the Leech family and mentions them several times in his letters. He also indicates that Mary Leech and William Bartram's niece, Nancy, were friends. "I have a request to make to Miss Bartram," he wrote to William. "We want well-coloured Specimens of the plates to be sent to Boston Charleston New York etc. . . . I have presumed to apply to her to colour the . . . impressions. Perhaps Mary Leech might be set to some parts of them with safety which would lesson the drudgery."[9] It is also possible that the family Wilson visited on the day of his return from his two-month trip to Niagara Falls was the Leech family. "The evening of my arrival I went to L———h's."[10] Here the wife of this friend had given birth to twins, a boy and a girl. The boy was named after Wilson, and he was so honored by this that he gave them a gift of his last six dollars for the child.

The journey to Niagara Falls began when the "three cheerful partners" set off from the banks of the Schuylkill River:

The sultry heats of Summer's sun were o'er,
And ruddy orchards poured their ripened store;
Stripped of their leaves the cherry av'nues stood,
While sage October ting'd the yellow wood.[11]

Alexander Wilson and his two companions covered about twelve hundred miles, mostly on foot. Wilson also added some important specimens to his collection, a few of which had not previously been identified. "I shot three birds of the Jay kind, all of one species, which appears to be undescribed. Mr. Bartram is greatly pleased at the discovery."[12]

Back at Kingsessing, William Bartram continued to educate Wilson in ornithology, but Wilson also received lessons in drawing from an engraver and fellow Scot, Alexander Lawson. It was to Lawson that Wilson first suggested the publication of *American Ornithology*, but Lawson considered it too expensive a venture. In April 1806, Wilson took a post as assistant editor of a new edition of *Rees's Cyclopaedia*. The publisher and editor was Samuel Bradford. Wilson approached him about publishing his work, and Bradford agreed to publish two hundred sets if Wilson would raise an equal number of subscribers for the work. Finding such subscribers was no easy task and Wilson traveled throughout the country seeking support for *American Ornithology*. There were unexpected and encouraging moments, such as unsolicited orders and one from Thomas Jefferson on 9 October 1807, on which Jefferson had written, "He salutes Mr. Wilson with great respect."[13]

The first volume of *American Ornithology* was published in 1808, and for the next five years Wilson traveled to every state searching for new birds to describe and for new subscribers. This was grueling work as much of the traveling was on foot. The effort involved and the hardship he endured probably contributed to his early death in 1813. In his last letter to Paisley, he mentioned that he was "far from being in good health. Intense application to study has hurt me much."[14] Among those he visited during this time was Thomas Jefferson at the President's House in Washington, where he was warmly received and given letters of recommendation. During the course of his travels he built up a correspondence with people who were reliable sources concerning the birds of their region. He wrote to a friend that "scarcely a wren or tit shall be able to pass along, from New York to Canada, but I shall get intelligence of it."[15] One of his correspondents was John Abbot, an Englishman who settled in Georgia and who was well known for his drawings of birds and insects. As a young man he was one of a small army of naturalists who had supplied drawings to John Fothergill. Abbot now became one of Wilson's major suppliers of specimens and drawings over the next four years.

Much of the last seven years of Wilson's life, when he was not traveling to collect specimens, seeking subscriptions, and drawing birds, was spent in the Bartram household. The garden, which Wilson described as "your little paradise" in a letter to Bartram, was the focus for many well-known visitors. Wilson befriended many of them, François Michaux being one; Wilson was able to provide letters of recommendation for some of Michaux's travels. Weather permitting, Wilson and Bartram would conduct day excursions into the woods around Kingsessing

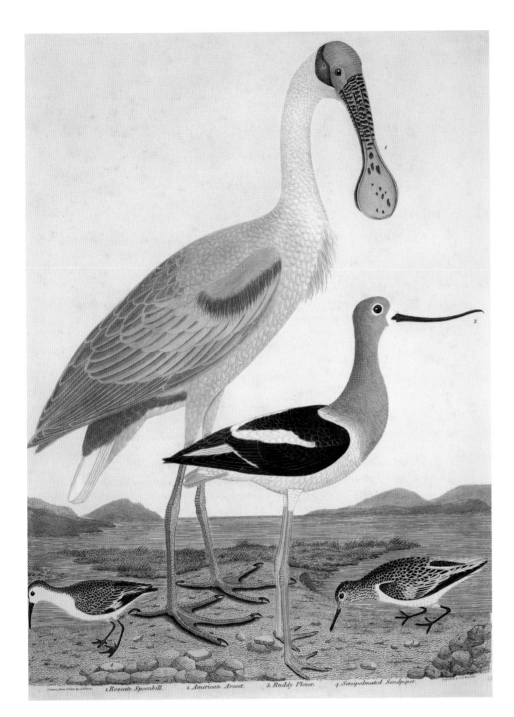

ALEXANDER WILSON
(1766–1813)

ROSEATE SPOONBILL
Ajaia ajaja (Linnaeus)

in search of birds, "I believe we had better put off our intended Jaunt untill some more auspicious day:

> *Cloudes, from Eastern regions driv'n,*
> *Still obscure the gloomy skies;*
> *Let us yield since angry Heav'n*
> *Frowns upon our enterprise."*[16]

The note ends by Wilson telling Bartram that he shall "call up" and see him that same evening.

Wilson relied not only on Bartram for his knowledge of birds but also on Ann Bartram, William's niece (whom the family called Nancy), for her drawing skills. Nancy Bartram had been tutored by her uncle William in drawing and was instrumental in the coloring of Wilson's plates for the early volumes. She was also an excellent botanist. The Scottish plant hunter David Douglas, after whom the Douglas Fir is named, visited the garden in 1823 and wrote that William Bartram's "niece is a considerable botanist and draws well."[17] One of Nancy Bartram's drawings was completed to illustrate an article William had written on a species of *Certhia*. From some of his letters and poetry it has been suggested that Wilson held a particular affection for Nancy, but this is only speculation since there is no firm evidence of such an attachment. Wilson was fond of several women throughout his lifetime and bitterly lamented his bachelorhood. In writing to an old friend from Paisley, he describes a May morning in which he observed the trees, birds, horses, sheep, and insects "cheerfully engaged in fulfilling that great command, 'Multiply and replenish the Earth.'" He saw all nature preoccupied with finding companions—all except himself. He went on to ask, "Is it not criminal to persist in a state of celibacy? And how comes it, that those whom science allures in her train, and whose hearts are most susceptible of the finer feelings of the soul, are so forgetful of this first and most exquisite of all human enjoyments."[18] Wilson had not yet met with William Bartram, but the sentiments he expressed in this letter may well have been written for both men. Like Bartram, Wilson never married and as far as it is known never achieved his great desire to be the father of "at least one of my own species." It was at times such as this, when Wilson was feeling low, that he would venture into the woods to observe nature and play his violin or flute. Romantic love had not abandoned Wilson completely, but it came too late in life. Before his death he had become attached to Sarah Miller, a relation of his landlord, and to whom he left in his will some very little money and his few belongings together with the rights to his published volumes.

It was Wilson who introduced Robert Carr, his printer, to the Bartrams, and Nancy soon became enamored of Carr. With Carr printing the plates and Nancy coloring them, it was not long before a romantic affection developed between the two, and in 1809 they were married. Wilson was traveling at the time and did not attend the wedding but sent his good wishes to the happy couple. Carr came to live at the Bartram house with Nancy, and her uncle William became very fond of him. In a gift to Carr of one of his books, William Aiton's *Hortus Kewensis*, he inscribed the following, "A present for Coll. Robert Carr from his affectionate friend and relative William Bartram, 1819." In 1812, with the approaching hostilities between Britain and America, Carr had successfully petitioned for a commission in the army and thereby earned his title of colonel. Robert Carr and Nancy inherited the garden and seed business from Nancy's father and continued to make a living from it. On his visit to the garden in 1823, David Douglas compared Nancy's accomplished botany to that of Carr's, who had "but a moderate share of knowledge; this deficiency, however, is made up by his pleasing manner."[19]

Wilson soon became active in the scientific community in Philadelphia, having been introduced by Bartram to some of its more prominent members, such as

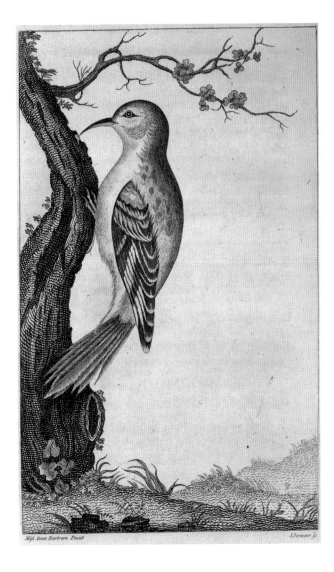

ANNE (NANCY)
BARTRAM (1779–1858)

BROWN CREEPER
Certhia Americana
Bonaparte

Benjamin Smith Barton and Charles Willson Peale, the founder of the first natural history museum in America. In 1804 one of the highlights of the year for this community was the visit of Alexander von Humboldt and his traveling companion, Aimé Bonpland, on their return journey from South America to Paris. Described by Darwin as "the greatest scientific traveller who ever lived," Humboldt spent six weeks in the United States, shared between Philadelphia, Washington, and Thomas Jefferson's home at Monticello. In a letter to Henry Muhlenberg of Lancaster, Humboldt mentioned that "we saw the Hamilton garden with astonished delight."[20] This was the famous "Woodlands" of William Hamilton, a wealthy Philadelphian who went to great lengths to obtain plants from all over the world. "The Woodlands" was considered by all as the most splendid of gardens of its time in North America. Thomas Jefferson described the grounds as "the chastest model of gardening which I have ever seen out of England."[21] There is no mention of Humboldt visiting the Bartram garden during his four-week stay in Philadelphia, but having already achieved celebrity status and being only a few miles from The Woodlands, it is unlikely that Humboldt passed it by. Further, in the same letter to Muhlenberg, Humboldt asked to be remembered to William

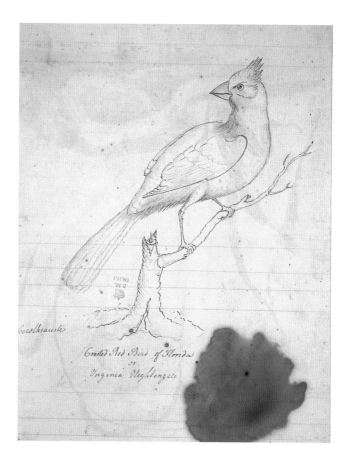

FLORIDA CARDINAL
Cardinalis cardinalis flori-danus Ridgeway

Barton. The explanation given as a footnote in Ewan's reproduction of this letter believes it to be William P. C. Barton, Benjamin Barton's nephew. This is unlikely, as he was only seventeen at the time of Humboldt's visit and was studying at Princeton University, and it is doubtful that he met the great man. It is more likely that either Humboldt or the transcriber of the letter has made a mistake and it was in fact to William Bartram that Humboldt sent his regards.[22] What is known is that a dinner was organized in Humboldt's honor at Peale's Museum and, according to the Reverend John Bachman of Charleston, who attended the dinner, also present were "the two Bartrams, Wilson, the ornithologist, Lawson, his engraver, George Ord and a few others."[23]

In nearly every aspect, *American Ornithology* was completely American. Everything from the ink and paper (and even the rags to make the paper), to the engraver, printer, and publisher were American. The only exception, as Wilson pointed out, was "the colors." He stated that it was "not without regret and mortification . . . that for these he has been principally indebted to Europe." He expressed his confidence in the "exertions of other intelligent and truly patriotic individuals, in the divine science of chemistry" that would lead him as author soon to be "completely independent of all foreign aid."[24] Wilson made a conscious effort to elevate all things American. Science, culture, and manufacturing were to be raised to equal rank with those of any European country. In natural history he was the continuum from Jefferson and Bartram, refuting the allegations made by European naturalists, and he was eager to escape from the reliance on Europeans to describe and

identify American species. Wilson was one of the foremost exponents of American identity in natural science writing. He advocated a national culture in the arts and sciences developed by and for Americans. This theme, which he first espoused in his proposal for publication of his *Ornithology*, ran throughout all his volumes and he expresses it directly in the preface to volume five, when he acknowledges his gratitude to the engravers, the founders of the letter press, the printers, and even "the unrivalled excellence of the paper, from the manufactory of Mr. Amies, proves what American ingenuity is capable of producing when properly encouraged. Let but the generous hand of patriotism be stretched forth to assist and cherish the rising arts and literature of our country, and both will most assuredly, and that at no remote period, shoot forth, increase and flourish with a vigor, a splendor and usefulness inferior to no other on earth."[25]

Wilson recognized his work as something new in American natural history; the content and the format of the work were to be quite different from anything that had preceded it. He described it as a "transcript from living nature" in which the engraved plates would be far superior to anything previously published and "coloured from nature with the most scrupulous adherence to the true tints of the original."[26] Wilson explained that the only previous works on American ornithology had been "the considerable list of our birds," some 109 species, in Jefferson's *Notes on the State of Virginia*, published in 1787. "The next, and by far the most complete that has yet appeared, was published in 1791, by Mr. William Bartram, in his 'Travels' in which 215 different species are enumerated and concise descriptions and characteristics of each added, in Latin and English."[27] Wilson's own work finally included 262 drawings of birds, of which 39 were new to science. In his introduction he noted that Europeans had introduced numerous errors concerning the birds of America and his work included corrections to some further 23 species.[28] As well as correcting the errors in the descriptions and identification of species, he also discredited the suppositions and conjectures made by some European naturalists about these birds. His style of writing was blunt and to the point, and he did not hesitate to express his indignation and "disgust" at some of the assumptions made about American birds. He stated that "novelty of fable, and the wildness of fanciful theory, are frequently substituted for realities." He believed that "Prejudice" had united with its parent "Ignorance" in treating with contempt "the whole interesting assemblage of the feathered tribes of this vast continent." Wilson expressed frustration with those naturalists whose only contact with the birds of America, he believed, was from the "stuffed cabinets of the curious, and among the abstruse pages and technical catalogues of dry systematic writers."[29]

Concerning the Gold-winged Woodpecker, *Picus auratus*, Wilson had this to say: "Some European naturalists (and among the rest Linnaeus himself) have classed this bird with the genus Cuculus, or Cuckoo . . . every one of which assertions I must say is incorrect, and could have only proceeded from an entire unacquaintance with the manners of the bird . . . while neither in the form of their body, nor any other part, except in the bill being somewhat bent, and the toes placed two before and two behind, have they the smallest resemblance whatever to the cuckoo."[30]

Wilson discussed the claims made by one of the most influential European naturalists, the Comte de Buffon. In describing the Woodpeckers and their habitat, appearance and behavior, Wilson derided Buffon, stating, "The abject and degraded character which the count de Buffon, with equal eloquence and absurdity, has drawn of the whole tribe of Woodpeckers, belongs not to the elegant and sprightly bird before us. . . . It is truly ridiculous and astonishing that such absurdities should escape the lips or pen of one so able to do justice to the respective merits of every species; but Buffon had too often a favourite theory to prop up that led him insensibly astray; and so, forsooth, the whole family of Woodpeckers must look sad, sour, and be miserable, to satisfy the caprice of a whimsical philosopher."[31] Wilson's attack on Buffon became more serious when he discussed the Wood Thrush (*Turdus melodus*). He started by praising his friend William Bartram, who named the bird and whom Wilson believed was "the first and almost only naturalist who has taken notice of the merits of this bird." He goes on to correct earlier authors such as Sir Hans Sloane, Mark Catesby, and George Edwards for their descriptions and for thinking that the bird was songless, and concluded that none had in fact described the correct bird. "Mr. William Bartram, who transmitted this bird, more than fifty years ago, to Mr. Edwards, by whom it was drawn and engraved, examined the two species in my presence; and on comparing them with the one in Edwards, was satisfied that the bird there figured and described is not the Wood Thrush."[32]

Buffon had made his own account of the bird from the works of Catesby and Edwards, and he too claimed the bird had no song but only a single cry or scream. Buffon's argument for the bird's want of song was that "the Song Thrush of Europe (Turdus Musicus) had, at some time after the creation, rambled round by the Northern ocean, and made its way to America; that advancing to the south it had there (of consequence) become degenerated by change of food and climate, so that its cry is now harsh and unpleasant 'as are the cries of all birds that live in wild countries inhabited by savages.'"[33] Wilson decried this as a "fanciful theory" and clearly took delight in correcting such views, dedicating several pages to describing the melodious notes of the bird and even quoting a letter from Jefferson, who claimed that it "perpetually serenades us with some of the sweetest notes, & as clear as those of the nightingale."[34]

In August 1809, Wilson wrote to Bartram: "The second volume of 'American Ornithology' being now nearly ready to go to press, and the plates in considerable forwardness, you will permit me to trespass on your time."[35] It was not published until 1810 and by then the number of copies had risen to five hundred. Each volume contained nine plates and this meant that forty-five hundred plates had to be colored by hand. One of the major problems throughout the production of all nine volumes was that of plate coloring. By 1813 Wilson was becoming worn out and he wrote to Bartram that "I have been extremely busy these several months, my colourists having all left me."[36] Wilson now had to complete most of the work himself. George Ord wrote that Wilson had suffered great anxiety on this account and that "one of his principal difficulties, in effect, was the process of coloring."[37]

1. *Turdus Melodus*, Wood Thrush. 2. *Turdus. Migratorius*, Redbreasted Thrush, or Robin . 3. *Sitta Carolinensis*, White breasted black-capped Nuthatch. 4. *Sitta Varia*, Red-bellied-black-capped Nuthatch.

ALEXANDER WILSON
(1766–1813)

WOOD THRUSH
Hylocichla mustelina
(J. F. Gmelin)

The year 1810 saw Wilson set out once again in search of subscribers and specimens. This time he ventured into the hinterlands across the Allegheny Mountains to the Ohio River. From there he purchased a small skiff, named it the *Ornithologist*, and set off down the river on 24 February. He arrived in Louisville, Kentucky—a journey of some 720 miles—on 17 March. Here he sold the "skiff for exactly half what it cost me; and the man who bought it wondered why I gave it such a droll Indian name."[38]

A resident of Louisville at the time was John James Audubon, a man who came to rival Wilson in his knowledge of birds, and surpass him as an artist. Audubon

ALEXANDER WILSON
(1766–1813)

PASSENGER PIGEON
Ectopistes migratorius
(Linnaeus)

1. *Passenger Pigeon.* 2. *Blue mountain Warbler.* 3. *Hemlock W.*

lived at the Indian Queen Tavern, where Wilson boarded during his short stay in Louisville. George Ord relied on Wilson's own diary for the short biography that he wrote, a diary that regrettably has not been seen since. Ord quoted from the diary that Wilson had seen some of Audubon's drawings in crayon and thought they were very good. Wilson also mentioned that he went out shooting the afternoon of 21 March and "with Mr. A. saw a number of sandhill cranes." Wilson then continued to write, "I bade adieu to Louisville, to which place I had four letters of recommendation, and was taught to expect much of everything there; but neither received one act of civility from those to whom I was recommended, one subscriber, nor one new bird. . . . Science or literature has not one friend in this place."[39] In a letter to Lawson he claimed, "Every man here is so intent on making of money, that they have neither time nor disposition for improvements."[40]

Jean-Jacques Audubon, who later anglicized his name to John James, was born in Les Cayes, Santo Domingo, now Haiti. His mother, Jean Rebin, described as a "Creole woman of Saint Domingue," was the mistress of Jean Audubon, a French sailor, merchant, plantation manager, and dealer in slaves. At the age of four, Audubon's father returned to France, taking his son with him, where he was raised by his father's wife as one of her own children. In 1803 Audubon returned to the Americas and settled in the United States, where he spent some twenty years struggling to make a successful business of one kind or another before devoting himself fully to his production of bird portraits. Many of his business ventures ended in financial disaster for himself as well as others. Two who suffered as a consequence of Audubon's poor financial dealings was the English poet John Keats and his brother George, who had invested his own (and some of his brother's)

money in one of Audubon's schemes. Audubon had persuaded George Keats to invest in a Mississippi steamboat, but nothing ever came of the investment except bankruptcy for six of Audubon's partners. Keats wrote to his brother, "I cannot help thinking Mr. Audubon a dishonest man. Why did he make you believe him a Man of Property?"[41] Like his great rival Alexander Wilson, the entomologist Thomas Say, and William Bartram, Audubon was a poor businessman primarily because his focus was elsewhere. All of these men immersed themselves in natural history and were always looking to discover new species in unexplored territories of wilderness. Natural history and business were rarely a profitable combination.

Audubon is considered one of the greatest artists of birds, famous for his double elephant volumes of life-size portraits of American birds published between 1827 and 1838. The plates are magnificent not only for their size and technique but also because Audubon attempted to get away from the traditional "magpie and stump" manner of portraying birds motionless and in profile. In his published works Audubon broke new ground with his plates. Wilson and the bird artists before him, from Catesby to Edwards, Thomas Pennant, and even Audubon's friend William MacGillivray, with only a few exceptions, drew the bird suspended, as if glued to a branch or plant. Audubon set his birds in a background of their own habitat and imbued life into his drawings by depicting them in motion, flying, and in active poses. Audubon's drawings tower over Wilson's, who was never an accomplished artist and who set many of his birds without any background at all. William Bartram, however, predated Audubon with his drawings of birds in flight and in their natural surroundings. His drawings had of course not been published, but many of Bartram's subjects capture the same verve that Audubon's did. He animated the bird by depicting it in flight or in the act of devouring some other living creature. Likewise, in his *Birds of America,* with life-size images of birds, Audubon portrays many in the act of pursuing or killing their prey. Bartram, more than fifty years earlier, was conveying these themes in his drawings.

Bartram was one of the pioneers of the study of birds of America. His observations were far more thorough than most during the eighteenth century. His descriptions included not just the physical appearance of the birds but their feeding and nesting habits, their songs, and above all the subject of migration. His writing on this subject in *Travels* surpasses anything that had been written on American birds before then. His observations, which he conducted for much of the remainder of his life, probably qualified him as the greatest living ornithologist of his time. Bartram understood the importance of observation. He argued that in order to comment on the migration of birds it was essential to observe them over an entire year in the various climates from north to south, and that this could only be achieved by traveling. As recently as the late nineteenth century, scientists still believed in the hibernation of swallows, a theory that Bartram had rejected early in his life. The idea that swallows hibernated in lakes and rivers at the approach of winter, one that Linnaeus himself subscribed to, was dismissed by Bartram as lacking "reason or common sense" (285). Not only did Bartram have a great understanding of bird habitat and behavior, but he was also an excellent artist of birds and well practiced in the skinning and preservation of specimens in prepara-

JOHN JAMES AUDUBON
(1785–1851)

CAROLINA PARAKEET
Conuropsis carolinensis
(Linnaeus)

tion for mounting. "Thanks for your bird, so neatly stuffed, that I was just about to skin it,"[42] wrote Wilson to him in 1809. By this time William had been drying, stuffing, and drawing birds for over fifty years.

Audubon claimed that his artwork was drawn from nature, using living specimens, as did Wilson: "No drawings have been or will be made for this work, from any stuffed subjects, where living specimens of the same can be procured."[43] Neither of these claims is absolutely true, as Wilson sometimes and Audubon nearly always used skins, stuffed or dead specimens, albeit wired into lifelike positions. Nevertheless, both men were field naturalists, or what Audubon called "practical ornithologists," who had intimate knowledge of the birds they drew and described, unlike many of the "closet naturalists" they both disparaged.

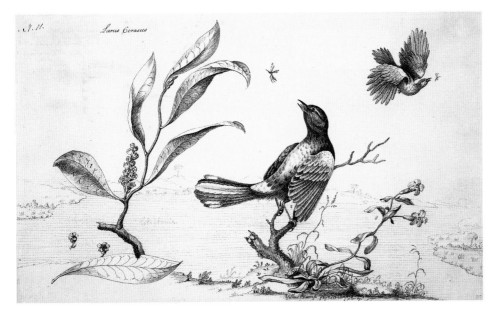

CAROLINA CHERRY
LAUREL
Prunus caroliniana Aiton
(Rosaceae)

MYRTLE WARBLER
OR YELLOW-RUMPED
WARBLER
Dendroica coronata
(Linnaeus)

FIRE PINK
Silene virginica L.
(Caryophyllaceae)

In 1831 Audubon published the first of five volumes of *Ornithological Biography*. Included in this edition was an account of his meeting with Alexander Wilson in Louisville. Audubon stated: "One fair morning, I was surprised by the sudden entrance into our counting-room of Mr. Alexander Wilson, the celebrated author of the 'American ornithology,' of whose existence I had never until that moment been apprised. . . . He, however, immediately proceeded to disclose the object of his visit, which was to procure subscriptions for his work. He opened his books, explained the nature of his occupations, and requested my patronage. . . . I . . . had already taken a pen to write my name in his favour, when my partner rather abruptly said to me in French, 'My dear AUDUBON, what induces you to subscribe to this work? Your drawings are certainly far better, and again you must know as much of the habits of American birds as this gentleman.' . . . I did not subscribe to his work, for, even at that time, my collection was greater than his."[44] In the fifth volume of this work, Audubon asserted that when Wilson visited him in Louisville he found "in my already large collection of drawings" a figure of the Small-headed Flycatcher, *Muscicapa minuta*, "which being at that time unknown to him, he copied and afterwards published in his great work."[45] Wilson had been dead nearly twenty years, but such remarks did not go unnoticed by his friends. Both George Ord and Charles Waterton became vociferous defenders of Wilson and turned the tables by accusing Audubon of plagiarism. A number of commentators, including Clark Hunter, editor of Wilson's letters, and F. H. Herrick, biographer of Audubon, have demonstrated that certain images from Audubon's work are "strikingly similar" to birds illustrated in Wilson's *American Ornithology*. Wilson's image of the Gold-winged Woodpecker, the Red-winged Starling, and the Mississippi Kite are just some that have clearly been copied either by Audubon or his engraver, Robert Havell. Audubon denied any influence from Wilson, but, without doubt, he used Wilson's work as a sourcebook and failed to give credit where credit was due. To have pretended that it was Wilson who had done the copying was disingenuous.

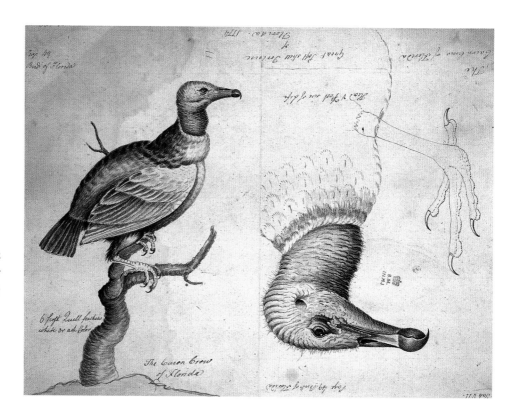

BLACK VULTURE
Coragyps atratus
(Bechstein)

Audubon was not only critical of Wilson but also of William Bartram, exclaiming that Bartram's descriptions of his travels in the southeastern states were exaggerated. When Audubon visited the region in 1832, he was disenchanted with it. In writing to his wife, Lucy, he described it as "a wild and dreary and desolate part of the World. . . . My account of what I have or shall see of the Floridas will be far, very far from corroborating of the flowery sayings of Mr. Barton [Bartram] the Botanist."[46] In describing the flora and fauna of Florida, he declared that the "representations given of it by MR. BARTRAM and other poetical writers, were soon found greatly to exceed the reality."[47] He further criticized Bartram for his comments on the American Coot and the Wood Ibis, believing that Bartram had misidentified the one and had few opportunities in studying the other. Forty years span the publication of *Travels* and Audubon's visit to Florida; nevertheless, it was Bartram's book that Audubon used as a guide. Audubon was not the first or last to consider that Bartram embroidered his tales, but most naturalists who have taken the time and effort to retrace Bartram's journey have validated his descriptions. The remarks by Audubon and the ensuing controversy between Wilson and Audubon supporters all occurred after the deaths of both Wilson and Bartram. This was just as well, as neither of these men would have been a willing party to such an unpleasant dispute.

Wilson spent an unsuccessful five days in Louisville and from there traveled to Lexington, Kentucky, and Nashville, Tennessee, and then on to the Mississippi region where he visited the site of the death in 1809 of Meriwether Lewis, of the Lewis and Clark Expedition. Wilson had become friends with Lewis in Philadelphia through their mutual involvement in Peale's Museum, to which each con-

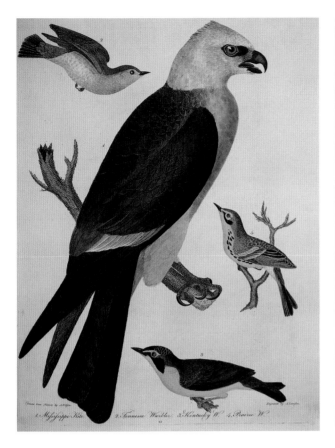

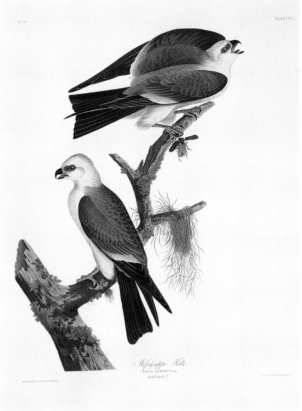

tributed specimens. Wilson sometimes used the museum as a studio. Lewis made
available to Wilson the specimens he collected during his expedition with Clark
in 1804–6 along the Missouri to the mouth of the Columbia River in the Oregon
Country. Surprisingly, there were only three new bird specimens from this expe-
dition. Wilson drew and named them and placed them together on the same plate
in volume three of his *Ornithology*.

 Not all the towns Wilson visited were as disappointing as Louisville. He man-
aged to raise as many as fifteen subscribers in Lexington alone. However, the
overall experience of his travels in the South and West were clouded by what he
described in his journal as "Damned, damned slavery," the "one infernal custom
which the Virginians have brought into this country."[48] When writing to Sarah
Miller about the beating his landlady dealt her slave, he said that his "heart sickens
at such barbarous scenes."[49]

 Throughout 1811 and 1812, Wilson continued to make excursions despite
his deteriorating health. On some of the local day excursions, William Bartram
would be his companion, while for at least two longer journeys to Cape May,
New Jersey, George Ord was his fellow traveler. The year 1812 also saw Wilson
elected to the American Philosophical Society, something he was proud of as it
confirmed his place among American scientists and acknowledged his contribu-
tion to the intellectual development of the country. In 1813 Wilson made his last
excursion to Great Egg Harbor, New Jersey, with George Ord and remained
there for four weeks collecting material for the eighth volume. Ord relates in

(LEFT)
ALEXANDER WILSON
(1766–1813)

MISSISSIPPI KITE
Ictinia mississippiensis
(Wilson)

(RIGHT)
JOHN JAMES AUDUBON
(1785–1851)

MISSISSIPPI KITE
Ictinia mississippiensis
(Wilson)

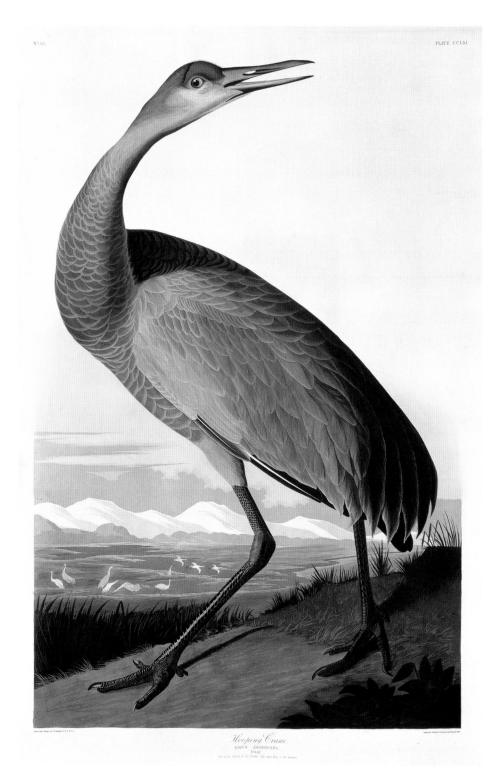

JOHN JAMES AUDUBON
(1785–1851)

SANDHILL CRANE
Grus Canadensis
(Linnaeus)

his biography of Wilson that by August, Wilson "had succeeded in completing the letter-press of the eighth volume, though the whole of the plates were not finished. But unfortunately his great anxiety to conclude the work, condemned him to excess toil, which, inflexible as was his mind, his bodily frame was unable to bear. . . . The dysentery, after a sickness of ten days, closed the mortal career of Alexander Wilson, on the twenty-third of August 1813."[50] It was Ord who

ALEXANDER WILSON
(1766–1813)

LEWIS'S WOODPECKER
Melanerpes lewis
(G. R. Gray)

WESTERN TANAGER
(LOUISIANA TANAGER)
Piranga ludoviciana
(Wilson)

CLARK'S NUTCRACKER
(CLARK'S CROW)
Nucifraga columbiana
(Wilson)

completed the publication of Wilson's work with the final, ninth volume in 1814 together with a short biography of his friend. He devoted much of his life to promoting Wilson's work, bringing out a new edition in 1824–25, and was one of his fiercest defenders when he came under attack from Audubon and his supporters. There is no mention anywhere of William Bartram's reaction to the death of his friend and protégé, but it can only be imagined that he felt the loss severely.

Wilson and his mentor, William Bartram, belonged to the old school of scientists that studied nature in all its forms. They understood Linnaean classification, but they were primarily field naturalists who observed the appearance and behavior of species in their natural habitat. Men such as Wilson and Bartram were not privy to the academic discipline and training that a university education provided. They were men who learned much of their science through experience in the field, through traveling in the wild and observing nature in its living environment. These activities made them excellent observers of nature. Wilson believed this was the true way of instruction in natural history and expressed these sentiments in his published work. He claimed he had turned a thousand times from the "barren and musty records" of the systematic writers with a "delight bordering on adoration, to the magnificent repository of the woods and fields."[51] These men were more than natural scientists; they were also artists and poets, and they were the link between such amateur naturalists as Cadwallader Colden, John Bartram, and Benjamin Franklin and the professional naturalists of the nineteenth century, such as Thomas Say and Constantine Rafinesque. By the nineteenth century,

science was emphasizing systematic classification as a basis for the study of ideas about origin, relationships between species, and evolution itself. Now in America, as in Europe, by the early decades of that century systematics and taxonomic classification had become the dominant trends adopted by younger scientists. They were helped by the circumstances of the new Republic and the desire and need to establish an independent scientific community involved in naming, classifying, and describing American species. The mood of nationalism prompted a more disciplined and systematic study of natural history. Jefferson and Bartram's work set the trend for others to follow and establish American science through American expertise. Wilson was most determined to stamp the American seal on his work and the naturalists who continued this trend were emphatically patriotic. Among them was Thomas Say, a man who became known as the father of American entomology.

American Science Comes of Age: Entomology

"THE BOTANICAL ACADEMY OF PENNSYLVANIA" was the name William and his brother John Bartram gave to their garden. Their motivation came from the many visits by naturalists from around the world and by Benjamin Smith Barton, professor of Materia Medica at the University of Pennsylvania, who brought his students to the garden for botanical lessons. Nevertheless, Philadelphia still did not have a Learned Society devoted to the natural sciences in the opening years of the nineteenth century. This deficiency was rectified in 1812, when the Academy of Natural Sciences was founded by a group of Philadelphia scientists that included Thomas Say. Say was born in Philadelphia in 1787. His father, Benjamin Say, had married the daughter of Ann Bartram, William Bartram's sister, thereby making William the great-uncle of Thomas Say. Thomas's mother died when he was six and his father remarried two years later. The Say family, like the Bartrams, had arrived in Philadelphia in the 1680s from England and, like the Bartrams, were members of the Society of Friends. Thomas's father and grandfather, also Thomas, were both doctors and ran apothecary shops. It was Thomas Say Sr. whom William's brother Isaac joined as a partner in the shop in 1756. Thomas Say Jr. attended the local Quaker school as a young boy and at the age of twelve was sent to Westtown, the Quaker boarding school some twenty miles from Philadelphia, where he remained for three years. His recollections of these years are ones of unhappiness and throughout his life he

Oh but we went merrily.

—LORD BYRON, "SIEGE OF CORINTH, PROLOGUE"

maintained a great dislike of the school and of his schooling as a whole. This feature was one that no doubt influenced his views on education in his later life. At fifteen, he joined his father in the apothecary shop while also taking courses in medicine at the University of Pennsylvania. By 1812 he had formed a partnership with a fellow Quaker, John Speakman, in an apothecary business.

Biographers have described Say as modest, selfless, and thoughtful of others. His name was "synonymous with honour," according to George Ord. Many paid tribute to his generosity toward others in sharing his knowledge and time without seeking credit or fame. In this he was similar to his great-uncle, William Bartram. Other aspects of Say's life mirrored those of his great-uncle. Like Bartram, Say was not only a poor businessman, with several of his financial ventures ending in ruin, but he also was disdainful of wealth. Neither man was comfortable with his own father's eagerness to prosper, and both lived very frugal lives. Say's grandfather and father were both successful doctors and his father, Benjamin, became one of the wealthiest men in Philadelphia during his lifetime through income from his real estate. By his mid-twenties Say had made the decision to devote himself to his first and overwhelming love, the study of nature. His particular interest lay in the study of insects, and in 1817 he wrote to his friend John Melsheimer, "You will see in the 'Journal' that I have been describing the Crustacea of our waters; but my dear Sir I assure you that Shells and Crustacea are but secondary things with me, INSECTS are the great objects of my attention. I hope to be able to renounce everything else and attend to them only."[1]

There were two major influences in Say's formation that led him to study natural history. The first was his regular visits to his great-uncle and the Bartram garden. Say was not the first to fall under the inspiration of William Bartram, nor would he be the last. Jacob Gilliams, one of the founding members of the Academy of Natural Sciences, became a regular visitor with Say to the Bartram garden "about the time (1808)," and attributed "his love of nature mainly to the influence of those visits."[2] The second influence on Say was Charles Willson Peale's museum in Philadelphia. Peale was a portrait artist by profession who had painted most of the political figures in postrevolutionary America as well as those involved in the sciences. Franklin, Jefferson, Thomas Paine, and William Bartram all sat for Peale at some stage. When Humboldt visited Philadelphia in 1804, Peale painted his portrait and provided his museum for the celebratory dinner. Peale's philosophical outlook was guided by Jean-Jacques Rousseau and he brought up his large family on the principles promulgated in Rousseau's *Émile*. His interest in natural history stemmed from such ideals. In 1784 Peale was asked to draw some mastodon bones given him by a Hessian doctor. These bones initiated the idea of creating a museum of natural history. For the next five years Peale worked on transforming his art gallery at Third and Lombard Streets in Philadelphia, also home to his family, into a museum of natural history. Within a decade the museum had expanded and Peale was devoting all his time to it and involving his very large family as well.

The museum became the depository for some of the most important collections of this period of American history. Specimens from expeditions, including

Lewis and Clark's, were held at Peale's Museum. It was also a place of entertainment and became one of the main attractions in Philadelphia, where it opened two nights a week to the public and visitors could see by gaslight preserved animals from around the world together with living ones, such as the grizzly bear cubs that Major Pike brought back from the Rockies in 1807. Thomas Say made many visits to the museum as a young boy and was fascinated by the large collections of insects kept in glass cases. With some of the Peale children, he would venture out to the local fields and woods collecting specimens of his own. Like many scientists and artists of his day, Charles Willson Peale was conscious of the need for a national identity and saw a national museum of natural history as a major contribution toward realizing that dream. In a lecture on the science of nature, he described the work he had done for his museum and asked, "When the public mind shall become fully convinced of its utility, can anyone suppose that government will not then provide the means of rendering it permanent."[3] Despite enormous efforts on his part and by others, including a personal plea to Thomas Jefferson by Alexander Humboldt, the museum never succeeded in becoming recognized as a national institution. Nevertheless, for the early years of the nineteenth century, Philadelphia continued to lead the way in the development of the arts and sciences in America, and the museum, though not in name, served as (and was considered by many) a national institution.

The forging of a national identity in the arts and sciences truly began to take form in the early nineteenth century when individual states began to establish their own museums, universities, botanical gardens, and scientific and cultural institutions and learned societies. In Philadelphia the American Philosophical Society, founded by Benjamin Franklin, John Bartram, and others in 1743, continued to embrace all aspects of learning, including science, the arts, and technology, but there was no institution dedicated solely to the study and development of the natural sciences. This was soon to change in 1812, when on the evening of 25 January Dr. Gerard Troost, Dr. Camillus Macmahon Mann, Jacob Gilliams, John Shinn, Nicholas Parmantier, and John Speakman met to form an association whose members would devote themselves to the study of natural sciences. Several meetings took place between that date and 21 March, when the name of the society was recorded in the minutes. This event was the birth of the Academy of Natural Sciences.

Thomas Say was not present at the first few meetings of the Academy, but the other members determined that "his name should be enrolled among those of the founders."[4] Almost immediately Say became one of the most active members of the Academy, devoting all his time to it and even living in the rooms there. By May he was elected curator of the collections, which had been donated by each of the founders and continued to come in from scientists from around the world. From the beginning, the founders stated that the Academy's purpose was exclusively for the cultivation of natural knowledge. Any political and religious discussion as well as national partialities were seen as being "adverse to the interests of science."[5] National partialities may well have been out of order within the Academy, but the concept of American identity was one of the determining factors that

led to the formation of the Academy and continued to prevail throughout the first decade of its history. Thomas Say was intensely nationalistic and was one of the most vociferous in his objections to specimens being sent to Europe for description and naming. He passionately argued for scientists to describe and name their own flora and fauna and was crucial in fostering the idea that American scientific authority was essential to the development of a national cultural identity. Say unhesitatingly spoke out in criticism of men like John Eatton Le Conte, who, despite requests by others, continued to send his specimens abroad for identification. Say wrote to a friend: "We must therefore be content to labor onward as we may, with our efforts directed to the honour and support of *American* science, with *pro nobos* [for us] for our motto, not so much in a *personal* as a *national* sense."[6]

Say had grown up in a family in which American independence and national identity were important issues. His father, Benjamin Say, was one of the founding members of the "Free Quakers," the group that had split from the Society of Friends in the belief that it was right to take up arms in the defense of American independence against the British. In the year of the founding of the Academy of Natural Sciences, the United States embarked on a three-year war with Britain. The war only served to strengthen the sense of nationalism in America. Several of the founding members of the Academy, including Say and Speakman, both Quakers, served as volunteers of one kind or another during this period.

One of the earliest members of the Academy who was to become crucial to the Society's survival was William Maclure. Born in Scotland in 1763, Maclure was a wealthy merchant. He became known among natural scientists for his *Observations on the Geology of the United States*, published in 1809. On 6 June 1812, Maclure became a member of the Academy and in 1817 he was elected president, a position he held until his death in 1840. During the initial years Maclure was instrumental in keeping the Academy financially solvent. William Ruschenberger, in his history of the Academy, explained that Maclure donated over $25,000 to the Academy and contributed well over five thousand books to its library. He also financed expeditions and bought the first printing press for publication of the Academy's journal, the first issue of which was produced in 1817. Thomas Say, George Ord, and William Maclure were responsible for the journal and with others made up the Publication Committee. Sporadic breaks occurred in its publication, which usually coincided with Say's absence from Philadelphia on an expedition, but by the late 1820s the journal was printed regularly. Thomas Say, George Ord, and a new arrival from France, Charles Lesueur, were the three contributors to the first issue. Lesueur's English was rather poor, so Ord helped in the translation of his work, but it was Say who was the most generous in his unstinting aid to those who either found they lacked the writing ability or style required for the journal or whose English was not sufficient. Lesueur became Say's closest friend and together with Titian Peale illustrated Say's volumes of *American Entomology*.

In December 1817, William Maclure, as the newly elected president of the Academy, organized and financed a scientific collecting expedition to Georgia and Florida with the intention of following the route William Bartram described in his *Travels*. The party of explorers was made up of George Ord, Thomas Say,

Smerinthus geminatus

TITIAN RAMSAY PEALE
(1799–1866)

SPHINX MOTH
Sphingidae *Smerinthus jamaicensis* (Drury)

Titian Peale, and Maclure himself. All four were members of the Academy. Ord was elected in 1815 (and by then was serving on the Publication Committee of the journal), and Peale, second youngest son of Charles Willson Peale, was newly elected to the Academy at the age of eighteen.

Titian Ramsay Peale was born in 1799 and like his brothers was named after a famous artist. As a child growing up in the rooms next to his father's museum, he

Red bellied Bream ƚ Johns E: Florida

W B

1774

RED-BREAST SUNFISH
Lepomis auritus (Linnaeus)

This description of the mayfly was more than a show of poetic flair. Bartram was also asserting the equal worth of all life forms. The "frame and organization" of these tiny creatures was for Bartram as "wonderful" and "complicated" as the "most perfect human being." Bartram witnessed this wondrous scene toward the end of April, but Say and his companions were deprived of the experience by having had to return to Philadelphia. The specimens collected on this trip were somewhat disappointing for Say. George Ord had returned to Philadelphia to attend to business matters and Say wrote to him of his disappointment, declaring that they had "not met with a single new vertebral animal & but very few new ones in the Invertebral departments, one additional new Genus we hope to add to the Crustacea."[12] Say possessed a broad knowledge of natural history; after entomology, his interest was conchology. Despite his frustration, he managed to amass a large collection of shells, crustacea, and a new fish, which Lesueur described in the Academy journal. In fact, the collections made on this trip kept many Academy members busy for several years.

Having had a taste of exploration, Say and Peale were eager for more, and in 1819 they had the opportunity to join Major Stephen Harriman Long on a government expedition to the West, up the Missouri River and to the Rocky Mountains. Major Long's orders were to explore the country between the Mississippi and the Rockies. Say was the official zoologist on the expedition and Peale the assistant naturalist and artist of natural history. A botanist was also appointed, one William Baldwin from Wilmington, Delaware. Baldwin was a physician and botanist who had studied under Benjamin Smith Barton at the University of Pennsylvania. This was a military expedition, so the men, including the civilian scientists, were issued uniforms and their portraits were painted by Charles Willson Peale before the expedition commenced. On 4 May 1819 the party set off by steamboat from Pittsburgh and arrived back in December 1820. The success of the expedition was mixed, with science coming off the better. Say and others, immediately on their return, set about describing the long list of species of flora and fauna from their collections, many of which were unknown to science. The collections were deposited in Peale's Museum, alongside those of Lewis and Clark. In the report of the expedition from the notes of Major Long and Thomas Say, the challenge laid down by Wilson in 1807 was repeated: "We cannot but hope . . . that the time will arrive, when we shall no longer be indebted to the men of foreign countries, for a knowledge of any of the products of our own soil, or for our opinions in science."[13]

The following year Say was elected to the American Philosophical Society. He was now establishing himself as a formidable scientist, one who followed in the footsteps of his great-uncle William Bartram as a field naturalist, combined with the discipline of a systemisist. In 1823 Say had another opportunity to explore unknown American territories, when he was offered the position of zoologist on another expedition led by Major Long. This time they would explore the territory from Philadelphia to Lake Superior. The expedition set off at the end of April and returned in October. On his return this time, Say knuckled down to his own work of creating the first thorough study of American insects. In late 1824 the first volume of *American Entomology* was published, with color plates by Titian Peale and Charles Lesueur. Publication of the second and third volumes followed in 1825 and 1828. Say dedicated the first volume to his friend and father figure, William Maclure, the "munificent patron, of the Natural Sciences" to whom Say was indebted for being allowed to pursue his scientific work without many financial worries. Bartram no doubt would have applauded Say's work as a valuable contribution to American science.

In 1825 Maclure suggested to Say and Lesueur a collecting trip to Mexico with the possibility of stopping en route to visit New Harmony, Indiana. Robert Owen, a mill owner and philanthropist with strong socialist leanings, had recently purchased the town of Harmonie, which he renamed New Harmony. Owen was born in Wales and, like Maclure, was financially a self-made man. He had become famous for the model community he built up around his cotton mill in New Lanark, Scotland. Here workers were paid higher wages for fewer working hours.

LUCY SAY (1801–1866)

BUTTERFLY MUSSEL
Ellipsaria lineolata
(Rafinesque)

In addition, their children were given an education and what were considered lavish social services were provided for all workers and their families. Owen's views had been influenced by William Godwin, husband of Mary Wollstonecraft, who believed that man was a product of his surroundings and that by changing the conditions in which he lived, he could change himself. Owen immediately began a recruiting campaign for his "socialist paradise" and convinced Maclure,

who had been to the New Lanark community, to visit. Thomas Say was familiar with Owen's ideas and wanted to see New Harmony for himself, but he had also been influenced by Maclure's radical views on education. Maclure believed that education was the only method for improving peoples' lives, and he had financed a school in Philadelphia based on the principles of the radical Swiss educator Johann Pestalozzi.

On 8 December 1825 a keelboat, named the *Philanthropist* by those traveling on it, but later dubbed "The Boatload of Knowledge" because of the eminent scientists aboard, set off from Pittsburgh along the Ohio River for New Harmony. Among the scientists were Say, Maclure, and Lesueur. Also traveling with them were Robert Owen and his son, along with Mme. Fretageot, a teacher with radical ideas on education, and her assistant, Lucy Way Sistare. For Thomas Say and Lucy Sistare, this journey was not only an adventure into an experimental lifestyle but also the beginning of romance. In January 1827, just before Say's fortieth birthday, they were married. Needless to say, like her husband, Lucy had a great interest in natural history and in 1841 she became the first woman member of the Academy of Natural Sciences.

Owen's "community of equality" never managed to get off the ground and within months disillusionment and schisms emerged. Owen sold the town back to its residents and returned to Britain. These residents now included Say and Maclure. New proposals for community life were put forward by Maclure and adopted by the members, who then embarked on an uphill struggle, which lasted many years, to make New Harmony a success. The community never truly came close to the ideals of many of its members, despite the efforts of people like Thomas Say, who continued to work for it while completing his scientific writings and publishing his books. Say lived out the rest of his life at New Harmony and made only a few collecting trips. Once when asked by his oldest friend, Reuben Haines, why he remained at New Harmony, his reply was a single word, "poverty." One of the few collecting trips that Say made during this period was to Mexico with Maclure, who was so taken with the country that he returned to live out his days there, dying of pneumonia at San Angel in 1840. With his work on entomology complete, Say turned his attention to conchology and in 1830 the first installment of *American Conchology* was published. The original drawings for the plates were executed by his wife, Lucy, and seven parts were produced in all by 1834. However, the struggle for survival at New Harmony and the years of physical neglect soon began to take their toll. Say not only worked on his scientific projects but also published the weekly New Harmony newspaper, the *Disseminator*. For many years Say had suffered from a recurring abdominal illness, and in 1834 he finally succumbed to its latest attack and died on 10 October.

Following in Bartram's Footsteps

WHEN THOMAS SAY DIED IN 1834, he left behind a scientific community that was growing ever stronger in its institutions and authority. Say had been instrumental in the development of both of these areas with the work he accomplished for the Academy of Natural Sciences and his efforts in taxonomy and classification, persuading Americans to describe their own flora and fauna. His Jeffersonian ideals helped him create this American scientific establishment independent of European expertise and led him to be critically outspoken about men who continued to send their specimens to Europe. He was also uncompromising when it came to the naming of species and believed the person who published first should be credited with the description. Here he came up against Constantine Samuel Rafinesque, an ambitious and dedicated naturalist who in his eagerness to name species was often less thorough than he should have been. His habit of rushing into print in order to be the first to have discovered or named a species unfortunately led him at times to duplicate his own finds by attributing different names to the same species. His practice of sometimes describing someone else's species as his own was considered more unethical. Many plants first described by Bartram in his *Travels* ended up with different names in Rafinesque's publications. Commentators have described Rafinesque as having a brilliant mind, but his sometimes erratic and volatile behavior opened the way for others to accuse him of being scientifically unreliable. In contrast, Say was totally scrupulous

Each man the maker of his own fortune.

—FRANCIS BACON, *The Essays or Counsels Civil and Moral*

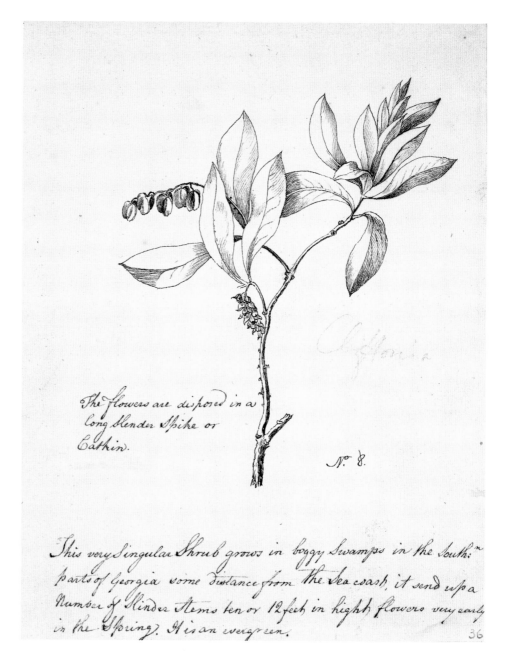

The flowers are disposed in a
long slender Spike or
Catkin.

N.º 8.

This very singular Shrub grows in boggy Swamps in the South:ⁿ
parts of Georgia some distance from the Sea coast, it send up a
Number of slender Stems ten or 12 feet in height flowers very early
in the Spring. It is an evergreen.

36

BUCKWHEAT TREE
Cliftonia monophylla
(Lam.)Britton ex Sarg.
(Cyrillaceae)

when it came to naming species and acknowledging the rightful author. These two men, so dissimilar in their methods, inevitably came into conflict with each other. Indeed the first paper Say rejected for publication in the Academy's journal was from the pen of Rafinesque. By 1824 Say had concluded that "with respect to Mr. Rafinesque I am sorry to say that I cannot place any reliance upon his writings & I therefore do not consult them at all."[1]

Rafinesque appeared to be indifferent to his critics, dismissing them and their work and taking heart in what he saw as his own "genius." He considered himself akin to "Bacon and Galileo, somewhat ahead of my age and my neighbors."[2] He published prolifically and claimed to have attributed more than 6,700 scientific names in botany alone. In 1832 Rafinesque published a list of *New Plants from Bartram's Botanic Garden*. He had visited Bartram's garden on a number of oc-

casions and was inspired by it, so much so that when he accepted a teaching post at the Transylvania University in Lexington, Kentucky, in 1819, he attempted to establish a botanical garden based on Bartram's, but he was never able to secure the funding.

Another man who was critical of Rafinesque was William Baldwin, the botanist and physician appointed to the Major Long Expedition to the West in 1819. Baldwin described Rafinesque as an "indefatigable Botanist," but he agreed with his friend Muhlenberg that Rafinesque was too quick to name species and "unnecessarily changed some of the Linnaean names."[3] Baldwin was born into a Quaker family in 1779 in Chester County, Pennsylvania, and studied to become a doctor in Philadelphia. In 1805, before completing his studies, he joined a merchant ship as a surgeon and sailed to Canton, China. This experience stimulated him to write a thesis on the diseases that prevailed among the American seamen on board ship when he returned to America, which enabled him to complete his medical studies and qualify as a doctor.

Baldwin settled in Wilmington, Delaware, in 1807, where he married and practiced medicine. In his study of botany he was tutored by Benjamin Smith Barton at the University of Pennsylvania. Barton often took his students to visit William Bartram and the Botanical Garden at Kingsessing as part of their studies. Baldwin was already familiar with the Botanical Garden at Marshallton, founded by John Bartram's cousin, Humphry Marshall, author of *Arbustrum Americanum*, but the visits to the Bartram garden confirmed Baldwin's lifelong interest in botany and led him to greatly admire William Bartram, seeking out many of the plants Bartram first described in *Travels*.

Baldwin described himself as having a "feeble constitution" and declared that for years he had been "struggling on the brink of the grave."[4] In an attempt to improve his health, he moved to Georgia in 1811, mainly to avoid the harsh northern winters. Here he spent his spare time visiting the old haunts of William Bartram in Georgia and East Florida in an attempt to verify the plants Bartram mentioned in *Travels*, which other scientists had not yet seen. Baldwin maintained a regular correspondence with his friend the Reverend Henry Muhlenberg, of Lancaster, Pennsylvania, whom many considered the American Linnaeus. Both men were devoted to the study of plants and both were concerned that the plants Bartram described in *Travels* should be confirmed by other scientists. Muhlenberg encouraged Baldwin in his plant hunting in Georgia: "You are now at St. Mary's—an excellent situation to elucidate BARTRAM's Travels. If you have a copy, pray let me have your observations on his dubious plants."[5] Baldwin did have a copy of *Travels*, but in March 1813 he reported that he had had the great misfortune to lose it in Savannah. It took two months of searching before he was able to find another copy, and this one he could only borrow. Again Muhlenberg requested Baldwin to seek out Bartram's plants. He was particularly interested in having Baldwin identify *Isia coelestina, Btr.*, which had not yet been discovered by any other botanist. Baldwin responded as best he could to many of these requests but explained that sometimes he found it difficult to locate the plants and, with the exception of only a few names, was unable to communicate anything of value. It

was a long and arduous task and required longer periods of traveling than Baldwin could devote to it. Later, in 1817, Baldwin made another excursion to East Florida with the intention of identifying and thereby verifying "our good old friend BARTRAM's doubtful plants."[6] Soon after this plant-hunting trip, Baldwin was able to write to Lambert, vice president of the Linnean Society in London, about the plants he had found: "Among them, were Crinum Floridanum, Lantana Camara, Pancratium, and some others, that have been noticed by MR. WILLIAM BARTRAM,—but not confirmed, that I know of, by any succeeding Botanist."[7] Baldwin's years of plant hunting in Georgia and East Florida led him to rediscover many of Bartram's plants and vindicate many of his observations, particularly his descriptions of alligators and rattlesnakes. At one time Baldwin lamented to his friend William Darlington that in all five years of his time in the South he had seen only one live rattlesnake. However, he was soon rewarded when only two months later he was able to report that "I had the pleasing horrible prospect of a living rattlesnake, six feet in length. He had the generosity, when unperceived by us, to give the dread alarm. . . . Never have I seen anything so awfully, so horribly terrific, as this rattlesnake in anger."[8] More rewarding for Bartram was Baldwin's confirmation of his description of alligators when he wrote Darlington that "had not BARTRAM been here before me, I would astonish you with my account of the Alligators."[9] William Bartram had been much affected by the allegations that he exaggerated the ferocity of the alligator in his *Travels* in order to embroider his story. Baldwin's testimony put such accusations to rest, and his observations were given greater credence when he reported that on a visit to a Mrs. Spalding on the St. Johns River, "This venerable old lady requested me to present her best respects to W. BARTRAM—whom she well remembers, when, in days of yore, he traveled in Florida. She says that his account of the Alligators is not exaggerated."[10]

In 1817 William Baldwin was in Philadelphia and paid a short visit to his friend William Bartram. Here he discovered that Bartram, though advanced in years, remained in good health and "all the facilities of his mind were as brilliant as in the morning of life." The two men shared information about East Florida, an area they both loved. Bartram revealed to Baldwin that such was his "partiality for that delightful country, that he often fancied himself transported thither in his dreams by night." Baldwin was able to bring good news that he had found and confirmed several of the plants Bartram was seeking, which was met with extreme gratitude. Bartram was anxious for Baldwin to return to Florida and continue the search for his plants before he died. Baldwin took delight in being able to verify Bartram's plant discoveries and vindicate his character, describing it as "truly a feast to me" when he was greeted by Bartram's response to such news. He wrote, "By this visit I am prepared to make his *Lantana Camera* a new species, without hesitation."[11] Baldwin was familiar with the South American *Lantana* and saw it as distinctly different from the Florida plant of that name that Bartram had discovered. Having determined this and described it, he then ascribed the species name of *Bartramii* to the Florida plant. When in 1818 Baldwin returned from a government-sponsored mission to Buenos Aires, Argentina, he paid another visit to his "worthy old friend" Bartram, where he was able to observe the "Lantana

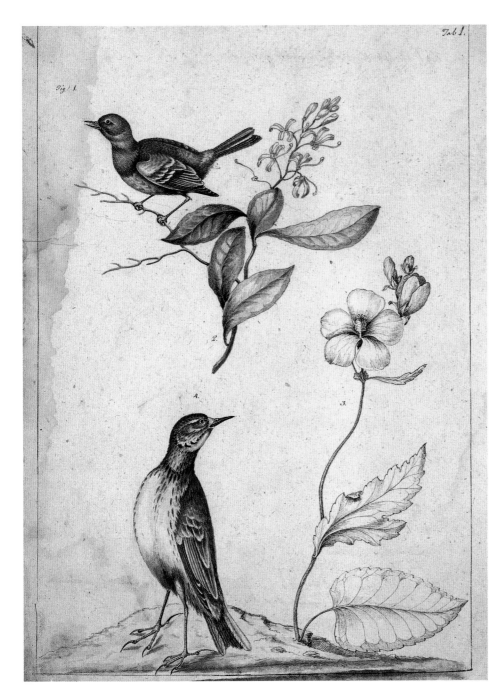

ACADIAN FLYCATCHER
Empidonax virescens
(Vieillot)

ELLIOTTIA OR
GEORGIA PLUME
Elliottia racemosa Muhl.
(Ericaceae)

POPPY MALLOW
Callirhoe triangulata
(Leavenw.) A. Gray
(Malvaceae)

AMERICAN PIPIT
Anthus rubescens rubescens
(Tunstall)

Bartramii (for the first time) in flower in his garden."[12] On this visit Baldwin persuaded Robert Carr, the man who had married Nancy Bartram, to cultivate the plants Baldwin had brought back with him from South America. Carr had by this time taken over the management of the garden after the death of his father-in-law, John Bartram Jr., in 1812.

When William Baldwin sat for his portrait by Charles Willson Peale before setting off on the Major Long Expedition, he complained to Darlington that "my portrait is completely finished; and ought to be,—as I have sat little short of 12 hours. The old gentleman considered it one of his most finished performances; and spoke of sending it (on this account—and not, I presume, on account of my

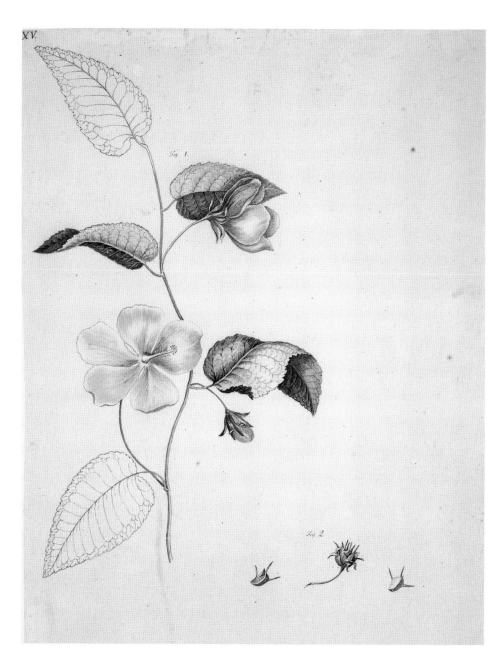

beauty—) to the Academy of Fine Arts."[13] The Major Long Expedition set off at the beginning of May 1819, but on 22 July Baldwin wrote to Darlington for the last time. Within four months of the expedition's start, Baldwin had become too ill to continue and was forced to leave the group of explorers and seek treatment in Franklin, now in Missouri. On 1 September 1819, William Baldwin died of tuberculosis. He was only forty years old.

The man who had taken William Baldwin and his fellow students to the Bartram garden to study botany was Benjamin Smith Barton. Barton was professor of botany and natural history at the University of Pennsylvania, a post that had first been offered to William Bartram. Barton had held the post since 1789, and in 1795 he was appointed professor of Materia Medica. The teaching of botany as an academic subject had been long overdue in American universities. As late as 1775

Manasseh Cutler complained that "botany has never been taught in any of our colleges."[14] Barton's post was the first of its kind in Philadelphia.

Barton was born in Lancaster, Pennsylvania, in 1766 and was the nephew of David Rittenhouse, the well-known astronomer. By the time he reached fourteen, both his parents had died and he went to live with his elder brother. He studied for a time at the College of Philadelphia but then went abroad in 1786 to study for a medical degree at the University of Edinburgh. Although an excellent student, serving as president of the Royal Medical Society, he did not graduate. It is understood that he was found to have misused the funds of the Medical Society and for this reason left Edinburgh for London, and then to the University of Göttingen in Germany, but even here it is uncertain that he ever obtained a degree.

It was while he was in Britain that he began a correspondence with William Bartram and posed the series of questions concerning the culture, history, and appearance of the Creek and Cherokee people. Barton's interest in Native Americans had probably been influenced by his father's work with Native Americans living at Conestoga Creek, near Carlisle, Pennsylvania. It was further stimulated by his own research when he accompanied his uncle, David Rittenhouse, who was a member of the commission charged with marking the western boundary of Pennsylvania. Here he began his studies of medicinal plants used by Native Americans and soon became interested in their culture and history. In his efforts to enrich this interest, he turned to Bartram, whose knowledge of the subject was probably the most comprehensive at the time. It was in this period that Barton was accused of attempting to hijack the publication of Bartram's *Travels*. As early as 1786, the publisher Enoch Story had begun to advertise Bartram's work in order to raise money for its publication. Several explanations could account for why publication was delayed for another five years. As late as 1787 Bartram maintained that his work was still in embryonic form. He may well have been waiting for confirmation of identification of some of the plants he had discovered. His effort in sending to England the drawing of *Franklinia* in 1788 was one attempt to confirm the plant as a new genus. Further, his collection of papers, journals, drawings, and personal effects from his travels that had been left in his trunk and stored at the Thomas house in Charleston was only sent to him in 1787, ten years after he returned to Philadelphia. His notes from his journals may well have induced him to make considerable amendments to his original draft of *Travels*. Nevertheless, despite all these factors, it is generally thought that Barton's intervention contributed to the initial publication delay of *Travels*. Before leaving for Europe, Barton had offered to have Bartram's work published in England together with some of his own writings. Story and others were highly suspicious of Barton's motives and accused him of trying to promote himself on the notability and work of others, an accusation that resurrected itself several times in Barton's later life. In August 1787, Barton, writing from Edinburgh, again proposed that he edit Bartram's work and have it published in London at his own expense. William Bartram of course was aware of the sense of national identity that many around him were struggling for and had no intention of having his work published in England, or combined with someone else's work, for that matter. Barton himself

vigorously denied any intention of deceit or of having ambitious motives: "I hope, Sir, the pains Mr. Storey took to injure me with have no avail with you. I most solemnly protest the affair was, just as I've presented it to you, a few days before I left America, and those who are well acquainted with me, have, I am sure, too good opinion of my honesty to harbour any unfavourable suspicions of me. Mr. Storey insinuated to you, and to many others, that I had it in view to publish your *Journal* in Europe either with ambitious or lucrative motives: now, Sir, is it not very improbable that such an intention would ever have activated me? a native of the same country with yourself; a person who means to spend his life there."[15]

Benjamin Smith Barton was not a modest man; he was ambitious, anxious to promote himself in the scientific world, and intent on achieving a large body of work, much of which never materialized. Nevertheless, he was a serious, knowledgeable, and dedicated botanist who, among other things, produced the first botanical textbook for students in America, *Elements of Botany*. Another reputation Barton managed to acquire was as someone who guarded his knowledge outside his formal teaching arena. Some believed that he took advantage of William Bartram's own knowledge and generosity. Henry Muhlenberg found that "with Dr. Barton I correspond but seldom except when he puts some queries to me, I could never persuade him to let me see his Herbarium although he has seen mine twice. His Principle seems to be 'it is more blessed to receive than give' however he is indefatigable in Collecting and has done much for Botany."[16] Others have directly accused Barton of exploiting Bartram's work. It has been suggested that his *Collections for an essay toward a Materia Medica of the United States*, *Part 1*, published in 1798, "was based on William's [Bartram] manuscript 'Pharmacopoeia.'"[17]

Alexander Wilson was one person who had little regard for Barton and was most indignant when Barton failed to mention his friend William in the American edition of John Pinkerton's *Modern Geography*. This version was published in two volumes in 1804 and the chapter on America was "Corrected, and considerably Enlarged" by B. S. Barton.[18] On reviewing the volumes, Wilson wrote to Bartram with venomous zeal:

> I had indeed expected from the exertions of Dr. Barton, as compleat an account of the natural history of this part of the world as his means of information, and the limits of the work, would admit. I have been miserably disappointed; and you will pardon me when I say that his omitting entirely the least reference to your researches in Botany and Natural History, and seeming so solicitous to let us know of his own productions, bespeak a narrowness of mind, and self-consequence and is an ungrateful and unpardonable omission. Every man acquainted with you both, would have confidently trusted that he would have rejoiced in the opportunity of making the world better acquainted with a man whose works show such a minute and intimate knowledge and attention to these subjects and from whose superior abilities and experience he had himself received so many obligations and much information. But no—All is silent not even the slightest allusion, lest posterity might discover that there existed, at

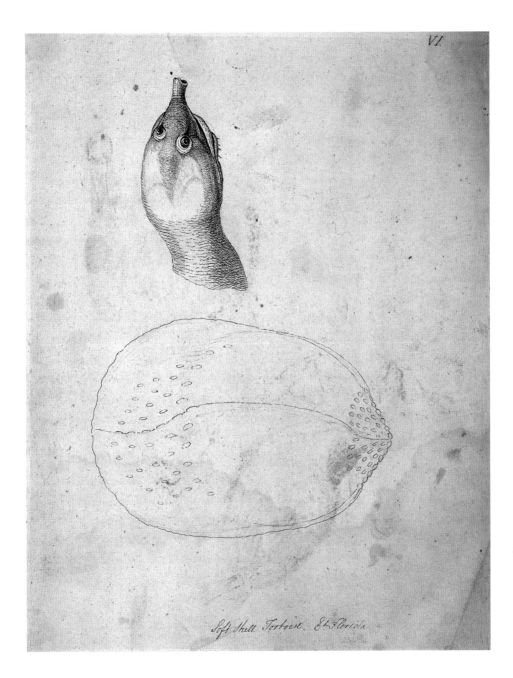

Soft Shell Tortoise. E. Florida

FLORIDA SOFTSHELL
Apalone ferox (Schneider)

this time, in the United States, a man of Genius and information superior
to himself.[19]

The opinions of Wilson may well have been apposite, but William Bartram
neither held such views nor was prepared to entertain such criticism. William
maintained a strong and loyal friendship with Benjamin Barton until his death in
1815. His letters testify to this friendship: "My Dr. frd dont be afraid of troubling
me by Your friendly requisition . . . they are entirely agreable to me, & add greatly
to my pleasure & health. . . . We will be much gratifyed by a visit from You as
soon as convenient."[20] These sentiments are repeated many times in Bartram's let-
ters to Barton. Barton likewise was very fond of Bartram. He made several gifts of
books to William, including a copy of Buffon's *Natural History*, "which I request

Plate I.

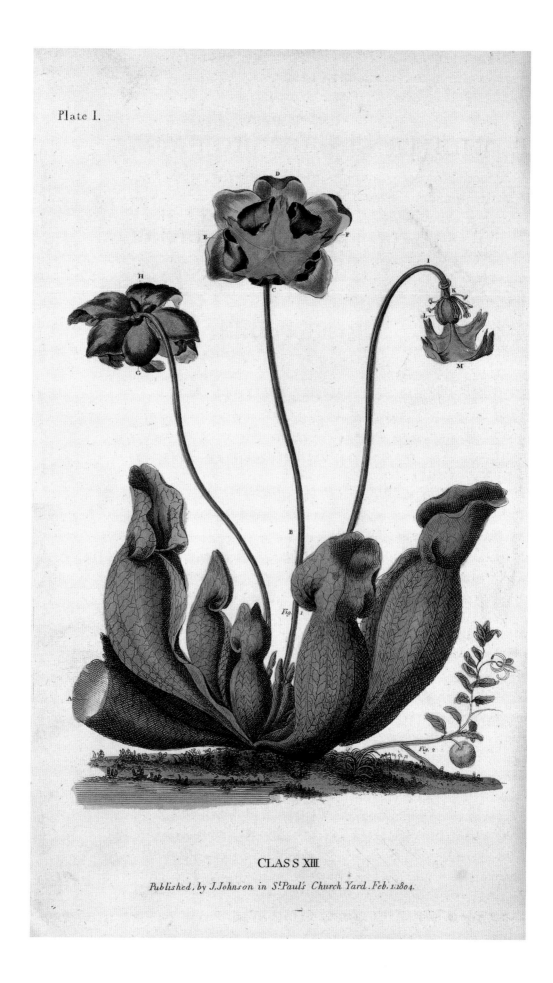

CLASS XIII.

Published, by J.Johnson in St.Paul's Church Yard. Feb. 1.1804.

preference for European scientists, or the widely held view concerning his own ambition, which came before any national cause. Nevertheless, his nephew, William P. C. Barton, wrote of him that "he possessed some high virtues; among the most elevated of them was his unaffected love of country. Indeed, his patriotic feelings were not only strong, but frequently expressed with unreserved warmth. He always spoke with extreme impatience of the arrogance of pretending foreigners of the literary grade, too many of whom resort to our country, being nothing in their own, and perpetually insult us by their vain and insufferable denunciations of our claims to national genious, talents, and learning."[30]

In 1815 Barton embarked on a long sea voyage in the hope of improving his health. Throughout his life he suffered from ill health, particularly in the form of gout. When he returned to his home in Philadelphia, his health had considerably worsened and in December of the same year he died.

William Bartram's influence on all of the men discussed here was significant and his reputation among scientists throughout America and Europe was considerable. The two Michaux, father and son naturalists from France, were frequent visitors to the Bartram household and were always warmly welcomed. André Michaux, a well-seasoned traveler who had journeyed across the Mediterranean through Turkey to Persia between 1782 and 1785, arrived in America in November 1785. He had become a widower in 1770, within a year of his marriage, after his wife, Cecile, had died in childbirth, leaving Michaux an infant boy to raise alone. When he set sail for America from France, he took his son François André, then fifteen, with him. Michaux's mission was to obtain plants and seeds of American trees and shrubs that would grow in French soil and climate. The exchange of plants between Europe and America had existed for as long as Europeans had traveled across the Atlantic, but this exchange had predominantly been with England. The War of Independence put an abrupt halt to this trade with Britain, while it stimulated the direct exchange of plants and seeds with other European countries. This was particularly so for France, a country that was a strong supporter of the new American Republic and where two of the most influential Americans, Benjamin Franklin and Thomas Jefferson, resided as successive ambassadors. Both men were interested in the exchange of scientific knowledge, including natural history. By 1783 William Young had established a trade with Parisian gardeners and nurserymen and published a *Catalogue d'Arbres, Arbustes et Plantes Herbacées d'Amerique*, which listed fifty-three pages of plants with some description of their appearance and time of flowering.

The loss of Louisiana and Canada by the French in 1763 had exacerbated their growing need for timber, particularly for shipbuilding, which was vital if France hoped to compete with the British for dominance of the seas. Thus in 1785 André Michaux arrived in New York as the King's Botanist with instructions to collect "trees and forest plants" that could be introduced and acclimatized in France. Acting for the king of France, Michaux bought land in New Jersey and immediately began to design a garden and nursery for plants that would be destined for export.

In the spring of 1786, Michaux visited Philadelphia and made his first contact with William Bartram. Thus began a friendship between the two men that

WILLIAM BARTRAM
(1739–1823)

PURPLE PITCHER PLANT
Sarracenia purpurea L.
(Sarraceniaceae)

AMERICAN CRANBERRY
Vaccinium macrocarpon
Aiton (Ericaceae)

lasted until Michaux's death in 1802. Michaux made regular visits to the Bartram garden during his stay in Philadelphia, always leaving his horses at the garden to avoid the expense of stabling them in the city. He would also visit the splendid garden of William Hamilton, The Woodlands, a few miles from the Bartrams. When Michaux set off on his trip to the Southeast in the footsteps of William Bartram, he went armed with letters of recommendation from both Bartram and Hamilton. Accompanying Michaux to the Carolinas, Georgia, and Florida was his son, now sixteen years old, a young boy who at this stage in his life inspired little confidence in his father: "I do not recognise in him either the energy or the disposition for any kind of knowledge."[31] Little did Michaux suspect that this son would surpass him in his achievements in the field of botany and his descriptions of American trees.

The Michaux arrived in Charleston, South Carolina, where André made his base for his travels south. He purchased land and created a second garden for his southern plants. The following spring he and François conducted a journey that took them through Georgia to the Appalachian Mountains and to the source of the Tennessee River. The only botanist to travel through this country in search of plants before them had been William Bartram. Michaux spent eleven years in the New World and this was the first of his many long explorations through the American wilderness, which took him from Florida to the Hudson Bay and as far west as the Mississippi. When time permitted, Michaux would take his son to visit Bartram for a few days of solace. Here, in the tranquil environs of the garden, they could sit at leisure, recover from the exertions of traveling, and escape from the financial worries that dogged the father throughout his time in America.

In 1789 François accompanied his father on one last winter collecting excursion to the mountains of North Carolina. Some weeks earlier he had suffered a serious gunshot wound to his eye while out walking near their home. The wound took several weeks to heal and is thought to have been responsible for the problems with his eyesight in later life. It probably also prompted his return to France the following spring, where he took up his studies that had been interrupted some three years earlier. André Michaux remained in America for another seven years, adding to his collections and garden and shipping young plants and seeds back to his native country. In 1796 he returned to France with every intention of returning to North America, but his plans were never realized. In 1800 he joined the expedition to the southern hemisphere led by Nicolas Baudin. When they stopped off at Ile de France, Michaux withdrew from the expedition and spent the next nine months collecting and growing plants there. He then sailed to Madagascar with the intention of traveling to India, but sadly he contracted a fever and died in November 1802.

François by this time had become as passionate a botanist as his father and in August 1801 he sailed for the United States, having been appointed by the French government to report on the condition of the nursery gardens his father had established as well as to study trees that might be useful for planting in France. He remained for two years in North America but returned again in 1806. His visits rekindled the friendship between himself and William Bartram, and Bartram in-

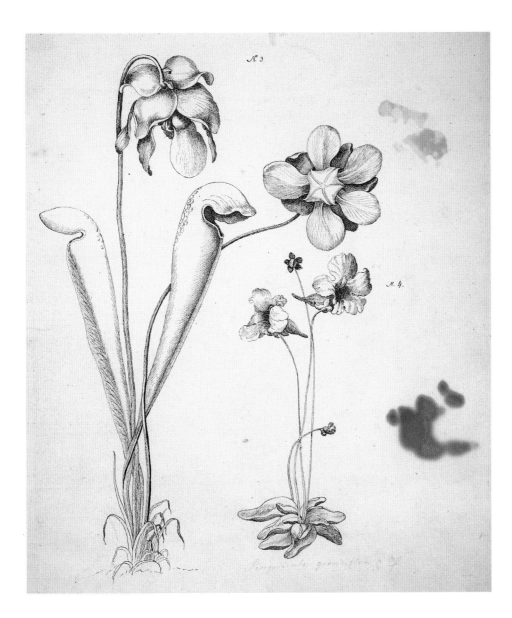

troduced him to Alexander Wilson. These two became firm friends, both conducting similar work with equal passion. Wilson had already embarked on his *American Ornithology* and Michaux was working on his *American Sylva*. Both these works were the firsts in their respective subjects. François André Michaux became a regular visitor to the Bartram household and spent long periods living there during 1809. When fortune allowed and Wilson and Michaux were both resident at Kingsessing, they shared with each other and the Bartrams tales of their travels and adventures. Wilson was able to give Michaux a letter of recommendation when he visited Niagara Falls, a journey that Wilson had accomplished in 1804 and that had been his first extensive trip in bird identification. When unable to meet and compare experiences, they corresponded with each other and continued to do so when Michaux returned to France in 1809. Michaux also continued to correspond with William Bartram and in 1810 he expressed his friendship for him, thanking him for seeds that Bartram had sent. He also enclosed "somme Literary journals for the Philosophical Society" and some seeds of "two sorts of Pine."[32]

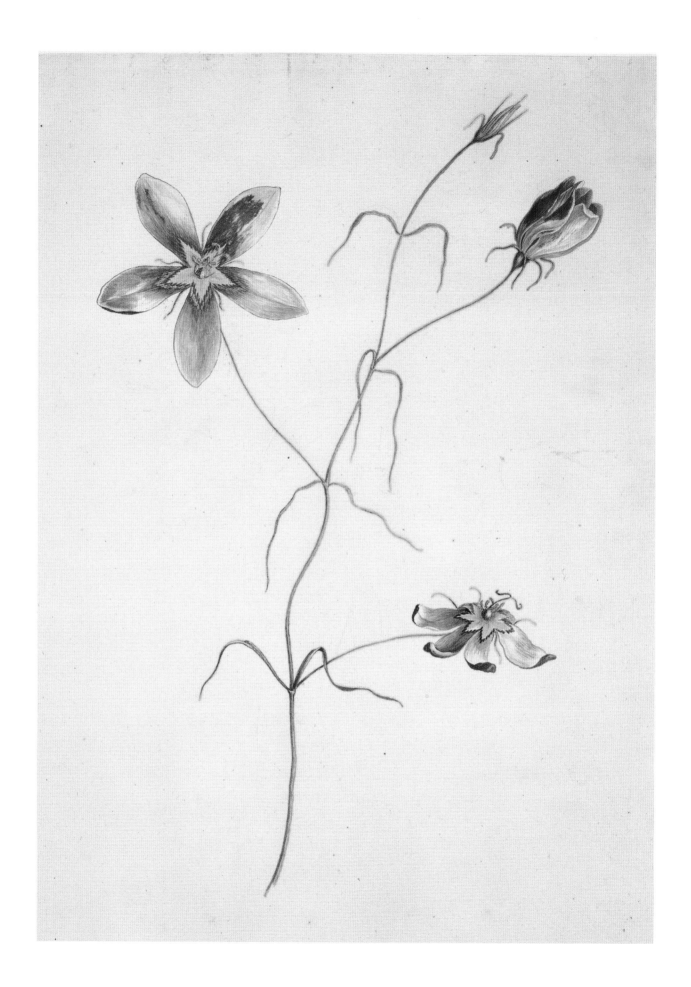

Michaux published his three-volume work, *Histoire des Arbres forestiers de l'Amerique septentrionale,* in 1810 and the English translation, *North American Sylva,* in 1817. In the preface he paid tribute to William Bartram, "known equally for his travels and various knowledge in natural history, for the amiability of his character and the obliging readiness with which he communicates to others the result of his studies and observations."[33] Correspondence among Wilson, Bartram, and Michaux continued and included the exchange of drawings. Some drawings were lost in transport during the Napoleonic Wars with ships being captured and cargo never reaching its destination. Nevertheless, some drawings that Bartram sent to Michaux are held at the Museum of Natural History in Paris. Three years after Michaux left America, Wilson was still able to write that "I had the pleasure of receiving a letter from you, dated April 10, 1812; but living at Mr. Wm. Bartram's, I have not yet seen Mr. Correa, the gentleman who brought it over. . . . Mr. Wm. Bartram is still as you left him, and you are frequently the subject of our conversation at table."[34]

The Michaux, father and son, have become the authority for many plant genera and species in North America and were also responsible for introducing new plants, such as *Camillia japonica, Albizzia julibrissin* (Mimosa), *Osmathus fragrans* (Sweet Olive). After he returned to France, François became one of the main links between American and European scientists, maintaining a correspondence with many interested and active scientists throughout North America. He was honored with membership in the American Philosophical Society and corresponded with some of its leading members, exchanging plants, journals, and other scientific news. François Michaux never returned to America but settled in Paris and continued his botanical work there. He died in 1855 at the age of eighty-five.

Michaux's *American Sylva,* similar to Wilson's volumes on birds, inspired others to continue his work. In Wilson's case, Charles Lucien Bonaparte conducted the work in collaboration with George Ord. For Michaux it was Thomas Nuttall who continued the search for new and undescribed trees. Thomas Nuttall arrived as a young man in America from England in 1808. His interest in botany immediately put him into contact with Benjamin Smith Barton, who gave him lessons in the subject and sponsored his plant-collecting trips. Being friends with Barton, it was not long before Nuttall was introduced to William Bartram and soon was making regular visits to the Bartram garden, often in the company of Thomas Say. So often did he stay at the Bartram house that one of the rooms has been unofficially named after him. Although not documented, it is possible that on one of these visits Nuttall met François Michaux, who wrote in 1808 that he "passed a great part of the summer with Messrs. John and William Bartram at their charming residence at Kingsessing." It was here that Nuttall found friendship and inspiration in the presence of William Bartram, to whom Nuttall referred in his writings as his "venerable friend" or the "amiable & excellent Wm. B." Nuttall spent thirty-four years in the United States and became one of the greatest plant collectors the country has ever had.

Although Nuttall was born in England and died there at the age of seventy-three, he spent most of his adult life in the United States and had an emotional and

LARGEFLOWER ROSE
GENTIAN
Sabatia grandiflora
(A. Gray) Small
(Gentianaceae)

spiritual attachment to the country. Before he left to return to England to manage his uncle's estate in 1841, he wrote, "How often have I realised the poet's buoyant hopes amid these solitary rambles through interminable forests! For thousands of miles my chief converse has been in the wilderness with the spontaneous productions of nature; and the study of these objects and their contemplation has been to me a source of constant delight. . . . I must now bid a long adieu to the 'New World,' its sylvan scenes, its mountains, wilds, and plains."[35] There are echoes here of Bartram in his prose and his love of nature.

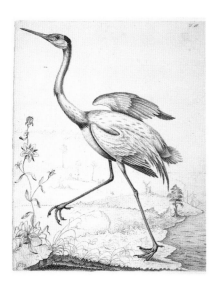

Contentment and Serenity

FOLLOWING THE WAR OF INDEPENDENCE, Philadelphia remained the center for intellectual and cultural activity in the United States and continued to be so well into the nineteenth century, even after the capital was moved to Washington, D.C., in 1800. William Bartram was part of this community, although he shunned public attention, instead preferring the company of other naturalists, with whom he could discuss recent discoveries and make local excursions into the woods and surrounding countryside. He outlived most of his contemporaries and many of the younger men that he influenced. He spent his days monitoring the weather, documenting bird migration, and taking delight in the variations in nature that came with each season. In the years following his return from the South, he assisted his brother in the garden and the seed trade that John had inherited from their father. Between them, they grew new plants that had been discovered by William's followers and delighted in the exotic plants brought from distant lands by men such as William Hamilton. Bartram made regular visits to The Woodlands and never ceased to wonder at the great delights he found there: "Have you seen the most beautiful Hydrangia from China now in flower at Hamilton's gardens . . . the celestial blue of the flowers is inexpressibly pleasing."[1]

Bartram's most public achievement was the publication of *Travels* in 1791, which soon became widely read by naturalists in America and Europe. It en-

The greatest thing in the world is to know how to be one's own.

—MONTAIGNE, ESSAY 39, "ON SOLITUDE"

hanced his already established reputation, and now politicians and scientists alike and visitors from far and wide came to pay their respects to this early pioneer of American botany. Bartram also wrote several short articles for Barton's publication and some unpublished tracts on slavery and Native Americans. He kept journals, his Commonplace Books, where he recorded the weather, species of birds that visited the garden, and comments from authors that he had found impressive. He also maintained a pharmacopoeia, a book describing the medicinal value of some of the plants he had spent his life studying. He lists remedies for various ailments with the prescribed dosage and method of preparation.

Of William's drawings, which he continued to produce for many years, some were published by Barton in his works and others were completed for Wilson and Michaux. While he maintained an interest in the development of the natural sciences, he did so away from the public arena. He never took up the offer of a professorship of botany at the University of Pennsylvania in 1782. His election to the Academy of Natural Sciences in 1812 was flattering, but he did not attend its meetings. He was recorded as a member of the American Philosophical Society as early as 1770 but was never actively involved, unlike his brothers Isaac and Moses, both of whom wrote for the Society's *Transactions;* Isaac was also a curator of its collections. The invitations William received to participate in expeditions were all eventually declined. Instead, he preferred to sit beneath the pear tree reading or writing with his faithful dog, which held "a particular attachment" to William, lying at his feet. At other times he would take pleasure in having his "neck and ears" tickled by his pet crow, which he had reared from the nest and whom he named Tom.[2]

William Bartram's adolescent struggles with his father, which he never brought into the open, coupled with his business failures, created an element of self-doubt that he never truly overcame. Personally modest, he denied any ability as a philosopher or of having any outstanding characteristics. He was never active in science in the broad public sense but instead preferred an individual approach to his work, whereby his influence was more subtle but equally powerful. At times, his personal battles in not meeting his father's aspirations led him into periods of despair and to question his self-worth, "What a poor impotent contemptible creature I am."[3] He strove against what he considered two evils: ambition and wealth. Money was the "bane of true Morality as it encourages every vice and immorality."[4] And in a letter to his nephew, Moses, he urged him to "Be moderate in all thy aims and acquisition[s] with respect to reputation, riches or gratification of the passions."[5]

William's long life spanned the period of the Enlightenment and the early Romantic Movement, and he is recognized as a link between the two. On the one hand, he was steeped in the ideas of the early and mid-eighteenth century, reflecting the ideas of the day in his views on morality, nature, religion, and society. On the other hand, he expressed views that were almost modern and not too dissimilar to some late nineteenth- and early twentieth-century thinking.

Bartram recognized many contradictions in current theories on the nature of the universe, and such contradictions were no less present in him. He claimed to

be a Christian, but, like his father, doubted the divinity of Christ. He acknowl-
edged the Great Chain of Being and the superiority of humans in that chain, yet
his own observations led him to assert that both plants and animals were some-
times comparable if not equal to humans and that "man . . . acts the part of an
absolute tyrant."[6] He was a utilitarian in his approach to land use and agriculture,
while he bemoaned the destruction of the wilderness by plantation owners and
land-hungry settlers. Some of his ideas were somewhat radical compared with
the conventional notions of the day, particularly in his concept of nature, wherein
the interdependence of species was critical to the life-cycle of all living things, and
the interplay of underlying natural forces was integral to the renewal of the living
earth. These ideas indeed predated those of modern ecologists. His observations
on the extinction of animals and plants and his fear of possible future extinctions
were similarly ahead of his time. Bartram saw nature as inferring the existence of
God while also recognizing the struggle for the reproductive success of individual
organisms. This is not to say that he anticipated Darwin's theory of natural selec-
tion, but that his perception of nature questioned the theories of the day.

List of Illustrations

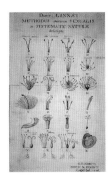

PAGE 5
GEORG DIONYSIUS EHRET (1708–1770)
Methodus plantarum sexualis in sistemate naturae descripta: The sexual system of linnaeus.
Watercolor and brown ink, 1736, 335 x 210 mm
The original watercolor for Linnaeus's sexual system of plants, which is based on the number of male (stamens) and female (pistils) parts of the flower. The number and arrangement of these parts were diagnostic for classification.

PAGE 6
SAVANNAH PINK OR BARTRAM'S SABATIA
Sabatia bartramii Wilbur (Gentianaceae)
IMPERIAL MOTH
Eacles imperialis (Drury) (Saturnidae)
Watercolor, [1774], 380 x 243 mm
"A beautiful Fly of Et. Florida."
"The large yellow Gourd fly Tab X is the most beautiful of this genus I have ever seen" (Journal, 2:56). The Imperial Moth is a large insect with a wingspan ranging from 8 to 17 cm. It is widespread across most territories from Maine to the Florida Keys and as far west as eastern Nebraska and central Texas.

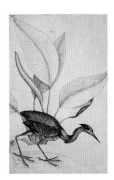

PAGE 9
THALIA
"A famous aquatic plant of East Florida"
Thalia sp L. (Marantaceae)
GREEN HERON
Butorides virescens (Linnaeus)
Black ink and watercolor, [1774], 377 x 245 mm
". . . a little green Bitern, a pretty bird, represented here of natural size and colour" (Bartram Mss. Text for Tab. I–XVIII)

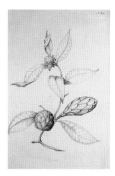

PAGE 18

CAROLINA ALLSPICE OR STRAW-BERRY SHRUB

Calycanthus floridus L. (Calycanthaceae)

Black ink, [1776], 275 x 183 mm

This is one of several plants that Bartram and his brother included in their catalogue of 1783. The *Catalogue of American Trees, Shrubs and Herbacious Plants* was a list of plants and seeds available for sale from their garden.

PAGE 21

HALE'S CORYDALIS

Corydalis halei (Small) Fernald & B.G.Schub. (Fumariaceae)

FALSE GARLIC

Nothoscordum bivalve (L.) Britton (Liliaceae)

Brown ink, [1772], 161 x 180 mm

Described as growing in "dry Outer Shell land near the Sea Shore Cape Fear No. Carolina," the *Nothoscordum* resembles other small lilies such as wild garlic or onion, but it lacks the garlic scent. It is also known as Crowspoison.

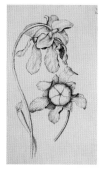

PAGE 22

TRUMPET OR YELLOW PITCHER PLANT

Sarracenia flava L. (Sarraceniaceae)

Brown ink, [1772], 302 x 178 mm

Flava is Latin for the yellow color of the trumpets of this species. Bartram described the yellow *Sarracenia* as representing "a silken canopy, the yellow pendant petals are the curtains, and the hollow leaves are not un-like the cornucopia or Amaltheas horn, what a quantity of water a leaf is capable of contain-ing, about a pint." (*Travels*, xviii) This plant was first cultivated in 1773.

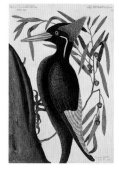

PAGE 23

MARK CATESBY (1683–1749)

IVORY-BILLED WOODPECKER

Campephilus principalis (Linnaeus)

WILLOW OAK

Quercus phellos L. (Fagaceae)

Hand-colored engraving, 1731, 380 x 255 mm

One of the first natural history books of colored illustrations that William Bartram read was Catesby's *Natural History of Carolina*, a work that very much influenced his interest in drawing. The Ivory-billed Woodpecker was thought to be extinct in the United States, but recent possible sightings in a protected forest in eastern Arkansas have led to claims of rediscovery. Before 2004, the last recorded sighting was in 1944. (*Natural History of Carolina*, vol. 1, plate 16)

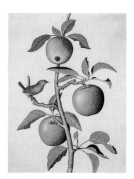

PAGE 24

WILLIAM KING (FL. 1750s)

APPLE TREE AND BIRD

Malus sp. Var. (Rosaceae)

Bodycolor and watercolor, c. 1750s, 410 x 325 mm

William King was one of many botanical art-ists who visited Peter Collinson's garden to draw his collection of plants.

PAGE 26

GEORG DIONYSIUS EHRET (1708–1770)

SIBERIAN LARCH

Larix sibirica Ledeb. (Pinaceae) (LEFT)

NORTH AMERICAN LARCH

Larix laricina (Du Roi) K. Koch (Pinaceae) (RIGHT)

Watercolor and black ink, 1763, 321 x 200 mm

The specimens were "sent me by Mr. P. Collinson May 17 1763," wrote Ehret on this drawing. Ehret made a number of compari-sons between the Siberian and Newfoundland larch, revealing his knowledge of morphol-ogy and botanical form.

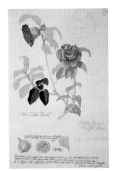

PAGE 29
GEORG DIONYSIUS EHRET (1708–1770)
CAMELLIA
Camellia japonica L. (Theaceae)

Graphite, watercolor, and bodycolor, 1740 and 1741, 435 x 281 mm.

"in Horto My Lord Petri" wrote Ehret. When Ehret drew this plant, it was known as the Chinese Rose. It had been recently introduced in England and was first grown by James Gordon, Lord Petre's gardener. The depiction of the seeds in this illustration was completed in 1741.

PAGE 30
JANE COLDEN (1724–1766)
WILD BASIL OR DOG MINT
Clinopodium vulgare L. (Labiatae)

Black ink and wash, c. 1740/50s, 305 x 180 mm

Jane Colden's flora of New York consists of 248 pages, some of which are blank but for the name of the plant. The illustrations are line drawings of leaves together with detailed descriptions of the plant. Some have added notes giving the plant's medicinal properties.

"the Country People here make a Tea of the Leaves & use it for pain or sickness at their stomach" (No. 296).

PAGE 31
JANE COLDEN (1724–1766)
LEAF

Nature print, c. 1740/50s, 305 x 180 mm

Last page of Flora nov. Eboracensis

This is the only example of Jane Colden's nature prints to have survived. The technique of taking prints from dried leaves, flowers, or insects was a popular pastime in the eighteenth century and Colden was thought to be quite skilled in this method of printing.

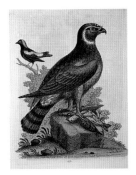

PAGE 35
GEORGE EDWARDS (1694–1773)
MARSH HAWK OR NORTHERN HARRIER
Circus cyaneus (Linnaeus)

Hand-colored engraving, 1758 (published 1760), 285 x 120 mm (paper size)

"The Marsh-Hawk is engraved from a drawing done from the life in Pensilvania, and sent to me, by my obliging friend, Mr. William Bartram. . . . Though I have not seen the bird itself, I have great reason to think Mr. Bartram very correct in his drawing, and exact in his colouring, having compared many of his drawings with the natural subjects, and found a very good agreement between them" (*Gleanings of Natural History*, vol. 6, plate 291).

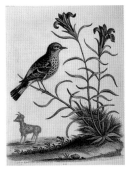

PAGE 36
GEORGE EDWARDS (1694–1773)
MAGNOLIA WARBLER OR YELLOW FLYCATCHER
Dendroica magnolia (Wilson)
GENTIAN
Gentiana autumnalis L. (Gentianaceae)

Hand-colored engraving, 1757 (published 1758), 285 x 120 mm (paper size)

The bird and flower were both drawn by Bartram and sent to Peter Collinson for George Edwards. Edwards included his version of them in his plate for *Gleanings of Natural History* (vol. 5, plate 255).

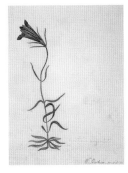

PAGE 37
PINE-BARREN GENTIAN
Gentiana autumnalis L. (Gentianaceae)

Watercolor over graphite, [1755/6], 243 x 191 mm

William's father, John Bartram, described in a letter to Peter Collinson how for many years he had attempted to raise "this delicate flower." (Eventually he succeeded.) John and William found this wildflower while traveling in Maryland, and John described it as growing "in a desert far from inhabitance."

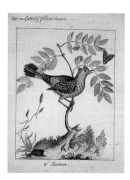

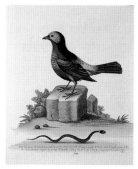

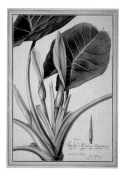

PAGE 37
MAGNOLIA WARBLER
Dendroica magnolia (Wilson)
Watercolor and black ink, [1755/6],
245 x 193 mm
George Edwards received this drawing together with the Gentian and reproduced them in volume 5 of *Gleanings of Natural History*. Edwards called the bird Yellow-Rumped Flycatcher and dates his drawing 1757. From the correspondence between John Bartram and Peter Collinson, these two drawings were probably executed in late 1755 or early 1756. Bartram would have been about sixteen years old.

PAGE 38
GEORGE EDWARDS (1694–1773)
PARADISE TANAGER AND SNAKE
Tangara chilensis (Vigors)
Hand-colored engraving, 1759 (published 1764), 285 x 120mm (paper size)
The snake was sent by "my good friend and correspondent Mr. William Bartram," wrote Edwards in his *Gleanings of Natural History* (vol. 7, plate 349).

PAGE 41
**GEORG DIONYSIUS EHRET
(1708–1770)**
TARO
Colocasia esculenta (L.) Schott (Araceae)
Watercolor and bodycolor, c. 1740s,
519 x 360 mm
William Bartram was not that familiar with this plant, and describes what he calls the *Arum esculentum*, which is much cultivated "for the sake of its large Turnip-like root, which when boiled or roasted, is excellent food." He continued by wondering if "this may be the Arum Colocasia." (*Travels*, 469)

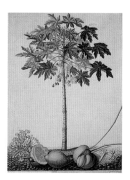

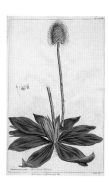

PAGE 42
**GEORG DIONYSIUS EHRET
(1708–1770)**
PAPAYA OR MELON PAWPAW
Carica papaya L. (Caricaceae)
Watercolor and bodycolor, c. 1742,
466 x 350 mm
The completed watercolor was reproduced in *Plantae et Papiliones rariores* (1748).

PAGE 43
**GEORG DIONYSIUS EHRET
(1708–1770)**
PAPAYA OR MELON PAWPAW
Carica papaya L. (Caricaceae)
Graphite and watercolor, 1742, 530 x 377 mm
This sketch was drawn from the garden of Lord Petre. It was later developed as a finished watercolor and engraved for Ehret's *Plantae et Papiliones rariores* (1748).

PAGE 44
WILLIAM BARTRAM (1739–1823)
SWAMP PINK
Helonias bullata L. (Liliaceae)
Hand-colored engraving, 1756 (1758), 335 x 215 mm (plate)
Engraved by Philip Miller from a drawing by William Bartram. Miller notes in the text that it was drawn by "J. Bartram the younger," who would have been fourteen or fifteen at the time. The drawing was in fact by William, as his father explains in a letter to Peter Collinson in 1756. (*Figures of the most beautiful, useful, and uncommon Plants described in the Gardeners Dictionary*, vol. 2, plate 272)

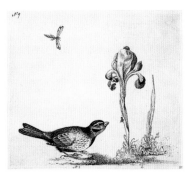

PAGE 47
SOUTHERN ARROW-WOOD
Viburnum dentatum L. (Caprifoliaceae)
Brown ink, [1772], 189 x 152 mm
Bartram mentions seeing this plant several times during his travels in Georgia. This image, however, was drawn in 1772, when he was probably still at his uncle's house at Ashwood, near Cape Fear, North Carolina.

PAGE 48
EASTERN FOX SPARROW
Possibly *Passerella iliaca iliaca* (Merrem)
DWARF IRIS
Iris verna L. (Iridaceae)
Brown ink, [1772], 180 x 207 mm
The identification of this bird is problematic because it does not truly resemble a Fox Sparrow. Bartram listed in his *Travels* "Fringilla rufa, the red, or fox-coloured ground or hedge sparrow" and calls the bird in this drawing *Little brown hedge sparrow . . . of North Carolina*. (verso of illustration)

PAGE 49
JOHN BARTRAM (1699-1777)
VENUS FLYTRAP
Dionaea muscipula J. Ellis (Droseraceae)
Specimen, 1765, 375 x 130 mm
This is the type specimen that John Bartram sent to Peter Collinson in 1765.

PAGE 51
WILLIAM YOUNG (1742-1785)
VENUS FLYTRAP (FIG. 8)
Dionaea muscipula J. Ellis (Droseraceae)
Watercolor, 1767, 378 x 234 mm
William Young named this plant *Youngsonia*, after himself, but John Ellis was either not aware of that or chose to ignore it. This drawing, with that of William Bartram's, is the first known depiction of the plant. Also displayed are *Gleditsia* (fig. 6) and *Mentha* (fig. 7).

PAGE 52
WILLIAM KING (FL. 1750S)
GARDENIA
Gardenia sp. J. Ellis (Rubiaceae)
Watercolor and bodycolor on vellum, c. 1750s, 410 x 287 mm
The Gardenia was named after Alexander Garden of Charleston, South Carolina, a Fellow of the Royal Society and friend of John Ellis, who proposed the name to Linnaeus. (Smith letters, 1:86)

PAGE 54
FRANZ ANDREAS BAUER (1758-1840)
BIRD OF PARADISE
Strelitzia reginae Banks ex Dryander (Strelitziaceae)
Watercolor on paper, c. 1818, 527 x 395 mm
The Bird of Paradise originates from South Africa and was first grown in Kew Gardens in 1773. Sir Joseph Banks named the plant after Queen Charlotte, Princess of Mecklenburg-Strelitz. Franz Bauer worked as the botanical artist at Kew for over forty years and is considered one of the most accomplished botanical artists of all time.

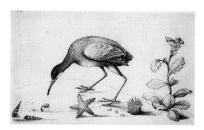

PAGE 79
AMERICAN SEA ROCKET
Cakile edentula (Bigelow) Hook. (Brassicaceae)
NORTHERN CLAPPER RAIL
Possibly *Rallus longirostris crepitans* Gmelin
PURPLE SPINED SEA URCHIN
ARBACIA PUNCTULATA (L)
SEA STAR, FORBES
Asterias forbesi (L)
TOWER SHELL
Terebra dislocata (Say)
Brown ink, [1772], 185 x 302 mm
Bartram described the bird as being similar to both "the Water Hen and Bitern. Its about the size of a curlew." The bird was "shot on the Sea Shore" and is depicted with other creatures and a plant from the shore of Cape Fear.

PAGE 80
SPINY SOFTSHELL
Apalone spinifera (Le Sueur)
Black ink, [1776], 244 x 191 mm
FIG. 1 *Soft shell'd Tortoise of Georgia*
FIG. 2 *Shews the top of the head*
FIG. 3 *the under shell*
In his mid-teens, Bartram gave Peter Collinson a collection of tortoise drawings, two of which Collinson published in the *Gentleman's Magazine and Historical Chronicle* in 1758. After his return from the South, Bartram completed two more drawings for *Travels*.

PAGE 82
GREEN-WINGED TEAL
Anas crecca carolinensis Gmelin
WATER SHIELD
Brasenia schreberi J. F. Gmel (Nymphaeceae)
Blue ink, 1774, 200 x 245 mm
Bartram described this bird as the "smallest of any of the Duck kind I have yet seen. . . . They visit Et. Florida in the Autumns." (Bartram Mss. Text for Tab. I–XVIII) Many of the plants depicted in Bartram's drawings were also sent as specimens to John Fothergill and the Water Shield is one example.

PAGE 83
BLUE TOAD FLAX
Linaria canadensis (L.) Dumort. (Scrophulariaceae)
RUBY-THROATED HUMMINGBIRD
ARCHILOCHUS COLUBRIS (Linnaeus)
STONE CRAB
MENIPPE MERCENARIA (Say)
VARIABLE COQUINA
Donax variabilis Say
Brown and black ink, [1772], 176 x 301 mm
"All from the Seacoast of Cape Fear No Carolina."
One of a set of thirteen drawings that Bartram sent to John Fothergill in 1772. The images helped persuade Fothergill to sponsor Bartram's travels through the Southeast for the next four years.

PAGE 84
BALSAM PEAR OR BITTER MELON
Momordica charantia L. (Cucurbitaceae)
Black ink, [1769], 398 x 295 mm
Bartram describes the opening of the tubercles of this Bitter Melon as "disclosing a scene of still greater beauty and wonder." He obtained a branch of this plant from a cultivated species raised by "Mr. Alexander the Proprieter's Gardner" and one of the first American-born professional gardeners. (Text from illustration)

PAGE 86
NETTED OLIVE
Oliva reticularis Lamarck
Brown ink, [1772], 90 x 177 mm
Bartram had sent several drawings of shells to patrons in England in the late 1760s. These ended up in the collection of the Duchess of Portland, which was dispersed soon after her death. The whereabouts of the Bartram drawings are unknown.

PAGE 87
SPOTTED TURTLE
Clemmys guttata (Schneider)
MILK SNAKE OR CORN SNAKE
Lampropeltis triangulum triangulum (Lace-pede) or *Elaphe guttata* (Linnaeus)
Watercolor and black ink, [1769], 238 x 298 mm

The first drawings completed for John Fothergill included this one of the tortoise and snake. Fothergill had asked Bartram to draw all the tortoises of the region and this drawing was his first contribution.

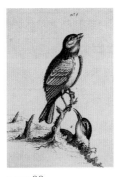

PAGE 88
PINE WOODS SPARROW (FIG. 1)
Aimophila aestivalis (Lichtenstein)
"The little brown Sparrow of Florida or Savanah bird sings most sweetly during the Summer Season."
CAROLINA WREN (FIG. 2)
Thryothorus ludovicianus ludovicianus (Latham)
Brown ink, [1772], 173 x 152 mm
"The largest Wren, of a redish brown colour beautifully marked with transverse lines, Throat breast & belly Cream colour." (verso of illustration)

PAGE 89
MALLARD
Anas platyrhynchos platyrhynchos Linnaeus
Blue ink, [1774], 200 x 243 mm
"The great Mallard of Florida. . . . They arrive in Carolina & Florida at the approach of Winter"

Bartram was probably the most knowledge-able person during his lifetime about the birds of North America, including bird migration. He wrote that the priests and philosophers of the ancients saw the study of the passage of birds as of "real and indispensable use to the state, next to astronomy." (*Travels*, 285)

PAGE 91
EASTERN COACHWHIP
Masticophis flagellum flagellum (Shaw)
Black ink and watercolor, [1774], 215 x 269 mm
Coach whip snake from Et Florida

Bartram came across this snake struggling with a large hawk while out riding one morning. He alighted from his horse intent on "parting them; when, on coming up, they mutually agreed to separate themselves, each one seeking their own safety, probably considering me as their common enemy." (*Travels*, 218–19)

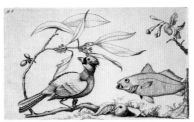

PAGE 92
DEVILWOOD OR WILD OLIVE
Osmanthus americanus (L.) A. Gray (Oleaceae)
CARDINAL (POSSIBLY NORTHERN CARDINAL)
Cardinalis cardinalis (Linnaeus)
CRAB APPLE
Pyrus angustifolia Aiton (Rosaceae)
ATLANTIC CROAKER
Micropogonias undulatus (Linnaeus)
Brown ink, 1772, 181 x 304 mm

A wonderful example of an almost surreal drawing in which Bartram has consciously framed the bird and fish within the beautifully curved Devilwood and Crab Apple.

PAGE 98
MAP FROM WILLIAM BARTRAM'S JOURNAL
Printed map with crayon, 180 x 280 mm
Map of Bartram's travels with his routes marked in red.

This map has been bound in with his journal but was probably done much later by some-one at the Natural History Museum, or pos-sibly by Joseph Ewan on one of his visits.

PAGE 112
FLY-POISON
Amianthium muscitoxicum (Walter) A. Gray
(Liliaceae)

Black ink and watercolor, [1773],
304 x 178 mm

Bartram describes how this plant was used as
a poison to kill flies in Georgia. The root was
bruised and soaked in water overnight. Hon-
ey or treacle was added and a dish laid out
"into which the Flys swarm & almost instantly
[after] tasting the fatal Nectar turn giddy and
die in incredible numbers. On this account it
is a most useful Plant." (Journal, 1:7–8)

PAGE 113
FEVER BARK
Pinckneya bracteata (W. Bartram) Raf.
(Rubiaceae)

Black ink and watercolor, [1773],
181 x 162 mm

In 1765 Bartram was traveling through the
Southeast with his father when they lost their
way along the Altamaha River, ending up
four miles south of Fort Barrington, Georgia,
where they were lodging. Here they "found
severall very curious shrubs." One was the
Fever Bark; the other was *Franklinia*.

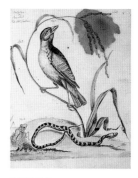

PAGE 114
BOBOLINK (FIG. 1)
Dolichonyx oryzivorus (Linnaeus)
RICE (FIG. 2)
Oryza sativa L. (Gramineae)
IMMATURE CORN SNAKE (FIG. 3)
Elaphe guttata guttata (Linnaeus)
GREEN TREE FROG (FIG. 4)
Hyla cinerea cinerea (Schneider)

Black ink over graphite and watercolor,
[1774/75], 256 x 202 mm

The Bobolink depicted here is either a female
or a nonbreeding male. Mentioning the snake
in his Journal, Bartram had this to say: "I
have seen a pretty little snake about 12 inches
long, small, round bodied, speckled with dark
redish brown spots on a dove col'd ground,
but take it to be a young wampo[m] snake."
(Journal, 2:53)

PAGE 117
OAKLEAF HYDRANGEA
Hydrangea quercifolia W. Bartram
(Hydrangeaceae)

Watercolor and brown ink, 1788,
250 x 199 mm

Bartram completed a similar drawing of this
plant, which he included in *Travels*.

PAGE 118
**BANDANA OF THE EVERGLADES OR
GOLDEN CANNA**
Canna flaccida Salisb. (Cannaceae)
STONE PIPE-BOWL
GASTROPOD
INSECT

Black and brown ink, [1776], 249 x 188 mm

During Bartram's travels from the Mississippi
River to Georgia in 1775, he passed through
the Native American town of Mucclasse.
Here he was presented to one of the elders, a
blind old chief, who gave him a present of a
stone pipe-bowl and some tobacco. Bartram
included the present in this drawing.

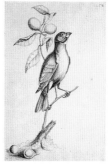

PAGE 126
PHYSIC NUT OR INDIAN OLIVE
Nestronia umbellula Raf. (Santalaceae)
EVENING GROSBEAK
Possibly a female *Coccothraustes
vespertinus* (Cooper)

Black ink, [1776], 276 x 181 mm

The bird is difficult to identify. It bears a re-
semblance to a female Evening Grosbeak, but
this species rarely travels as far south as South
Carolina or Georgia, where Bartram drew
it. The Physic Nut, Bartram explained, was
an "Indian name" and it was carried while
hunting, "supposing it to have the power of
attracting deer." (Book E Mss. to Barclay)

PAGE 130
**LARGEROOT OR INDIAN-MIDDEN
MORNING GLORY**
Ipomoea macrorhiza Michx. (Convolvulaceae)
Black ink, [1776], 239 x 190 mm
This Morning Glory blooms only in the late evening and early in the morning and is said to thrive on kitchen middens (the name applied to shell mounds made by Native Americans), hence one of its common names.

PAGE 132
WILLIAM BARTRAM (1739–1823)
LONG WARRIOR
Mico Chlucco, King of the Seminoles
Engraving, 1791, 177 x 110 mm
This is the only known drawing that Bartram completed of a Native American. It was first used to raise subscriptions for his book and then placed as the frontispiece for *Travels*.

PAGE 134
PRAIRIE WARBLER
Dendroica discolor (Vieillot)
VARIOUS SHELLS
Brown ink, [1772], 305 x 186 mm
Bartram calls this bird *Muscicapa*, flycatcher, which he lists in his *Travels* and describes as "the little olive col[ore]d flycatcher." Bartram noted that it appeared in North Carolina at the beginning of April and continued northward to breed.

PAGE 137
BLUEGILL
Lepomis macrochirus mystacalis Cope
Black ink, 1774, 200 x 273 mm
Great Black Bream of St. John's E Florida, WB
"This beautiful fish is plentiful in all Fresh water Rivers Springs & holes in Et. Florida. His mouth appears remarkably small but by means of moveable Plates is capable of being extended wide enough to take young fish which is their prey." (Bartram Mss. Text for Tab. I–XVIII) Bartram's descriptions of fish, as of birds and plants, reveal an excellent knowledge of anatomy.

PAGE 138
STRAWBERRY
Fragaria sp. L. (Rosaceae)
PINELAND DAISY
Chaptalia tomentosa Vent. (Compositae)
VIOLET
Viola emarginata (Nutt.) LeConte (Violaceae)
Brown ink, [1772], 183 x 302 mm
Bartram completed this drawing of the strawberry several years before his encounter with the "young, innocent Cherokee virgins." It grew "in or near to the Savanas in North Carolina," where Bartram was staying in 1772.

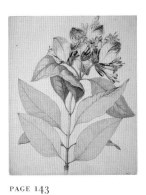

PAGE 143
FEVER BARK
Pinckneya bracteata (W. Bartram) Raf. (Rubiaceae)
Watercolor and brown ink, [1788], 238 x 202 mm
William first discovered this plant while traveling with his father in East Florida in 1765. He drew this illustration and sent it to Robert Barclay in 1788 along with the *Franklinia* watercolor. In his letter to Barclay, he wrote: "If it should prove to be a New Genus, I have a Request that it may be call'd *Bartramia (bracteata)* in Memory of my Father John Bartram deceas'd." (Bartram Mss., letter to Robert Barclay)

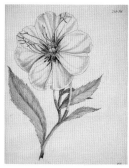

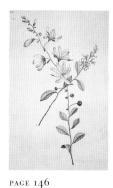

PAGE 144
EVENING PRIMROSE
Oenothera grandiflora L'Hér. (Onagraceae)
Watercolor and brown ink, [1788],
249 x 201 mm
William Bartram discovered this plant "growing in the old fields of the rich low lands on the Mobile River, Wst. Florida. I bro't the Ripe seeds to Pensylvania where they grew in equal perfection in the open garden."
(Bartram Mss., letter to Robert Barclay)

PAGE 146
TARFLOWER
Bejaria racemosa Vent. (Ericaceae)
ELLIOTTIA OR GEORGIA PLUME
Elliottia racemosa Muhl. ex Elliott (Ericaceae)
Watercolor and black ink, [1774],
380 x 244 mm
The Elliottia was named for the South Carolina botanist Stephen Elliott, who was thought to have discovered this plant in 1808. It is now listed as threatened in Georgia.

PAGE 147
PURPLE GERARDIA (FIG. 1)
Agalinis fasciculata (Elliott) Raf. (Scrophulariaceae)
WILLOW PRIMROSE (FIG. 2)
Ludwigia leptocarpa (Nutt.) H. Hara (Onagraceae)
YELLOW BUTTERWORT (FIG. 3)
Pinguicula lutea Walter (Lentibulariaceae)
Black ink and watercolor, [1774],
386 x 242 mm
All three of these plants were potential new species that could have been named for Bartram. Each was described and named several decades after Bartram completed the drawing and sent specimens of the plants to John Fothergill in London.

PAGE 148
WARMOUTH
Lepomis gulosus (Cuvier)
Watercolor and black ink, 1774, 98 x 294 mm
Great Yellow Bream call'd Old Wife of St. Johns E Florida, WB
Bartram encountered several species of fish in his *Travels*. One evening he mused about the Warmouth: "What a most beautiful creature is this fish before me! Gliding to and fro, and figuring in the still clear waters, with his orient attendants and associates . . . a warrior in a gilded coat of mail." (*Travels*, 153)

PAGE 150
AMERICAN LOTUS (FIG. 1)
Nelumbo lutea Willd. (Nymphaeaceae)
WHITELIP SNAIL (FIG. 2)
Triodopsis albolabris (Say)
RUBY-THROATED HUMMINGBIRD
Possibly *Archilochus colubris* (Linnaeus)
BLACK-ROOT
Pterocaulon pycnostachyum (Michx.) Elliott (Compositae)
ARROW ARUM
Peltandra virginica (L.) Schott (Araceae)
UNIDENTIFIED SNAKE, DRAGONFLY, AND FROG
Watercolor and black ink, [1769],
240 x 299 mm
John Fothergill was so impressed by the drawings he saw at Peter Collinson's house in 1768 that he asked Bartram to execute some for himself. This is one of a set of three that he sent to Fothergill in 1769.

PAGE 151
TARFLOWER
Bejaria racemosa Vent. (Ericaceae)
Black ink, [1774/75], 235 x 366 mm
This sketch is on the verso of the drawing of the alligators and is accompanied by a large amount of text that describes the characters of the plant "according to the Linnaean System of Botany." There is also a caption in a legible hand describing the actions of the alligators.

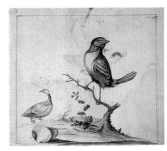

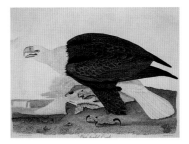

PAGE 158
WITCH HAZEL
Hamamelis virginiana L. (Hamamelidaceae)

Brown ink, [1772], 157 x 196 mm

This is one of the plants grown in the Bartram garden and offered for sale through the Bartrams catalogue of 1783, *Catalogue of American Trees, Shrubs and Herbacious Plants.*

PAGE 159
SWAMP SPARROW
Melospiza georgiana (Latham)
SNOW GOOSE
Chen caerulescens caerulescens (Linnaeus)
FRESH WATER CLAM OF FLORIDA
Unidentified

Black ink and watercolor, [1774/75], 206 x 244 mm

The bird that Bartram called the "grey" or Brant Goose and that others have called the Blue-winged Goose is in fact the blue phase of the Snow Goose. Bartram noted that these birds arrived in Pennsylvania in the autumn and "continued their journeys as far as South Carolina and Florida." (*Travels*, 289)

PAGE 160
ALEXANDER WILSON (1766–1813)
BALD EAGLE
Haliaeetus leucocephalus (Linnaeus)

Hand-colored engraving, 1811, 340 x 260 mm

The background of this engraving is Niagara Falls, the location of Wilson's first expedition in 1804. He called this bird the White-headed Eagle. (*American Ornithology*, vol. 4, plate 36)

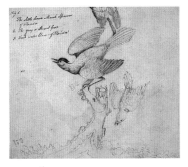

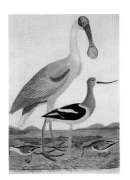

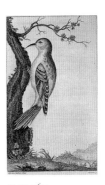

PAGE 163
BLUE JAY
Possibly *Cyanocitta cristata* (Linnaeus)
FLORIDA SCRUB JAY
Possibly *Aphelocoma coerulescens* (Bosc)

Brown ink, [1774/75], 206 x 244 mm

Bartram never completed this sketch of a Blue Jay and Florida Scrub Jay.

PAGE 165
ALEXANDER WILSON (1766–1813)
ROSEATE SPOONBILL
Ajaia ajaja (Linnaeus)

Hand-colored engraving, 1813, 345 x 260 mm

The Roseate Spoonbill was another bird that ended up at Peale's Museum. Wilson had received the bird from the William Dunbar family of Natchez, Mississippi. This family was one of many in the army of bird spotters that Wilson relied on from around the country. (*American Ornithology*, vol. 7, plate 63)

PAGE 167
ANNE (NANCY) BARTRAM (1779–1858)
BROWN CREEPER
Certhia Americana Bonaparte

Engraving, 1805, 220 x 130 mm

"Correctly copied from an elegant drawing by Miss Anne Bartram, of Kingsess, near Philadelphia" (BSBarton). (*The Philadelphia Medical & Physical Journal*, Plate 4)

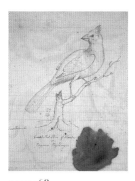

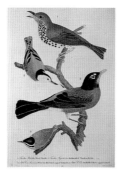

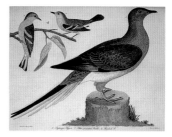

PAGE 168
FLORIDA CARDINAL
Cardinalis cardinalis floridanus Ridgeway

Black ink over graphite, [1774/75],
256 x 202 mm

Crested Red Bird of Florida or Virginia Nightingale. This bird is a subspecies of the Northern Cardinal. The sketch was never developed into a full watercolor drawing, which is a shame because these birds are a beautiful bright red.

PAGE 171
ALEXANDER WILSON (1766–1813)
WOOD THRUSH
Hylocichla mustelina (J. F. Gmelin)

Hand-colored engraving, 1808, 345 x 260 mm

The name Wilson gave to this bird was *Turdus melodus,* which he adopted from "Mr. William Bartram, who seems to have been the first and almost only naturalist who has taken notice of the merits of this bird" (1:29). (*American Ornithology,* vol. 1, plate 2)

PAGE 172
ALEXANDER WILSON (1766–1813)
PASSENGER PIGEON
Ectopistes migratorius (Linnaeus)

Hand-colored engraving, 1812, 340 x 260 mm

The Passenger Pigeon is now extinct, but when Wilson drew this bird he witnessed seeing millions of them fill the sky for days on end on their migratory journey. He remarked that the birds gathered in such "prodigious numbers as almost to surpass belief." (*American Ornithology,* vol. 5, plate 44)

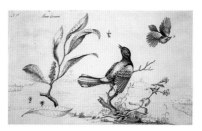

PAGE 174
JOHN JAMES AUDUBON (1785–1851)
CAROLINA PARAKEET
Conuropsis carolinensis (Linnaeus)

Hand-colored engraving, 1827–38, Double Elephant Folio

The Carolina Parakeet is now extinct, the last remaining two birds having died in the Cincinnati Zoo in 1914. Audubon commented on their decline in 1832: "Our Parakeets are very rapidly diminishing in number." The main cause for extinction has been attributed to the rapid cultivation of the land. (*Birds of America,* plate XXVI)

PAGE 175
CAROLINA CHERRY LAUREL
Prunus caroliniana Aiton (Rosaceae)
**MYRTLE WARBLER OR
YELLOW-RUMPED WARBLER**
Dendroica coronata (Linnaeus)
FIRE PINK
Silene virginica L. (Caryophyllaceae)

Pen and brown ink, 1772, 180 x 304 mm

One of Bartram's perspectives on nature was that species are interdependent, particularly within the food chain. For this reason he liked to depict animals in the act of pursuing or consuming their prey.

PAGE 176
BLACK VULTURE
Coragyps atratus (Bechstein)

Black ink and watercolor, 1774, 242 x 319 mm

The Caron Crow of Florida: Head and foot of the Caron Crow size of life

Bartram described this bird as being "heavy on the wing" and having a "heavy laborious flight." The Black Vulture is most common in central Florida and remains in the Southeast throughout the year. Its range is from Texas through Florida and north to Pennsylvania. It is listed as threatened in North Carolina.

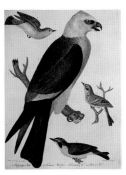

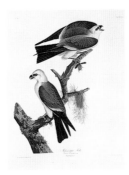

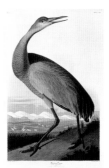

PAGE 177
ALEXANDER WILSON (1766–1813)
MISSISSIPPI KITE
Ictinia mississippiensis (Wilson)
Hand-colored engraving, 1811, 340 x 260 mm
See Audubon No. 94 (*American Ornithology*, vol. 3, plate 25)

PAGE 177
JOHN JAMES AUDUBON (1785–1851)
MISSISSIPPI KITE
Ictinia mississippiensis (Wilson)
Hand-colored engraving, 1827–38, Double Elephant Folio
Wilson published his drawing of the male Kite in 1811. In Audubon's plate, figure 2 is described as a female, but is the mirror image of Wilson's bird. The original drawing by Audubon in 1821 does not include Wilson's image. Whether it was added by Audubon or his engraver, Robert Havell, is not known. (*Birds of America*, plate CXVI)

PAGE 178
JOHN JAMES AUDUBON (1785–1851)
SANDHILL CRANE
Grus Canadensis (Linnaeus)
Hand-colored engraving, 1827–38, Double Elephant Folio
Audubon called this bird the Hooping Crane, *Grus Americana*, mistaking it for a juvenile of the Whooping Crane, in fact a separate species. (*Birds of America*, plate CCLXI)

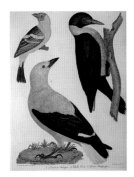

PAGE 179
ALEXANDER WILSON (1766–1813)
LEWIS'S WOODPECKER
Melanerpes lewis (G. R. Gray)
WESTERN TANAGER (LOUISIANA TANAGER)
Piranga ludoviciana (Wilson)
CLARK'S NUTCRACKER (CLARK'S CROW)
Nucifraga columbiana (Wilson)
Hand-colored engraving, 1811, 340 x 260 mm
The birds depicted here were brought back from the Lewis and Clark Expedition to the Pacific Ocean. They were kept at Peale's Museum in Philadelphia, where Wilson went to illustrate them. (*American Ornithology*, vol. 3, plate 20)

PAGE 185
TITIAN RAMSAY PEALE (1799–1866)
SPHINX MOTH
Sphingidae *Smerinthus jamaicensis* (Drury)
Hand-colored engraving, 1824–28, 225 x 140 mm (page size)
Titian Peale was the principal illustrator for Thomas Say's work, having completed six plates for Say as early as 1817, when Peale was only eighteen. (*American Entomology*, vol. 1, plate 12)

PAGE 187
RUELLIA OR WILD PETUNIA
Ruellia caroliniensis (Walter) Steud. (Acanthaceae)
Black ink, [1775], 149 x 93 mm
"Roella near Sea coast of Georgia
This beautiful plant grows 3 or 4 inches high producing long blue Purple Flowers." (verso of illustration)

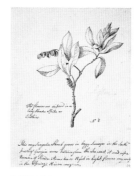

PAGE 188
RED-BREAST SUNFISH
Lepomis auritus (Linnaeus)

Black ink over graphite, 1774, 246 x 294 mm

Red bellied Bream of St. John's E. Florida

This fish was drawn on St. Johns River, East Florida, but Bartram, early in his travels, describes a similarly named species from Liberty County, Georgia. "Towards the evening we made a little party at fishing. We chose a shaded retreat, in a beautiful grove of magnolias, myrtles and sweet bay trees. We presently took some fish, one kind of which is very beautiful; they call the red-belly." (*Travels*, 11–12)

PAGE 190
LUCY SAY (1801–1866)
BUTTERFLY MUSSEL
Ellipsaria lineolata (Rafinesque)

Hand-colored engraving, 1834, 200 x 130 mm (plate size)

Thomas Say's *American Conchology* was published in seven parts. Parts 1–6 were published in 1832–34; part 7 was published after Say's death in 1836. It was completed and edited by Timothy A. Conrad. Lucy Say, Thomas's wife, was the artist for 66 of the 68 plates. (*American Conchology*, plate 68)

PAGE 194
BUCKWHEAT TREE
Cliftonia monophylla (Lam.)Britton ex Sarg. (Cyrillaceae)

Black and brown ink, [1773], 177 x 138 mm

Bartram was the first to record this plant, but Daniel Solander, who studied Bartram's specimen and drawing, named it after William Clifton, governor of West Florida. Joseph Ewan has identified the penciled name *Cliftonia* as being in the hand of Daniel Solander.

Bartram describes it as growing in "boggy swamps in the South'n parts of Georgia some distance from the sea coast."

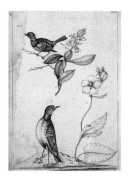

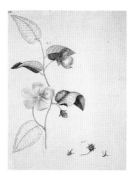

PAGE 197
ACADIAN FLYCATCHER
Empidonax virescens (Vieillot)

ELLIOTTIA OR GEORGIA PLUME
Elliottia racemosa Muhl. (Ericaceae)

POPPY MALLOW
Callirhoe triangulata (Leavenw.) A. Gray (Malvaceae)

AMERICAN PIPIT
Anthus rubescens rubescens (Tunstall)

Blue ink and watercolor, [1774/75], 327 x 248 mm

Bartram referred to the Poppy Mallow as "purple malva" and the Pipit as "a little brown Lark." (verso of illustration)

PAGE 198
PAVONIA OR GINGERBUSH
Pavonia spinifex (L.) Cav. (Malvaceae)

Black ink and watercolor, [1774], 382 x 245 mm

Believed to be native to South and Central America, the Gingerbush has naturalized in Florida. The epithet *spinifex* means "bearing spines." In this plant the mericarp has three spinelike awns that attach themselves to fur or clothes. The awns can be seen in the lower right of the drawing.

PAGE 201
FLORIDA SOFTSHELL
Apalone ferox (Schneider)

Black ink, 1774, 319 x 242 mm

Soft Shell Tortoise Et. Florida

Bartram had been asked several times to draw the tortoises of North America for patrons in England, but he never succeeded in completing the full list of species. He included a more detailed image of the soft-shelled tortoise in *Travels*.

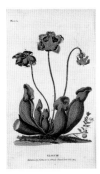

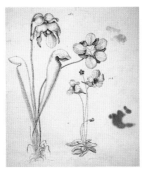

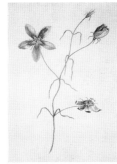

PAGE 204

WILLIAM BARTRAM (1739–1823)
PURPLE PITCHER PLANT
Sarracenia purpurea L. (Sarraceniaceae)
AMERICAN CRANBERRY
Vaccinium macrocarpon Aiton (Ericaceae)
Hand-colored engraving, 1804 (published),
233 x 140 mm

This is one of many drawings that Bartram
completed for Benjamin Smith Barton, who
praises William's skills in the introduction to
this work. (*Elements of Botany*, Plate 1)

PAGE 207

HOODED PITCHER PLANT (FIG. 3)
Sarracenia minor Walter (Sarraceniaceae)
BUTTERWORT (FIG. 4)
Pinguicula caerulea Walter (Lentibulariaceae)
Black ink, [1773], 289 x 238 mm

The *Sarracenia minor* is one of the most com-
mon and widespread of the pitcher plants in
the southeastern United States, but it is now
on the threatened species list in Florida. As
the Michaux traveled south, they too would
have come across these plants.

PAGE 208

LARGEFLOWER ROSE GENTIAN
Sabatia grandiflora (A. Gray) Small
(Gentianaceae)
Watercolor, [1774], 379 x 243 mm

Bartram described this plant with one of his
specimens as "a charming inhabitant of our
vast flowering Savanahs & is as distinguished
a beauty as any in Florida . . . rises 3 or 4 feet
high deviding at top into numerous slender
branches, at the extremities of which sits this
lovely Pink col'd flower, having a golden
starr in the midst & is extremely fragrant."
(Book 1, *East Florida Plants*) It is often con-
fused with the Marsh Pink, *Sabatia stellaris*,
both of which are widespread in Florida.

PAGE 213

CHARLES WILLSON PEALE
(1741–1827)
Portrait of William Bartram, 1808, oil on
canvas. The only known portrait of William
Bartram. Peale was the principal portrait artist
of the day, specializing in figures of the Amer-
ican Revolution. He included this painting in
his museum collection. The plant is a sprig of
Jasmine, *Jasminum officinale* L. (Oleaceae).

Biographical Notes

ABBOT, JOHN (1751–1840) Born in London and left for Virginia in 1773. Two years later he moved to Georgia, where he remained until his death. He dedicated his life to collecting and drawing insects and birds.

AUDUBON, JOHN JAMES (1785–1851) Born in Santo Domingo (now Haiti) but was raised in southwestern France. Returned to America at the age of eighteen. Published 435 elephant-folio-size drawings of birds for his book *The Birds of America* (1827–38).

BALDWIN, WILLIAM (1779–1819) Born to a Quaker family in Chester County, Pennsylvania. After qualifying as a physician, he moved to Wilmington, Delaware, and later to Georgia. Collected plants in the area where Bartram traveled, using *Travels* as his guide. Appointed as botanist on the Major Long Expedition of 1819–20.

BANISTER, JOHN (1650–1692) Early plant collector who traveled to North America, collecting for Bishop Compton of Lambeth.

BANKS, SIR JOSEPH (1743–1820) FRS. A leading figure in natural history and president of the Royal Society of London for forty-one years. Accompanied Captain Cook on the *Endeavour* voyage (1768–71). His library and collections were presented to the British Museum in 1827. Part of the collection was the Fothergill album containing William Bartram's drawings and manuscripts.

BARCLAY, DAVID (1729–1809) Member of the influential Quaker family living in Cheapside, London. He was the uncle of Robert Barclay and friend of John Fothergill.

BARCLAY, ROBERT (1751–1830) Born in Philadelphia but moved to England as a child. Lived in Cheapside with his uncle's family. Friend of William Bartram, who sent him the portrait of *Franklinia* in 1788.

BARTON, BENJAMIN SMITH (1766–1815) Friend of William Bartram and author of the first botanical textbook in America, *Elements of Botany*. Appointed in 1789 as the first professor of botany and natural history at the University of Pennsylvania. In 1795 he was appointed professor of Materia Medica.

BARTON, WILLIAM P. C. (1786–1856) Nephew of Benjamin Smith Barton. Surgeon in the American navy. Appointed professor of botany at the University of Pennsylvania in 1815.

BARTRAM, ANN MENDENHALL (D. C. 1784) Second wife of John Bartram and mother of William Bartram.

BARTRAM, ANN (1741–1777) Sister of William Bartram.

BARTRAM, ANN (CALLED NANCY) (1779–1858) Niece of William Bartram, daughter of John Bartram Jr. Married Robert Carr. Inherited the garden and nursery from her father after his death in 1812.

BARTRAM, BENJAMIN (1748–1826) Youngest brother of William Bartram.

BARTRAM, ELIZABETH (1739–1824) Twin sister of William Bartram.

BARTRAM, GEORGE Married William Bartram's sister Ann.

BARTRAM, ISAAC (1725–1801) Second son of John Bartram and Mary Maris (d. 1727), John's first wife. He settled in Philadelphia as an apothecary. Member of the

American Philosophical Society and for several years served as the curator.

BARTRAM, JAMES (1730–?1814) Brother of William Bartram and first son of John and Ann Bartram.

BARTRAM, JOHN (1699–1777) Father of William Bartram. Famous for his garden and nursery, from which he sent his five-guinea boxes of seeds to Europeans. He was appointed the King's Botanist in 1765.

BARTRAM, JOHN, JR. (1743–1812) Brother of William Bartram. Inherited the garden and nursery business from his father.

BARTRAM, MARY (1736–1817) Sister of William Bartram.

BARTRAM, MOSES (1732–1809) Brother of William Bartram. The only son of John Bartram to travel to England. Settled in Philadelphia and shared an apothecary practice with his brother Isaac. Member of the American Philosophical Society and wrote several articles for the APS Transactions.

BARTRAM, WILLIAM (1711–1772) John Bartram's half-brother and uncle of William Bartram. It was this uncle with whom William stayed in North Carolina.

BARTRAM, WILLIAM (D. 1772) Son of William Bartram, John Bartram's half-brother in North Carolina and cousin to William Bartram.

BAUER, FRANZ ANDREAS (1758–1840) Austrian-born botanical artist who worked at the Botanic Gardens at Kew in London for forty years. Considered one of the greatest botanical artists of all time.

BREINTNALL, JOSEPH (D. 1746) Quaker merchant in Philadelphia, friend of Benjamin Franklin. Served as secretary of the Library Company. Introduced Peter Collinson to John Bartram.

BUFFON, GEORGE LOUIS LECLERC, COMTE DE (1707–1788) French naturalist and author of *Histoire Naturelle*, 44 vols. (1749–1804), the first popular work on natural history.

CARR, ANN (NANCY) *See* Ann Bartram.

CARR, ROBERT (1778–1858) Husband of Ann (Nancy) Bartram. Printer for Alexander Wilson's *American Ornithology*. Lived at the Bartram house at Kingsessing after his marriage.

CATESBY, MARK (1683–1749) FRS. English artist and naturalist. Twice visited North America, after which he published *The Natural History of Carolina, Florida, and the Bahama Islands* (1731–43).

CHALMERS, LIONEL (1715–1777) Scottish physician who settled in Charleston, South Carolina. Became the agent of William Bartram for Dr. John Fothergill during William's travels in the South.

CHILD, CAPTAIN JAMES Merchant in Philadelphia with whom William Bartram served his apprenticeship from 1756 to 1761.

COLDEN, CADWALLADER (1688–1776) Scottish physician who settled in America. Became governor of New York.

COLDEN, JANE (1724–1766) Daughter of Cadwallader Colden. The first American-born woman botanist. Prepared a manuscript on the flora of New York, *Flora Nov-Eboracensis*, with 341 line drawings of leaves.

COLLINSON, MICHAEL (1729–1795) Son of Peter Collinson, who, after his father's death, continued to act as agent for John Bartram's seed trade in England.

COLLINSON, PETER (1694–1768) FRS. Friend and correspondent of John Bartram. Agent for John Bartram's seed trade in England.

COWKEEPER A Seminole chief in Cuscowilla, Florida. Gave the name "Puc Puggy" (Flower Hunter) to William Bartram in 1774.

DOBBS, ARTHUR (1689–1765) Governor of North Carolina and the first to write to Peter Collinson of the *Dionaea muscipula*, Venus Flytrap.

DUNCAN, WILLIAM (BILLY) (B. 1778) Nephew of Alexander Wilson, who traveled to America with his uncle in 1794 and accompanied him on his trip to Niagara Falls in 1804.

EDWARDS, GEORGE (1693–1773) FRS. English artist and naturalist. Author of *A Natural History of Uncommon Birds*, 4 vols. (1743–51) and *Gleanings of Natural History*, 3 vols. (1758–64).

EHRET, GEORG DIONYSIUS (1708–1770) FRS. German-born botanical artist and botanist who settled in London in 1737. Became the most celebrated botanical artist of his day, working with Linnaeus and visiting Peter Collinson and his garden, where he drew many of its plants.

ELLIS, JOHN (1710–1776) FRS. Described and named *Dionaea muscipula*, Venus Flytrap.

FOTHERGILL, JOHN (1712–1780) FRS. Quaker and London physician with a passion for plants. His garden at Upton, Essex, was considered one of the most spectacular during his lifetime. Patron to William Bartram, 1773–76. The majority of the Bartram drawings in the Natural History Museum collection were originally sent to John Fothergill.

FRANKLIN, BENJAMIN (1706–1790) FRS. Friend of the Bartram family. In addition to his scientific and political eminence, he founded the Library Company and the American Philosophical Society.

GALPHIN, GEORGE (D. 1780) Owned a trading post at Silver Bluff on the Savannah River. Because of his influence over the Lower Creek Indians, he became the rival of John Stuart, the Superintendent of Indian Affairs.

GARDEN, ALEXANDER (1730–1791) FRS. Scottish physician who practiced in Charleston, South Carolina. Returned to Britain after the revolution.

GORDON, JAMES (1708–1780) Gardener to Lord Petre and later had his own nursery at Mile End in London.

HAMILTON, WILLIAM (D. 1813) Owner of "The Woodlands," a few miles from the Bartram garden, one of the most splendid landscape gardens of its time in North America.

HILL, JOHN (1716–1775) English physician and botanist. Tutor to William Young when Young paid his first visit to England as the Queen's Botanist.

HUMBOLDT, ALEXANDER VON (1769–1859) German-born scientist and naturalist who traveled through South America from 1799 to 1804 researching and collecting the natural history of the continent. On his return journey he spent six weeks in the United States as the guest of Thomas Jefferson.

JEFFERSON, THOMAS (1743–1826) President of the United States, 1801–9. Friend and correspondent of William Bartram. Resided across the Schuylkill River from Bartram, 1790–93.

KALM, PETER (1715–1779) Student of Linnaeus. Visited America and the Bartram household in 1748.

KING, WILLIAM (FL. 1750S) Botanical artist of whom very little is known. Visited Peter Collinson's garden to draw plants.

LAMBOLL, THOMAS (1694–1774) Planter in Charleston, South Carolina, at whose house William lodged when in Charleston during his travels.

LAURENS, HENRY (1724–1792) Friend of John Bartram and father figure to William. Later became president of the Second Continental Congress (1777–78).

LAWSON, ALEXANDER (DATES UNKNOWN) Engraver for Alexander Wilson's *American Ornithology* (1808–14).

LESUEUR, CHARLES ALEXANDER (1778–1846) French naturalist. He was Thomas Say's closest friend and one of the illustrators for *American Entomology*.

LETTSOM, JOHN COAKLEY (1744–1815) FRS. Quaker physician born in the Caribbean but settled in London. Friend and biographer of John Fothergill.

LINNAEUS, CAROLUS (1707–1778) Swedish botanist. Known, among other things, as the father of the modern plant classification system and the binomial system of taxonomic nomenclature.

LOGAN, JAMES (1674–1751) Secretary to William Penn. Considered the first scientist of Philadelphia, friend of John Bartram. Owner of the foremost scientific library in America.

LYON, JOHN (D. 1814) Scottish plant collector who traveled in North America. Made the last recorded sighting of *Franklinia alatamaha* in the wild in 1803.

McINTOSH, JOHN (1757–1792) Son of Lachlan McIntosh and young companion of William Bartram in the early days of Bartram's travels, May to August 1773.

McINTOSH, LACHLAN (D. 1806) Head of a large family who adopted William Bartram as a family member while he was traveling in Georgia. Rose to the rank of major general for his part in the War of Independence.

MACLURE, WILLIAM (1763–1840) Born in Scotland but made his home in America. Studied geology and was the financial mainstay of the early years of the Academy of Natural Sciences in Philadelphia. Friend and father figure to Thomas Say, with whom he was a founding member of the community at New Harmony, Indiana.

MARSHALL, HUMPHRY (1722–1801) Cousin of John Bartram. Owner of a nursery business and author of *Arbustum Americanum* (1785).

MARSHALL, MOSES (1758–1813) Nephew of Humphry Marshall. Assisted his uncle in the horticultural and nursery business.

MICHAUX, ANDRÉ (1746–1802) French naturalist. Traveled to America in 1785 for the French government in search of new plants, particularly trees, that would grow well in France. Established two gardens in America, one in New Jersey the other in Charleston, South Carolina.

MICHAUX, FRANÇOIS ANDRÉ (1770–1855) Son of André Michaux. French naturalist and author of *Histoire des Arbres forestiers de l'Amerique septentrionale* (1810).

MICO CHLUCCO, King of the Seminoles. His portrait by William Bartram was used as the frontispiece for *Travels* (1791).

MILLER, JOHN FREDERICK (FL. 1770–90S) Son of Johann Sebastian Mueller from Nuremberg, who was himself

a well-known botanical artist. John Frederick produced one of the first illustrations of the Venus Flytrap in flower in 1772.

MILLER, PHILIP (1691–1771) FRS. Director of Chelsea Physic Garden in London. Author of *The Gardeners Dictionary* (1731).

MILLER, SARAH (B. 1781) Alexander Wilson's probable bride-to-be and to whom he willed all rights and interests in *American Ornithology*.

MUHLENBERG, HENRY (1753–1815) Lutheran minister from Lancaster, Pennsylvania. He was an avid botanist and correspondent of William Bartram.

NUTTALL, THOMAS (1786–1859) English-born naturalist who lived in the United States for thirty-four years and published *The North American Sylva, or, A description of the forest trees of the United States* . . . (1842–49).

ORD, GEORGE (1781–1866) Friend of William Bartram and Alexander Wilson. Completed Wilson's last volume of *American Ornithology*.

PAINE, THOMAS (1737–1809) English revolutionary. Author of *Common Sense* (1776) and *The Rights of Man* (1791).

PARRISH, ROBERT (DATES UNKNOWN) Friend of William Bartram in Philadelphia. Raised subscriptions for *Travels* when he was in New York (1790), signing up President George Washington and Vice President John Adams, among others.

PEALE, CHARLES WILLSON (1741–1827) Portrait artist and founder of the first public museum in the United States in Philadelphia in 1786, known as Peale's Museum.

PEALE, TITIAN RAMSAY (1799–1885) Youngest son of Charles Willson Peale. An artist and naturalist, he was the principal illustrator of Thomas Say's *American Entomology*. Elected to the Academy of Natural Sciences, Philadelphia, at the age of eighteen. Appointed assistant naturalist and painter on the Major Long Expedition (1819–21).

PENN, THOMAS (1702–1775) Son of William Penn. Corresponded with William Young, the first person to bring living specimens of *Dionaea muscipula*, Venus Flytrap, to Europe.

PENN, WILLIAM (1644–1718) Proprietor of Pennsylvania, obtaining the Charter in 1681. The colony was for Penn a "holy experiment," a refuge for religious dissenters persecuted in Britain.

PETRE, ROBERT JAMES, EIGHTH BARON (1713–1742) FRS. Owner of Thorndon Hall, Essex, England, and its magnificent garden.

PORTLAND, MARGARET CAVENDISH, DUCHESS OF (1715–1785) A passionate collector of natural-history specimens and drawings. Requested drawings of shells from William Bartram during the late 1760s and early 1770s. Several Bartram drawings were sent to the duchess. After her death her enormous collection was sold at auction and the whereabouts of the Bartram drawings are unknown.

"PUC PUGGY" (Flower Hunter) Native American name given to William Bartram by Cowkeeper, a Seminole chief (1774).

RAFINESQUE, CONSTANTINE (1783–1840) Born in Constantinople and brought up in France and Italy. Worked for two years in Philadelphia and finally settled in America in 1815, where he became professor of botany at Transylvania University, Kentucky, 1819–26.

RUSH, BENJAMIN (1746–1813) Eminent Philadelphia physician and signer of the Declaration of Independence.

SAY, BENJAMIN (1755–1813) Father of Thomas Say, married William Bartram's niece Ann Bonsall.

SAY, THOMAS (1787–1834) Father of American entomology, grandnephew of William Bartram.

SISTARE, LUCY WAY (1801–1886) Wife of Thomas Say and the first woman elected to the Academy of Natural Sciences in Philadelphia.

SLOANE, SIR HANS (1660–1753) British physician, founder of the British Museum, and author of *A Voyage to the Islands Madeira, Barbados, Nieves, S. Christophers and Jamaica* (1707–25).

SOLANDER, DANIEL (1736–1782) Swedish-born student of Linnaeus. Moved to England in 1759 through the invitation of Peter Collinson. Became the secretary and librarian for Sir Joseph Banks, with whom he traveled on Captain Cook's voyage of the *Endeavour* (1768–71).

SPALDING, JAMES (1734–1794) Owner of two trading stores on the St. Johns River in Florida, which William used as a base during his travels.

STORY, ENOCH (DATES UNKNOWN) Publisher in Philadelphia. Offered to publish Bartram's *Travels* in 1786.

STUART, JOHN (1718–1779) Superintendent of Indian Affairs for the Southern Department.

STUART, JOHN 3RD EARL OF BUTE (1713–1792) Prime Minister under George III. Assisted in the remodeling of the Botanic Gardens at Kew in London. Author of the nine-volume *Botanical Tables Containing the Families of British Plants* (1785). Friend of John Hill, who dedicated his *Vegetable System* (1759–75) to Bute.

THOMAS, MARY LAMBOLL (D. 1817) Daughter of Thomas Lamboll. William Bartram lodged at her house in Charleston in 1766 before returning to Philadelphia. It was here that he left his trunk, which was returned to him in Philadelphia a decade later.

THOMSON, CHARLES (1729–1824) Tutor to William Bartram. Secretary of the Continental and Confederation Congress (1774–89).

WALTER, THOMAS (1740–1789) Born in Southampton, England. Settled in South Carolina, where he established a mercantile business. Author of *Flora Caroliniana* (1788).

WASHINGTON, GEORGE (1732–1799) First president of the United States (1789–97).

WATERTON, CHARLES (1782–1865) Born in Yorkshire, England, and squire of Walton Hall, where he is credited with founding the world's first nature reserve. Traveled in North and South America, wrote essays on natural history, chiefly ornithology. Became a defender of Alexander Wilson in the dispute between Audubon and George Ord.

WHITE KING Indian chief in Talahasochte, Florida, where William Bartram met him in 1774.

WILSON, ALEXANDER (1766–1813) Father of American ornithology. Protégé and friend of William Bartram.

YOUNG, WILLIAM (1742–1785) Neighbor of John and William Bartram. Appointed the Queen's Botanist in 1763. First to bring live specimens of *Dionaea muscipula*, Venus Flytrap, to Europe

FRS = Fellow of the Royal Society Of London

Notes

PROLOGUE

1. William Bartram, *Travels through North and South Carolina, Georgia, East and West Florida . . .*, 1791, 341–42. *Travels* was published fourteen years after Bartram returned from the South.

2. Thomas Jefferson, *Notes on the State of Virginia*, 1785. This rare publication was a response to questions by a "foreigner of Distinction, then residing among us."

3. *To the lovers of Natural history*, 6/4/1807. Proposals for publishing by subscription . . . *American Ornithology*, LOC. This was the traditional method of raising subscriptions prior to publishing a new work. Wilson needed to collect two hundred subscriptions before Samuel Bradford would commence printing.

4. For a detailed summary, see Oleson and Brown, eds., *The Pursuit of Knowledge in the Early American Republic.*

5. Brooke, *Science and Religion*, 152.

6. Lowes, Introduction to *The Travels of William Bartram*, 1940 edition.

7. Harper, ed., *The Travels of William Bartram.*

8. Fagin, *William Bartram*. Lowes, *The Road to Xanadu.*

9. Slaughter, *The Natures of John and William Bartram*. Cashin, *William Bartram and the American Revolution.*

10. Waselkov and Braund, *William Bartram on the Southeastern Indians.*

11. Darlington, *Memorials of John Bartram and Humphry Marshall*, in Berkeley and Berkeley, eds., *The Correspondence of John Bartram, 1734–1777* [hereafter Darlington, *Memorials*].

12. Hunter, *The Life and Letters of Alexander Wilson.*

13. Frazier, *Cold Mountain* (New York: Atlantic Monthly Press, 1997), 402. This novel was made into a Hollywood film in 2003.

CHAPTER 1

1. P. Collinson to J. Bartram, 6/12/1763, HSP BP.

2. Tindal, *Christianity as Old as the Creation* (1730), 23.

3. Jacques, *Georgian Gardens*, 28.

4. Loudon, *The Suburban Gardener, and Villa Companion* (1838), 162.

5. J. Bartram to Alexander Catcott, 26/5/1742, HSP BP.

6. Peter Collinson, "An Account of the Introduction of American Seeds into Great Britain: Memorandum," Ms. Botany Library, NHM.

7. P. Collinson to J. Bartram, 12/3/1735/36, HSP BP.

8. P. Collinson to J. Bartram, 1/9/1741, HSP BP.

9. J. Bartram to P. Collinson, 20/8/1753, HSP BP.

10. J. Bartram to J. Gronovius, 16/12/1754, Linnean Society Ward, Ms. 325.

11. P. Collinson to J. Bartram, 10/8/1753, HSP BP.

12. C. Colden to J. Gronovius, 1/10/1755, *American Journal of Science and Arts* 44 (1843).

13. P. Collinson to J. Bartram, 20/1/1756, HSP BP.

14. P. Collinson to C. Colden, 6/4/1757, N-YHS, Cadwallader Colden Papers, Box 5, 1750–57.

15. A. Garden to J. Ellis, 25/3/1755, in Smith, ed.,

A Selection of the Correspondence of Linnaeus, and Other Naturalists [hereafter Smith, *Linnaeus*].

16. P. Collinson to C. Linnaeus, 12/5/1756, in Smith, *Linnaeus*.

17. J. Ellis to C. Linnaeus, 25/4/1758, in Smith, *Linnaeus*.

18. Jane Colden, "Flora Nov-Eboracensis," Banks Mss. Collection No. 99, Botany Library, NHM.

19. *Journal of Botany British and Foreign* 33 (1895): 14.

20. C. Colden to J. Gronovius, 1/10/1755, "Selections from the Scientific Correspondence of C. Colden," *American Journal of Science and Arts* 44 (1843).

21. Vail, "Jane Colden, an Early New York Botanist," 32.

22. J. Bartram to P. Collinson, Fall 1753, HSP BP.

23. J. Bartram to J. Colden, 24/1/157, HSP BP.

CHAPTER 2

1. P. Collinson to J. Custis, 24/12/1737, Curwen Family Papers, American Antiquarian Society.

2. J. Bartram to Charles Magnus Wrangle, 6/7/1771, Royal Swedish Academy of Science.

3. J. Bartram to A. Garden, 14/3/1756, HSP BP.

4. J. Bartram to P. Collinson, 27/5/1743, HSP BP.

5. J. Bartram to J. Colden, 24/1/1757, HSP BP.

6. Edwards, *Gleanings of Natural History* 2:174.

7. J. Bartram to P. Collinson, 27/4/1755, HSP BP.

8. J. Bartram to A. Garden, 14/3/1756, HSP BP.

9. P. Collinson to J. Bartram, 20/1/1756, HSP BP.

10. J. Bartram to P. Collinson, 28/9/1755, HSP BP.

11. C. Colden to J. Bartram, 9/5/1746, in Darlington, *Memorials*.

12. J. Bartram to P. Collinson, 6/12/1739, HSP BP.

13. J. Bartram to P. Collinson, Summer 1742, HSP BP.

14. J. Bartram to P. Collinson, 27/5/1743, HSP BP.

15. Darby Friends Monthly Meeting, 5/4/1757, and 1/2/1758, APS, Francis D. West Collection B 28wl.

16. Ord, "Biographical Sketch of William Bartram," 63.

17. P. Collinson to J. Bartram, 20/1/1756, HSP BP.

18. P. Collinson to Linnaeus, 12/5/1756, in Smith, *Linnaeus*.

19. P. Collinson to J. Bartram, 18/2/1756, HSP BP.

20. J. Bartram to P. Collinson, 28/9/1755, HSP BP.

21. Miller, *Figures of the Most Beautiful, Useful, and Uncommon Plants*, 182, plate 272.

22. J. Bartram to P. Collinson, 12/6/1756, HSP BP.

23. J. Bartram to P. Collinson, 27/4/1755, HSP BP.

24. J. Bartram to W. Bartram, Summer 1761, HSP BP.

25. W. Bartram to brother J. Bartram, 11/6/1762, HSP BP.

CHAPTER 3

1. W. Bartram to J. Bartram, 6/5/1761, HSP BP.

2. W. Bartram to J. Bartram, 20/5/1761, HSP BP.

3. J. Bartram to W. Bartram, Summer 1761, HSP BP.

4. J. Bartram to W. Bartram, 1/9/1761, N-YHS.

5. J. Bartram to W. Bartram, 27/12/1761, HSP BP.

6. J. Bartram to brother W. Bartram, 27/12/1761, HSP BP.

7. J. Bartram to W. Bartram, Summer 1761, HSP BP.

8. J. Bartram to Moses and W. Bartram, 9/11/1762, HSP BP.

9. J. Bartram to P. Collinson, 4/3/1764, HSP BP.

10. P. Collinson to J. Bartram, 1/6/1764, HSP BP.

11. Arthur Dobbs to P. Collinson, 2/4/1759, Linnean Society, Collinson Ms. Commonplace Book.

12. P. Collinson to J. Bartram, 25/7/1762, HSP BP.

13. J. Bartram to P. Collinson, 29/8/1762, HSP BP.

14. P. Collinson to J. Bartram, 5/10/1762, HSP BP.

15. P. Collinson to J. Bartram, 10/12/62, HSP BP.

16. P. Collinson to J. Bartram, 30/6/1763, HSP BP.

17. McKinley, Postscript, in Nelson, *Aphrodite's Mousetrap*, 130–31.

18. P. Collinson to J. Bartram, 30/6/1764, HSP BP.

19. J. Ellis to Linnaeus, 23/9/1769, in Smith, *Linnaeus*.

20. Linnaeus to J. Ellis, 16/10/1768, in Smith, *Linnaeus*.

21. Darwin, *Insectivorous Plants*, 286.

22. J. Bartram to B. Rush, 5/12/1767, HSP Library Company.

23. Thomas Penn to John Penn, 1763, HSP Penn Letter Book.

24. J. Bartram to P. Collinson, 23/9/1764, HSP BP.

25. Kinch, *The Meteoric Career of William Young Jr.*

26. A. Garden to J. Ellis, 25/7/1761, in Smith, *Linnaeus*.

27. Letter to his sister from Mark Beaufoy, in Corner and Booth, *Chain of Friendship*, 223n.

28. J. Bartram to P. Collinson, 15/10/1764, HSP BP.

29. Queen Charlotte was Princess Mecklenburg-Strelitz before her marriage to George III.

30. J. Bartram to P. Collinson, 15/10/1764, HSP BP.

31. J. Bartram to P. Collinson, 15/10/1764, HSP BP.

32. J. Bartram to P. Collinson, July 1754, HSP BP.

33. James Boswell, *Life of Johnson* (Oxford: Oxford University Press, 1953), 383.

34. Israel Pemberton to J. Fothergill, 22/9/1764, HSP Pemberton Papers.

35. P. Collinson to J. Bartram, 10/2/1767, HSP BP.

36. T. Penn to W. Young, 4/3/1767, HSP Penn Letter Book 1766–69.

37. J. Bartram to P. Collinson, 5/12/1766, HSP BP.

38. Thomas Penn to W. Young senior, 28/2/1767, HSP Penn Papers, Private Collection.

39. Thomas Penn to W. Young senior, 28/9/1765, HSP Penn Papers.

40. J. Bartram to P. Collinson, 23/9/1764, HSP BP.

41. B. Franklin to P. Collinson, 24/9/1764, Linnean Society, Collinson Ms. Commonplace Book.

42. P. Collinson to J. Bartram, 9/4/1765, HSP BP.

43. A. Garden to J. Ellis, 15/7/1765, in Smith, *Linnaeus*.

44. A. Garden to J. Ellis, January 1761, in Smith, *Linnaeus*.

45. A. Garden to C. Linnaeus, 2/1/1760, in Smith, *Linnaeus*.

46. Jonas Dryander, *Catalogus Bibliothecae Historico-Naturalis Josephi Banks*, vol. 3 (1797), 186.

CHAPTER 4

1. J. Bartram to W. Bartram, 7/6/1765, HSP BP.

2. Letter of attorney, 6/8/1765, Archives of the Ewell Sale Stewart Library, Academy of Natural Sciences, Philadelphia Coll. 364, no. 19.

3. Francis Harper, *Transactions APS, N.S.*, vol. 33, pt. 1 (1942): 3.

4. Ibid., 1.

5. Ibid., 77.

6. J. Bartram Diary, *Transactions APS, N.S.*, vol. 33, pt. 1 (1942): 31.

7. Marshall, *Arbustum Americanum*, 49.

8. John Lyon's Journal 1799–1814: *Transactions of the APS*, n.s., vol. 53, pt. 2 (1963): 22–23.

9. W. Bartram to R. Barclay (1788), Book E, Botany Department, NHM.

10. Bozeman and Rogers, "This Very Curious Tree."

11. *Atlantic Journal and Friend of Knowledge* 1, no. 2, article 26 (1832): 79.

12. T. Parke to Humphry Marshall, 18/5/1789, in Darlington, *Memorials*.

13. Joseph Banks to H. Marshall, 6/5/1789, in Darlington, *Memorials*.

14. Fry, "*Franklinia alatamaha*," 11.

15. P. Collinson to J. Bartram, 20/1/1756, HSP BP.

16. J. Fothergill to W. Bartram, 22/10/1772, HSP BP.

17. Banks, *Delineations of Exotick Plants Cultivated in the Royal Garden at Kew*, ii–iii.

18. J. Bartram to P. Collinson, 27/2/1736/7, HSP BP.

19. J. Bartram to P. Collinson, 13/6/1738, HSP BP.

20. J. Bartram to P. Collinson, 30/6/1766, HSP BP.

21. Sanders, *Guide to William Bartram's Travels*, 3.

22. H. Laurens to J. Bartram, 9/8/1766, in Darlington, *Memorials*.

23. J. Bartram to W. Bartram, 5/4/1766, HSP BP.

24. J. Bartram to W. Bartram, 3/7/1766, N-YHS, Misc. Mss. Bartram.

25. H. Laurens to J. Bartram, 9/8/1766, in Darlington, *Memorials*.

26. Slaughter, *The Natures of John and William Bartram*.

27. H. Laurens to J. Bartram, 9/8/1766, in Darlington, *Memorials*.

28. William Bartram, "Commonplace Book," in Slaughter, *The Natures of John and William Bartram*, 163.

29. J. Bartram to P. Collinson, 26/8/1766, HSP BP.

30. *The Philadelphia Medical and Physical Journal*, vol. 1, pt. 1 (1804): 121–22.

31. J. Bartram to W. Bartram, 9/4/1766, N-YHS, Misc. Mss. Bartram.

32. Archives of the Ewell Sale Stewart Library, Academy of Natural Sciences of Philadelphia, Coll. 15.

33. J. Fothergill to C. Linnaeus, 4/4/1774, Linnaen Society.

34. Unpublished tract on the verso of the Bartram Catalogue, HSP BP.

35. Abraham, *Lettsom: His Life, Times, Friends and Descendants*, 56.

36. P. Collinson to J. Bartram, 25/12/1767, HSP BP.

37. P. Collinson to J. Bartram, 17/2/1768, HSP BP.

38. P. Collinson to W. Bartram, 16/2/1768, in Darlington, *Memorials*.

39. Edwards, *A Natural History of Birds*, vol. 1 (1743), xvii.

40. Catesby, *The Natural History of Carolina*, 1:xi–xii.

41. Edwards, *Gleanings of Natural History*, vol. 1 (1758), x.

42. Catesby, *The Natural History of Carolina*, 1:xi.

43. W. Bartram to B. Rush, 5/12/1767, HSP Library Company.

44. P. Collinson to W. Bartram, 18/7/1768, in Darlington, *Memorials*.

45. J. Fothergill to J. Bartram, 29/10/1768, HSP Gratz Collection.

46. "Some Account of the Late P. Collinson," 1769, reproduced in Lettsom, *The Works of John Fothergill*, 2:338–47.

CHAPTER 5

1. J. Fothergill to Linnaeus, 4/4/1774, Linnean Society.

2. Lettsom, *Memoirs of John Fothergill M.D.*, 4th ed., 37–41.

3. Corner and Booth, *Chain of Friendship*, 20.

4. J. Fothergill to J. Bartram, 29/10/1768, HSP Gratz Collection.

5. J. Fothergill to W. Bartram, 22/10/1772, HSP BP.

6. J. Fothergill to W. Bartram, 4/9/1773, HSP BP.

7. Harper, ed., *The Travels of William Bartram*, xix.

8. C. Linnaeus to J. Ellis, 8/8/1771, in Smith, *Linnaeus*.

9. C. Linnaeus to J. Ellis, 22/10/1771, in Smith, *Linnaeus*.

10. J. Fothergill to H. Marshall, 11/2/1771, HSP Misc. Scientist Collection.

11. Joseph Banks in Lettsom, *Memoirs of John Fothergill M.D.*, 41.

12. J. Bartram to J. Fothergill, 30/9/1770, Botany Library, NHM.

13. W. Bartram to Mary Bartram Robeson, 7/9/1788, HSP Gratz Collection.

14. J. Bartram to W. Bartram, 25/4/1771, HSP BP.

15. J. Bartram to J. Fothergill, 26/11/1769, Botany Library, NHM.

16. Text of drawing sent to John Fothergill, Botany Library, NHM.

17. J. Bartram to P. Collinson, 27/2/1736/37, The Royal Society, LBC.25.118.

18. J. Bartram to J. Fothergill, 26/11/1769, Botany Library, NHM.

19. J. Bartram to W. Bartram, 15/7/1772, HSP Society Collection.

20. Moses Bartram to W. Bartram, 9/7/1772, HSP Gratz Collection.

21. J. Fothergill to W. Bartram, 22/10/1772, HSP BP.

22. J. Fothergill to J. Bartram, September–October 1772, HSP BP.

23. J. Fothergill to Lionel Chalmers, 23/10/1772, HSP BP.

24. J. Fothergill to W. Bartram, 22/10/1772, HSP BP.

25. J. Fothergill to Lionel Chalmers, 23/10/1772, HSP BP.

26. J. Bartram to W. Bartram, 22/10/1772, HSP BP.

27. William Bartram, "Commonplace Book," in Slaughter, *The Natures of John and William Bartram*, 163.

28. W. Bartram to J. Bartram, 27/3/1775, HSP BP.

29. W. Bartram to Lachlan McIntosh, 31/5/1796, N-YHS Misc. Mss. Bartram.

30. Waselkov and Braund, *William Bartram on the Southeastern Indians*, 29.

31. Fagin, *William Bartram*, 22.

32. J. Bartram to his children, 1777, HSP BP.

33. Paine, *The Age of Reason*, in *The Thomas Paine Reader*, 419–21.

34. J. Bartram to P. Collinson, 6/7/1742, HSP BP.

35. Brooke, *Science and Religion*, 160. Edward Said states in *Orientalism* (London: Penguin, 1976) that Whiston was expelled from Cambridge because of his Islamic enthusiasm (76). The two, of course, are not mutually exclusive.

36. Ord, "Biographical Sketch of William Bartram," 67.

37. Hutton, *Theory of the Earth*, 100.

CHAPTER 6

1. Waselkov and Braund, *William Bartram on the Southeastern Indians*, 12.

2. William Bartram, Journal, vol. 1 (1773), 40, Botany Library, NHM.

3. Goldsmith, *A History of the Earth*, chap. 1, p. 1.

4. Ray, *The Wisdom of God Manifested in the Works of the Creation*, 161.

5. Hale, *The Primitive Origination of Mankind*, 370.

6. J. Fothergill to J. Bartram, 1/5/1769, HSP BP.

7. William Bartram, Journal, vol. 1 (1773), 3, Botany Library, NHM.

8. Ibid., 4, Botany Library, NHM.

9. Ibid., 7, Botany Library, NHM.

10. Ibid., 14–15, Botany Library, NHM.

11. William Bartram, *Some Hints and Observations*, N-YHS Henry Knox Papers, Gilder Lehrmann Collection.

12. Cashin, *William Bartram and the American Revolution*, 74.

13. William Bartram, Journal, vol. 1 (1773), 58, Botany Library, NHM.

14. Cashin, *William Bartram and the American Revolution*, 258.

15. William Bartram, Journal, vol. 1 (1773), 56, Botany Library, NHM.

16. J. Fothergill to W. Bartram, 4/9/1773, HSP BP.

17. William Bartram, Journal, vol. 1 (1773), 7–8, Botany Library, NHM.

18. Ibid., 8, nos. 37 and 38, Botany Library, NHM.

19. Lionel Chalmers to WB, 15/12/1773, HSP Gratz Collection.

20. William Bartram to Barclay, Botany Library, NHM.

21. J. Fothergill to J. Bartram, 8/7/1774, in Darlington, *Memorials*.

22. L. Chalmers to J. Bartram, 12/7/1774, HSP BP.

23. L. Chalmers to W. Bartram, 6/5/1774, HSP BP.

24. William Bartram, Journal, vol. 2 (1774), 53, Botany Library, NHM.

25. Ibid., 59, Botany Library, NHM.

26. J. Bartram to P. Collinson, 4/3/1764, HSP BP.

27. W. Bartram to J. Bartram, 27/3/1775, HSP BP.

28. Declaration of Independence (1776).

29. Autobiography of Benjamin Rush, *Memoirs of the APS* 25 (1948): 114.

30. Cashin, *William Bartram and the American Revolution*, 218.

31. Ord, "Biographical Sketch of William Bartram," 63.

32. Cashin, *William Bartram and the American Revolution*, 231.

33. Ord, "Biographical Sketch of William Bartram," 63.

34. J. Bartram to W. Bartram, 9/4/1766, N-YHS, Misc. Mss. Bartram.

CHAPTER 7

1. W. Baldwin to W. Darlington, 3/7/1817, in Darlington, comp., *Reliquiae Baldwinianae: Selections from the Correspondence of the Late William Baldwin, M.D. . . .* [hereafter Darlington, *RB*], 235.

2. B. S. Barton to W. Bartram, 13/12/1788, HSP BP.

3. William Bartram, *Some Hints and Observations*, N-YHS Henry Knox Papers, Gilder Lehrmann Collection.

4. Ibid.

5. Waselkov and Braund, *William Bartram on the Southeastern Indians*, 190.

6. J. Bartram to P. Collinson, 8/8/1763, HSP BP.

7. J. Bartram to P. Collinson, 30/9/1763, HSP BP.

8. William Bartram, Journal, vol. 2 (1774), 24, Botany Library, NHM.

9. Paine, *The Age of Reason*, in *The Thomas Paine Reader*, 436.

10. William Bartram, *Observations on the Creek Indians*, HSP BP.

11. Count de Buffon, *Natural History General and Particular*, 130–31.

12. William Bartram, *Some Hints and Observations*, N-YHS Henry Knox Papers, Gilder Lehrmann Collection.

13. Robert Parrish to W. Bartram, 20/6/1797, N-YHS Misc. Mss. Darlington.

CHAPTER 8

1. *Massachusetts Magazine*, vol. 4 (1792), in Harper, ed., *The Travels of William Bartram*, xxiv.

2. *The Universal Asylum and Columbian Magazine*, vol. 1 (April 1792), in Harper, ed., *The Travels of William Bartram*, xxiv.

3. Harper, ed., *The Travels of William Bartram*, xxvi.

4. William Blake, *Marriage of Heaven and Hell* (1793).

5. Samuel Taylor Coleridge, *Frost at Midnight* (1798).

6. William Wordsworth, *Lines Composed a Few Miles Above Tintern Abbey* (1798).

7. Lowes, *The Road to Xanadu*, 46.

8. William Wordsworth, note to *Ruth* (1798–99).

9. William Bartram, text from original drawing, Botany Library, NHM.

10. Wordsworth, *Lines Composed a Few Miles Above Tintern Abbey* (1798).

11. Burke, *A Philosophical Enquiry*, 41.

12. Ibid., 42.

13. Virgil, *Georgics* 1, trans. L. P. Wilkinson (Harmondsworth: Penguin, 1982), 6.

CHAPTER 9

1. Verily Anderson, *Friends and Relations: Three Centuries of Quaker Families*, 165.

2. Manuscript notes to Robert Barclay, Botany Library, NHM.

3. Ewan, *William Bartram, Botanical and Zoological Drawings*, 51.

4. Ewan, *A Short History of Botany in the United States*.

5. W. Bartram to Robert Barclay, Book E, Botany Department, NHM.

6. Merrill, "Defence of the Validity of William Bartram's Binomials."

7. Wilbur, "A Reconsideration of Bartram's Binomials."

8. Berra, "William Bartram (1739–1823) and North American Ichthyology," 443–44.

9. Pope, *Essay on Man* (1732–34).

10. W. Bartram to B. S. Barton, 29/12/1792, APS Bartram Collection.

11. J. Bartram to M. Collinson, 21/7/1773, HSP BP.

CHAPTER 10

1. B. Franklin to J. Bartram, 27/5/1777, in Darlington, *Memorials*.

2. William Dunlap, diary entry for 9 May 1797, in *A History of the American Theatre* (1832), 170.

3. Ord, "Life of Wilson, xliii."

4. Keane, *Tom Paine: A Political Life*, 308.

5. A. Wilson to A. Lawson, 3/11/1808, Alexander Wilson Scrapbook of Letters, MCZ 869.15, Ernst Mayr

Library, Museum of Comparative Zoology Archives, Harvard University.

6. A. Wilson to W. Bartram, 2/7/1805, in Ord, "Life of Wilson," xxviii.

7. Ord, "Life of Wilson, cvii."

8. A. Wilson to W. Bartram, 21/4/1813, in *The Poems and Literary Prose of Alexander Wilson*, ed. Grosart, 1:235.

9. A. Wilson to W. Bartram, 22/5/1807, ANSP.

10. A. Wilson to William Duncan, 24/12/1804, in Ord, "Life of Wilson," xxxiv.

11. "The Foresters," in *The Poems and Literary Prose of Alexander Wilson*, ed. Grosart, vol. 2.

12. A. Wilson to William Duncan, 24/12/1804, in Ord, "Life of Wilson," xxxv.

13. Thomas Jefferson to A. Wilson, 9/10/1807, LOC.

14. A. Wilson to unknown, 6/7/1813, in Crichton, *Biographical Sketches of the Late Alexander Wilson*, 71.

15. A. Wilson to a friend, 10/10/1808, in Crichton, *Biographical Sketches of the Late Alexander Wilson*, 60.

16. A. Wilson to W. Bartram, 16/6/1804, HSP BP.

17. *Journal kept by David Douglas during his travels in North America, 1823–27*, RHS (1914), 25.

18. A. Wilson to Charles Orr, 23/7/1800, National Library of Scotland Ms. 3218, fol. 11.

19. *Journal kept by David Douglas during his travels in North America, 1823–27*, RHS (1914), 25.

20. Humboldt to H. Muhlenberg, 27/6/1804, reproduced in Ewan, "Humboldt and American Botany," 191–97.

21. Jefferson to Hamilton, 7/5/1809, *Thomas Jefferson's Garden Book*, in *Memoirs of the APS*, vol. 22 (1944): 411.

22. On several occasions Humboldt mistakenly referred to Benjamin Smith, omitting the "Barton" from his name altogether.

23. Herrick, *Audubon the Naturalist*, vol. 2, 2nd ed., 284.

24. Wilson, *American Ornithology*, vol. 2 (1810), vi.

25. Ibid., vol. 5 (1812), x.

26. Ibid., vol. 1 (1808), 2.

27. Ibid., 8.

28. Hunter, *The Life and Letters of Alexander Wilson*.

29. Wilson, *American Ornithology*, vol. 5 (1812), vi.

30. Ibid., vol. 1 (1808), 48–49.

31. Ibid., 50–51.

32. Ibid., 29.

33. Ibid., 34.

34. T. Jefferson to A. Wilson, 7/4/1805, LOC.

35. A. Wilson to W. Bartram, 4/8/1809, in Ord, "Life of Wilson," lxviii.

36. A. Wilson to W. Bartram, 21/4/1813, in Ord, "Life of Wilson," cvii.

37. Ord, "Life of Wilson," cx.

38. A. Wilson to Alexander Lawson, 4/4/1810, in Ord, "Life of Wilson," lxxx.

39. Ord, "Life of Wilson," xcviii.

40. A. Wilson to Alexander Lawson, 4/4/1810, in Ord, "Life of Wilson," lxxx.

41. John Keats to George Keats, 17–27 September 1819, in H. E. Scudder, ed., *Complete Works and Letters of John Keats*.

42. A. Wilson to W. Bartram, 11/10/1809, Alexander Wilson Scrapbook of Letters, MCZ 869.15, Ernst Mayr Library, Museum of Comparative Zoology Archives, Harvard University.

43. Wilson, *American Ornithology*, vol. 2 (1810), viii.

44. Audubon, *Ornithological Biography*, 1:438–39.

45. Ibid., 5:292.

46. J. J. Audubon to Lucy Audubon, 17/2/1832, in Proby, *Audubon in Florida*, 31.

47. Audubon, *Ornithological Biography*, 2:360.

48. Wilson, journal entry, April 9, 1810, in Ord, "Life of Wilson," xcix.

49. A. Wilson to Sarah Miller, 1/5/1810, Alexander Wilson Scrapbook of Letters, MCZ 869.15, Ernst Mayr Library, Museum of Comparative Zoology Archives, Harvard University.

50. Ord, "Life of Wilson, cxiii."

51. Wilson, *American Ornithology*, vol. 5 (1812), vi.

CHAPTER 11

1. T. Say to J. Melsheimer, 6/11/1817, Archives of the Ewell Sale Stewart Library of the ANSP.

2. Ruschenberger, *A Notice of the Origin, Progress, and Present Condition of the Academy of Natural Sciences of Philadelphia*, 47.

3. Peale, *Introduction to a Course of Lectures on Natural History*, 31.

4. Ruschenberger, *A Notice of the Origin, Progress, and Present Condition of the Academy of Natural Sciences of Philadelphia*, 49.

5. Minutes of the Academy of Natural Sciences Philadelphia, March 17, 1812.

6. T. Say to Thaddeus W. Harris, 10/11/1823, Thomas Say Correspondence with T. W. Harris, MCZ F

731, Ernst Mayr Library, Museum of Comparative Zoology Archives, Harvard University.

7. Rubens Peale, "Autobiographical Notes." Ms. quoted in Poesch, *Titian Ramsay Peale*, 8.

8. T. Say to Jacob Gilliams, 30/1/1818, HSP Mss. Collection.

9. Peale Mss., American Museum of Natural History, New York. In Poesch, *Titian Ramsay Peale*, 21.

10. T. Say to J. Melsheimer, 10/6/1818, Archives of the Ewell Sale Stewart Library of the ANSP.

11. T. Say to Jacob Gilliams, 30/1/1818, HSP Mss. Collection.

12. T. Say to G. Ord, 11/4/1818, HSP Dreer Collection.

13. Edwin James, *Account of an expedition from Pittsburgh to the Rocky Mountains* (1832), 2.

CHAPTER 12

1. T. Say to Baron de Ferussac, 5/6/1824, APS Thomas Say Papers.

2. Rafinesque to Bory St. Vincent, published by Rafinesque in *Western Minerva*, 1:71–74, in Merrill, *Index Rafinesquianus*, 49.

3. W. Baldwin to H. Muhlenberg, 14/1/1811, in Darlington, *RB*.

4. W. Baldwin to W. Darlington, 19/9/1812, in Darlington, *RB*.

5. H. Muhlenberg to W. Baldwin, 18/6/1812, in Darlington, *RB*.

6. W. Baldwin to W. Darlington, 15/1/1817, in Darlington, *RB*.

7. W. Baldwin to Aylmer Lambert, 7/2/1817, in Darlington, *RB*.

8. W. Baldwin to W. Darlington, 15/5/1817, in Darlington, *RB*.

9. W. Baldwin to W. Darlington, 30/3/1817, in Darlington, *RB*.

10. W. Baldwin to W. Darlington, 30/5/1817, in Darlington, *RB*.

11. W. Baldwin to W. Darlington, 20/8/1817, in Darlington, *RB*.

12. W. Baldwin to W. Darlington, 14/8/1818, in Darlington, *RB*.

13. W. Baldwin to W. Darlington, 21/3/1819, in Darlington, *RB*.

14. Manasseh Cutler, *Memoirs of the American Academy of Arts and Science*, vol. 1 (1885), 397.

15. B. S. Barton to W. Bartram, 26/8/1787, HSP BP.

16. H. Muhlenberg to William D. Peck, 19/5/1812, in Greene, *American Science in the Age of Jefferson*, 257.

17. Ewan, *William Bartram, Botanical and Zoological Drawings, 1756–1788*, 40.

18. *The Philadelphia Medical and Philosophical Journal*, vol. 1, pt. 2 (1805).

19. A. Wilson to W. Bartram, 17/9/1804, HSP BP.

20. W. Bartram to B. S. Barton, 23/8/1801, APS Bartram Collection.

21. B. S. Barton to W. Bartram, 20/9/1787, HSP BP.

22. W. Bartram to B. S. Barton, 1802/03, APS Bartram Collection.

23. B. S. Barton to W. Bartram, 19/8 (no year given), HSP Etting Collection.

24. B. S. Barton to W. Bartram, 30/11/1805, APS Bartram Collection.

25. W. Bartram to B. S. Barton, 30/11/1805, APS Bartram Collection.

26. William Bartram, "Commonplace Book," quoted in Slaughter, *The Natures of John and William Bartram*, 250.

27. W. Bartram to B. S. Barton, 23/8/1801, APS Bartram Collection.

28. W. Bartram to B. S. Barton, 7/3/1804, APS Bartram Collection.

29. Barton, *Elements of Botany*, viii–ix.

30. W. P. C. Barton, "Biographical Sketch," in Introduction to *Elements of Botany*.

31. A. Michaux to Comte d'Angiviller, 1786, in Savage, *André and François André Michaux*, 56.

32. Savage, *André and François André Michaux*, 299.

33. Michaux, *The North American Sylva*, viii.

34. A. Wilson to F. A. Michaux, 6/6/1812, in Ord, "Life of Wilson," civ–cv.

35. Thomas Nuttall, *The North American Sylva*, vol. 1 (1859), 9–10.

EPILOGUE

1. W. Bartram to B. S. Barton, 16/7/1800, APS Bartram Collection.

2. William Bartram, "Anecdotes of an American Crow," in *Philadelphia Medical and Physical Journal*, vol. 1.

3. William Bartram, "Commonplace Book," in Slaughter, *The Natures of John and William Bartram*, 6.

4. William Bartram, HSP BP.

5. W. Bartram to Moses Bartram, 1791, HSP BP.

6. William Bartram, HSP BP.

7. Humboldt, *Cosmos: Sketch of a Physical Description of the Universe*, 1:5.

8. William Bartram, "Commonplace Book," in Slaughter, *The Natures of John and William Bartram*, 6.

9. W. Bartram to James Bartram, 23/9/1804. Quoted in Fagin, *William Bartram: Interpreter of the American Landscape*, 201.

10. Ord, "Biographical Sketch of William Bartram," 67.

Bibliography

Abraham, James Johnston. *Lettsom: His Life, Times, Friends and Descendants.* London: W. Heinemann, 1933.

Alderson, William T., ed. *Mermaids, Mummies, and Mastodons: The Emergence of the American Museum.* Washington, D.C.: American Association of Museums, 1992.

Allen, Elsa Guerdrum. *The History of American Ornithology Before Audubon.* Transactions of the American Philosophical Society, n.s., 41, pt. 3. Philadelphia: American Philosophical Society, 1951.

Anderson, Verily. *Friends and Relations: Three Centuries of Quaker Families.* London: Hodder & Stoughton, 1980.

Audubon, John James. *Ornithological Biography*, 5 vols. Edinburgh: A. Black, 1831–39.

Barber, Lynn. *The Heyday of Natural History, 1820–1870.* London: Jonathan Cape, 1980.

Barton, Benjamin Smith. *Elements of Botany; or, Outlines of the Natural History of Vegetables.* Rev. ed. London, 1804.

Bartram, John. *Diary of a Journey Through the Carolinas, Georgia, and Florida from July 1, 1765, to April 10, 1766.* Annotated by Francis Harper. Transactions of the American Philosophical Society, n.s., 33, pt. 1. Philadelphia: American Philosophical Society, 1942.

Bartram, William. "Anecdotes of an American Crow." *Philadelphia Medical and Physical Journal* 1, pt. 1 (1804).

———. *Botanical and Zoological Drawings, 1756–1788: Reproduced from the Fothergill Album in the British Museum (Natural History).* Edited by Joseph Ewan. Memoirs of the American Philosophical Society, no. 74. Philadelphia: American Philosophical Society, 1968.

———. "Description of an American Species of Certhia, or Creeper." *Philadelphia Medical and Physical Journal* 1, pt. 2 (1805).

———. Mss. Journals from Georgia and Florida. Banks Mss. 78 and 79. 1773–74.

———. "Some Account of the Late Mr. John Bartram of Pennsylvania." *Philadelphia Medical and Physical Journal* 1, pt. 1 (1804).

———. *Travels in Georgia and Florida, 1773–74: A Report to Dr. John Fothergill.* Annotated by Francis Harper. Transactions of the American Philosophical Society, n.s., 33, pt. 2. Philadelphia: American Philosophical Society, 1943.

———. *Travels through North & South Carolina, Georgia, East & West Florida, the Cherokee country, the extensive territories of the Muscogulges, or Creek confederacy, and the country of the Chactaws: containing an account of the soil and natural productions of those regions, together with observations on the manners of the Indians.* Philadelphia, 1791.

The Bartram Trail Conference. *Bartram Heritage: A Study of the Life of William Bartram.* Montgomery, Ala.: The Bartram Trail Conference, 1979.

Bauer, Franz. *Delineations of Exotick Plants Cultivated in the Royal Garden at Kew*. London: W. T. Aiton, 1796.

Bennett, Thomas Peter. *A Celebration on the 200th Anniversary of Bartram's Travels, 1791*. [S.I.] 1991.

Berkeley, Edmund, and Dorothy Smith Berkeley. *Dr. Alexander Garden of Charles Town*. Chapel Hill: University of North Carolina Press, 1969.

———. *The Life and Travels of John Bartram: From Lake Ontario to the River St. John*. Tallahassee: University Press of Florida, 1982.

———, eds. *The Correspondence of John Bartram, 1737–1777*. Gainesville: University Press of Florida, 1992.

Berra, Tim M. "William Bartram (1739–1823) and North American Ichthyology." In *Collection Building in Ichthyology and Herpetology*, edited by Theodore W. Pietsch and William D. Anderson. Special publication, American Society of Ichthyologists and Herpetologists, no. 3. Lawrence, Kans.: American Society of Ichthyologists and Herpetologists [1997].

Boewe, Charles. "Biographical Sketch of C. S. Rafinesque." *Newsletter of the Connecticut Botanical Society* 20, no. 4 (1992).

———. "A Rafinesque Rejoinder." *Archives of Natural History* 17, no. 3 (1990): 367–68.

———, ed. *Profiles of Rafinesque*. Knoxville: University of Tennessee Press, 2003.

Bonta, Marcia Myers. *Women in the Field: America's Pioneering Women Naturalists*. College Station: Texas A & M University Press, 1991.

Bozeman, John, and George Rogers. "This Very Curious Tree." *Tipularia: A Botanical Magazine*, November 1986.

Britten, James. "William Young and His Work." *Journal of Botany, British and Foreign* 32 (1894): 332–37.

Brooke, John Hedley. *Science and Religion: Some Historical Perspectives*. Cambridge: Cambridge University Press, 1991.

Brotherston, R. P. "Sir John Hill." *Gardeners' Chronicle*, vol. 58, no. 1503 (October 16, 1915).

Buffon, George Louis Leclerc de, Count. *Historie Naturelle, Générale et Particulière*. 44 vols. Paris: De l'Imprimerie Royale, 1749–1804.

———. *A Natural History, General and Particular*. Translated into English by William Smellie. 8 vols. Edinburgh: William Creech, 1780–81.

Burke, Edmund. *A Philosophical Enquiry into the Origin of our Ideas of the Sublime and Beautiful*. London, 1757.

Cashin, Edward J. *William Bartram and the American Revolution on the Southern Frontier*. Columbia: University of South Carolina Press, 2000.

Castiglioni, Luigi. *Botanical Observations*. Translated by Antonio Pace and edited by Joseph and Nesta Ewan. Syracuse, N.Y.: Syracuse University Press, 1983.

———. *Luigi Castiglioni's Viaggio: Travels in the United States of North America, 1785–87*. Translated and edited by Antonio Pace. Syracuse, N.Y.: Syracuse University Press, 1983.

Catesby, Mark. *The Natural History of Carolina, Florida, and the Bahama Islands*. 2 vols. London, 1731–43.

Chancellor, John. *Audubon: A Biography*. London: Weidenfeld & Nicolson, 1978.

Clarke, Larry R. "The Quaker Background of William Bartram's View of Nature." *Journal of the History of Ideas* (1985): 435–48.

Coats, Alice M. *Lord Bute: An Illustrated Life of John Stuart, Third Earl of Bute, 1713–1792*. Lifelines, vol. 27. Aylesbury: Shire Publications, 1975.

———. *The Quest for Plants: A History of the Horticultural Explorers*. London: Studio Vista, 1969.

Coker, W. C. "The Distribution of Venus's Flytrap (*Dionaea muscipula*)." *Journal of the Elisha Mitchell Scientific Society* 43 (1928): 221–28.

Colden, Jane. "Flora Nov-Eboracensis: Plantas in Solo Natali collegit, descripsit, delineavit, Coldenia Cadwallader Coldens filia." Autograph Mss. Botany Library. Banks Ms. No. 99. London: Natural History Museum.

Coleridge, Samuel Taylor. *Poems*. Everyman's Library. London: Dent, 1970.

Collinson, Peter. "An Account of the Introduction of American Seeds into Great Britain." Autograph Mss. Botany Library. London: Natural History Museum, 1766.

———. *Forget Not Mee and My Garden: Selected Letters, 1725–1768, of Peter Collinson, FRS*. Edited, with an introduction, by Alan W. Armstrong. Memoirs of the American Philosophical Society, vol. 241. Philadelphia: American Philosophical Society, 2002.

Corner, Betsy C., and Christopher C. Booth, eds. *Chain of Friendship: Selected Letters of Dr. John Fothergill of London, 1735–1780*. Cambridge, Mass.: Harvard University Press, 1971.

Crichton, Thomas. *Biographical Sketches of the Late Alex-*

ander Wilson, Author of "Poems" and "American Ornithology." Paisley, 1819.

Cutler, Manasseh. *An account of some of the vegetable productions, naturally growing in this part of America, botanically arranged.* Memoirs of the Academy of Arts and Science, vol. 1. Boston, 1885.

Darlington, William. *Memorials of John Bartram and Humphry Marshall: With Notices of Their Botanical Contemporaries.* Philadelphia: Lindsay & Blakiston, 1849.

———, comp. *Reliquiae Baldwinianae: Selections from the Correspondence of the Late William Baldwin, M.D., Surgeon in the U.S. Navy, with Occasional Notes and a Brief Biographical Memoir.* Philadelphia: Kimber & Sharpless, 1843.

Darwin, Charles. *Insectivorous Plants.* London: John Murray, 1875.

Dickenson, Victoria. *Drawn from Life: Science and Art in the Portrayal of the New World.* Toronto: University of Toronto Press, 1998.

Dunaway, Wilma A. "The Southern Fur Trade and the Incorporation of Southern Appalachia into the World Economy, 1690–1763." *Review of the Fernand Braudel Centre* 17 (spring 1994).

Earnest, Ernest. *John and William Bartram, Botanists and Explorers.* Philadelphia: University of Pennsylvania Press, 1940.

Edwards, George. *A Natural History of Birds.* 7 vols. London: 1743–64. Volumes 5, 6, and 7 were issued under the title *Gleanings of Natural History, Exhibiting Figures of Quadrupeds, Birds, Insects, Plants.* London, 1758–64.

Elman, Robert. *First in the Field: America's Pioneering Naturalists.* New York: Van Nostrand Reinhold, 1977.

Evelyn, John. *Sylva, or, A Discourse of Forest-Trees, and the Propagation of Timber in His Majesties Dominions.* Printed by J. Martyn & J. Allestry (for the Royal Society), 1664.

Ewan, Joseph. "Annals of 'the Most Wonderful Plant in the World' (Darwin)." In *Festschrift für Claus Nissen: Zum siebzigsten Geburtstag, 2. September 1971.* Edited by E. Geck and G. Pressler. Wiesbaden: Guido Pressler, 1973.

———. "Humboldt and American Botany," *Rhodora,* vol. 58 (1956).

———. *John Lyon, Nurseryman and Plant Hunter and His Journal, 1799–1814.* Transactions of the American Philosophical Society, n.s., vol. 53, pt. 2. Philadelphia: American Philosophical Society, 1963.

———. *William Bartram, Botanical and Zoological Drawings, 1756–1788,* reproduced from the Fothergill album in the British Museum (Natural History), ed. and with an introduction and commentary by Joseph Ewan. Philadelphia: APS, 1968.

———, ed. *A Short History of Botany in the United States.* New York: Hafner, 1969.

Fagin, Nathan Bryllion. *William Bartram: Interpreter of the American Landscape.* Baltimore: Johns Hopkins Press, 1933.

Fishman, Gail. *Journeys Through Paradise: Pioneering Naturalists in the Southeast.* Gainesville: University Press of Florida, 2000.

Fortune, Brandon Brame, and Deborah J. Warner. *Franklin and His Friends: Portraying the Man of Science in Eighteenth-Century America.* Washington, D.C.: Smithsonian National Portrait Gallery; Philadelphia: University of Pennsylvania Press, 1999.

Fothergill, John. *Chain of Friendship: Selected Letters of Dr. John Fothergill, 1735–1780.* Introduction and notes by B. C. Corner and C. C. Booth. Oxford: Oxford University Press, 1971.

Fox, R. Kingston. *Dr. John Fothergill and His Friends: Chapters in Eighteenth Century Life.* London: Macmillan, 1919.

Fry, Joel T. "Bartram's Garden Catalogue of North American Plants, 1783." *Journal of Garden History* 16, no. 1 (1996).

———. "*Franklinia alatamaha:* A History of That 'Very Curious' Shrub." *Bartram Broadside* (2000).

Goldsmith, Oliver. *An History of the Earth, and Animated Nature.* London, 1774.

Goode, George Brown. *The Origins of Natural Science in America: The Essays of G. B. Goode.* Washington, D.C.: Smithsonian Institution Press, 1991.

Graustein, Jeanette E. *Thomas Nuttall, Naturalist: Explorations in America, 1808–1841.* Cambridge, Mass.: Harvard University Press, 1967.

Gray, Asa, arr. *Selections from the Scientific Correspondence of Cadwallader Colden with Gronovius, Linnaeus, Collinson, and Other Naturalists.* From the *American Journal of Science and Arts,* conducted by Professor Silliman and Benjamin Silliman Jr., vol. 44. New Haven, 1843.

Greene, John C. *American Science in the Age of Jefferson.* Ames: Iowa State University Press, 1984.

Grosart, Alexander B., ed. *The Poems and Literary Prose of Alexander Wilson.* 2 vols. Paisley: Alex Gardner, 1876.

Hale, Matthew. *The Primitive Origination of Mankind, Considered and Examined According to the Light of Nature.* London, 1677.

Hanley, Wayne. *Natural History in America: From Mark Catesby to Rachel Carson.* New York: Quadrangle: The New York Times Book Co., 1977.

Harkanyi, Katalin. "Jane Colden (1724–1766)." In *Women in the Biological Sciences: A Biobibliographic Sourcebook*, edited by Louise S. Grinstein, Carol A. Biermann, and Rose K. Rose. Westport, Conn.: Greenwood Press, 1997.

Harper, Francis. "The Bartram Trail Through the Southeastern States." *Bulletin of the Garden Club of America*, September 1939.

———, ed. *The Travels of William Bartram.* Naturalist's Edition. With commentary and an annotated index by Francis Harper. Athens: University of Georgia Press, 1998 (originally published by Yale University Press, 1958).

———. "William Bartram and the American Revolution." *Proceedings of the American Philosophical Society* 97, no. 5 (1953): 571–77.

Harper, Francis, and Arthur N. Leeds. "A Supplementary Chapter on *Franklinia alatamaha.*" *Bartonia*, no. 19 (1938).

Harshberger, John William. "Some Old Gardens of Pennsylvania." *Pennsylvania Magazine of History and Biography* 48 (1924).

———. "William Young Jr. of Philadelphia, Queen's Botanist." *Torreya* 17, no. 6 (1917): 91–99.

Harvey, John. *Early Nurserymen.* Chichester: Phillimore, 1974.

Hedley, Olwen. *Queen Charlotte.* London: John Murray, 1975.

Herbst, Josephine. *New Green World.* London: Weidenfeld & Nicolson, 1954.

Herrick, Francis Hobart. *Audubon the Naturalist: A History of His Life and Times.* 2nd ed. 2 vols. in one. New York: Appleton-Century Co., 1938.

Hill, C. P. *A History of the United States.* 3rd ed. London: Edward Arnold, 1974.

Hindle, Brooke. *The Pursuit of Science in Revolutionary America, 1735–1789.* Chapel Hill: University of North Carolina Press, 1956.

Humboldt, Alexander von. *Cosmos: Sketch of a Physical Description of the Universe.* Translated by Elizabeth Sabine. New Edition. London: Longman, Brown, Green, and Longmans; and John Murray, 1846–58.

Hunter, Clark, ed. *The Life and Letters of Alexander Wilson.* Memoirs of the American Philosophical Society, vol. 154. Philadelphia: American Philosophical Society, 1983.

Hutton, James. *The Theory of the Earth.* Edinburgh, 1795.

Irmscher, Christoph. *The Poetics of Natural History: From John Bartram to William James.* New Brunswick, N.J.: Rutgers University Press, 1999.

Jacques, David. *Georgian Gardens: The Reign of Nature.* London: B. T. Batsford, 1983.

Jaffe, Bernard. *Men of Science in America: The Role of Science in the Growth of Our Country.* New York: Simon & Schuster, 1944.

James, Edwin. *Account of an expedition from Pittsburgh to the Rocky Mountains . . . in . . . 1819 and '20 . . . under the command of Major S. H. Long: from the notes of Major Long, Mr. T. Say, and other gentlemen.* London, 1823.

Kastner, Joseph. *A World of Naturalists.* London: John Murray, 1978.

Keane, John. *Tom Paine: A Political Life.* London: Bloomsbury; Boston: Little, Brown, 1995.

Kinch, Michael P. "The Meteoric Career of William Young, Jr. (1742–1785), Pennsylvania Botanist to the Queen." *Pennsylvania Magazine of History and Biography* 110 (1986).

Laird, Mark. *The Flowering of the Landscape Garden: English Pleasure Grounds, 1720–1800.* Philadelphia: University of Pennsylvania Press, 1999.

Leighton, Ann. *American Gardens of the 18th Century: "For Use or For Delight."* Boston: Houghton Mifflin, 1976.

Lettsom, John Coakley. *Memoirs of John Fothergill M.D.* 4th ed. London, 1786.

———, ed. *The Works of John Fothergill.* 3 vols. London, 1783–84.

Looby, Christopher. "The Constitution of Nature: Taxonomy as Politics in Jefferson, Peale, and Bartram." *Early American Literature* 22 (1987): 252–73.

Loudon, John C. *The Suburban Gardener and Villa Companion.* London: privately printed, 1838.

Lowes, John Livingston. *The Road to Xanadu: A Study in the Ways of the Imagination.* Boston: Houghton Mifflin, 1927.

————. Introduction to *Travels through North & South Carolina, Georgia, East & West Florida*, by William Bartram. New York: Facsimile Library, 1940.

Macphail, Ian. "Natural History in Utopia: The Works of Thomas Say and François André Michaux Printed at New Harmony, Indiana." In *Contributions to the History of North American Natural History*, Society for the Bibliography of Natural History, no. 2. London, 1983.

Marshall, Humphry. *Arbustum Americanum* (1785). Philadelphia: Joseph Cruikshank. (On the title page of the 1785 edition, the word *Arbustum* is spelled *Arbustrum*.)

Martin, Edwin Thomas. *Thomas Jefferson: Scientist*. London: Abelard-Schuman, 1952.

Martin, Peter. *The Pleasure Gardens of Virginia: From Jamestown to Jefferson*. Princeton: Princeton University Press, 1991.

Merrill, Elmer Drew. "In Defence of the Validity of William Bartram's Binomials." *Chronica Botanica* 10, no. 3/4 (1946): 375–93. Reprinted from *Bartonia*, no. 23 (1945): 100–121.

————. *Index Rafinesquianus*. Jamaica Plain, Mass.: Arnold Arboretum of Harvard University, 1949.

Merritt, J. I., 3rd. "William Bartram in America's Eden." *History Today* 28 (November 1978): 712–21.

Meyers, Amy R. W. "Sketches from the Wilderness: Changing Conceptions of Nature in American Natural History Illustration, 1680–1880." Ph.D. diss., Yale University, 1985.

————, and Margaret Beck Pritchard, eds. *Empire's Nature: Mark Catesby's New World Vision*. Chapel Hill: University of North Carolina Press, 1998.

Michaux, François André. *The North American Sylva; or, A Description of the Forest Trees of the United States, Canada, and Nova Scotia*. Philadelphia, 1817.

Miller, Philip. *Figures of the Most Beautiful, Useful, and Uncommon Plants Described in the Gardeners Dictionary, Volume 1*. London: F. C. and J. Rivington, 1809. (Copy of the 1760 publication.)

Nelson, E. Charles. *Aphrodite's Mousetrap: A Biography of Venus's Flytrap with Facsimiles on an Original Pamphlet and the Manuscript of John Ellis F.R.S.* With a "Tipitiwitchet" Postscript by Daniel L. McKinley. Aberystwyth: Boethius Press, 1990.

Nuttall, Thomas. *The North American Sylva, or, A description of the Forest Trees of the United States, Canada, and Nova Scotia, not described in the work of F. Andrew Michaux*, 3 vols. forming parts 4–6 of Michaux's *North American Sylva*. Philadelphia: J. Dobson, 1842–49.

Oeland, Glenn. "A Naturalist's Vision of Frontier America: William Bartram." *National Geographic* 199, no. 3 (2001): 104–23.

Oleson, Alexandra, and Sanborn C. Brown, eds. *The Pursuit of Knowledge in the Early American Republic*. Baltimore: Johns Hopkins University Press, 1976.

Ord, George. *Sketch of the Life of Wilson*, in *American Ornithology; or, the Natural History of the Birds of the United States* by Alexander Wilson and Charles Lucian Bonaparte. Vol. 1. Philadelphia: Porter & Coates, 1859. (This is a much enlarged version of the *Sketch* that Ord wrote for volume 9 of *American Ornithology*.)

Paine, Thomas. *The Age of Reason*, in *The Thomas Paine Reader*. London: Penguin, 1987.

Peabody, William B. O. *Life of Alexander Wilson*. The Library of American Biography, vol. 2. New York: Harper & Bros., 1839.

Peale, Charles Willson. *Introduction to a Course of Lectures in Natural History: Delivered in the University of Pennsylvania, November 16, 1799*. Philadelphia, 1800.

Peck, Robert McCracken. "Books from the Bartram Library." In *Contributions to the History of North American Natural History*, Society for the Bibliography of Natural History, special publication, no. 2. London, 1983.

————. "William Bartram and His Travels." In *Contributions to the History of North American Natural History*, Society for the Bibliography of Natural History, 35–50. London, 1983.

Plate, Robert. *Alexander Wilson: Wanderer in the Wilderness*. New York: David McKay Co., 1966.

Poesch, Jessie. *Titian Ramsay Peale, 1799–1885, and His Journals of the Wilkes Expedition*. Memoirs of the American Philosophical Society, vol. 52. Philadelphia: American Philosophical Society, 1961.

Porter, Charlotte M. "The Drawings of William Bartram (1739–1823), American Naturalist." *Archives of Natural History* 16, pt. 3 (1989).

————. *The Eagle's Nest: Natural History and American Ideas, 1812–1842*. Tuscaloosa: University of Alabama Press, 1986.

Porter, Roy. *Enlightenment: Britain and the Creation of the Modern World*. London: Allen Lane, Penguin Press, 2000.

Proby, Kathryn Hall. *Audubon in Florida: With Selections from the Writings of John James Audubon.* Coral Gables, Fla.: University of Miami Press, 1974.

Rankin, Helen, and E. Charles Nelson, eds. *Curious in Everything: The Career of Arthur Dobbs of Carrickfergus, 1689–1765.* Carrickfergus: Carrickfergus & District Historical Society, 1990.

Ray, John. *The Wisdom of God Manifested in the Works of the Creation.* 7th ed. London, 1717.

Regis, Pamela. *Describing Early America: Bartram, Jefferson, Crèvecoeur, and the Rhetoric of Natural History.* DeKalb: Northern Illinois University Press, 1992.

Rhoads, Samuel N. *Botanica Neglecta. William Young Jr. (of Philadelphia) "Botaniste de Pensylvanie" and His Long-forgotten Book: Being a Facsimilie Reprint of the "Catalogue d'Arbes Arbustes et Plantes Herbacees d'Amerique."* Published in Paris 1783. Philadelphia: privately printed, 1916.

Rousseau, G. S., ed. *The Letters and Papers of Sir John Hill, 1714–1775.* AMS Studies in the Eighteenth Century, no. 6. New York: AMS Press, 1982.

Ruschenberger, W. S. W. *A Notice of the Origin, Progress, and Present Condition of the Academy of Natural Sciences of Philadelphia.* Philadelphia, 1852.

Rush, Benjamin. *The Autobiography of Benjamin Rush: His "Travels Through Life" Together with His Commonplace Book for 1789–1813.* Edited, with an introduction, by George W. Corner. Memoirs of the American Philosophical Society, vol. 25. Princeton: Princeton University Press, 1948.

Sanders, Albert E., and William D. Anderson. *Natural History Investigations in South Carolina: From Colonial Times to the Present.* Columbia: University of South Carolina Press, 1999.

Sanders, Brad. *Guide to William Bartram's Travels: Following the Trail of America's First Great Naturalist.* Athens, Ga.: Fevertree Press, 2002.

Sanger, Marjory Bartlett. *Billy Bartram and His Green World.* New York: Farrar, Straus & Giroux, 1972.

Savage, Henry. *Lost Heritage.* New York: William Morrow, 1970.

———, and Elizabeth J. Savage. *André and François André Michaux.* Charlottesville: University Press of Virginia, 1986.

Say, Thomas. *American Conchology; or, Descriptions of the Shells of North America.* New Harmony, Ind., 1830–34.

———. *American Entomology; or, Descriptions of the Insects of North America.* With a memoir of the author by George Ord. New York: J. W. Bouton, 1869.

Scudder, H. E., ed. *Complete Works and Letters of John Keats.* Boston and New York: Houghton Mifflin, 1899.

Sellers, Charles Coleman. "Peale's Museum and 'The Museum Idea.'" *Proceedings of the American Philosophical Society* 124, no. 1 (1980).

Shteir, Ann B. *Cultivating Women, Cultivating Science: Flora's Daughters and Botany in England, 1760 to 1860.* Baltimore: Johns Hopkins University Press, 1996.

Silver, Bruce. "Clarke on the Quaker Background of William Bartram's Approach to Nature." *Journal of the History of Ideas* (1986): 507–10.

———. "William Bartram's and Other Eighteenth-Century Accounts of Nature." *Journal of the History of Ideas* (1979): 597–614.

Slaughter, Thomas P. *The Natures of John and William Bartram.* New York: Alfred A. Knopf, 1996.

———. "The Nature of William Bartram." *Pennsylvania History* 62, no. 4 (1995).

Smallwood, William Martin. *Natural History and the American Mind.* New York: Columbia University Press, 1941.

Smith, Sir James Edward. *A Selection of the Correspondence of Linnaeus, and Other Naturalists, from the Original Manuscripts.* 2 vols. London: Longman, 1821.

Souder, William. *Under a Wild Sky: John James Audubon and the Making of "The Birds of America."* New York: North Point Press, 2004.

Spraker, Leslie. *Tulip Trees and Quaker Gentlemen: 19th-Century Horticulture at Longwood Gardens.* Kennett Square, Pa.: Longwood Gardens, 1975.

Stafleu, Frans A. "The Bartram Drawings." *Taxon* 18, pt. 4 (1969): 443–45.

Stearns, Raymond Phineas. *Science in the British Colonies of America.* Urbana: University of Illinois Press, 1970.

Stewart, Gail, ed. *The Cabinet of Natural History and American Rural Sports.* Introduction by Wilson G. Duprey. Barre, Mass.: Imprint Society, 1973.

Stroud, Patricia Tyson. *Thomas Say: New World Naturalist.* Philadelphia: University of Pennsylvania Press, 1992.

Swem, E. G. *Brothers of the Spade: Correspondence of Peter Collinson of London and of John Custis of Williamsburg, Virginia, 1734–1746.* Barre, Mass.: Barre Gazette, 1957. Reprinted from the Proceedings of the American Antiquarian Society, 1949.

Taylor, Walter Kingsley, and Eliane M. Norman. *André Michaux in Florida: An Eighteenth-Century Botanical Journey*. Gainesville: University Press of Florida, 2002.

Teich, Mikulas, Roy Porter, and Bo Gustafsson, eds. *Nature and Society in Historical Context*. Cambridge: Cambridge University Press, 1997.

Tindal, Matthew. *Christianity as Old as the Creation: or, the Gospel, a Republication of the Religion of Nature*. London, 1730.

Vail, Anna Murray. "Jane Colden, an Early New York Botanist." *Torreya* 7, no. 2 (1907).

Vorsey, Louis de. "Searching for William Bartram's Buffalo Lick." *Southeastern Geographer* 41, no. 2 (2001).

Waselkov, Gregory A., and Kathryn E. Holland Braund, eds. *William Bartram on the Southeastern Indians*. Lincoln: University of Nebraska Press, 1995.

Wilbur, Robert L. "A Reconsideration of Bartram's Binomials." *Journal of the Elisha Mitchell Scientific Society* 87, no. 2 (1971).

Wilson, Alexander. *American Ornithology; or, The Natural History of the Birds of the United States*. 9 vols. Philadelphia: Bradford & Inskeep, 1808–14.

Winearls, Joan. *Art on the Wing: British, American, and Canadian Illustrated Bird Books from the Eighteenth to the Twentieth Century: An Exhibition in the Thomas Fisher Rare Book Library, 25 January–9 April 1999*. Toronto: Thomas Fisher Rare Book Library, University of Toronto, 1999.

Wordsworth, William. *Lines Composed a Few Miles Above Tintern Abbey*, in *William Wordsworth*. Everyman's Library. London: J. M. Dent, 1998.

Young, William. *Catalogue d'Arbres, Arbustes et Plantes Herbacées d'Amerique*. Paris, 1783.

MANUSCRIPT SOURCES

Academy of Natural Sciences Philadelphia: ANSP
 Bartram Papers
 Thomas Say Papers

American Antiquarian Society

American Philosophical Society: APS
 Bartram Collection
 Francis D. West Collection
 Thomas Say Papers

Archives of the Museum of Comparative Zoology, Ernst Mayr Library of MCZ, Harvard University

Historical Society of Pennsylvania: HSP
 Bartram Papers
 Dreer Collection
 Etting Collection
 Gratz Collection
 Society Collection
 Penn Letter Book
 Penn Letters Private Collection
 Pemberton Papers
 Library Company
 Miscellaneous Scientists Collection

Library of Congress, Manuscript Division: LOC

Linnean Society, London

National Library of Scotland, Manuscripts Division

Natural History Museum, London: NHM

New-York Historical Society: N-YHS
 Misc. Mss. Bartram
 Misc. Mss. Darlington
 Henry Knox Papers, Gilder Lehrman Collection

The Royal Society, London

Index

Abbot, John, 164, 237
Academy of Natural Sciences of Philadelphia, 181, 183, 191, 212
Academy of Philadelphia, 7, 37, 127
Alachua Savanna, 105, 107, 139
Alexander, James, 85, 86
Alligator-Hole, 107–8, 227
alligators, 8, 108–9, 119, 125, 196
American Conchology, 191
American Entomology, 184, 189
American Ornithology, xi, 160, 164, 170, 177
 patriotic work, 2, 168
American Philosophical Society, ix, 3, 183
 founding of, 7, 27
American Revolution, 3, 97, 120–21
Ata-culculla, 115
Audubon, John James, 171–76, 237

Bachman, John, 168
Baldwin, William, 158, 189, 195–98, 237
 death of, 198
Banister, John, 22, 237
Banks, Sir Joseph, 50, 68, 82, 145, 237
 Franklinia alatamaha, 67, 145
 plant transportation, 83
 Strelitzia reginae, 53
Barclay, David, 141–42, 237
Barclay, Robert, 111, 115, 141–45, 237
 Franklinia alatamaha, 67–68, 75, 141

Quakers, 141–42
slavery, 75
Barton, Benjamin Smith, 3, 189, 198–205, 237
 American Philosophical Society, 203
 Bartram garden, 158, 181, 195, 198
 death of, 205
 Native Americans, 125, 131, 162, 199
 publishing *Travels*, 123
 rattlesnakes, 68
 slavery, 73
 Thomas Nuttall, 209
Barton, William P. C., 168, 237
Bartram Garden, 15–17, 157, 164, 181, 195
Bartram, Ann (neé Mendenhall),15, 16, 19, 37, 122, 237
Bartram, Ann (sister of William), 181
Bartram, Ann (niece of William). *See* Nancy Bartram
Bartram, Elizabeth, ix, 15, 33, 102, 237
Bartram, Isaac, 15, 19, 121, 181, 212, 237
Bartram, James, 18, 121, 238
Bartram, James (nephew), 202, 203, 204, 214–15
Bartram, John, 238
 birth of, 17
 character, 19, 33, 90
 concern for his children, 18, 33–34
 concern for William, 19, 35, 47, 71–72, 85, 87
 death of, 122
 education, 24, 37–38
 Florida travels, 64, 71
 garden, 7,16,17, 122

Bartram, John (cont.)
house, 15, 16
interest in botany, 23, 24
King's Botanist, 7, 57, 63
Library Company, 39
marriage, 15
named by Derby meeting of Quakers, 39, 91
Native Americans, 127–28
plant collecting, 7, 27–28
plant introduction, 7, 21, 23
rattlesnakes, 68
religious views, 20, 90–92
seed trade, 17, 25
slavery, 73–74
snakes, 86
Unitarian, 20, 91
Venus Flytrap, 48–49
views of plants possessing sense, 50
visit to Colden Estate, 28
William Young, 52, 53, 56
Bartram, John, Jr., 17, 238
death of, 197
inherits garden, 18, 87, 122
Bartram, Moses, 19, 87, 121, 212, 238
Bartram, Nancy, xi, 163, 166, 197, 237
Bartram, Richard, 15
Bartram, William
active in hostilities in Georgia, 120–21
American Philosophical Society, 212
animal naming, 147–48
authority on birds, 8, 169, 173
birth of, 15
career, 19, 34, 36; as merchant in Cape Fear, 34, 44–46; as planter in Florida, 71–73
character, 19, 90
death of, 215
drawings, 7, 34, 75–79, 109–10; admired by others, 34, 40, 76, 80; for Fothergill, 102, 109–14; for Philip Miller, 42; Linnaean style, 68, 78, 112–13, 152; reproduced by Edwards, 28, 34; technique, 8; view of nature, 76–79; Venus Flytrap, 50, 51, 58, 59
education, 37, 40
fall from tree, 89
flees creditors, 85
influence on Romantic poets, 93, 134–36
Native Americans, 2, 102, 104; admiration for, 8, 125–29; mounds, 130–31; observations of, 89–90, 128; sympathetic view of, 124–26, 132; travels with, 118

Pantheism, 135
plant naming, 145–47
Puc Puggy, 106, 119, 240
rattlesnakes, 68–70
Red River Expedition, x, 202
rejection of Buffon's ideas, 3, 8, 129, 132
rejection of Great Chain of Being Theory, 8, 93, 213
relationship with father, 7, 19, 114
religious views, 90–93
republican views, 40
slavery, 73–75
snakes, 86
Sublime, 105, 139
Unitarian, 92
utilitarian, 7, 98, 213, 214
views on nature, 91–93, 149–51, 213
visit to Colden Estate, 28, 32
Bartram, William (cousin), 44, 85, 238
Bartram, William (uncle), 44, 46, 85, 238
Bauer, Franz, 53, 68, 238
Beaufoy, Mark, 53
Blake, William, 135
Bonaparte, Charles Lucien, 209
Bonpland, Aimé, 167
Bonsall, Benjamin, 33
Bradford, Samuel, 164
Breintnall, Joseph, 25, 32, 39, 238
British Museum, 22, 82
Buffalo Lick, 103–4
Buffon, George Louis Leclerc, Comte de, 79, 170, 238
degeneration of American species, 3, 8, 123
Histoire Naturelle, 4
Native Americans, 129, 132
Burke, Edmund, 139
Burns, Robert, 160
Bute. See John Stuart
Byrd, John, 27

Carpodacus purpureus, 109, 227
Carr, Robert, xi, 166, 197, 238
Catch Fly sensitive. See Dionaea muscipula
Catesby, Mark, 22, 43, 64, 77–78, 170, 238
plant transportation, 83
Chalmers, Lionel, 88, 97, 100, 112, 121, 238
on William Bartram's drawings, 110–11
Chelsea Physic Garden, 26, 42
Chester, Governor, 116
Cherokee, 103–4, 115, 127–28, 130, 138, 199

Child, Captain James, 43–44, 238

Circus cyaneus, 34, 40, 219

Colden, Cadwallader, 27–31, 38, 238

Coldengham, 28

Colden, Jane, 28–32, 34, 238

Coleridge, Samuel Taylor, 8, 10, 135–37

Collinson, Michael, 152

Collinson, Peter, ix, x, 54, 57, 68, 238

 admires William Bartram's drawings, 28, 40, 76

 birth of, 25

 concern for William, 19, 35–37, 47, 75

 death of, 80

 garden, 40

 in praise of Jane Colden, 29–30

 in praise of John Bartram Jr., 17–18

 introduced to John Bartram, 25

 Library Company, 39

 plant transportation, 83, 85

 promotes John Bartram, 28, 57

 promotes William Bartram, 28, 40, 80

 receives drawings from William, 28, 34, 44, 58, 73, 75

 Venus Flytrap, 48–49

 William Young, 54, 56

Comical sensitive plant. See *Dionaea muscipula*

Common Sense, 74, 120

Confucius, 39

Congress of Augusta, x, 97, 100, 103

Congress of Picolata, ix, 64, 70, 131

Continental Congress, 119, 127

Cook, Captain James, 20, 50, 83, 145

Cowkeeper, 105–7, 238

Creek, 64, 103–4, 115, 127, 199

 Government, 129

Cuscowilla, 104, 105–6, 107, 136

Darlington, William, 196, 197, 198

Darwin, Charles, 50, 93, 167, 213

Declaration of Independence, x, 57, 74, 119, 120

Deists, 20, 90

Delaware, 17, 40

Dendroica magnolia, 34, 36, 37, 219

Dionaea muscipula, ix, 48–59, 76, 84, 221–23

Dobbs, Arthur, ix, 47–49, 238

Douglas, David, 166

Duncan, Billy, 162, 238

Dunlap, William, 158

Edwards, George, 28, 40, 43, 77–78, 170, 238

in praise of William Bartram, 34

Ehret, Georg Dionysius, 25, 34, 40, 43, 77–78, 238

Elliott, Stephen, 67

Ellis, John, 53, 54, 57, 58, 238

 in praise of Jane Colden, 30–31

 plant transportation, 83–84

 Venus Flytrap, 50–51

Enlightenment, 4, 90 133–34, 212, 214

 and progress, 98, 132

 and religious toleration, 19

 civilizing notion, 125

Evelyn, John, 83, 98

Evening Primrose. See *Oenothera grandiflora*

Farquhar, William, 32

Fever Bark. See *Pinckneya bracteata*

Florida Sandhill Crane (Savanna Crane). See *Grus canadensis*

Fothergill, John, x, 1, 25, 81, 82, 238

 Barclays, 141–42

 Benjamin Franklin, 82

 education, 81

 garden, 82

 patron of William Bartram, 68, 83, 85, 87–88, 97

 Peter Collinson, 80, 81

 plant transportation, 83, 85

 receives drawings from William, 68, 76, 80, 86, 109, 110

 receives specimens from William, 102, 111, 117, 145

 slavery, 74

 William Young, 54, 56, 85

Franklin, Benjamin, ix, 25, 142, 157, 182, 239

 Ambassador to France, 205

 Amercian Philosophical Society, 7, 27, 183

 career of William Bartram, 36

 Franklinia alatamaha, 67, 68 157

 Library Company, 39

 slavery, 75

 support for John Bartram, 56

Franklinia alatamaha, x, 16, 111, 157, 122

 discovery of, 16, 64–67

 drawings of, 68

 in flower, 66, 111, 119, 121

 naming of, 67, 68, 144–45

 sent to Barclay, 143

Fraser, John, 144

Free Quakers, 121, 184

Galphin, George, 70, 97, 102–3, 239

Garden, Alexander, 27, 30, 57, 97, 121, 239

career for William Bartram, 36
 in praise of Jane Colden, 30–31
 William Young, 53
Gardenia, 57
Gentiana autumnalis, 34, 36, 37, 219
Gilliams, Jacob, 182, 183, 186, 187
Gordon, James, 25, 27, 49, 239
Gordonia pubescens, 67
Great Chain of Being Theory, 4, 8, 50, 148–51
Gronovius, Johann, 28, 32, 38, 40
Grus canadensis, 102, 109–10, 131, 227, 233

Hamilton, William, 167, 206, 211, 239
 garden, 158, 167, 206
Havell, Robert, 175
Haven, Samuel, 131
Hawkins, Benjamin, 128
Hill, John, ix, 51, 54–56, 57, 239
Humboldt, Alexander von, x, 167, 168, 182, 214, 239
 Peale Museum, 183, 186
Hutton, James, 93
Hydrangea quercifolia, 115, 143, 145, 228

International Code of Botanical Nomenclature, 145–46, 147
International Commission on Zoological Nomenclature, 148
International Union for Conservation of Nature, 48

Jefferson, Thomas, x, 1, 158, 161, 182, 239
 Ambassador to France, 205
 American Ornithology, 164, 170
 Monticello, 167
 Native Americans, 125, 128, 131
 patriotism, 1
 Peale Museum, 183
 Red River Expedition, 202
 rejection of Buffons ideas, 3, 123
 religious views, 92
 slavery, 74
Jeffersonian ideals, 3, 193, 203
John Bartram Association, 15
Johnson, Samuel, 56, 142

Kalm, Peter, 64, 239
Kalmia. See *Lyonia ferruginea*
Keats, George, 172–73
Keats, John, 172–73
King Charles II, 17
King George III, 53, 54, 56, 57, 142

King, William, 25, 40, 239

Lamboll, Thomas, 72, 89, 114, 239
Lantana camera, 196
Laurens, Henry, 70, 74, 100, 120, 239
 concern for William, 71–72
Lawson, Alexander, 161, 164, 172, 239
Lawson, John, 22
Leclerc, George Louis. *See* George Louis Leclerc Buffon
Leech, Isaac, 163
Leibniz, Gottfried, 4
Lepomis gulosus, 147–48, 241
Lesueur, Charles, 184, 186, 188, 189, 191, 239
Lettsom, John Coakley, 75, 84, 239
 plant transportation, 85
Lewis, Meriwether, 176, 177
Lewis and Clark expedition, x, 176–77, 183
 collections, 183, 189
Library Company, ix, 39
Linnaean classification, 4, 77, 79, 148, 179
 Cadwallader Colden, 28
 John Hill, 55
Linnaean binomial system, 143, 146
Linnaeus fils, 67, 203
Linnaeus, Carolus von, ix, 30, 31, 40, 79, 239
 intrduced to John Bartram, 27
 plant transportation, 83
 Venus Flytrap, 49, 50, 84
Linnean Society of London, 143, 196
Linnean Society of Philadelphia, 203
Locke, John, 20, 92
Logan, James, 27, 38, 39, 121, 239
Long Expedition, 195, 197, 198
Long, Major Stephen Harriman, 189
Loudon, John, 21
Lyon, John, x, 66, 239
Lyonia ferruginea, 104, 139, 227

Maclure, William, 75, 184, 190–1, 202, 239
 collecting trips, 186–87, 189
Magnolia Warbler. See *Dendroica magnolia*
Major Farmer, 115, 116
Maris, Mary, 15
Marshall, Humphry, 66, 67, 144, 195, 239
Marshall, Moses, 66, 239
Marsh Hawk. See *Circus cyaneus*
McCulloh, James, 131
McIntosh, John, 101–2, 103, 104, 239

McIntosh, Lachlan, 74, 97, 100, 120–22, 239

Mann, Camillus Macmahan, 183

Melsheimer, John, 182, 186

Mendenhall, Ann. See Ann Bartram

Michaux, André, 83, 158, 205–9, 239

Michaux, François, 145, 158, 159, 164, 205–9, 239

Mico Chlucco, 131–32, 229, 239

Miller, Johannes (John), 58, 222, 239

Miller, Philip, 26, 42, 83, 240

Miller, Sarah, 166, 177, 240

Montesquieu, 129

Muhlenberg, Henry, 167, 195, 200, 240

Muscogulge, 115, 125, 127

Native Americans, 2, 199. See also Cherokee, Creek, Delaware, Muscogulge, Seminole, Tuscarora
 deerskin trade, 103
 economy, 103
 languages, 128, 130
 Lost Race Theory, 131
 mound building, 130–31
 music, 128–29
 physical appearance, 130
 slavery, 74
 trade embargo, 104, 106, 107
 treatment by traders, 105

Natural History Museum, London, 8, 31, 112

Nelumbo lutea, 59, 76–77, 223

New Harmony, 189–91

Newton, Isaac, 3, 92

Newtonian science, 3, 4, 19, 90

Notes on the State of Virginia, 8, 123, 169

Nuttall, Thomas, 209–10, 240

Oenothera grandiflora, 116, 143, 145, 230

Ord, George, 158, 168, 177, 184, 215, 240
 Academy of Natural Sciences, 185
 American Ornithology, 160, 179
 biographer of Alexander Wilson, 160, 162, 170
 biographer of William Bartram, 92
 defender of Alexander Wilson, 175
 John James Audubon, 172
 on William's activities during American revolution, 120
 Thomas Say, 182, 187

Owen, Robert, 189, 190, 191

Paine, Tom, x, 129, 161–62, 182, 214, 240
 Common Sense, 74, 120

 religious views, 90
 slavery, 74

Parke, Thomas, 67

Parmantier, Nicholas, 183

Parrish, Robert, 131, 240

Peale, Charles Willson, x, 167, 197, 240
 Museum of Natural History, 168, 176, 182–83, 189
 portrait painter, 186, 189

Peale, Rubens, 186

Peale, Titian, 184–87, 189, 240

Pemberton, Israel, 56

Penn, Thomas, 56, 85, 240

Penn, William, 17, 19, 39, 121, 240

Pennant, Thomas, 173, 203

Petiver, James, 22, 83

Petre, Robert James, Eighth Baron, 27, 39, 228, 229, 240

Pinckneya bracteata, 64, 143, 228, 229
 in flower, 111, 119
 naming, 145

Pine-barren Gentian. See *Gentiana autumnalis*

plant collectors, 22–23, 25

plant introduction to Europe, 21–23, 53, 116, 205

plant transportation, 82–85

Pope, Alexander, 20, 39, 148

Portland, Margaret Cavendish, Duchess of, 80, 85, 86, 240

Puc Puggy. See William Bartram

Purple Finch. See *Carpodacus purpureus*

Quakers, ix, 25, 39, 91, 141
 American revolution, 121
 Darby Meeting, 39–40, 91
 education, 24, 37
 founding of Pennsylvania, ix, 16, 17, 19
 music, 129
 slavery, 73–75

Queen Charlotte, 51, 53, 56, 57

Rafinesque, Constantine, 67, 158, 179, 193–95, 240
 naming *Pinckneya bracteata*, 145

rattlesnake, 8, 68, 196, 223

Religious Society of Friends. See Quakers

Rittenhouse, David, 199

Roberts, James, 50, 58

Romanticism, 133–35, 212

Romantic poets, 8, 10, 133, 214
 William Bartram's influence, 93, 133–40

Rousseau, Jean Jacques, 126, 182

Royal Society, 3, 4, 55

Royal Society of Uppsala, 50
Rumsey, Mr., 116
Rush, Benjamin, 50, 74, 79, 120, 203, 240

Say, Benjamin, 181, 182, 184, 240
Say, Lucy, 176, 191, 234, 240
Say, Thomas, 3, 75, 173, 179, 193–94, 240
 Academy of Natural Sciences, 181, 183, 184
 Bartram garden, 158, 182
 death of, 191
 following Bartram's travels, 186–88
 interest in natural history, 182–83
 Long expedition, 189
 Native Americans, 186
 New Harmony, 189–91
 patriotism, 180, 184
 Quakers, 121, 181–82, 184
Schlegel, Karl Friedrich, 135
Seminole (Southern Creeks), 70, 124, 130, 131–32, 151
Sharp, Granville, 74
Shinn, John, 183
Silver Bluff, 70, 102
Sistare, Lucy Way. *See* Lucy Say
slavery, 73–75
Sloane, Sir Hans, 22, 26, 33, 170, 240
Solander, Daniel, 50, 80, 145, 240
Song Thrush. See *Turdus melodus*
Somerset, James, 74, 240
Spalding, James, 240
Spalding Stores, x, 89, 104, 106, 131, 186
Speakman, John, 182, 183, 184
Story, Enoch, 123, 199, 200, 240
Strelitzia reginae, 53, 54, 221
Stuart, John, 70, 97, 121, 128, 240
 Native Americans, 100–104
Stuart, John, Third Earl of Bute, 25, 54, 55, 240
Sublime, 105, 135, 139, 140
Swedish Royal Academy of Sciences, 50

Taylor, Simon, 40
Thomas, Mary, 89, 113, 122, 241
Thomson, Charles, 40, 121, 127, 241
Thorndon Hall, 27
Tindal, Matthew, ix, 20
Tipitiwitchet. See *Dionaea muscipula*
Tradescant, John, 22
Travels through North & South Carolina, Georgia, East & West Florida, x, 1, 89, 123–25

Troost, Gerard, 183
Tulipomania, 20
Turdus melodus, 170, 232
Tuscarora, 128

University of Pennsylvania, x, 37, 181, 182, 212
 William Bartram, 198, 203

Veratrum, 42
Venus Flytrap. See *Dionaea muscipula*

Walter, Thomas, 144–45, 241
Ward, Nathaniel, 82
Warmouth. See *Lepomis gulosus*
Washington, George, x, 158, 241
Waterton, Charles, 175, 241
Wedgwood, Josiah, 75
Whiston, William, 92
White King, 107, 241
Wilson, Alexander, x, xi, 3, 75, 241
 American citizen, 161
 American ornithology, 159, 160, 164, 209
 Benjamin Smith Barton, 200–201
 birth of, 159
 death of, 178
 desire to father a child, 166
 John James Audubon, 172–73, 175–76
 music, 159, 166
 Peale Museum, 186
 slavery, 177
 first meeting with William Bartram, 162
 living at Bartram house, 159, 162, 164
 Niagara Falls expedition, 163–64
 patriotism, 2, 168–69, 180
 poet, 159, 161, 163
 politics, 159, 161
 rejection of Buffon's ideas, 169–70
Woodlands. *See* Hamilton garden
Woolman, John, 73, 74
Wordsworth, William, 8, 135–39

Young, William, ix, x, 49–59, 63, 241
 Leech family, 163
 plant transportation, 85
 Queen's Botanist, 51–53
 trade with France, 205
 Venus Flytrap, 49, 51, 76

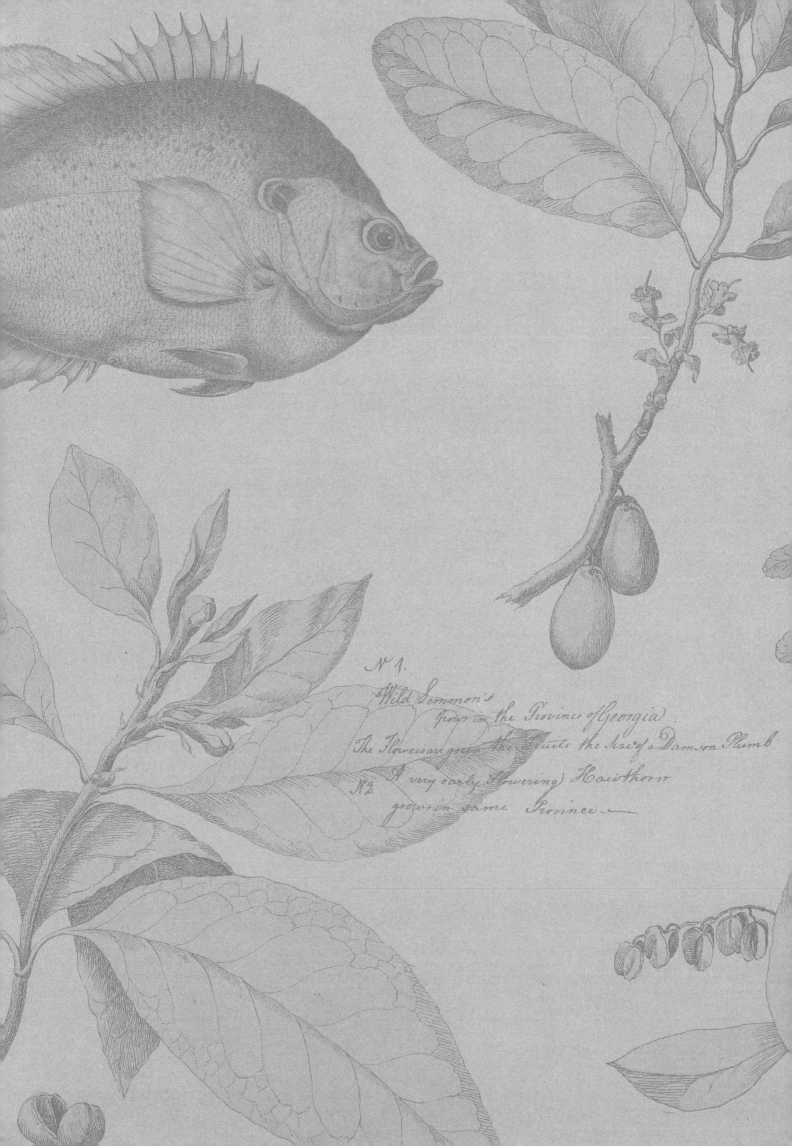

Nº 1.

Wild Lemmon's
grow in the Province of Georgia.
The Flowers are green the fruit the size of a Damson Plumb

Nº 2. A very early flowering Hawthorn
grow in same Province —